MASTERS *of*
NEW JEWELLERY
DESIGN

éclat

promopress

ÉCLAT Masters of New Jewellery Design
ÉCLAT Maestros de la Joyería Contemporánea
ÉCLAT Maîtres de la Bijouterie Contemporaine
ÉCLAT Mestres da Joalheria Contemporânea

Translators:
English: Tom Corkett
French: Marie-Pierre Teuler
Portuguese (Brazilian): Elisa Lopes Mayo
Editor: Montse Borràs
Curator: Carlos Pastor Climent
Graphic Design and Layout: Gemma Alberich
Cover Design: spread: David Lorente
with the collaboration of Carla Bosch

Cover images (clockwise)
Attai Chen: ©Attai Chen
Jiro Kamata: ©Jiro Kamata, Gesa Simons
Tanel Veenre: © Tanel Veenre
Backcover images (clockwise)
Kim Buck: © Kim Buck
Hilde de Decker: ©Hilde de Decker; Michiel Heffels
Ursula Güttmann: ©Elisabet Grebe

ISBN English version: 978-84-92810-97-0
ISBN Spanish version: 978-84-15967-36-1
ISBN French version: 978-84-15967-35-4
ISBN Portuguese version: 978-84-15967-37-8

Copyright © 2014 Promopress
Promopress is a brand of:
Promotora de Prensa Internacional S.A.
C/ Ausiàs March 124
08013 Barcelona, Spain
Phone: +34 93 245 14 64
Fax: +34 93 265 48 83
email: info@promopress.es
www.promopress.es
www.promopresseditions.com
Facebook: Promopress Editions
Twitter: Promopress Editions @PromopressEd

First published in English, Spanish, French and Portuguese:
2014

Printed in China.

MASTERS *of*
NEW JEWELLERY
DESIGN

éclat

MAESTROS
de la JOYERÍA
CONTEMPORÁNEA

MAÎTRES *de la*
BIJOUTERIE
CONTEMPORAINE

MESTRES *da*
JOALHERIA
CONTEMPORÂNEA

promopress

Introduction
/ English

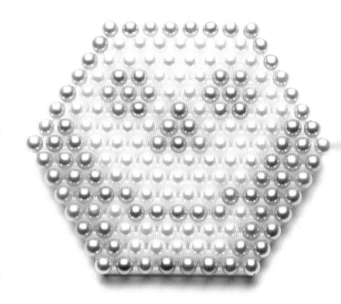

The jewellery scene is changing: while precious metals are traded at sky-high prices and many people sell their grandmother's jewellery because they believe that it is better to turn it into money than leave it stored in a case, some jewellers are creating wonderful works out of materials that nobody would have paid a penny for. The following pages show the beauty of everyday materials—paper, recycled wood or plastics, rubber, bone, charcoal—which can often be combined with other, more traditional ones but which also have their own aesthetic value. In the same way, and despite its use in jewellery since ancient times, silver is essential for technical and formal experimentation which, as many creators have shown, has no limits. There are some that still dare to work with gold, giving their pieces a meaning which stands out above the brightness of the metal itself. On the other hand, metals traditionally associated with industry such as titanium, steel or aluminium never cease to surprise us through the ways that some artists who know how to exploit their expressive qualities work with them.

What motivates jewellers to take risks like these? It is probably a challenge that has no rational explanation, yet it is one that is easy to understand if we think about the fact that gold and silver jewellery produced in large series has little much more value than its weight. What artist, at any point in history, would accept the value of his or her work being based only in the weight of its paint, clay or marble?

At the same time, by an opportune coincidence people who acquire jewellery are rejecting ostentation, preferring instead for a piece to have a power beyond its appearance. These are not times for ostentation, something which is in any case definitely in poor taste. Artists such as Kim Buck have understood this as well. The pieces in his series "Pumpous" (2012) explore with subtle irony the representation of content-free luxury: folded-up pure gold rings, which must be blown up with compressed air to be able to be used.

ÉCLAT: MASTERS OF NEW JEWELLERY DESIGN hopes to show that jewellery has ceased to be mere ornamentation. While it continues to fulfil the ancient need to embellish, it has developed other, overlapping values, resulting in objects that have meaning. Certain creators have come to sacrifice the wearability of their jewellery with a view to provoking some kind of public reaction, even a negative one, at the same time as reasserting a freedom that is very appealing to a sector of the public. After all, in many cultures jewellery is nothing but uncomfortable artefacts whose main function is symbolic and not practical.

The question "What is jewellery and what is its function?" serves for many creators as a starting point for creating jewellery that does not try to be beautiful in the classical sense of the term. This is the case of the Italian jeweller Fabrizio Tridenti: the beauty of his pieces is found on other levels, from their visual forcefulness to the multiple meanings they suggest.

Jewellery freed itself some time ago from many of its technical constraints and it does not just use the jeweller's own methods. Rather, it has investigated the heritage of other crafts and other technologies to integrate them based on the artistic language that each creator wants to develop. Artists such as the British Anthony Roussel offer good examples of this exploration through their exquisite marquetry works.

It has not been many years since the value of artisanal objects and the trades that made them possible fell practically into disuse with the arrival of industrial production. It was not only the low cost but also the novelty of the design that caused a substitution of artisanally produced everyday objects for new ones. Demand fell sharply and many trades disappeared during the twentieth century, in what was a great crisis of handicraft. Others survived because some craftsmen refused to simply disappear. Jewellery, among other handicrafts, was saved by this. And in order to save itself it decided at the same time to evolve towards avant-garde artistic currents, without rejecting the trade or age-old know-how. Artists like the masterful Hermann Jünger (Hanau, 1928-2005), a German jeweller who learned his craft after the Second World War under the influence of the ideas that the Bauhaus had previously promoted, left a lesson for subsequent generations by taking up his trade as a tool for formal and conceptual research without taking into account the value of the materials used. And this premise has been and is still valid for a large section of avant-garde jewellers, from the 1970s to the present.

Currently, various arts such as painting, engraving, sculpture or photography, and also very varied movements (minimalism, pop art and even arte povera and conceptual art) are converging, independently of how trends have been set, in the jeweller's work as ways of exploring the world. For the masters of this new jewellery, their craft is definitely an art as well as a form of artisanship and design.

I must end by thanking the generosity shown by the artists selected for contributing to this book's goal, which is none other than raising awareness of an exciting development whose cultural importance the media do not always reflect. Here we put it in the public eye so that everyone can make their own judgements.

Carlos Pastor.
Valencia, 2014.

Introducción
/ español

El panorama de la joyería está cambiando: mientras los metales preciosos se cotizan por las nubes y mucha gente vende las joyas de la abuela porque cree que es mejor convertirlas en dinero que tenerlas guardadas en un estuche, algunos joyeros realizan maravillosos trabajos en materiales por los que nadie hubiera dado un céntimo. Las páginas que siguen muestran de la belleza de materiales cotidianos - papel, maderas o plásticos reciclados, caucho, huesos, carbón- que, si bien a menudo se combinan otros más tradicionales, también demuestran su propio valor estético. Del mismo modo, la plata es esencial para la experimentación técnica y formal que, según demuestran muchos autores, no tiene límites, pese a la antigüedad de su empleo en joyería. Los hay que todavía se atreven a trabajar con oro, transmitiendo a sus piezas un significado que destaca por encima del brillo del material. Por otro lado, metales como el titanio, el acero o el aluminio, que asociamos con la industria, no dejan de sorprendernos al ser manipulados por algunos artistas que saben cómo explotar sus cualidades expresivas. ¿Qué motiva a los nuevos joyeros a arriesgar de esta forma? Probablemente es un desafío que no tiene explicación racional y, sin embargo, es fácil de entender si pensamos que la joyería en oro y plata fabricada en grandes series no tiene más valor que el de su peso. ¿Qué artista, en cualquier época de la historia, aceptaría que el valor de su obra consistiera solo en el peso de la pintura, la arcilla o el mármol?

Junto a esto, se da una oportuna coincidencia: a menudo, quien adquiere una joya rechaza la ostentación y prefiere que la pieza tenga un poder más allá de su apariencia. No están los tiempos para la ostentación que, en todo caso, es definitivamente algo de muy mal gusto. Artistas como Kim Buck lo han entendido así: sus piezas de la serie "Pompous" (2012) exploran con sutil ironía la representación del lujo sin contenido: anillos de oro puro plegados, que deben hincharse con aire a presión para poder ser usados.

ÉCLAT; MAESTROS DE LA JOYERÍA CONTEMPORÁNEA quiere demostrar que la joyería ha dejado de ser solo un adorno. Si bien sigue cumpliendo la necesidad ancestral de embellecer, desarrolla otros valores que se superponen, resultando en objetos con significado. Determinados autores llegan a sacrificar la portabilidad de sus joyas buscando en el público algún tipo de reacción, incluso negativa, a la vez que reafirman una libertad que para un sector del público resulta muy atractiva. Al fin y al cabo, en muchas culturas, las joyas no son sino artefactos incómodos cuya principal función es simbólica y no práctica. La misma pregunta "¿qué es la joyería y cuál es su función?" sirve a muchos autores como punto de partida para crear joyas que no tratan de ser bellas en el sentido clásico del término. Es el caso del joyero italiano Fabrizio Tridenti,. La belleza de sus piezas reside en otros registros, desde su contundencia visual hasta los múltiples significados que sugieren.

Hace tiempo que la joyería también se ha liberado de muchas ataduras en el aspecto técnico y no solo se utilizan los procedimientos propios del joyero sino que se investiga en el acervo de otras artesanías y otras tecnologías para integrarlas en función del lenguaje plástico que desea desarrollar cada autor. Bueno ejemplos de esto nos proponen creadores como el británico Anthony Roussel, con sus exquisitos trabajos en marquetería.

No hace tantos años que el valor de los objetos de artesanía, los oficios que los hacían posibles y la demanda, en definitiva, cayeron con la llegada la producción industrial. No solo era el bajo coste sino también la novedad del diseño los que impulsaban a sustituir los objetos cotidianos producidos artesanalmente por los nuevos. Muchos oficios desaparecieron a lo largo del siglo XX en esa gran crisis de la artesanía. Otros sobrevivieron porque algo tenía que sobrevivir y porque algunos artesanos se negaron a desaparecer sin más. La joyería, entre otras artesanías, se salvó gracias a esto. Y para ello decidió evolucionar en paralelo hacia las corrientes artísticas de vanguardia, sin despreciar un oficio o saber hacer milenario. Artistas como el maestro Hermann Jünger (Hanau 1928- 2005), joyero alemán formado después de la Segunda Guerra Mundial bajo la influencia de las ideas que anteriormente había promovido la Bauhaus, dejó una lección para las generaciones siguientes asumiendo su oficio como una herramienta para la investigación formal y conceptual sin importar el valor de los materiales utilizados. Y esta premisa sigue siendo válida para una buena parte de los joyeros de vanguardia desde los años setenta hasta el presente.

Actualmente diversas artes, como la pintura, el grabado, la escultura o la fotografía, y muy variadas tendencias ajenas a lo que marcan las modas (el minimalismo, el pop-art, incluso el *arte povera* y el arte conceptual) confluyen en el quehacer joyero: tienen cabida como formas de explorar el mundo para los maestros de la nueva joyería.

Hay que agradecer, por último, la generosidad mostrada por los autores seleccionados al contribuir con el propósito de este libro, que no es otro sino divulgar una excitante actualidad que los medios de comunicación no siempre reflejan en la medida de su importancia cultural y que ahora ponemos al alcance del público para que cada uno haga sus propias valoraciones.

Carlos Pastor.
Valencia, 2014.

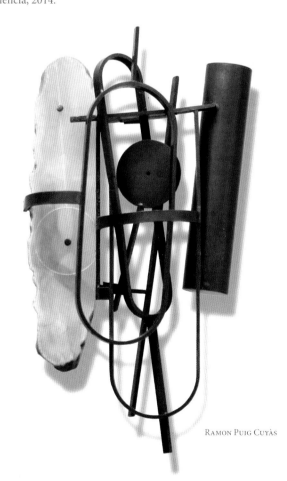

RAMON PUIG CUYÀS

Introduction
/ français

Le monde de la bijouterie est en pleine mutation. Alors que le prix des métaux précieux s'envole et que les gens convertissent en argent sonnant et trébuchant leurs bijoux de famille, certains artisans se sont mis à créer de magnifiques parures dans des matières pour lesquelles personne n'aurait donné un centime. Le présent ouvrage montre la beauté des matériaux de la vie quotidienne – papier, bois ou plastique recyclé, caoutchouc, os, charbon – qui possèdent une réelle valeur esthétique et sont souvent combinés à d'autres matières plus classiques. Par ailleurs, même si l'argent est employé en bijouterie depuis l'antiquité, il fait aujourd'hui l'objet d'expérimentations techniques et de nouvelles applications qui repoussent ses limites, comme le démontrent les œuvres de certains artistes exposées dans ces pages. D'autres créateurs choisissent l'or pour donner à leurs bijoux un sens allant bien au-delà de l'éclat de la matière. Des métaux comme le titane, l'acier ou l'aluminium, généralement associés à l'industrie, nous surprennent lorsqu'ils sont travaillés par des artistes qui savent tirer partie de leurs qualités expressives.

Qu'est-ce qui pousse les nouveaux bijoutiers à se risquer hors des sentiers battus ? Leur défi n'est probablement pas un choix rationnel. Mais on les comprend facilement quand on sait que les bijoux en or et en argent fabriqués en série ne valent guère plus que leur poids en métal. Quel artiste, et de quelle époque, accepterait que la valeur de son œuvre soit égale au poids de la peinture, de l'argile ou du marbre employé ?

Une heureuse coïncidence favorise également ce changement : de nos jours, une personne n'achète pas un bijou pour son côté ostentatoire. Elle recherche un objet qui possède un pouvoir situé au-delà de son apparence. À notre époque, le faste fait mauvais genre.

Des artistes comme Kim Buck l'ont bien compris. Ses bijoux de la série « Pompous » (2012) explorent avec une ironie subtile la représentation du luxe sans contenu : ce sont des bagues d'or pur cousu que l'on doit gonfler d'air pour pouvoir les porter.

L'ouvrage ÉCLATS démontre que le bijou n'est plus un simple ornement. S'il a toujours la mission ancestrale d'embellir, il possède de nos jours d'autres valeurs qui le transforment en objet chargé de sens. Certains artistes vont jusqu'à sacrifier la notion de portabilité pour provoquer une réaction quelconque, positive ou non, afin de réaffirmer une liberté de création très appréciée d'un certain public. Après tout, il existe de nombreuses cultures où les bijoux sont des objets peu pratiques qui ont une fonction symbolique et non pas fonctionnelle. La question « qu'est-ce qu'un bijou et à quoi sert-il ? » est le point de départ de nombreux artistes qui cherchent à créer des objets pas forcément beaux dans le sens classique du terme. Dans le cas du bijoutier italien Fabrizio Tridenti, la beauté de ses créations existe à d'autres niveaux, comme leur force visuelle et les significations multiples qu'elles suggèrent.

Cela fait un moment que la joaillerie et la bijouterie se sont libérées de certaines contraintes techniques, et qu'elles tirent partie de procédés d'autres branches artisanales et de diverses technologies pour développer un langage plastique propre à chaque créateur. Des artistes comme le Britannique Anthony Roussel nous offrent, à travers leur travail de marqueterie, de magnifiques exemples de cette fusion.

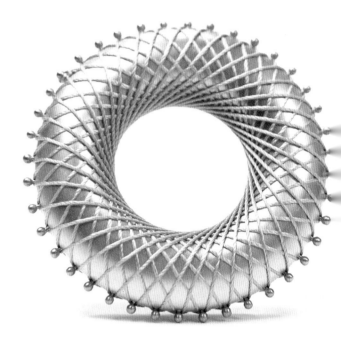

EZRA SATOK-WOLMAN

Il n'y a pas si longtemps que les produits et le travail artisanaux sont tombés en désuétude : la crise de ce secteur a commencé avec l'arrivée de la production industrielle. Si les objets quotidiens fabriqués de manière artisanale ont disparu aussi rapidement, c'est parce qu'ils ont été remplacés par des articles moins chers et d'un style entièrement nouveau, deux qualités qui ont su conquérir le public. La demande de produits artisanaux s'est réduite comme peau de chagrin et de nombreux métiers ont disparu au cours du XXᵉ siècle. Certains savoir-faire ont cependant survécu grâce à la ténacité de quelques artisans. C'est le cas de la bijouterie et de la joaillerie qui ont dû s'adapter en parallèle aux différents courants artistiques d'avant-garde, tout en restant fidèle à leurs acquis et à leurs traditions millénaires. Des artistes comme l'orfèvre allemand Hermann Jünger (Hanau 1928- 2005), qui s'est formé après la Seconde Guerre mondiale et a été influencé par le courant du Bauhaus, a montré l'exemple aux générations suivantes en se servant de son métier comme d'un outil de recherche formel et conceptuel, au-delà de la valeur des matériaux utilisés. Et ce principe est toujours valable pour bon nombre de bijoutiers d'avant-garde des années 70 à ce jour.

À l'heure actuelle, différents arts comme la peinture, la gravure, la sculpture et la photographie et diverses tendances (le minimaliste, le pop-art, l'arte povera et l'art conceptuel) imperméables aux diktats de la mode font partie de la panoplie du bijoutier qui lui permet d'explorer le monde. Il est clair qu'au-delà d'une forme d'artisanat ou de création, les maîtres de la bijouterie contemporaine considèrent leur métier comme un art.

Il convient de remercier les différents artistes sélectionnés qui ont participé aimablement à ce livre. Il a pour but de diffuser une actualité fascinante sur ces objets dont l'importance culturelle est trop souvent ignorée par les médias et que nous présentons aujourd'hui au public qui saura les apprécier à leur juste valeur.

Carlos Pastor.
Valencia, 2014.

Introdução
/ português

O panorama da joalheria está mudando: enquanto os metais preciosos se valorizam as alturas e muita gente vende as joias da avó porque acredita que é melhor convertê-las em dinheiro do que tê-las guardadas num estojo; alguns joalheiros realizam maravilhosos trabalhos em materiais pelos quais ninguém daria um centavo. As páginas que seguem mostram a beleza dos materiais cotidianos – papel, madeira ou plástico reciclado, borracha, ossos, carvão – que com frequência se combinam com outros mais tradicionais, mas que também reclamam seu próprio valor estético. Do mesmo modo, levando-se em conta a longevidade do seu uso na joalheria, a prata é essencial para uma experiência técnica e formal que, segundo demonstram muitos autores, não tem limites. Há, no entantos que se atrevem a trabalhar com o ouro, dotando às suas peças de um significado que se destaca acima do brilho do material. Por outro lado, metais como o titânio, o aço ou o alumínio - tradicionalmente associados com a indústria, não deixam de nos surpreender ao serem manipulados por alguns artistas que sabem como explorar as suas qualidades expressivas. O que motiva os novos joalheiros a arriscarem desta forma? Provavelmente seja um desafio que não tem explicação racional e, no entanto, é fácil entender se pensarmos que a joia de ouro e prata fabricada em grande serie não tem muito mais valor que o do seu peso. Que artista, em qualquer época da história, aceitaria que o valor da sua obra consistisse só no peso da pintura, da argila ou do mármore?

Paralelamente, se produz uma coincidência oportuna: com frequência, quem adquiriu uma joia ignora a ostentação e prefere que a peça tenha um poder mais além da sua aparência. Estes não são tempos para a ostentação que, em todo caso, é definitivamente algo de muito mau gosto. Artistas como Kim · Buck entenderam assim: suas peças da serie "Pompous" (2012) exploram com a sua sutil ironia a representação do luxo sem conteúdo: anéis de ouro puro dobrados, que devem inchar-se com ar pressurizado para serem usados.

ÉCLAT: MESTRES DA JOALHERIA CONTEMPORÂNEA quer demonstrar que a joalheria deixou de ser só um ornamento. Ainda que segue cumprindo a necessidade ancestral de embelezar, desenvolve outros valores que se sobrepõem a este, resultando em objetos com significado. Determinados autores chegam a sacrificar o uso das suas joias buscando no público algum tipo de reação, até negativa, uma vez que reafirmam uma liberdade que, para um setor do público, resulta muito atrativa. No fim das contas, em muitas culturas, as joias não são senão artefatos incômodos cuja principal função é simbólica e não prática.

A pergunta "o que é a joia e qual é a sua função?" serve para muitos autores como o ponto de partida para criar joias que não se tratam de ser belas no sentido clássico do termo. É o caso do joalheiro italiano Fabrizio Tridenti: a beleza das suas peças se encontra em outros registros, desse a sua contundência visual até os múltiplos significados que sugerem. Faz tempo que a joalheria se liberou de muitas amarras no aspecto técnico e não só utilizam os procedimentos próprios do joalheiro e sim que se investiga no acervo de outros artesanatos e outras tecnologias para integrá-las em função da linguagem plástica que deseja desenvolver cada autor. Criadores como o britânico Anthony Roussel, com seus requintados trabalhos em marchetaria, nos propõem bons exemplos desta exploração.

Não faz tantos anos que o valor dos objetos de artesanato e as profissões que os tornavam possíveis caíram praticamente em desuso com a chegada da produção industrial. Não era só o baixo custo como também a novidade do desenho que os impulsionavam a substituir os objetos cotidianos produzidos artesanalmente pelos novos. A procura se reduziu drasticamente e muitas profissões desapareceram ao longo do século XX, nesta grande crise do artesanato. Outros sobreviveram porque alguns artesãos se negaram a desaparecer. A joalheria, entre outros artesanatos, se salvou graças a isto. E ela decidiu evoluir em paralelo com as correntes artísticas da vanguarda sem rejeitar uma profissão ou know-how milenar. Artista como o maestro Hermann Jünger (Hanau 1928-2005), joalheiro alemão formado depois da Segunda Guerra Mundial influenciado pelas influências das ideias que anteriormente Bauhaus havia promovido, deixou uma lição para as gerações seguintes assumindo sua profissão como uma ferramenta para a investigação formal e conceitual sem ter em conta o valor dos materiais utilizados. E esta premissa continua sendo válida para uma boa parte dos joalheiros de vanguarda desde os anos setenta até hoje.

Atualmente, diversas artes como a pintura, a gravura, a escultura ou a fotografia, e também muitas tendências variadas (o minimalismo, o pop-art, inclusive a arte povera e a arte conceitual), alheias ao que a moda manda, convergem na obra do joalheiro, como maneiras de explorar o mundo. Definitivamente, para os maestros da nova joalheria, sua profissão é uma arte mais além da forma de artesanato e desenho.

Quero agradecer por último, a generosidade mostrada pelos autores selecionados ao contribuir com o propósito deste livro, que não é outro senão o de divulgar uma emocionante atualidade que os meios de comunicação nem sempre refletem a altura da sua importância cultural e que agora colocamos ao alcance do público para que cada um faça as suas próprias avaliações.

Carlos Pastor.
Valencia, 2014.

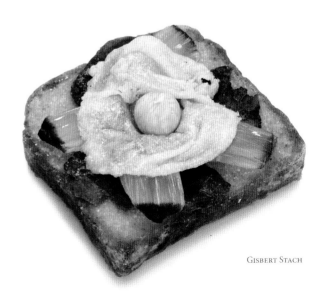

GISBERT STACH

index

Anat
Aboucaya

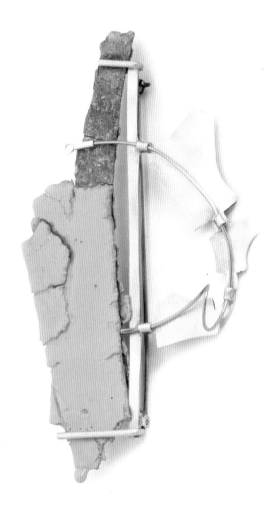

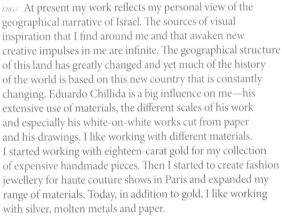

ENG / At present my work reflects my personal view of the geographical narrative of Israel. The sources of visual inspiration that I find around me and that awaken new creative impulses in me are infinite. The geographical structure of this land has greatly changed and yet much of the history of the world is based on this new country that is constantly changing. Eduardo Chillida is a big influence on me—his extensive use of materials, the different scales of his work and especially his white-on-white works cut from paper and his drawings. I like working with different materials. I started working with eighteen-carat gold for my collection of expensive handmade pieces. Then I started to create fashion jewellery for haute couture shows in Paris and expanded my range of materials. Today, in addition to gold, I like working with silver, molten metals and paper.

ESP / En la actualidad mi trabajo refleja mi visión personal de la narrativa geográfica de Israel. Son infinitas las fuentes de inspiración visual que encuentro a mi alrededor y que despiertan en mí nuevos impulsos creativos. La estructura geográfica de esta tierra ha cambiado enormemente y sin embargo, gran parte de la historia del mundo se asienta en este país nuevo y en constante transformación. Eduardo Chillida es una gran influencia para mí: su amplio uso de materiales, las distintas escalas de su trabajo y, especialmente, sus obras blanco sobre blanco a base de papel cortado y sus dibujos. Me gusta trabajar con distintos materiales. Empecé a trabajar con oro de 18 kilates para mi colección de valiosas piezas hechas a mano. Luego, comencé a crear joyería de moda para los desfiles de alta costura en París, y amplié mi abanico de materiales. Hoy en día, además del oro, me gusta trabajar con plata, metales fundidos y papel.

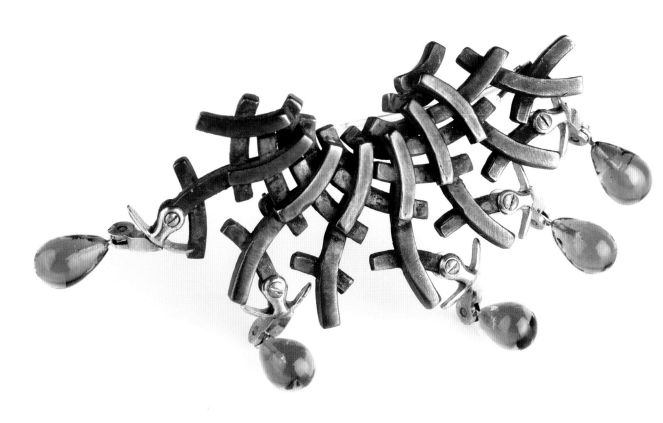

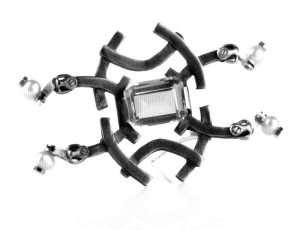

POR / Na verdade meu trabalho reflete minha visão pessoal da narrativa geográfica de Israel. São infinitas as fontes de inspiração visual que encontro ao meu redor e que despertam em mim novos impulsos criativos. A estrutura geográfica desta terra mudou muito e, no entanto, grande parte da história do mundo se assenta neste país novo e em constante transformação. Eduardo Chillida é uma grande influência para mim: seu amplo uso de materiais, as diferentes escalas de seu trabalho e, especialmente, suas obras branco sobre branco à base de papel cortado e seus desenhos. Eu gosto de trabalhar com materiais diferentes. Comecei a trabalhar com ouro de 18 quilates para a minha coleção de peças valiosas feitas à mão. Logo, comecei a criar joias de moda para os desfiles de alta-costura em Paris, e aumentei meu leque de materiais. Hoje em dia, além do ouro, eu gosto de trabalhar com prata, metais fundidos e papel.

FRA / Mon travail reflète ma propre vision de la narrative géographique d'Israël. Les sources d'inspiration visuelle qui m'entourent sont infinies ; elles réveillent en moi de nouveaux élans créateurs. La structure géographique de cette terre a énormément changé, et pourtant, une part importante de l'histoire du monde découle de ce pays neuf en constante transformation. Je dois beaucoup à Eduardo Chillida : son emploi de matériaux très variés, son travail dans différentes échelles et surtout ses œuvres en noir et blanc à base de papier découpé, ainsi que ses dessins. J'aime travailler avec différents matériaux. J'ai commencé avec de l'or à 18 carats pour ma collection de bijoux de prix faits à la main. Ensuite, je suis passée aux bijoux de mode pour les défilés de haute couture à Paris et j'ai agrandi ma palette de matériaux. Aujourd'hui, outre l'or, j'ai plaisir à utiliser l'argent, les métaux fondus et le papier.

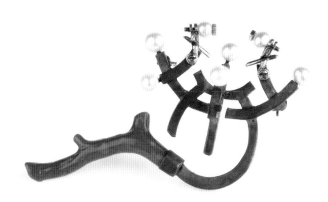

Tobias
Alm

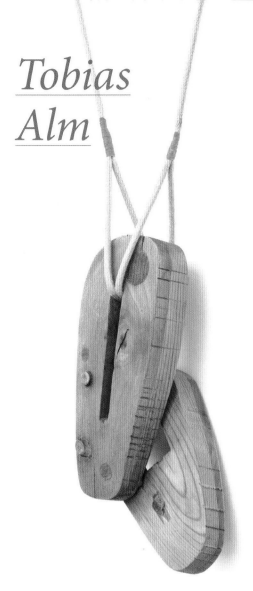

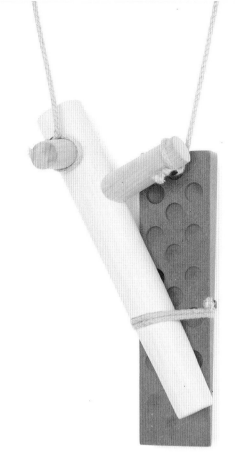

ENG/ At the moment I am very interested in exploring
what happens when a tool's functions are disabled, blocked.
Are the features that put it in action still there? Could this
transformation reveal new attributes that until now were
unknown? Making jewellery from objects that show traces
of their practical functions creates an interesting conflict
between ornamental and the pragmatic.

Lately I have been very influenced by Lawrence Weiner
and his interest in erasing the boundaries between
representation and represented, the idea and the action.
Antony Gormley's work on human skin as a membrane
that separates the internal world from the external is very
important to me as a jeweller.

I like to combine complex techniques for working with
wood with very basic DIY techniques. Through this I explore
concepts such as *professional* and *amateur*, *rigour*
and *play*. The pieces that interest me most are necklaces and
brooches. Necklaces are related to the lanyard: a piece
of rope that connects a valuable object to the body, ensuring that it
is not lost and also keeping it at hand, showing that a piece
of jewellery is both an ornament and a useful object.
The brooch, on the other hand, is the wearer's second
face and influences his or her identity.

ESP/ Hoy en día me interesa mucho explorar qué ocurre
cuando las funciones de una herramienta son desactivadas,
obstruidas. ¿Persiste todavía esa cualidad que llama a la acción?
¿Podría entonces esta transformación revelar nuevos atributos
hasta ahora desconocidos? Hacer joyas a partir de objetos que
muestran trazas de sus funciones prácticas crea un interesante
conflicto entre lo ornamental y lo pragmático.

Últimamente me siento muy influido por Lawrence Weiner
y su interés en borrar los límites entre la representación
y lo representado, la idea y la acción. También es muy
importante para mí como joyero el trabajo de Anthony
Gormley, su investigación de la piel humana como
membrana que separa el mundo interior del exterior.

Me gusta combinar técnicas complejas de trabajar la madera
con otras muy básicas de bricolaje. Así exploro conceptos
como *profesional* o *aficionado*, *rigor* y *juego*. Las piezas
que más me interesan son los collares y los broches. El collar
está relacionado con el lanyard: un pedazo de cuerda que
une un objeto de valor al cuerpo, asegurando que no se pierda
y también manteniéndolo a mano, poniendo de manifiesto
que una joya es tanto un ornamento como un objeto útil.
El broche en cambio es un segundo rostro del portador
e influye en su identidad.

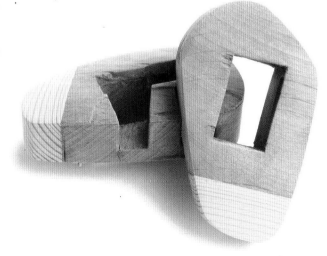

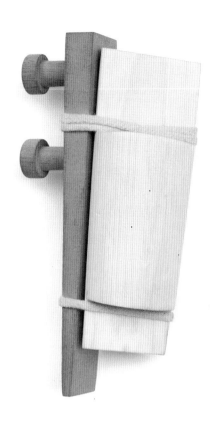

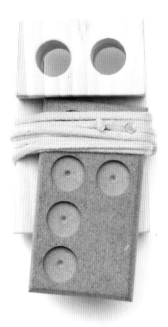

POR / Hoje em dia me interessa muito explorar o que ocorre quando as funções de uma ferramenta são desativadas, obstruídas. Ainda continua esta qualidade que busca uma ação? Poderia então esta transformação revelar novos atributos até agora desconhecidos? Fazer joias, a partir de objetos que mostram traços de suas funções práticas, cria um conflito interessante entre o ornamental e o pragmático.

Ultimamente me sinto muito influenciado por Lawrence Weiner e seu interesse em apagar os limites entre a representação e o representado, a ideia e a ação. Também é muito importante para mim, como joalheiro, o trabalho de Anthony Gormley, sua investigação da pele humana como membrana que separa o mundo interior do exterior.

Eu gosto de combinar técnicas complexas de trabalhar a madeira com outras muito básicas do "faça você mesmo". Assim, exploro conceitos como *profissional* ou *entusiasta*, *rigor* e *jogo*. As peças que mais me interessam são os colares e os broches.

O colar está relacionado com o "lanyard": um pedaço de corda que une um objeto de valor ao corpo, assegurando-o que não se perca e também mantendo-o a mão, demonstrando que a joia é tanto um ornamento como também um objeto útil. O broche, ao contrário, é um segundo rosto do usuário e influência a sua identidade.

FRA / Ce qui m'intéresse beaucoup en ce moment, c'est de voir ce qui se passe lorsque les fonctions d'un outil sont désactivées ou bloquées. Ses capacités d'action existent-elles toujours ? La transformation va-t-elle révéler des attributs qui n'étaient pas apparents jusque là ? Fabriquer des bijoux à partir d'objets qui conservent des traces de leurs fonctions pratiques crée un conflit intéressant entre le décoratif et le pragmatique. Ces derniers temps, je suis plutôt influencé par Lawrence Weiner qui cherche à effacer les limites entre la représentation et le représenté, entre l'idée et l'action. Les recherches d'Anthony Gormley sur la peau, vue comme une membrane qui sépare le monde extérieur de l'intérieur, ont aussi une incidence notable sur mon activité de bijoutier.

J'aime associer les techniques sophistiquées du travail du bois à des méthodes basiques de bricolage. Cela me permet d'explorer des concepts à titre de *professionnel* et *d'amateur*, en combinant la *rigueur* et le *jeu*. Ce qui me passionne le plus, ce sont les colliers et les broches. Le collier dérive du cordon que l'on portait autour du cou auquel on accrochait un objet de valeur pour ne pas le perdre et l'avoir toujours sous la main. On voit bien qu'un bijou est tout autant un ornement qu'un objet utilitaire. En revanche, une broche est comme le deuxième visage de celui qui le porte. Elle influence son identité.

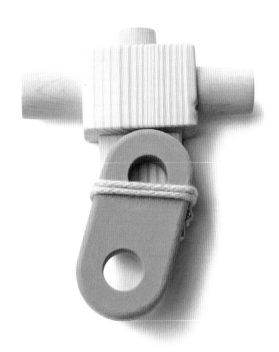

Eugènia Arnavat

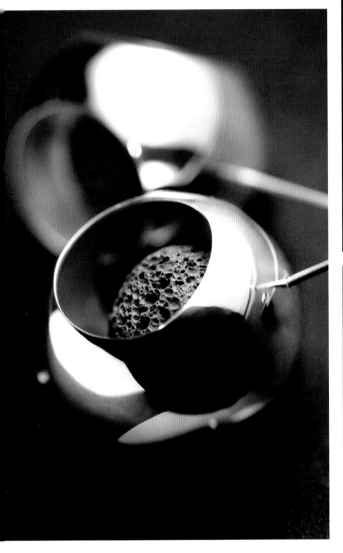

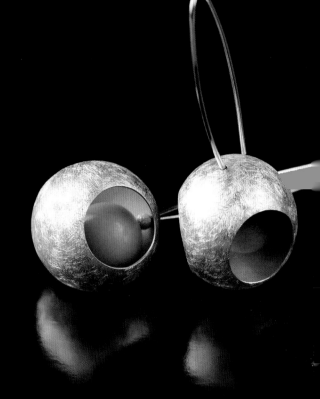

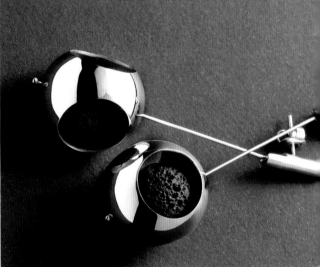

ENG / The main goal of my work is to externalise thoughts, emotions and experiences, and to translate concepts. Jewellery, like art, is a path to self-knowledge; it makes me ask questions and seek answers. My main inspiration source is nature. I like walking and collecting seeds, stones and plant elements that I then incorporate into my pieces. I also like to observe landscapes, objects and situations that suggest ideas to me for my work. I want to explore symbols, space, sex, motherhood… I don't seek inspiration from the world of jewellery, but I am interested in the work of jewellers such as Katja Prins, Hilde de Decker, Mari Ishikawa, Stefano Marchetti and Graziano Visintin, amongst others. I'm attracted to contemporary art, photography, architecture and sculpture: Chillida is a reference for me. I use the classic techniques of metallic jewellery, such as *embatado* to create volume, and embedded metal and combinations of different materials to give colour to my pieces. I'm fond of metals, especially silver. I also work with all kinds of natural materials. I use stones, gems, wood, bone, seeds, plant elements…

ESP / El objetivo principal de mi trabajo es exteriorizar pensamientos, emociones, vivencias… plasmar conceptos. La joyería, como el arte, es un camino hacia el auto-conocimiento, me hace plantear preguntas y buscar respuestas. Mi fuente de inspiración principal es la naturaleza. Me gusta caminar y recoger semillas, piedras y elementos vegetales que después incorporo en mis piezas. También me gusta observar paisajes, objetos y situaciones que me sugieren ideas para mi trabajo. Me interesa explorar símbolos, el espacio, el sexo, la maternidad… No busco la inspiración el mundo de la joyería pero me interesa el trabajo de joyeros como Katja Prins, Hilde de Decker, Mari Ishikawa, Stefano Marchetti o Graziano Visintin, entre otros. Me atrae el arte contemporáneo, la fotografía, la arquitectura y la escultura: Chillida es un referente para mí. Utilizo las técnicas clásicas de la joyería en metal, como el embatado para dar volumen, incrustaciones de metales y combinaciones de diferentes materiales para dar color a mis piezas. Tengo predilección por los metales, sobre todo la plata. También trabajo con todo tipo de materiales naturales. Utilizo piedras, gemas, madera, hueso, semillas, elementos vegetales…

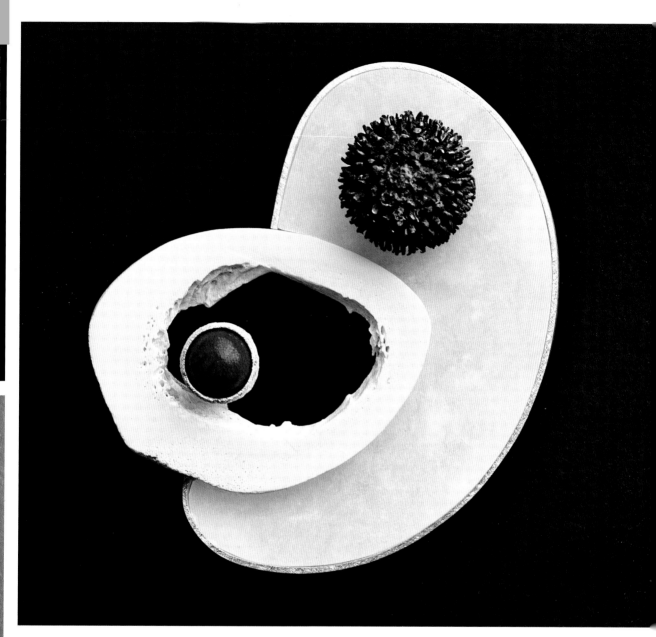

FRA / Le principal objectif de mon travail est d'extérioriser mes pensées, mes émotions, mes expériences, de donner une forme à des concepts. À l'instar de l'art, la joaillerie est une quête qui permet de se découvrir soi-même. Elle m'oblige à me poser des questions et à chercher des réponses. La nature est ma source d'inspiration de choix. J'adore me promener et ramasser des graines, des cailloux et des éléments végétaux que je vais ensuite intégrer à mes œuvres. J'aime aussi contempler les paysages, observer les objets et les situations qui m'inspireront ensuite des idées pour mon travail. Je trouve que c'est passionnant d'explorer les symboles, l'espace, la sexualité, la maternité… Le monde de la joaillerie n'est pas le moteur de ma créativité, même si j'apprécie le travail de joailliers comme Katja Prins, Hilde de Decker, Mari Ishikawa, Stefano Marchetti et Graziano Visintin. L'art contemporain, la photographie, l'architecture et la sculpture m'attirent. Chillida est pour moi une référence. J'utilise les techniques classiques en bijouterie pour travailler le métal. Par exemple, l'emboutissage qui donne du volume, l'incrustation de métaux et la combinaison de différentes matières qui donne de la couleur à mes créations. J'ai une prédilection pour les métaux, surtout pour l'argent. J'aime aussi travailler avec toutes sortes de matériaux naturels. J'utilise des pierres, précieuses ou pas, du bois, de l'os, des graines, des éléments végétaux…

POR / O objetivo principal do meu trabalho é exteriorizar os pensamentos, as emoções, as vivências… Traduzir conceitos. A joalheria, como a arte, é um caminho até o autoconhecimento, me faz questionar e buscar respostas. A minha fonte de inspiração principal é a natureza. Eu gosto de caminhar e colher sementes, pedras e elementos vegetais que depois eu incorporo em minhas peças. Também gosto de observar paisagens, objetos e situações que me sugerem ideias para o meu trabalho. Me interessa explorar símbolos, o espaço, o sexo, a maternidade…Não busco a inspiração no mundo da joalheria, mas me interessa o trabalho de ourives como Katja Prins, Hilde de Decker, Mari Ishikawa, Stefano Marchetti ou Graziano Visintin, entre outros. Me atraem a arte contemporânea, a fotografia, a arquitetura e a escultura: Chillida é uma referência para mim. Utilizo as técnicas clássicas da joalheria em metal, como a justaposição para dar volume, incrustações de metais e combinações de diferentes materiais para dar cor as minhas peças. Tenho preferência pelos metais, especialmente a prata. Também trabalho com todo tipo de material natural. Utilizo pedras, gemas, madeira, osso, sementes, elementos vegetais…

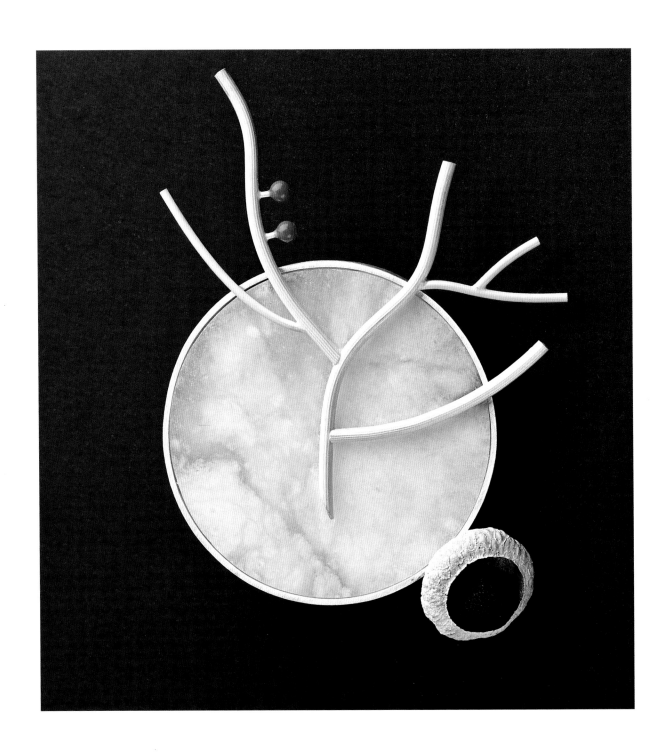

Jewellery, like art, is a path to
self-knowledge; it makes me ask
questions and seek answers.

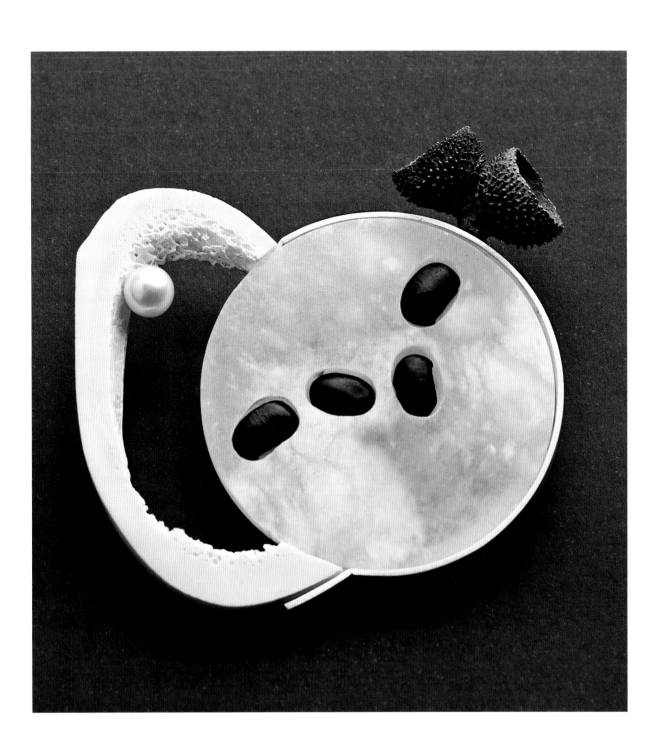

Volker Atrops

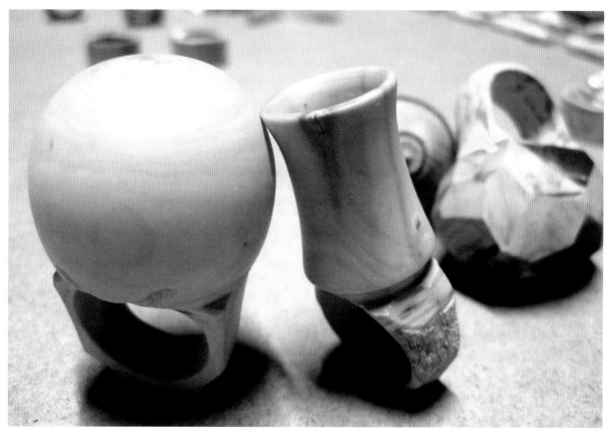

ENG / My favourite materials are skin, the body, wood, grass, fish, wool, caffeine... I use the techniques that I have to hand: when I prepare a meal, I likewise use the available ingredients. I read one book a year, I listen to one record a week, I see one show a month, I watch a film every day and have ten dreams every night. Everything inspires me: right now, it's the rain I see falling against the window. When I was twelve years old I wanted to be a scuba diver; I'm interested in what you can't see with the naked eye.

ESP / Mis materiales favoritos son la piel, el cuerpo, la madera, la hierba, los peces, la lana, la cafeína… Utilizo las técnicas que tengo a mano: cuando preparo un plato, también uso los ingredientes disponibles. Leo un libro al año, escucho un disco a la semana, veo una exposición al mes, veo una película cada día y tengo diez sueños cada noche. Me inspira todo: ahora mismo, la lluvia que veo caer tras la ventana. Cuando tenía doce años quería ser submarinista, me interesa aquello que no se puede ver a simple vista.

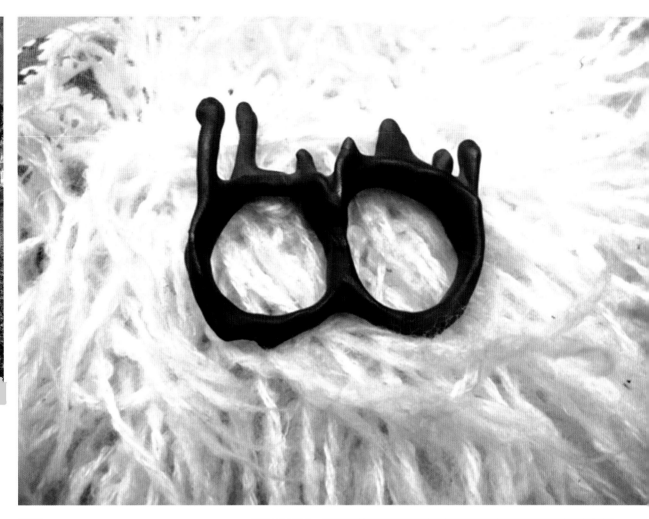

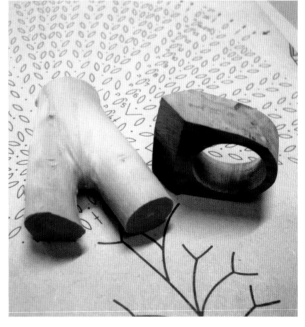

FRA / Mes matériaux préférés sont le cuir, le corps, le bois, l'herbe, les poissons, la laine, la caféine… J'utilise les techniques que j'ai sous la main. C'est comme quand je fais la cuisine, j'emploie les ingrédients dont je dispose. Je lis un livre par an, j'écoute un disque par semaine, je visite une exposition par mois, je vois un film par jour et je fais dix rêves par nuit. Tout m'inspire, comme la pluie qui tombe que je vois par la fenêtre. Quand j'avais douze ans, je voulais être sous-marinier. Je m'intéresse à tout ce qui ne se voit pas du premier coup d'œil.

POR / Meus materiais favoritos são o couro, o corpo, a madeira, a grama, os peixes, a lã, a cafeína… Utilizo as técnicas que tenho à mão: quando preparo um prato, também uso os ingredientes disponíveis. Leio um livro por ano, escuto um disco por semana, vejo uma exposição por mês, vejo um filme a cada dia e tenho dez sonhos a cada noite. Tudo me inspira: agora mesmo, a chuva que vejo cair pela janela. Quando eu tinha 12 anos queria ser mergulhador, me interessa aquilo que não se pode ver a olho nu.

Giampaolo Babetto

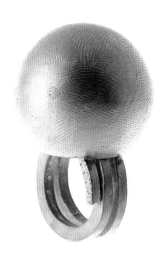

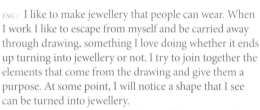

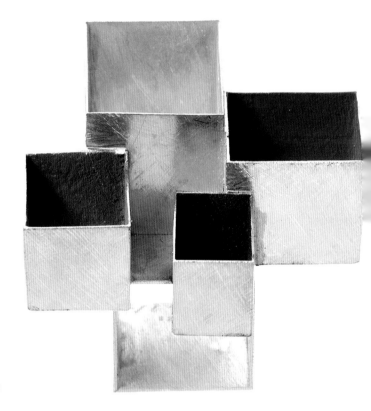

ENG / I like to make jewellery that people can wear. When I work I like to escape from myself and be carried away through drawing, something I love doing whether it ends up turning into jewellery or not. I try to join together the elements that come from the drawing and give them a purpose. At some point, I will notice a shape that I see can be turned into jewellery.

It is the same process that a sculptor follows, though in my case, the artistic object acquires a practical purpose. I always cut out ornamentation. I look for clean, clear lines, not so much to highlight the geometry or the mathematics that hides behind them, but because in some ways I feel more comfortable with pure forms. My work is not based around appearances; I want it to be something that comes from within, that conveys intimacy. I want to explore the relationship between the object I am making and what I am. I use geometric forms because I can relate to them, and I try to make them responsive and connect with them. These forms are often empty for the same reason. The internal void creates an external tension; if one of them were full, it would be dead. These forms have a very strong and solid appearance, but when you hold them in your hand there's an unexpected feeling of lightness.

ESP / Me gusta hacer joyas que la gente pueda llevar. Cuando trabajo me gusta empezar por mí mismo, dejarme llevar a través del dibujo, que es algo que adoro tanto si termina convirtiéndose en joya como si no. Intento unir los elementos que nacen del dibujo y darles una función. En un momento dado, veo una forma que creo que se convertirá en joya. Es el mismo proceso que sigue un escultor, solo que, en mi caso, el objeto artístico adquiere una función. Siempre elimino los ornamentos. Busco formas limpias, no tanto por resaltar la geometría o el juego matemático que se oculta tras la forma, sino porque, de algún modo, prefiero las formas puras. Mi trabajo no se centra en la apariencia, quisiera que fuese algo que nace del interior, que transmita intimidad. Quiero explorar la relación entre el objeto que realizo y lo que yo soy. Uso formas geométricas porque me son afines e intento hacerlas sensibles, comunicarme yo mismo con ellas. A menudo están vacías por la misma razón: el vacío interno crea una tensión externa, si una de ellas estuviera llena, estaría muerta. Estas formas tienen una apariencia sólida y maciza, pero cuando las sostienes en la mano la sensación es de una increíble ligereza.

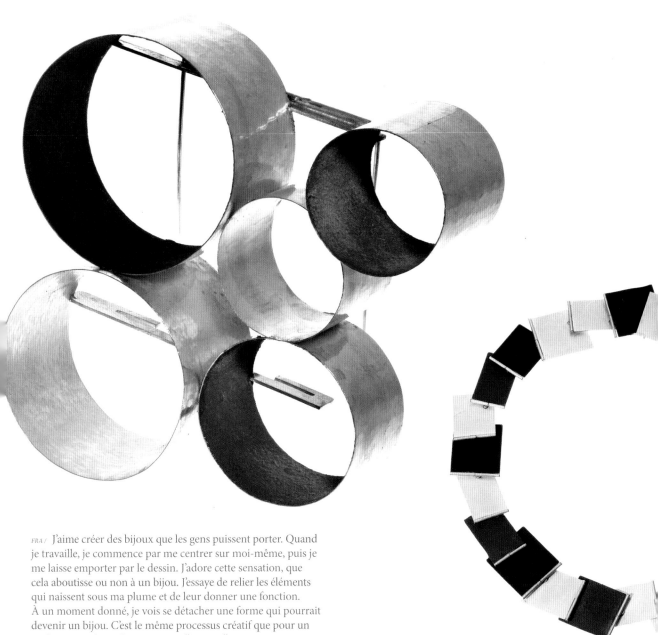

FRA / J'aime créer des bijoux que les gens puissent porter. Quand je travaille, je commence par me centrer sur moi-même, puis je me laisse emporter par le dessin. J'adore cette sensation, que cela aboutisse ou non à un bijou. J'essaye de relier les éléments qui naissent sous ma plume et de leur donner une fonction. À un moment donné, je vois se détacher une forme qui pourrait devenir un bijou. C'est le même processus créatif que pour un sculpteur, sauf que dans mon cas, l'œuvre d'art aura aussi une fonction. Je rejette les enjolivures. Je recherche des formes épurées, pas tant pour faire ressortir leur géométrie ou le jeu mathématique qui se cache derrière leur profil, mais tout simplement parce que j'aime les contours purs. Mon travail ne s'attache pas aux apparences. Je veux qu'il vienne de mon moi profond et qu'il exprime l'intimité. Je souhaite explorer le rapport entre l'objet que je crée et l'être que je suis. J'utilise des formes géométriques parce qu'elles me correspondent. J'essaye de leur communiquer une certaine sensibilité pour pouvoir dialoguer avec elles. Souvent, elles sont vides, parce que justement le vide interne produit une tension externe. Et si une des ces formes ne l'était pas, alors elle serait morte. Ces formes ont l'air solides, massives, mais quand on les tient dans la main, on s'aperçoit qu'elles sont étonnamment légères.

POR / Eu gosto de fazer joias que as pessoas possam usar. Quando trabalho eu gosto de começar por mim mesmo, deixar-me levar através do desenho, que é algo que tanto adoro tanto se termina convertendo-se em joia ou não. Tento unir os elementos que nascem do desenho e dar-lhes uma função. Em um dado momento, vejo uma forma que acho que se converterá em uma joia. É o mesmo processo que segue um escultor, só que, no meu caso, o objeto artístico adquiriu uma função. Busco formas limpas, não tanto para ressaltar a geometria ou o jogo matemático que se oculta atrás da forma, senão porque, de algum modo, prefiro as formas puras. Meu trabalho não se centra na aparência, queria que fosse algo que nasce do interior, que transmita intimidade. Quero explorar relação entre o objeto que realizo e o que sou. Uso formas geométricas porque tenho afinidade e tento fazê-las sensíveis, comunicando-me com elas. Com frequência estão vazias pela mesma razão: o vazio interno cria uma tensão externa: se uma delas estivesse preenchida, estaria morta. Estas formas tem uma aparência solida e maciça, mas quando se as carrega nas mãos a sensação é de uma leveza incrível.

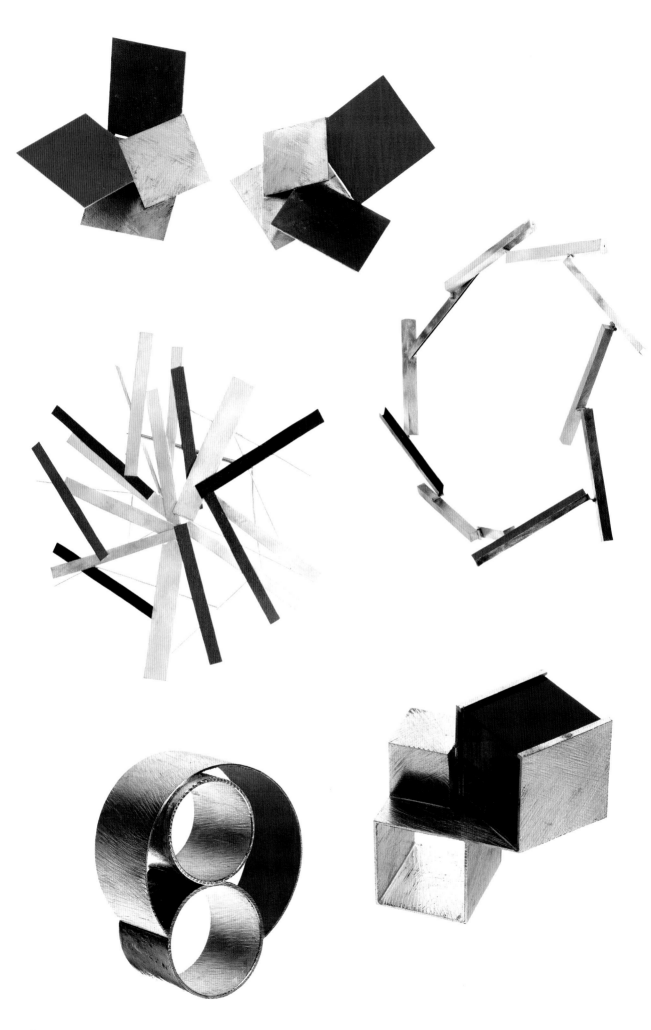

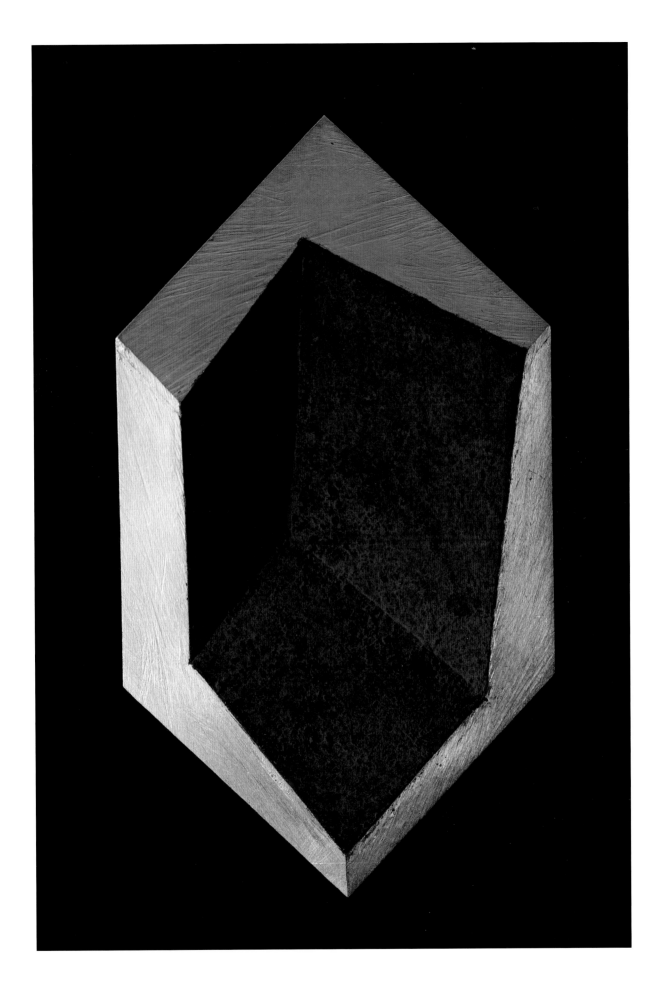

The internal void creates an external tension.

Gijs Bakker

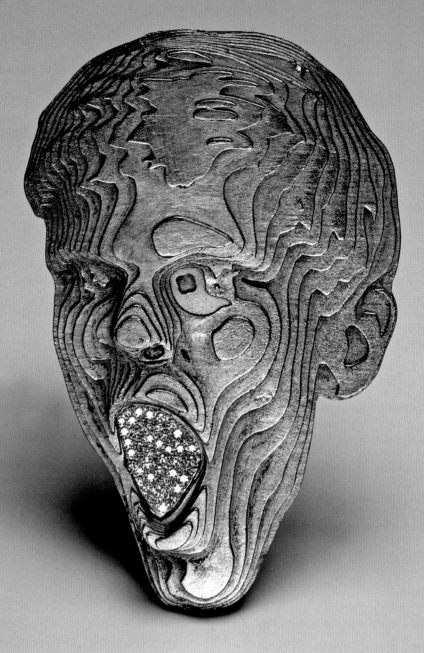

ENG / As a designer, I look for ideas, forms, values and symbols that play an important role in our society. I try to understand the meaning and the paradoxes they contain and present them in a revealing way to the world they come from, rather than mere pieces of design. Because of its close relationship to the body, a person's jewellery is part of the message that he or she wants to convey. An interaction between the piece, the individual and society is created.

My starting point is the challenge of giving a conceptual meaning to an object as small and delicate as a piece of jewellery. It is essential to execute designs with a maximum amount of precision and skill and push the limits of technique and production. The forms created depend on the materials and my work; they are the "tools" for communicating the message. For me, the only value of the materials is what they represent. Gold, silver and precious stones simply mean luxury and status. They are just ornaments until they are placed in a specific context that redefines their meaning.

In exploring this relationship and its consequences I find the freedom to turn a pearl into a football, a fire opal into a Ferrari window, diamonds and sapphires into the wreckage of a car accident, or plastic straws into a golden bracelet.

ESP / Como diseñador, busco ideas, formas, valores y símbolos que juegan un papel importante en nuestra sociedad. Trato de entender el significado y las paradojas que contienen y presentarlos de una manera reveladora al mundo del que salieron, no como un simple objeto de diseño. Por su estrecha relación con el cuerpo, la joya participa en el mensaje que la persona quiere transmitir. Se crea una interacción entre el objeto, el individuo y la sociedad.

Parto del desafío de darle un significado conceptual a un objeto tan pequeño y delicado como una joya. Es esencial ejecutar los diseños con la máxima precisión y destreza, llegar hasta el límite en la producción. Darle forma depende de los materiales y de mi trabajo; son las "herramientas" para comunicar el mensaje. Para mí, los materiales solo tienen el valor que representan: oro, plata, piedras preciosas, son ideas vacías de lujo y estatus. Son simples ornamentos, hasta que se sitúan en un contexto específico que redefine su significado.

Al explorar esta relación y sus consecuencias encuentro la libertad para convertir una perla en un balón de fútbol, un ópalo de fuego en la ventanilla de un Ferrari, diamantes y zafiros en los restos de un accidente de coche, o pajitas de plástico en una pulsera de oro.

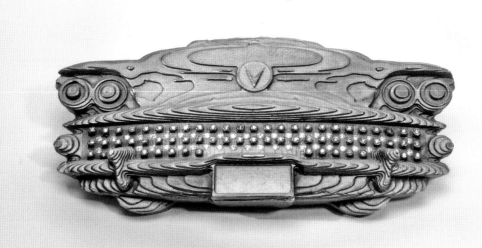

POR / Como desenhador, busco ideias, formas, valores e símbolos que caracterizam um papel importante em nossa sociedade. Trato de entender o significado e os paradoxos que contêm e apresentá-los de uma maneira reveladora ao mundo do qual saíram e não como um simples objeto de desenho. Por sua estreita relação com o corpo, a joia participa na mensagem que a pessoa quer transmitir. Cria-se uma interação entre o objeto, o indivíduo e a sociedade. Parto do desafio de dar um significado conceitual a um objeto tão pequeno e delicado como uma joia. É essencial executar os desenhos com a máxima precisão e destreza, até chegar ao limite da produção. Dar-lhe uma forma depende dos materiais e do meu trabalho; são as "ferramentas" para comunicar a mensagem.

Para mim, os materiais só têm o valor que representam: ouro, prata, pedras preciosas, são ideias vazias de luxo e status. São simples ornamentos, até que se situem em um contexto especifico que redefinem seu significado. Ao explorar esta relação e suas consequências, encontro a liberdade para converter uma perola em uma bola de futebol, um opala de fogo numa janela de uma Ferrari, diamantes e safiras nos restos de um acidente de carro, uma palhinha de plástico numa pulseira de ouro.

FRA / En tant que créateur, je suis sans cesse à la recherche d'idées, de formes, de valeurs et de symboles qui jouent un rôle important dans notre société. J'essaie de comprendre ce qu'ils signifient et les paradoxes qu'ils renferment. Puis, je les montre comme des éléments représentatifs du contexte dont ils sont issus, et non pas comme de simples objets de création. En raison de son rapport étroit avec le corps, le bijou participe au message que la personne veut transmettre. Il se crée une interaction entre l'objet, l'individu et la société.

J'aime relever le défi qui consiste à donner une valeur conceptuelle à un objet aussi petit et délicat qu'un bijou. Il est important d'exécuter les dessins avec une précision et une adresse maximales, jusqu'à atteindre les limites de ce qui puisse être produit. La forme que je vais choisir va dépendre des matériaux dont je dispose et de mon travail : ce seront les « outils » qui me permettront de transmettre mon message. Pour moi, les matériaux possèdent uniquement la valeur qu'ils représentent. L'or, l'argent et les pierres précieuses sont des notions vides attachées au luxe et au statut social. Ils restent de simples ornements jusqu'au moment où ils se retrouvent dans le contexte précis qui leur donne un sens. Lorsque j'explore cette relation et les conséquences qui en découlent, je me sens libre de transformer une perle en ballon de foot, une opale en vitre de Ferrari, des diamants et des saphirs en débris d'un accident de voiture et des pailles en plastique en bracelet d'or.

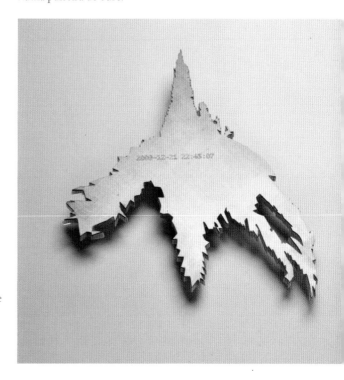

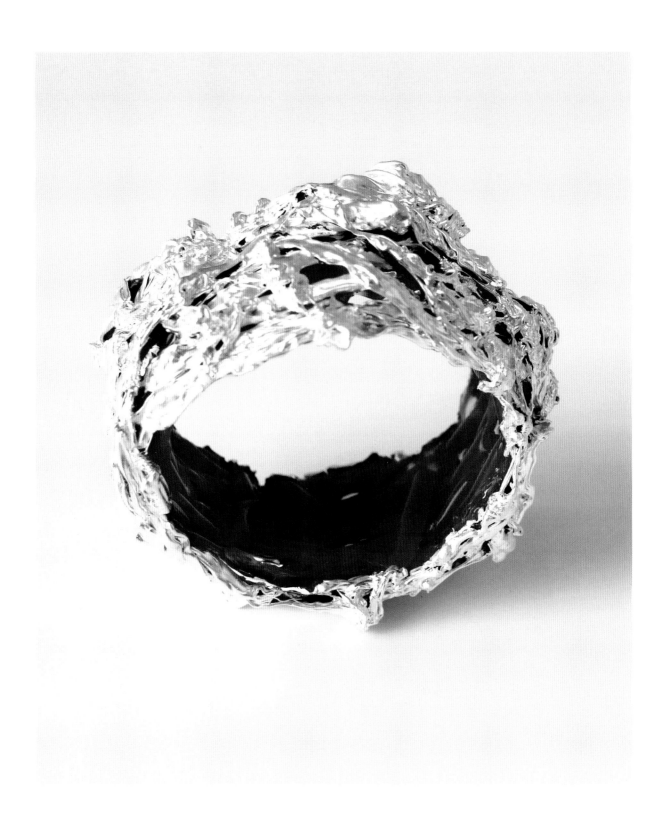

*It's essential to push the limits
of technique and production.*

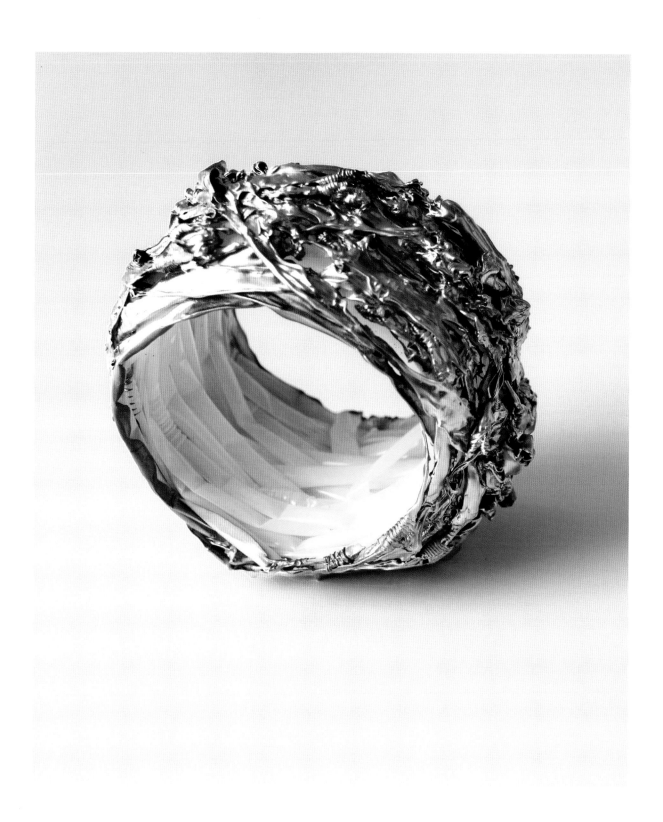

Ralph Bakker

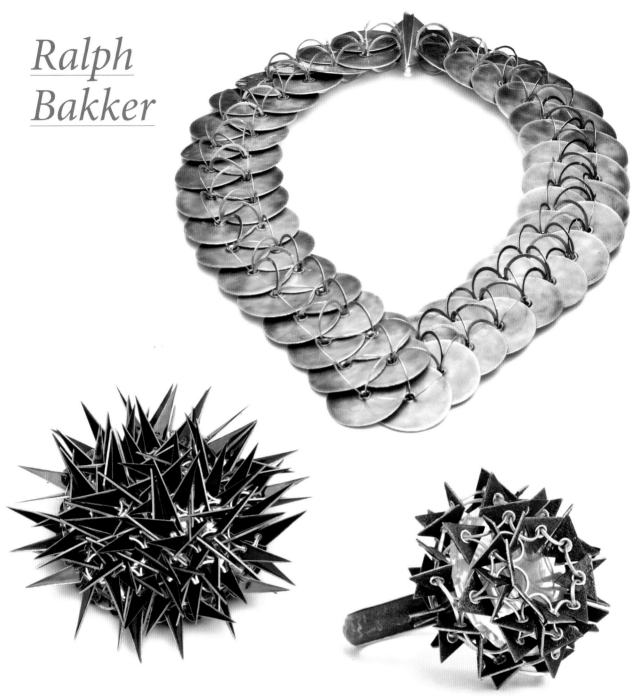

ENG / When an artist decides to commit himself or herself to the art of jewellery, it's possible that his or her pieces will be appreciated more as either useful objects, or, in contrast, as independent works of art. The result can attest to his or her technical skill or artistic talent. There are different options, like with the four points on a compass. In an artist's work, the wind may blow from one direction to the other.

Ralph Bakker, however, walks a tightrope that goes through the middle of the wind rose. His jewellery is solidly in the classical tradition and demonstrates his considerable technical ability, though his uniquely personal artistic perspective comes from a different source. For twenty years he has held a place of his own in the jewellery world in the Netherlands, without imitators or competitors. Many admire the subtlety of his colours and his ingenious assembly techniques but, above all, are surprised by the magic generated by his gold, silver and enamel works.

Adapted from a text by Ward Schrijver

ESP / Cuando un artista decide dedicarse al arte de la joyería, es posible que sus piezas se aprecien más como objetos útiles o, por el contrario, como obras de arte independientes. El resultado puede dar testimonio de su habilidad técnica o de su talento artístico. Las opciones son distintas, como las cuatro direcciones de una brújula. En el trabajo de un artista el viento puede soplar desde una dirección a la opuesta. Ralph Bakker, en cambio, es un equilibrista de la cuerda floja que se mantiene en el centro de la rosa de los vientos. Sus joyas se asientan firmemente en la tradición clásica y demuestran su considerable capacidad técnica, si bien su personalísima perspectiva artística nace de una fuente distinta. Durante veinte años ha mantenido una posición propia en el mundo de la joyería en Holanda, sin imitadores ni competidores. Muchos admiran la sutileza de sus colores y sus ingeniosas técnicas de ensamblaje pero, por encima de todo, se sorprenden con la magia que desprenden sus trabajos en oro, plata y esmaltes

Adaptado de un texto de Ward Schrijver

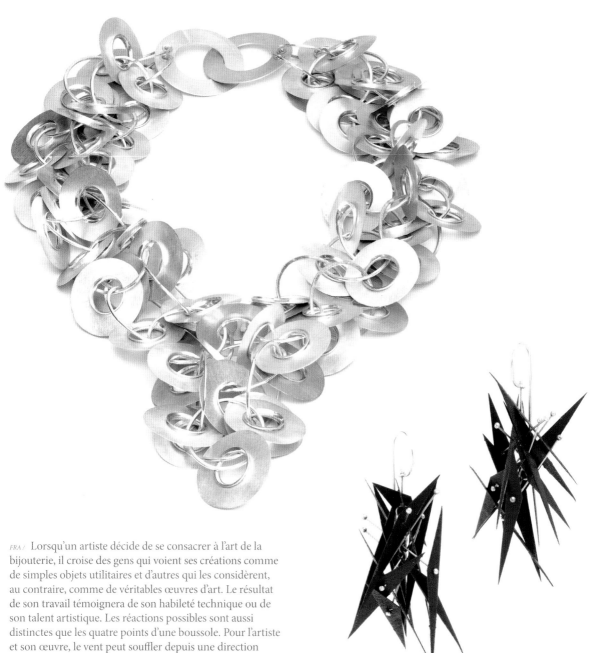

Lorsqu'un artiste décide de se consacrer à l'art de la bijouterie, il croise des gens qui voient ses créations comme de simples objets utilitaires et d'autres qui les considèrent, au contraire, comme de véritables œuvres d'art. Le résultat de son travail témoignera de son habileté technique ou de son talent artistique. Les réactions possibles sont aussi distinctes que les quatre points d'une boussole. Pour l'artiste et son œuvre, le vent peut souffler depuis une direction contraire. Ralph Bakker est un équilibriste consommé qui sait demeurer au centre de la rose des vents. Ses bijoux sont fermement ancrés dans la tradition classique et démontrent une incroyable maîtrise technique. Sa perspective artistique originale le place sur une catégorie à part. Il règne depuis vingt ans sur le monde de la bijouterie hollandaise où il ne connaît ni imitateur ni concurrent. Nombreux sont ceux qui admirent la subtilité de ses couleurs et l'ingéniosité de ses techniques d'assemblage, et tous sont sensibles à la magie qui émane de ses œuvres en or, argent et émail.

Adapté d'un texte de Ward Schrijver

Quando um artista decide dedicar-se à arte da joalheria, é possível que as suas peças se apreciem mais como objetos úteis ou, pelo contrario, como obras de arte independentes. O resultado pode ser um testemunho da sua habilidade técnica ou do seu talento artístico. As opções são distintas, como as quatro direções de uma bússola. No trabalho de um artista, o vento pode soprar desde uma direção à outra oposta. Ralph Bakker, em contraste, é um equilibrista na corda bamba que se mantem no centro da rosa dos ventos. Suas joias se acomodam firmemente na tradição clássica e demonstram a sua considerável capacidade técnica, se bem que, a sua particularíssima perspectiva artística nasce de uma fonte distinta. Durante vinte anos manteve uma posição própria no mundo da joalheria na Holanda, sem imitadores nem concorrentes. Muitos admiram a sutileza das suas cores e a sua técnicas engenhosas de montagem mas, acima de tudo, se surpreendem com a mágica que se desprende dos seus trabalhos de ouro, prata e esmaltes.

Adaptado de um texto de Ward Schrijver

Ángela Bermúdez

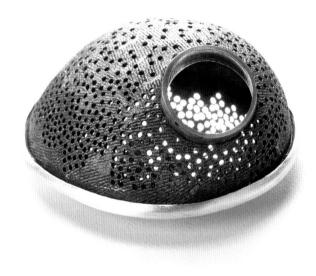

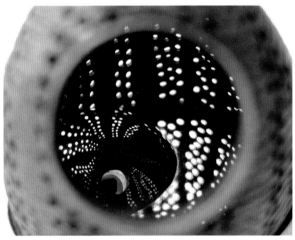

ENG/ Jewellery is about the body and movement. A person who wears a piece of jewellery is like a port that connects with other ports through everyday expression. Beyond the object there is an attitude that links human beings with their situation. When I am working I think about creating pieces that *report* my own world view and can *support* this responsibility. A walk, a conversation, question... any situation can suggest a story, and a jewel is a way to make it visible and bring it closer. Through jewellery I establish a dialogue—a real, imaginary or symbolic one—with life, about memory, perception and their interpretations.

The technique and material are there to serve the idea. The act of extracting metals from the soil implies darkness and brutality from ancestral rituals. Once you discover the magic of metal, it seems impossible not to surrender to them. But metal can be broken, burnt or dissolved; the technique challenges the insolent immutability of metal, and for that reason it comes closer to the human experience.

ESP/ La joyería significa cuerpo y movimiento. La persona portadora es un *puerto* que día a día se conecta a través de gestos con otros puertos. Más allá del objeto hay una actitud que vincula al ser humano con su circunstancia. Cuando trabajo pienso en crear piezas que aporten mi propia visión del mundo y soporten esta responsabilidad. Un paseo, una conversación, una duda...cualquier situación puede sugerir una historia y una joya es una manera de hacerla visible, cercana. A través de la joyería establezco un diálogo con la vida, un diálogo –real, imaginario, o simbólico- sobre la memoria, la percepción y sus interpretaciones. La técnica y el material están al servicio de la idea. Extraer metales de la tierra esconde una oscuridad y una brutalidad propias de los ritos ancestrales. Una vez descubierta su magia, parece imposible no rendirse ante ellos. Pero el metal puede romperse, quemarse, disolverse...La técnica desafía la insolente inmutabilidad del metal y por ello se acerca a la experiencia humana.

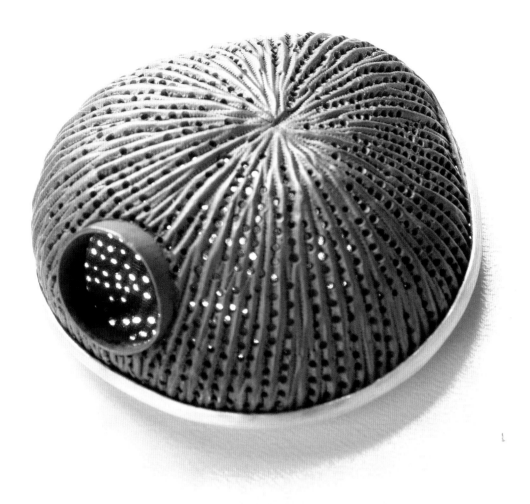

POR / A joalheria significa corpo e movimento. A pessoa usuária é um *porto* que diariamente se conecta através de gestos com outros portos. Mais além do objeto há uma atitude que vincula o ser humano com a sua circunstância. Quando trabalho penso em criar peças que possuem a minha própria visão do mundo e suportem esta responsabilidade.

Um passeio, uma conversa, uma dúvida... Qualquer situação pode sugerir uma história e uma joia é uma maneira de fazê-la visível, próxima.

Através da joia estabeleço um diálogo com a vida, um diálogo – real, imaginário ou simbólico – sobre a memória, a percepção e suas interpretações. A técnica e o material estão a serviço da ideia. Extrair metais da terra esconde uma obscuridade e uma brutalidade própria dos rituais ancestrais. Uma vez descoberta a magia do metal, parece impossível não render-se a ele.

Mas o metal pode romper-se, queimar-se, dissolver-se...

A técnica desafia a imutabilidade insolente do metal e por isso, se aproxima da experiência humana.

FRA / Le bijou implique corps et mouvement. La personne qui le porte est le *port* qui se connecte jour après jour à d'autres ports à travers ses gestes. Au-delà de l'objet, il y a une attitude qui relie l'être humain à ses circonstances. Lorsque je travaille, je pense à créer des œuvres qui reflètent ma propre vision du monde et endossent cette responsabilité.

Une promenade, une conversation, une question... n'importe quelle situation peut inspirer une histoire, et un bijou est une façon de la raconter, de la rendre plus proche.

À travers le bijou, j'établis un dialogue avec la vie, un dialogue – réel, imaginaire ou symbolique – sur la mémoire, la perception et ses interprétations. La technique et les matériaux sont au service d'une idée. L'extraction des métaux de la terre recouvre un aspect obscur et brutal lié à des rituels ancestraux. Une fois que l'on a découvert la magie du métal, il semble impossible de ne pas y succomber. Cependant, le métal peut se briser, brûler, fondre... La technique défit l'insolente immutabilité du métal et c'est en cela qu'elle se rapproche de l'expérience humaine.

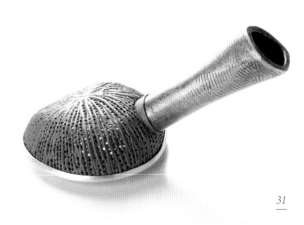

Doris
Betz

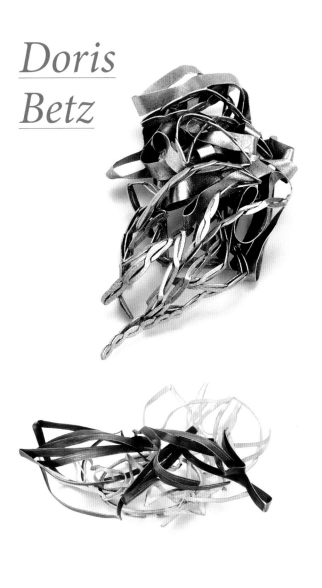

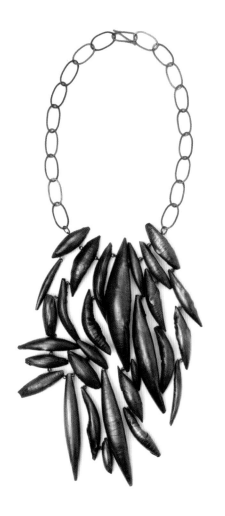

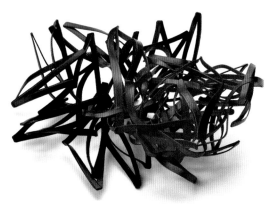

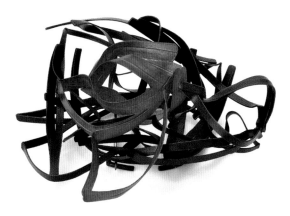

ENG / For me, making jewellery is like having a mysterious plane ticket to an unknown destination in my pocket, not knowing where I'm headed. But at the same time, I do have a goal: at the end of the journey I should have an incredibly nice piece of jewellery. I always try to invent and devise processes that I have no control over at all. I try to make things happen, I'm spontaneous and yet also very alert. I'm guided as much by my instincts as I am by my experience. This process of not knowing and not wanting, and instead just playing, moving freely and suddenly reaching an exciting point in which I perceive I must take control back, is my balancing act.

ESP / Para mí, hacer joyas es como si tuviera en el bolsillo un misterioso billete de avión con destino desconocido, sin saber a donde me dirijo. Pero, al mismo tiempo, sí tengo un objetivo: al final del trayecto debería haber una joya increíblemente buena.
Siempre intento inventar, concebir procesos que no puedo controlar del todo. Intento hacer que las cosas ocurran, soy espontánea y a la vez estoy muy atenta. Me dejo llevar por mi instinto tanto como por mi experiencia. Este proceso de no saber, no desear, solamente jugar, seguir adelante en libertad y, de repente, llegar a un punto emocionante en el que percibo que debo tomar el control de nuevo, es un acto de equilibrio.

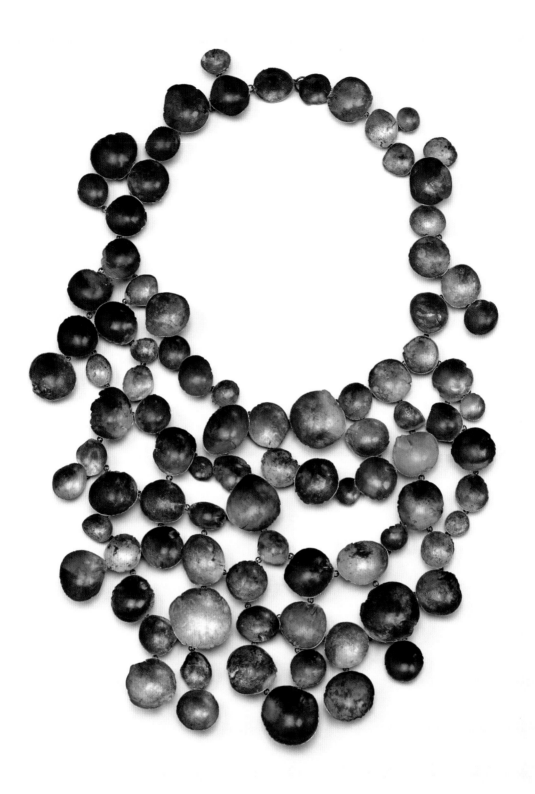

FRA / Pour moi fabriquer un bijou c'est comme avoir un mystérieux billet d'avion pour une destination inconnue et partir sans savoir où je vais atterrir. Toutefois, j'ai un objectif : au bout du voyage il y aura un bijou fabuleux.

J'essaie toujours d'inventer, de créer des processus que je ne peux pas entièrement contrôler. Je veux qu'il se passe quelque chose. Je suis à la fois spontanée et minutieuse. Je me laisse porter par mon instinct et par mon expérience. Au départ je ne sais pas où je vais, je ne désire rien de précis, je veux simplement jouer, laisser le processus suivre son cours ; et puis, il arrive un moment où l'émotion passe le relais et où je sens que je dois reprendre le contrôle. C'est un acte d'équilibre.

POR / Para mim, fazer joias é como se eu tivesse no bolso um misterioso bilhete de avião com destino desconhecido, sem saber aonde vou. Mas, ao mesmo tempo, sim que tenho um objetivo: no final da viagem deve ser uma joia incrivelmente boa.

Sempre tento inventar, conceber processos que não posso controlar totalmente. Tento fazer com que as coisas ocorram, sou espontâneo e ao mesmo tempo estou muito atenta. Me deixo levar pelos meus instintos tanto como pela minha experiência. Este processo de não saber, não desejar, somente jogar, seguir adiante em liberdade e de repente chegar a um ponto emocionante em que percebo que devo tomar o controle de novo, é um ato de equilíbrio.

Alexander
Blank

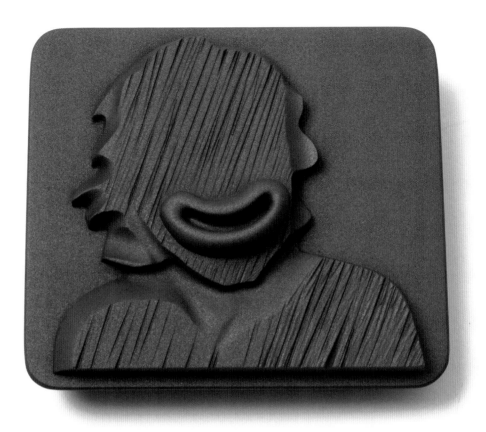

ENG / The jeweller can refuse to give information about their work or themselves, knowing that they would run the risk of being pigeonholed.

The jeweller has the right to remain silent about their parents or teachers.

They can also keep quiet about their social phobias, sexual fantasies, addiction to alcohol and/or caffeine, as well as the general grief that the world makes them feel.

No jeweller should be forced against their will to talk about their secrets. The secrets of jewellery are sacred.

The jeweller has their reasons to keep their intentions hidden. Under no circumstances can a jeweller be compelled to make a statement about their creative isolation, fear of failure or the omnipresence of death.

Before an exhibition, the jeweller should be informed of their right to refuse to comment.

The jeweller's work speaks for itself... most of the time.

ESP / El joyero puede negarse a dar información acerca de su trabajo o acerca de sí mismo, sabiendo que correría el riesgo de ser encasillado.

El joyero tiene derecho a permanecer en silencio acerca de sus padres o profesores.

También puede guardar silencio sobre sus fobias sociales, fantasías sexuales, adicción al alcohol y/o a la cafeína, así como sobre el dolor general que le causa el mundo.

Ningún joyero debe ser obligado contra su voluntad a hablar de sus secretos. Los secretos de la joyería son sagrados.

El joyero tiene sus razones para mantener sus intenciones ocultas.

Bajo ninguna circunstancia el joyero puede ser obligado a hacer una declaración ya sea sobre su soledad en la creación de joyas, el miedo al fracaso ni sobre la omnipresencia de la muerte.

Antes de una exposición, el joyero debe ser informado acerca de su derecho a negarse a hacer declaraciones.

El trabajo del joyero habla por sí mismo...la mayor parte del tiempo.

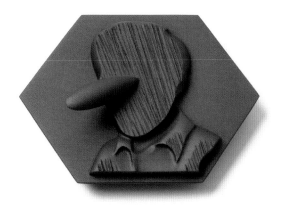

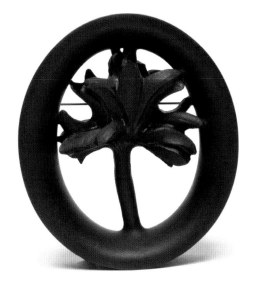

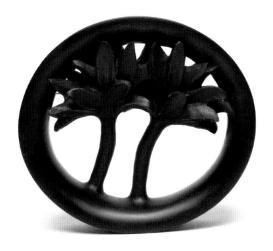

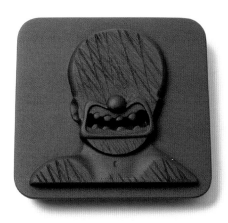

FRA / Un joaillier a le droit de refuser de donner des informations sur son travail ou sur lui-même, même s'il sait que cela ne sera pas forcément bien vu.

Un joaillier a le droit de garder le silence sur ses parents et sur ses professeurs.

Il peut aussi refuser de parler de ses phobies sociales, de ses fantasmes sexuels, de son addiction à l'alcool et/ou à la caféine, et de la douleur que lui cause l'état du monde.

Aucun joaillier n'est obligé de révéler ses secrets contre sa volonté. Les secrets de son art sont sacrés.

Le joaillier a ses raisons pour refuser de dévoiler ses intentions. Aucune circonstance ne peut l'obliger à parler de sa solitude face à la création d'un bijou, de sa peur de l'échec ni de l'omniprésence de la mort.

Avant une exposition, le joaillier doit être informé de son droit à garder le silence.

Le travail du joaillier parle pour lui... en général.

POR / O joalheiro pode negar-se a dar informação sobre o seu trabalho ou sobre si mesmo, sabendo que correria o risco de ser estereotipado.

O joalheiro tem o direito a permanecer em silêncio sobre seus pais ou professores.

Também pode guardar silêncio sobre suas fobias sociais, fantasias sexuais, o vicio ao álcool e/ou a cafeína, assim como a dor geral que o mundo lhe causa.

Nenhum joalheiro deve ser obrigado a falar dos seus segredos contra a sua vontade.

Os segredos de um joalheiro são sagrados.

O joalheiro tem suas razoes para manter suas intenções ocultas.

Sob nenhuma circunstância, o joalheiro deve ser obrigado a fazer uma declaração que seja sobre a sua solidão na criação de joias, o medo ao fracasso nem sobre a onipresença da morte.

Antes de uma exposição, o joalheiro deve estar informado sobre o seu direito a se negar a fazer declarações.

O trabalho do joalheiro fala por si mesmo... Na maior parte do tempo.

Helen
Britton

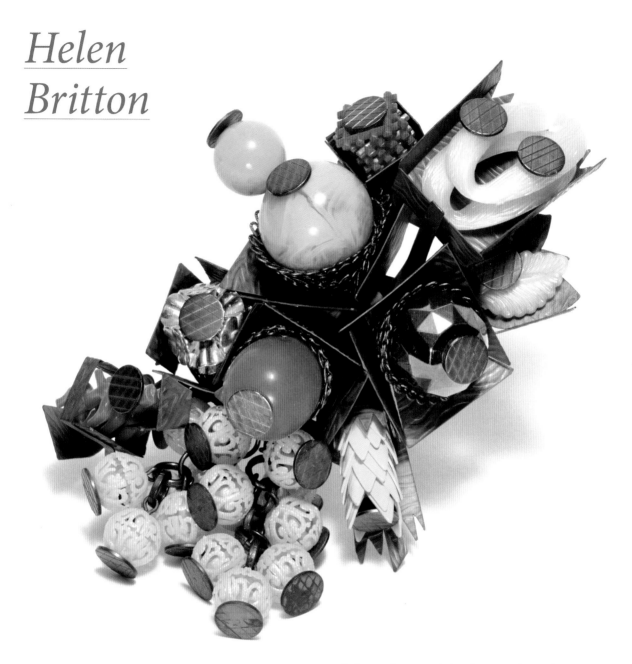

ENG/ I seek out aspects of popular culture: violence, love, wealth, sentimentality, humour, wisdom, the exotic, the valuable, the unusual. A small companion: a talisman, an amulet. Hope.

On their own, the components are really knick-knacks, but the feeling they express reaches the greatest depths and our most fundamental concerns. The parts are products of human history that have been spread across the world by waves of human life. They amass in huge piles, each piece sparkling, agitating and begging for us to notice it, like inhabitants of a wilderness of material emotions.

How were they made? Did they have a positive impact? Why were they created? In them I see all the effort, joy and failure of our existence. They very modestly represent what has led our species to create plastic versions of the shells that seventy thousand years ago were strung from Blombos Cave. The pieces are piled up at the entrance of my study, raw material that challenges my powers of creation. Working is a direct, intuitive process of construction. I don't try to control the outcome; I am completely immersed in my own reinvention.

ESP/ Indago en los temas de la cultura popular: Violencia, amor, opulencia, sentimentalismo, humor, sabiduría, lo exótico, lo valioso, lo inusual. Un pequeño compañero: un talismán, un amuleto. Esperanza.

Mientras que los componentes en sí son una auténtica baratija, el sentimiento que pretenden transmitir penetra en el abismo más profundo. Preocupaciones primarias. Estos componentes han emergido de la historia de la humanidad y alcanzado todo el planeta, arrastrando consigo mareas de actividad humana. Hay montones enormes; brillando, agitándose y llamando la atención con su risa y sus destellos. Habitantes amontonados en la selva de las emociones materiales.

¿Cómo se produjeron?¿Cambiaron algo?¿Cómo se impulsó su creación? Veo en ellos todo el esfuerzo, la alegría y el fracaso de nuestra existencia. Muy modestamente, representan aquello que ha llevado a nuestra especie a crear versiones de plástico de las conchas de cueva Blombos, ensartadas hace 70.000 años. Las piezas se amontonan a la entrada de mi estudio, se convierten en materias primas que desafían mis poderes de creación. El trabajo es un proceso de construcción e integración directo, intuitivo. No intento controlar el resultado. Estoy completamente inmersa en mi propio proceso de reinvención.

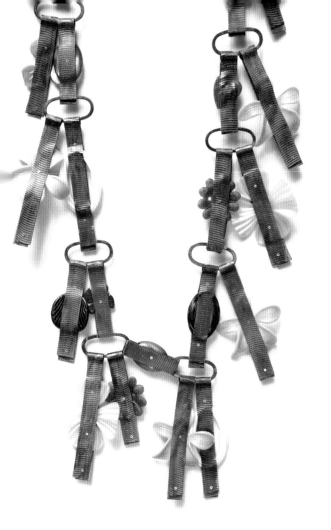

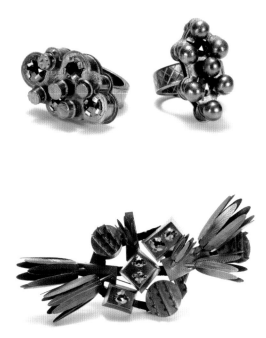

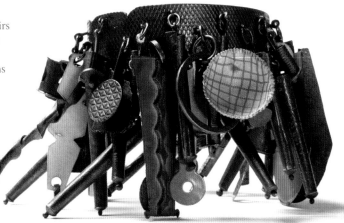

FRA / J'explore les grands thèmes de la culture populaire :
la violence, l'amour, l'opulence, le sentimentalisme, l'humour,
la sagesse, l'exotisme, le précieux, l'insolite ; un complice :
un talisman, une amulette. L'espoir.

Même s'ils sont complètement tocs, les sentiments qu'ils
transmettent n'en pénètrent pas moins jusqu'au fond de l'âme.
Ce sont des nécessités primordiales. Elles remontent à l'aube
de l'humanité et ont conquis la planète entière, charriant avec
elles des marées d'activités humaines. Leur nombre est infini :
elles brillent, s'agitent et nous interpellent avec leur rire et
leurs éclats. Ce sont les milliers d'habitants qui peuplent la
forêt de nos émotions matérielles. Comment sont-ils
apparus ? Ont-il changé quelque chose ? Qu'est-ce qui a
provoqué leur survenue ?

Je vois en eux tout l'effort, le bonheur et l'échec de notre
existence. Très modestement, ils représentent ce qui a poussé
notre espèce à créer des versions en plastique des coquillages
retrouvés dans la grotte Blombos que nos ancêtres ont enfilés
pour former des colliers il y a 70 000 ans.

Les objets s'amoncèlent dans l'entrée de mon studio, ils
deviennent les matières premières qui défient mes pouvoirs
de création. Mon travail est un processus de construction
et d'intégration directe, totalement intuitif. Je n'essaie pas
de contrôler le résultat. Je suis entièrement immergée dans
mon propre processus de réinvention.

POR / Indago sobre os temas da cultura popular: Violência,
amor, opulência, sentimentalismo, humor, sabedoria, o exótico,
o valioso, o inusitado. Um pequeno companheiro: um talismã,
um amuleto. Esperança.

Enquanto os componentes em si são uma autêntica bagatela,
o sentimento que pretende transmitir penetra no abismo
mais profundo. Preocupações primárias. Estes componentes
têm surgido na história da humanidade e chegaram em todo
o planeta, arrastando marés de atividade humana. Há uma
infinidade enorme; brilhando, agitando-se e chamando
a atenção com seu riso e seus resplendores. Habitantes
amontoados numa selva de emoções materiais. Como
se produziram? Mudaram algo? Como se impulsionou
sua criação?

Vejo neles todo o esforço, a alegria e o fracasso da nossa
existência. Bem modestamente, representam aquilo que
levou a nossa espécie a criar versões de plástico das conchas
da caverna Blombos, inseridas há 70.000 anos.

As peças se amontoam na entrada do meu estúdio,
se convertem em matérias-primas que desafiam meus
poderes de criação. O trabalho é um processo de construção
e integração direto, intuitivo. Não tento controlar o resultado.
Estou completamente imersa em meu próprio processo
de reinvenção.

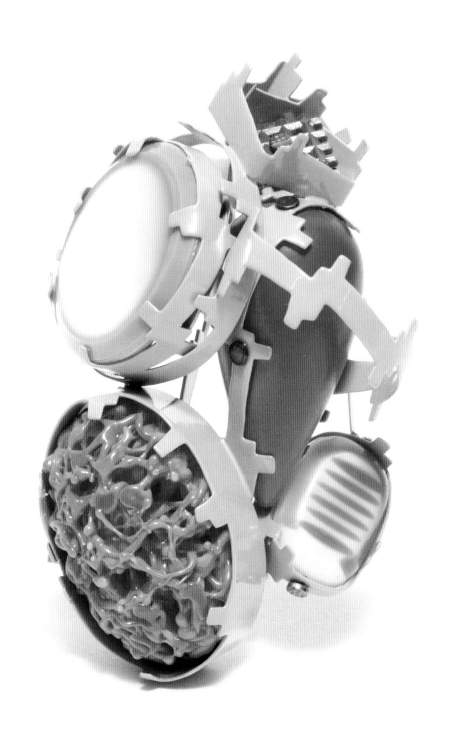

A small companion: a talisman,
an amulet. Hope.

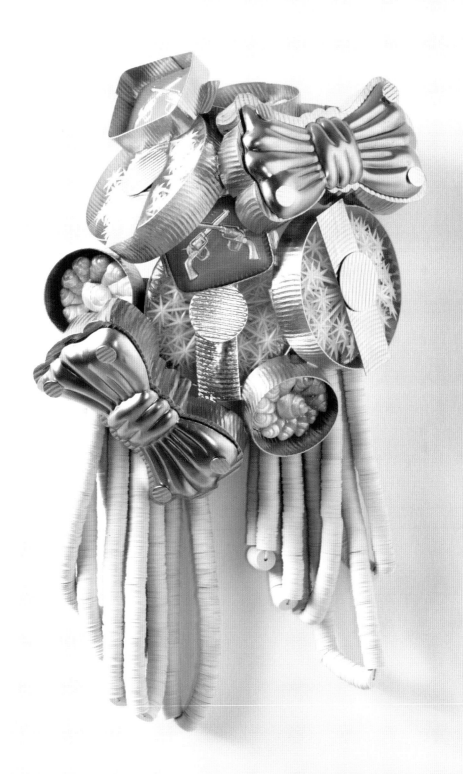

Kim
Buck

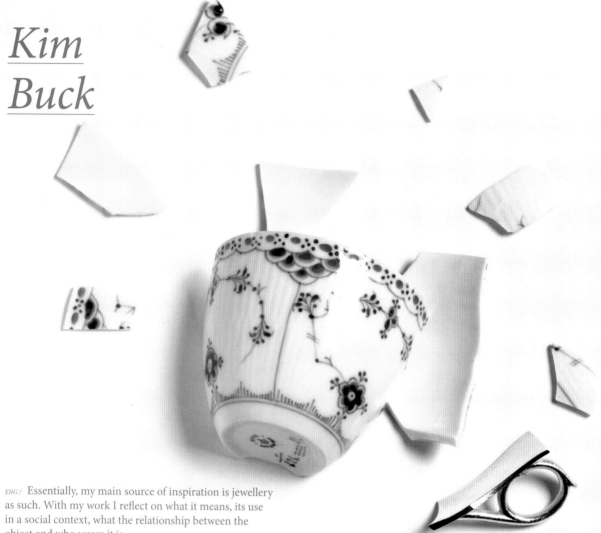

ENG / Essentially, my main source of inspiration is jewellery as such. With my work I reflect on what it means, its use in a social context, what the relationship between the object and who wears it is.

Lately, political issues and subject of public debate have emerged in my work, such as religion, tolerance and ethics. For me jewellery is the ideal means to address these issues and expose the hypocrisy and intolerance of today's society, as almost everyone has a relationship with jewellery and their own point of view about its meaning.

I see myself as a maker; making jewellery is a great pleasure for me. For each project, I tend to use or invent new techniques, which I explore and develop to express my ideas. To do this in my daily work, I use CAD/CAM and other similar techniques, not for the end result I'm looking for, but because they allow me to express ideas and create forms that otherwise I wouldn't manage to achieve.

My focus on technology, my techniques, have never been a secret and they aren't really important, they are only a tool to express an idea. On the other hand, as a producer, it is very important to me that every piece has been made in my studio.

ESP / Esencialmente, mi mayor fuente de inspiración es la joyería como tal. Con mi trabajo reflexiono sobre lo que significa, como la usamos en un contexto social, cuál es la relación entre el objeto y quien lo lleva. Últimamente en mi trabajo también aparecen cuestiones políticas y de debate público, como la religión, la tolerancia o la ética. Para mí la joyería es el medio ideal para tratar estos temas y exponer la hipocresía y la intolerancia de la sociedad actual, pues casi todo el mundo tiene una relación con la joyería y una perspectiva propia sobre su significado.

Me veo como un hacedor, para mí hacer joyas es un gran placer. Para cada proyecto tiendo a usar o inventar nuevas técnicas, que exploro y desarrollo para poder expresar mis ideas. Esto significa que, en mi trabajo diario, uso CAD/CAM y otras técnicas parecidas, no por el resultado final que busco, sino porque me permiten expresar conceptos y crear formas que de otro modo no conseguiría lograr.

Mi enfoque tecnológico, mis técnicas, nunca han sido un secreto y no son realmente importantes, son únicamente una herramienta para expresarme. Por otro lado, como productor, es muy importante para mí que cada pieza haya sido hecha en mi estudio.

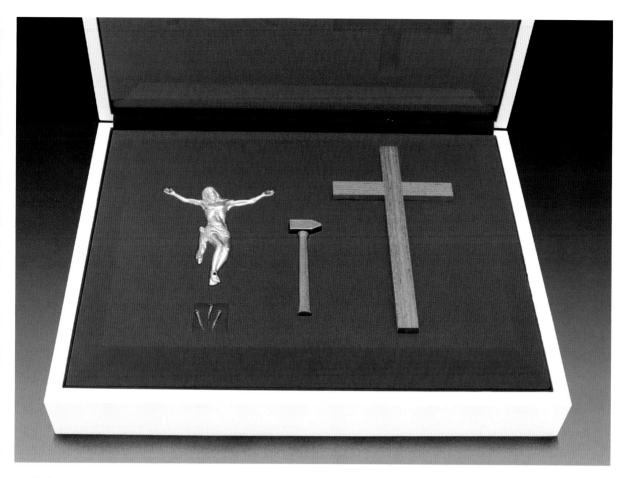

FRA / Le bijou en tant que tel est essentiellement ma plus grande source d'inspiration. Quand je travaille, je pense à ce qu'il signifie, à la manière dont nous l'utilisons dans un contexte social, à la relation qui existe entre l'objet lui-même et la personne qui le porte.

Depuis quelque temps, j'intègre aussi à mon travail des problématiques politiques et des sujets de débats publics, comme la religion, la tolérance et l'éthique. Je considère que le bijou est le support idéal pour traiter ces grands thèmes et mettre à nu l'hypocrisie et l'intolérance de la société actuelle : tout le monde a un lien avec les bijoux et une vision personnelle de leur signification.

Je me vois comme un créateur, j'éprouve un grand plaisir à fabriquer des bijoux. Pour chaque projet, j'invente le plus souvent de nouvelles méthodes que j'explore et développe pour exprimer mes idées. Cela signifie que dans mon travail, je fais appel au quotidien à la CAO/FAO et à d'autres techniques de ce genre, non pas pour obtenir un résultat précis, mais parce qu'ils me donnent la possibilité de traduire des concepts et de créer des formes.

Je n'ai jamais caché mon approche technologique ni mes méthodes : elles n'ont pas d'importance. Ce sont de simples outils qui me permettent d'exprimer mes idées. Par ailleurs, en tant que producteur, il est essentiel pour moi que chaque bijou soit fabriqué dans mon studio.

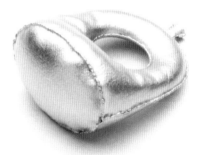

POR / Essencialmente, minha maior fonte de inspiração é a joalheria como tal. Com meu trabalho reflexiono sobre o que significa como a usamos em um contexto social, qual é a relação entre o objeto e quem o leva.

Ultimamente em meu trabalho também há questões políticas e de debate público, como a religião, a tolerância ou a ética. Para mim a joalheria é o meio ideal para tratar estes temas e expor a hipocrisia e a intolerância da sociedade, uma perspectiva própria sobre o seu significado.

Me vejo como um fazedor, para mim, fazer joias é um grande prazer. Para cada projeto a minha tendência é a de usar ou inventar novas técnicas, que exploro e desenvolvo para poder expressar as minhas ideias. Isto significa que, no meu trabalho diário, uso CAD/CAM e outras técnicas parecidas, não pelo resultado final que busco, mas sim porque me permitem expressar ideias e criar formas que de outro modo não conseguiria alcançar.

Meus enfoques tecnológicos, minhas técnicas, nunca foram um segredo e não são realmente importantes, são unicamente uma ferramenta para expressar uma ideia. Por outro lado, como produtor, é muito importante para mim que cada peça tenha sido feita em meu estúdio.

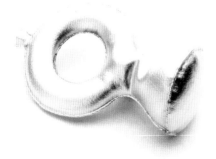

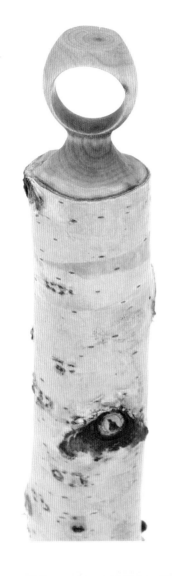
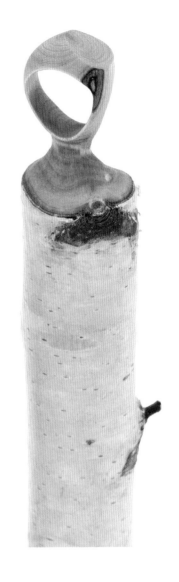
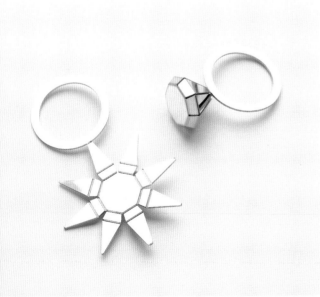
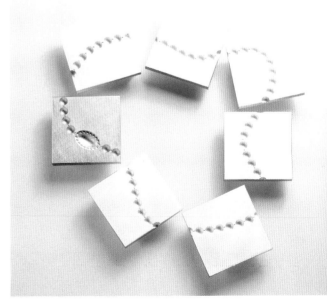

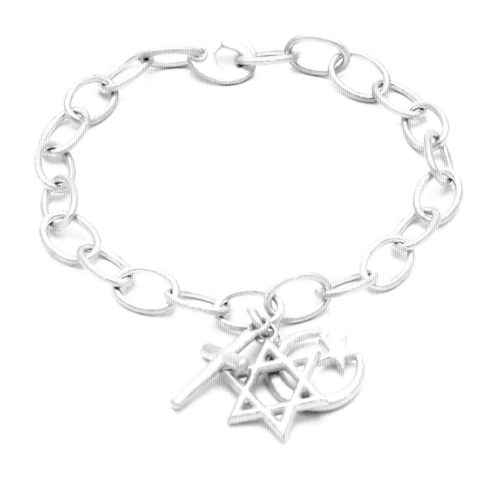

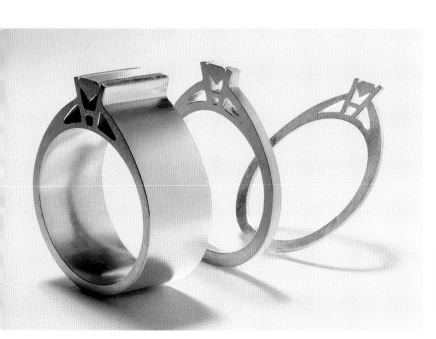

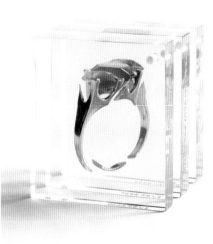

Kepa Carmona and Marie Pendairès

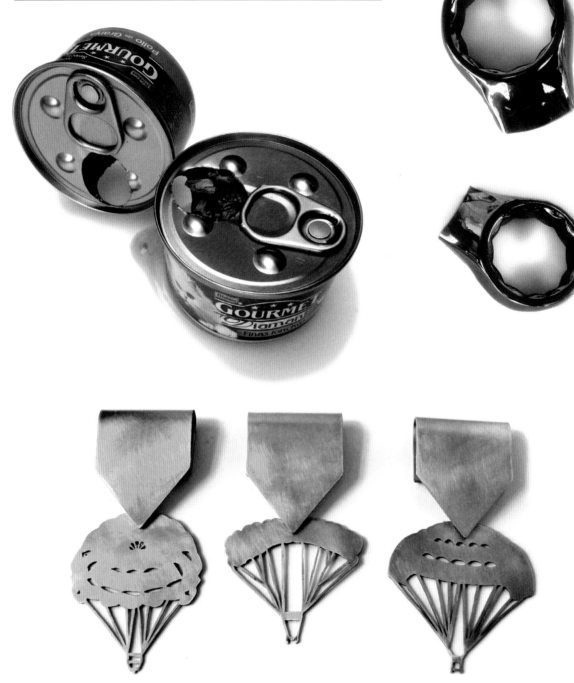

ENG / We are interested in both the ornamental and utilitarian aspects of jewellery. We explore this value of utility and, by the same token, we want to examine tradition, identity and the concept of belonging to a group through jewellery. We get inspiration from artistic expressions such as the art of the complaint, action art or performance. Our main technique is assembling, because we use materials that can't be soldered, only screwed or riveted. We like to use ready-mades, reused objects and materials, and all synthetic materials, mixed with traditional metal. These are the materials that surround us and shape our environment: a large, twenty-first century Western city.

ESP / Nos interesa el aspecto ornamental pero también utilitario de las joyas. Exploramos este valor de utilidad y, del mismo modo, nos interesa investigar en la tradición, la identidad, el concepto de pertenencia a un grupo a través de las joyas. Nos inspiramos en expresiones artísticas como el arte de la denuncia, el action art o el performance. Nuestra técnica principal es el ensamblaje, porque utilizamos materiales que no pueden ser soldados, solo atornillados o remachados. Nos gusta usar ready-mades, objetos y materiales reutilizados, y todos los materiales sintéticos mezclados con el metal tradicional. Son los materiales que nos rodean y conforman nuestro medio: una gran ciudad occidental del siglo XXI.

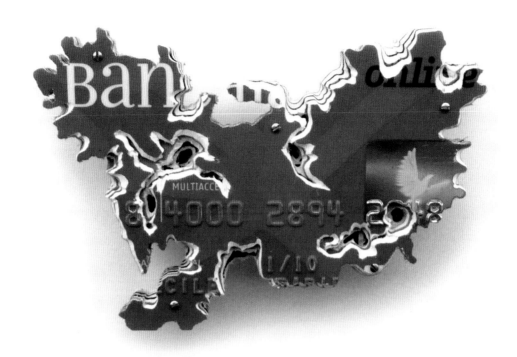

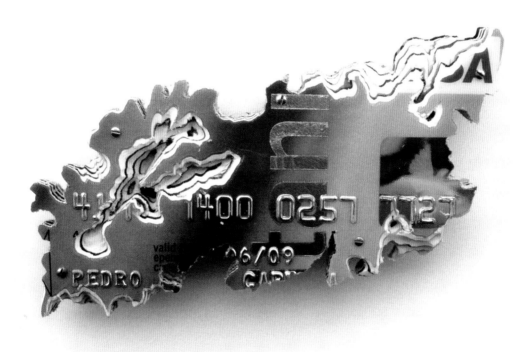

FRA / Nous nous intéressons à l'aspect décoratif et utilitaire des bijoux. Nous explorons leur côté utile ainsi que leur rôle en tant qu'élément de tradition, d'identité et d'appartenance à un groupe. Nous puisons notre inspiration à la source de l'art contestataire, de l'art action et de l'art performance. Nous faisons généralement appel à la technique de l'assemblage parce que les matériaux que nous employons ne peuvent pas être soudés entre eux, mais seulement vissés ou rivetés. Nous aimons utiliser des articles tout faits, réemployer des objets et des matériaux usagés et mélanger toutes sortes de matières synthétiques aux métaux traditionnels. Ce sont les éléments qui nous entourent et constituent notre milieu : une grande ville occidentale du XXI° siècle.

POR / Nos interessa o aspecto ornamental mas também utilitário das joias. Exploramos este valor de utilidade e, do mesmo modo, nos interessa investigar a tradição, a identidade, o conceito de pertencer a um grupo através das joias. Nos inspiramos em expressões artísticas como a arte da denúncia, o *action art* ou a performance. Nossa técnica principal é a montagem, porque utilizamos materiais que não podem ser soldados, só enroscados ou rebitados. Gostamos de usar *ready-made*, objetos e materiais reutilizados, e todos são materiais sintéticos misturados com o metal tradicional. Eles são os materiais que nos rodeiam e moldam o nosso ambiente: uma grande cidade ocidental do século XXI.

Attai
Chen

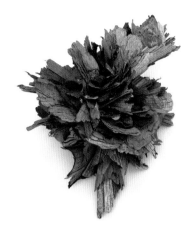

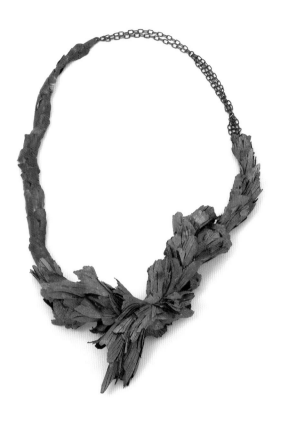

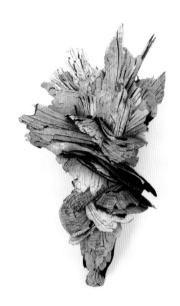

ENG/ My inspiration comes not so much from the visual but rather the emotional, a feeling or an *instinct*. I focus a lot on nature's cycles and often try to capture some of this process. I try to express that sense of endless movement in these objects, like that moment we catch or seize in the middle of an action. I often start with paper or thin recycled cardboard, on which I draw or paint with different types of paints. Sometimes I combine pieces of newspapers, books or other waste papers in a collage. Then I cut it into small pieces in quite a spontaneous way and these fragments become my raw material. From there I start building shapes with volume by gluing pieces together. I try to be very free and spontaneous. The forms create themselves, and I accept some of the accidents that occur during this process. When the form is complete I bathe it in acrylic polymer so that it hardens and becomes less delicate and fragile. I attempt to challenge the form through the relationship between form and colour and I think this relationship produces and transforms its volume and three-dimensional pieces. Basically what I do is play and try to explore different territories.

ESP/ Mi inspiración viene no tanto de lo visual sino de lo emocional, de una sensación o un *instinto*. Me centro mucho en los ciclos de la naturaleza y a menudo trato de captar algo de este proceso. Intento volcar esa sensación de movimiento infinito a estos objetos, como ese instante que podemos atrapar, aprehender, en medio de una acción. A menudo empiezo por un papel o cartón fino reciclado en el cual dibujo o pinto con distintos tipos de pinturas. A veces combino trozos de periódicos, libros u otros papeles usados, a modo de collage. Luego lo corto en pequeños trocitos de forma bastante espontánea y estos fragmentos se convierten en mi materia prima. A partir de ahí empiezo a construir volúmenes pegando las piezas. Intento ser bastante libre y espontáneo. Las formas se van creando por sí mismas, y acepto algunos de los accidentes que tienen lugar durante este proceso. Cuando la forma está completa la baño en polímero acrílico para que se endurezca y sea menos sensible y frágil. Intento desafiar a la forma mediante la relación entre forma y color y creo que esta relación produce y transforma el volumen y las piezas tridimensionales. Básicamente lo que hago es jugar e intentar explorar distintos territorios.

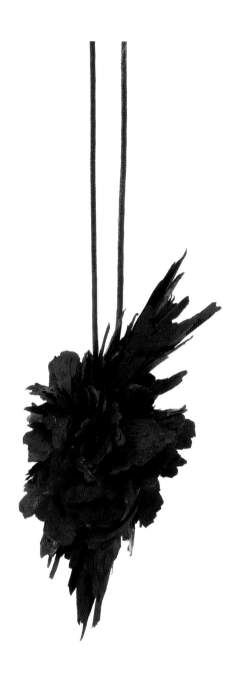

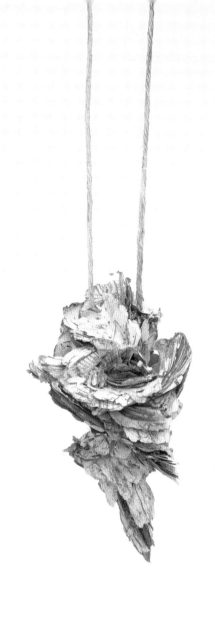

POR / Minha inspiração vem não tanto do visual, mas sim do emocional, de uma sensação ou um *instinto*. Me centralizo muito nos ciclos da natureza e com frequência trato de captar algo deste processo. Tento deixar esta sensação de movimento infinito a esses objetos, como nesse instante que podemos capturar, deter, no meio de uma ação. Com frequência começo por um papel ou cartão fino reciclado no qual desenho ou pinto com diferentes tipos de pinturas. Às vezes combino pedaços de jornal, livros ou outros papéis usados, à maneira de colagem. Logo os corto em pequenos pedaços de forma bastante espontânea e estes fragmentos se convertem na minha matéria-prima. A partir daqui, começo a construir volume colando as peças. Tento ser bastante livre e espontâneo. As formas vão se criando por si mesmo e aceito alguns dos acidentes que ocorrem durante este processo. Quando a forma está completa, eu a banho em polímero acrílico para que se endureça e seja menos sensível e frágil. Tento desafiar a forma mediante a relação entre forma e cor e acredito que esta relação produz e transforma o volume e as peças em tridimensionais. Basicamente o que faço é jogar e tentar explorar diferentes territórios.

FRA / Ce n'est pas une vision qui m'inspire, mais plutôt une émotion, une sensation, un *instinct*. Je suis à l'écoute des cycles de la nature et j'essaie de capter quelque chose de ce processus. Je cherche à transmettre cette perception de mouvement sans fin à des objets, comme un instant attrapé au vol. Je commence souvent à travailler avec du papier ou du carton recyclé de bonne qualité sur lequel je dessine ou je peins avec différents types de peintures. J'utilise parfois des bouts de journal ou de livre ou d'autres vieux papiers pour réaliser un collage. Ensuite, je le découpe en petits morceaux aléatoires. Ce sont ces fragments que je vais utiliser comme matière première. À partir de là je construis des volumes en collant les pièces à la manière d'un puzzle. J'essaie d'être libre et spontané. Les formes se créent toutes seules et j'accepte certains accidents qui peuvent survenir au cours du processus. Une fois la forme terminée, je la plonge dans du polymère acrylique pour qu'elle durcisse et soit moins fragile. Le défi est d'établir un rapport entre la forme et la couleur, parce que je crois que c'est cette relation qui produit et transforme le volume et les pièces tridimensionnelles. C'est un jeu et je m'amuse à explorer différents territoires.

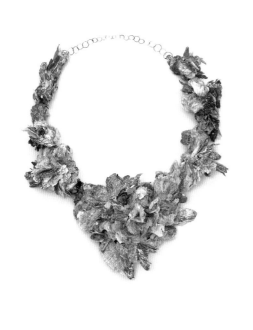

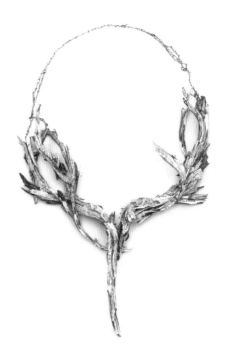

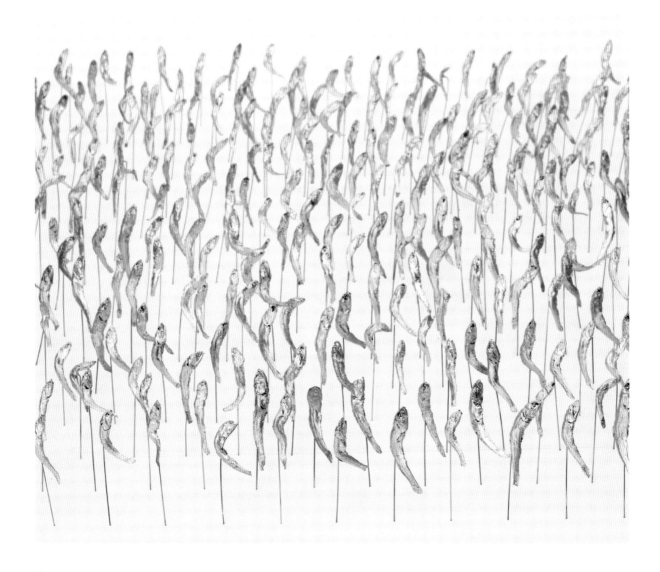

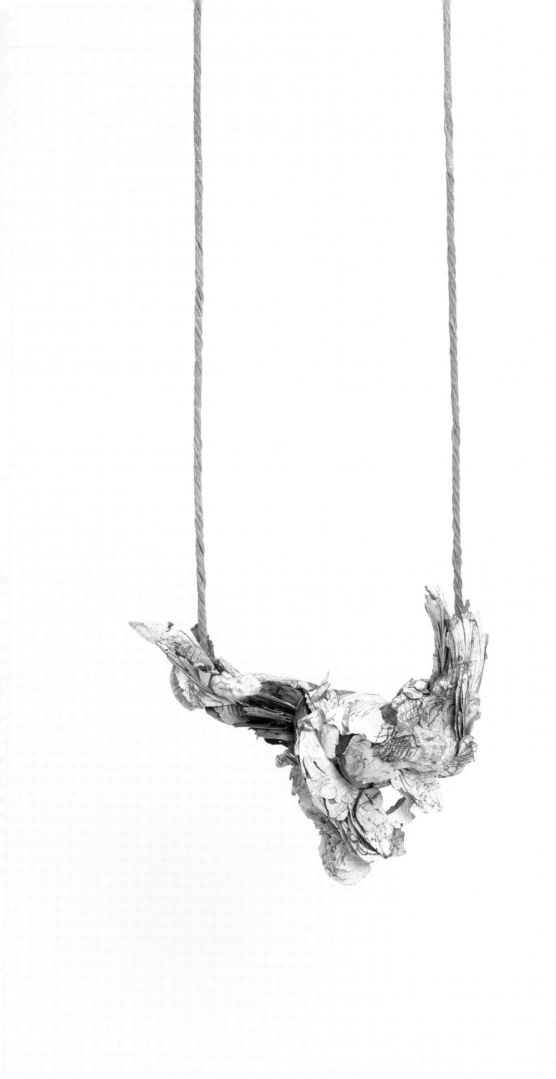

Walter
Chen

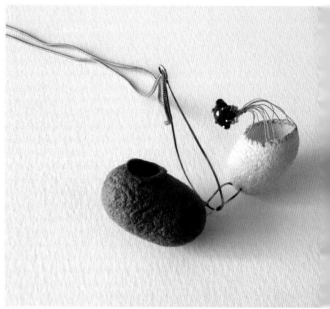

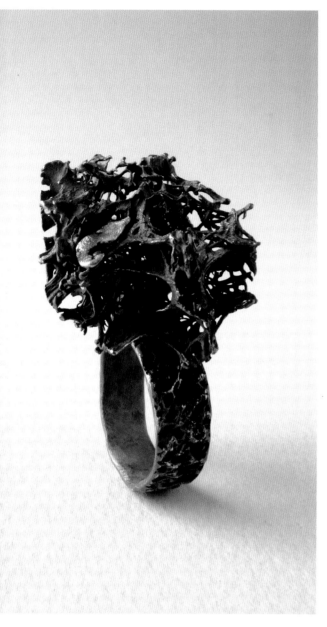

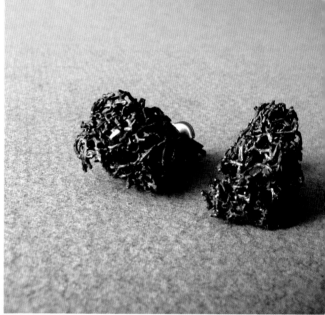

ESP/ La evolución y el crecimiento de la naturaleza son la base de mis creaciones, que buscan plasmar la plenitud y el vacío en objetos llenos de luz interior.
La cultura de mi país tiene una gran influencia en mi manera de pensar y mi percepción del mundo. Intento que esto esté presente en mi obra. La pintura china, por ejemplo, nace de formas e imágenes de la naturaleza y se convierte en un búsqueda de la belleza a través del trazo, de la línea. Busca el espíritu antes que la forma. En esencia, expresa sentimientos, estados del alma, mediante el pincel. Del mismo modo, yo busco reflejar la vitalidad, la constante transformación del mundo vegetal. Mis técnicas preferidas son el cincelado, que me permite crear volumen a partir de una lámina de metal, y también la fundición con materiales orgánicos. Cada material tiene características distintas. Cuando pruebo un material nuevo siempre aprendo algo que me servirá para manipular nuevos materiales en el futuro.

ENG/ Evolution and growth: these aspects of nature are the basis of my creations. With them I seek to capture the fullness and emptiness in objects that are filled with interior light. My country's culture has had a great influence on my thinking and my perception of the world. I try to make this apparent in my work. Chinese painting, for example, comes from natural forms and images and becomes a quest for beauty through strokes and lines. It seeks the spirit rather than the form. In essence it expresses, through the brush, feelings, spiritual states. Likewise, I seek to reflect the vitality and the constant transformation of the plant world. My favourite techniques are engraving, which allows me to create volume from a sheet of metal, and also casting with organic materials. Every material has different characteristics. When I test a new material I always learn something that will help me to work with new materials in the future.

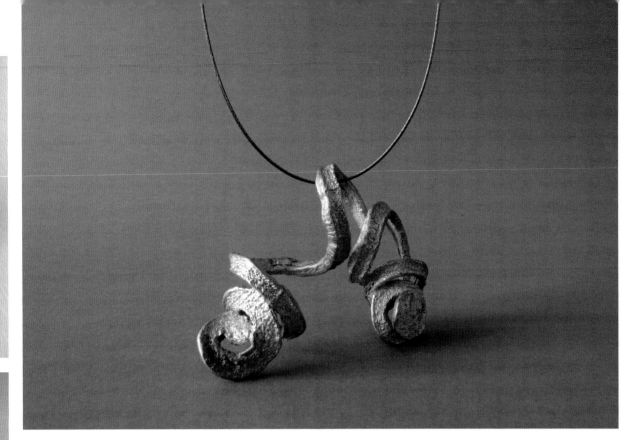

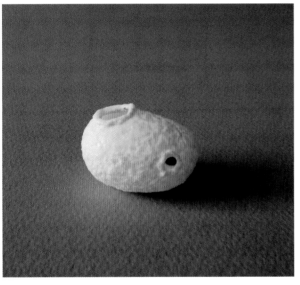

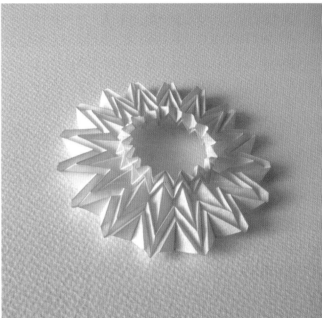

FRA / Mes créations reposent sur l'évolution et la croissance
de la nature. Elles tentent d'exprimer la plénitude et le vide
des objets remplis de lumière intérieure.

La culture de mon pays a une grande influence sur ma façon
de penser et ma perception du monde. J'essaie de transmettre
tout cela dans mes œuvres. La peinture chinoise, par exemple,
naît de formes et d'images de la nature. C'est une recherche
de la beauté par le biais de la toile et du tracé : c'est davantage
la recherche d'une essence que d'une forme. La peinture
exprime des sentiments, des états animiques, à l'aide d'un
pinceau. De la même manière, j'essaie de traduire la vitalité,
la transformation permanente du monde végétal. Les
techniques que je préfère sont la ciselure, qui me permet
de créer des volumes à partir d'une feuille de métal, et la fonte
associée à des matières organiques. Chaque matière possède
ses qualités propres. Lorsque je teste un nouveau matériau,
j'apprends toujours quelque chose qui me servira par la suite,
lorsque je travaillerai avec des matières nouvelles.

POR / A evolução e o crescimento da natureza são a base das
minhas criações, que buscam capturar a plenitude e o vazio
em objetos cheio de luz interior.

A cultura do meu país tem uma grande influência na minha
maneira de pensar e na minha percepção do mundo. Tento
que isto esteja presente em minha obra. A pintura chinesa,
por exemplo, nasce de formas e imagens da natureza e se
converte em uma busca da beleza através do traço, da linha.
Busca o espírito antes que a forma. Em essência, expressa
sentimentos, estados do espírito, diante do pincel. Do mesmo
modo, eu busco refletir a vitalidade, a constante transformação
do mundo vegetal. Minhas técnicas preferidas são o cinzelado,
que me permite criar volume a partir de uma lâmina de metal,
e também a fundição com materiais orgânicos. Cada material
tem características diferentes. Quando provo um material
novo sempre aprendo algo que me servirá para manipular
novos materiais no futuro.

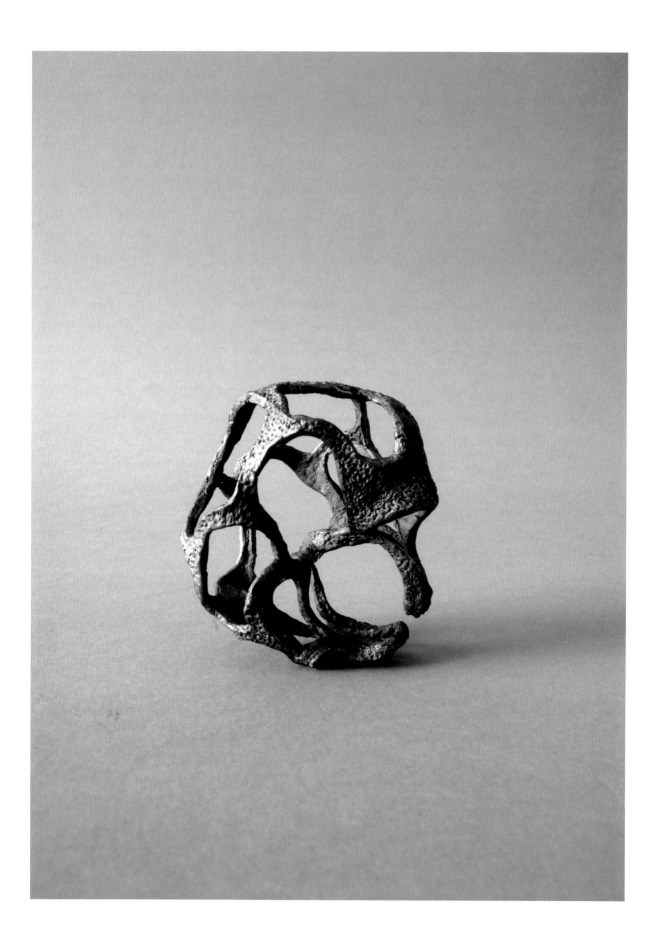

*I seek to capture the fullness and emptiness
in objects that are filled with interior light.*

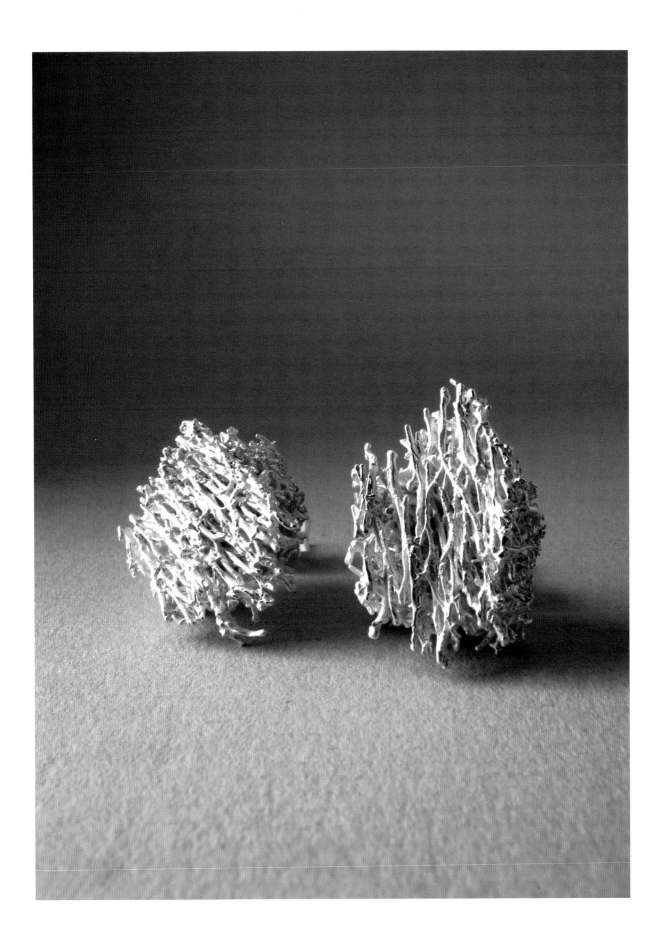

Carina
Chitsaz-Shoshtary

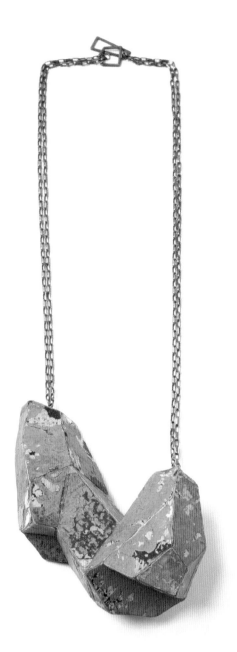

ENG / Often when I experiment with a new colour it means
the start of a piece. Of course, nature gives us our most
extraordinary colours and amazing colour combinations.
I like to turn artificial materials into natural-looking objects.
My plastic pieces look like they've been collected from the
bottom of the sea and the delicate fitting pieces create an
impression of decadence and decay, like dead leaves and
dry branches.
I prefer to work with simple techniques that require few tools.
I like to take my work wherever I go, so all my materials
and my tools need to fit in a bag.
I explore a material's potential to transform it into something
surprisingly different and make it unrecognisable. I choose
the materials according to the collection. I deconstruct
objects to turn them into pieces with different dimensions,
part by part.
I used to be a singer, and music is very important to me.
My work is very intuitive and emotional, and I think the
music we listen to while we create awakens our emotions
and definitely influences the work process.

ESP / Cuando experimento un color nuevo, especial, esto
a menudo significa el principio de una pieza. Por supuesto,
los colores más impresionantes y las combinaciones de color
más increíbles nos los da la naturaleza. Me gusta convertir
materiales artificiales en objetos de apariencia natural.
Mis piezas de plástico parecen recogidas del fondo del mar
y las delicadas piezas de encaje producen una impresión
de decadencia y descomposición, como hojas muertas
o ramas secas.
Prefiero trabajar con técnicas simples que requieran pocas
herramientas. Me gusta llevarme el trabajo allá donde voy,
por eso todo el material y las herramientas deberían caber
en una bolsa.
Exploro el potencial de un material para transformarlo en
algo sorprendentemente distinto y hacerlo irreconocible.
Elijo los materiales según la colección. Deconstruyo los
objetos para convertirlos en piezas con dimensiones
distintas, parte por parte.
Antes era cantante y la música es muy importante para mí.
Mi trabajo es muy intuitivo y emocional y creo que la música
que escuchamos despierta nuestras emociones e influye
definitivamente en el proceso de trabajo.

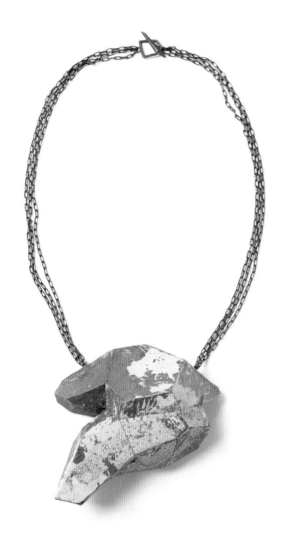

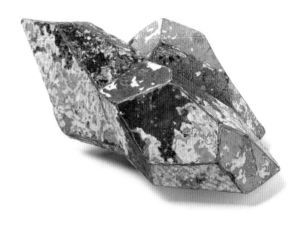

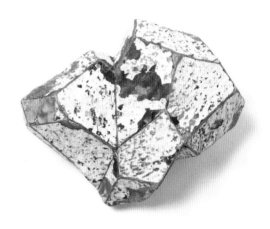

FRA / Lorsque je fais des essais avec une couleur inédite ou particulière, cela se termine souvent par la création d'un bijou. Il est clair que c'est dans la nature que l'on trouve les couleurs et les combinaisons tonales les plus percutantes. J'aime transformer des matières artificielles en objets qui paraissent naturels. Mes créations en plastique semblent sorties du fond des océans et les délicates dentelles évoquent la décadence et la décomposition, comme des feuilles mortes ou des branches sèches.

Je préfère utiliser des techniques simples qui ne font appel qu'à un nombre limité d'outils. J'aime emporter avec moi, partout où je vais, mon travail en cours : il faut donc que tous les matériaux et outils nécessaires tiennent dans mon sac. J'explore le potentiel d'un matériau et puis je le convertis en tout autre chose, en un produit totalement méconnaissable.

Je choisis les matières en fonction de la collection. Je déconstruis les objets pour les transformer en éléments de tailles distinctes, morceau par morceau. Autrefois, j'étais chanteuse et la musique a une grande importance dans ma vie. Mon travail est très intuitif et émotionnel. Je crois que la musique que nous écoutons réveille nos émotions. Elle influence résolument mon processus créatif.

POR / Quando experimento uma cor nova, especial, isto frequentemente significa o princípio de uma peça. Certamente, as cores mais impressionantes e as combinações de cores mais incríveis vêm da natureza. Eu gosto de converter materiais artificiais em objetos de aparência natural. Minhas peças de plástico parecem recolhidas do fundo do mar e as delicadas peças de encaixe produzem uma impressão de decadência e decomposição, como folhas mortas ou ramos secos.

Prefiro trabalhar com técnicas simples que requerem poucas ferramentas. Eu gosto de levar o trabalho onde quer que eu vá, por isso todo o material e as ferramentas devem caber em uma bolsa.

Exploro o potencial de um material para transformá-lo em algo surpreendentemente diferente e fazê-lo irreconhecível. Escolho os materiais segundo a coleção. Desconstruo os objetos para convertê-los em peças com dimensões diferentes, parte por parte.

Antes eu era cantora e a música é muito importante para mim. Meu trabalho é muito intuitivo e emocional e creio que a música que escutamos desperta nossas emoções e influencia definitivamente no processo de trabalho.

Sungho
Cho

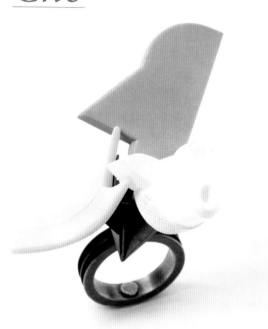

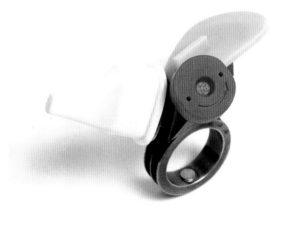

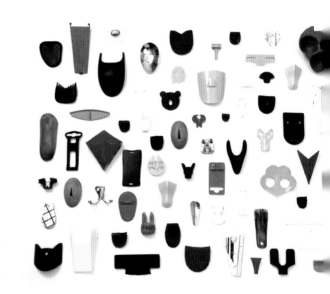

ENG / Who am I?

I wander aimlessly to find my place in the world, like a nomad. It's a long trip, finding myself. I lead a precarious life. What's in front of me is still blurry; I can't see past my nose. It's as if I were looking at an abstract portrait: the model could be you, me, any of us, even if it has no eyes, ears, nose or mouth. In the midst of the creative process, my jewellery reminds me of life itself and I feel like they help me to know myself better. Through my pieces I've created a secret place, I have deposited something precious from me in them. I offer myself words of comfort. In this way, my jewellery becomes a monument to my own life. And I hope that those who wear them discover new meanings in them.

My work is an extension of myself, and through it I want to find the way in which I want to live my life. The experience of change is what inspires me the most, like salvaged objects that lose their primary function when they're recycled and become something completely different. Their original form disappears in a moment of agony. In this way it's not only the material that is transformed, but also the form.

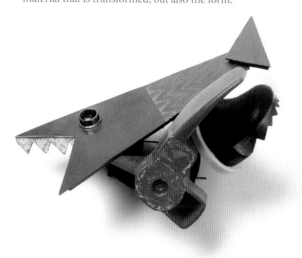

ESP / ¿Quién soy yo?

Vagabundeo sin dirección para encontrar mi lugar en el mundo, como un nómada. Es un largo viaje, este de encontrarme a mi mismo. Llevo una vida precaria. Lo que hay delante de mí está todavía borroso, no puedo ver más allá de mis narices. Igual que si estuviera mirando un retrato abstracto: el modelo podrías ser tú, yo, cualquiera de nosotros, aunque no tenga ojos, orejas, nariz o boca.

En medio del proceso creativo, mis joyas me recuerdan a la vida misma y siento que me ayudan a conocerme mejor. En mis piezas he creado un lugar secreto, he depositado algo precioso de mí en ellas. Me ofrezco palabras de consuelo. De esta manera, mis joyas se convierten en un monumento a mi propia vida. Y espero que quienes las lleven descubran en ellas un nuevo significado.

Mi trabajo es una extensión de mí mismo, y a través de él quiero encontrar la manera en que deseo vivir mi vida. La experiencia vital es lo que más me inspira, los objetos encontrados, que pierden su función primera al ser reciclados y se convierten en algo totalmente distinto. En un momento de agonía desaparece su forma original. De esta manera se transforma, no solo la materia, sino también la forma.

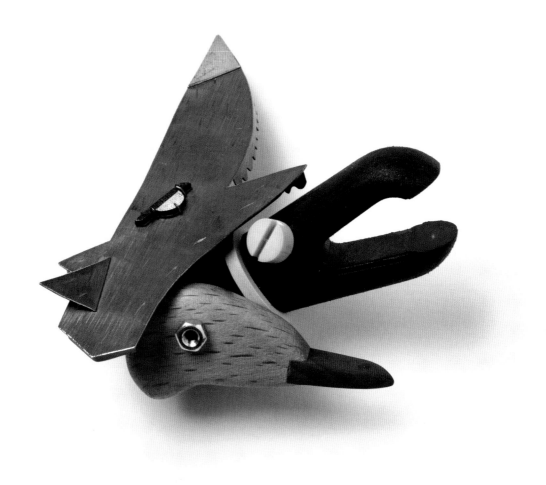

FRA / Qui suis-je?

Comme un nomade, je déambule sans but de par le monde
pour trouver ma place. C'est un long voyage, cette quête où je
me cherche moi-même. Je mène une vie précaire. Ce qui est
devant moi est encore flou, je n'arrive pas à voir plus loin
que le bout de mon nez. C'est comme si je contemplais un
portrait abstrait : le modèle pourrait être toi, moi, n'importe
lequel d'entre nous, même dépourvu d'yeux, d'oreilles, de nez
ou de bouche.

Au cours du processus créatif, mes bijoux me font penser à
la vie, et je sens qu'ils m'aident à mieux me connaître. Au cœur
de mes créations, j'aménage un endroit secret où je dépose une
précieuse partie de moi-même. Mais je me console, car de cette
façon mes bijoux forment un monument dédié à ma propre
vie. J'espère que les personnes qui les portent donneront à mes
créations un nouveau sens.

Mon travail est une extension de moi-même et, à travers lui,
je découvre la manière dont je veux vivre ma vie. L'expérience
vitale est ce qui m'inspire le plus. Les objets que je récupère
perdent leur fonction première lors du recyclage : ils deviennent
tout autre chose. Dans un moment d'agonie, la forme originale
disparaît. C'est ainsi que se métamorphosent non seulement
la matière mais aussi la forme.

POR / Quem sou eu?

Vagando sem direção para encontrar meu lugar no mundo,
como um nômade. É uma viagem longa, a de encontrar a mim
mesmo. Levo uma vida precária. O que está diante de mim
ainda não está claro, não posso ver mais além do meu nariz.
É como se eu estivesse observando um retrato abstrato: o
modelo poderia ser você, eu, qualquer um de nós, ainda que
não tenha olhos, orelhas, nariz ou boca.

No meio do processo criativo, minhas joias me lembram a
vida e sinto que me ajudam a me conhecer melhor.

Em minhas peças, criei um lugar secreto, depositei algo
precioso de mim nelas. Ofereço palavras de consolo.

Desta maneira, minhas joias se convertem num monumento
à minha própria vida. E espero que quem as leve descubram
nelas um novo significado.

Meu trabalho é uma extensão de mim mesmo, e através dele
quero encontrar a maneira no qual desejo viver a minha vida.
A experiência vital é o que mais me inspira; os objetos
encontrados, que perdem a sua função primordial ao serem
reciclados e se convertem em algo totalmente diferente.

Num momento de agonia desaparece a sua forma original.
Desta maneira se transforma, não só a matéria, assim como
também a forma.

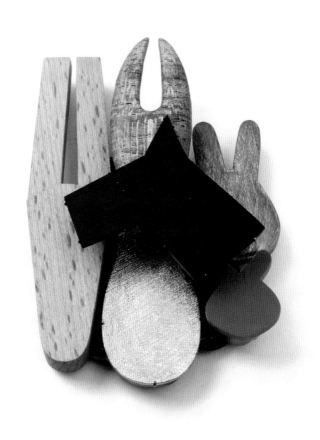

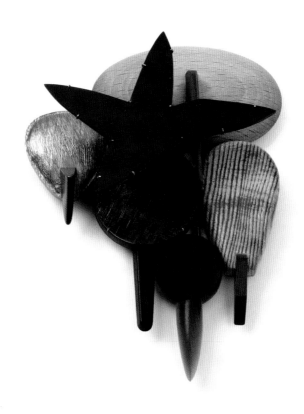

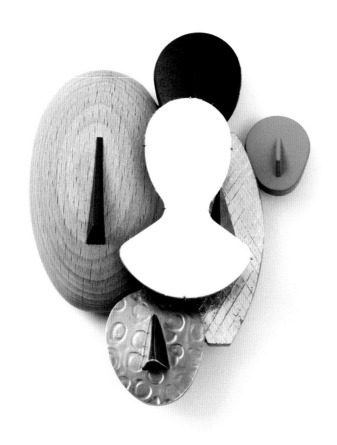

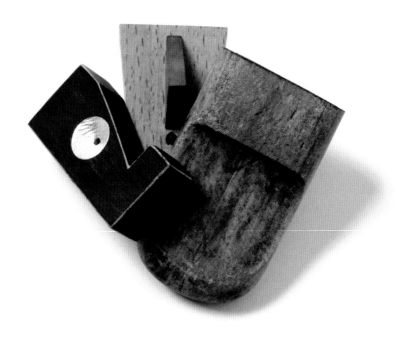

Andrea
Coderch

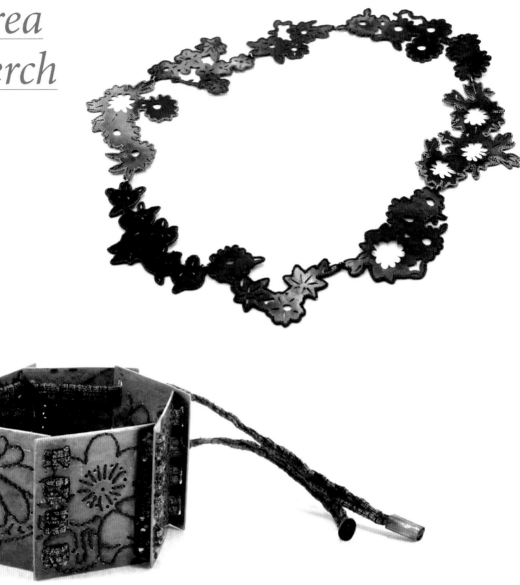

ENG/ I try to recount what happens to me through my pieces.
Some people write diaries, others run... I make jewellery.
I am primarily inspired by what I've seen or experienced,
situations that have had an impact on me in one way or another.
I let myself be carried away by my instinct, for example by
working with objects that I find on the street. Perhaps that
encounter is no accident. This object with its own life that now
appears before me—does it want to tell me something?
For me as a jeweller, my experience in Japan definitely marked
a before and an after. I think that from now on nothing will
be the same. Its architecture, jewellery techniques, sumi-e,
ukiyo-e, bookbinding, the Katana, kimono... Japan is a
never-ending source of inspiration for me. I am now
intensively exploring this experience and I daresay that
it will give me work for years and years to come.
I love to use thread in my work, sewing metal fascinates me,
and I find that making holes frees my mind. The techniques
that I use always depend on what each piece needs. I like
to work with metals, wood and fabrics that take me back
to my origins.

ESP/ Intento relatar lo que me ocurre a través de mis piezas.
Algunos escriben diarios, otros corren…yo hago joyería.
Principalmente me inspiro en aquello que he visto o vivido,
situaciones que me han marcado de una forma u otra.
Me dejo llevar por mi instinto, por ejemplo, trabajar con
objetos que encuentro por la calle. Quizá el encuentro no
es casual; este objeto con su propia vida que ahora aparece
ante mí…¿me querrá contar algo?
Como joyera, mi experiencia en Japón ha marcado
definitivamente un antes y un después. Creo que ya nada
volverá a ser igual. La arquitectura, las técnicas de joyería,
el sumi-e, el ukiyo-e, la encuadernación, las katanas,
los kimonos…Japón es para mí una fuente interminable
de inspiración. Ahora exploro intensamente esta experiencia
y casi me arriesgaría a decir que esto me dará para años y
años de trabajo.
Me encanta emplear hilo en mi trabajo, el hecho de coser
metal me fascina, y encuentro que realizar agujeros libera
mi mente. Las técnicas que uso siempre dependen de lo que
cada pieza necesita. Me gusta trabajar con metales, maderas
y tejidos que me devuelven a mis orígenes.

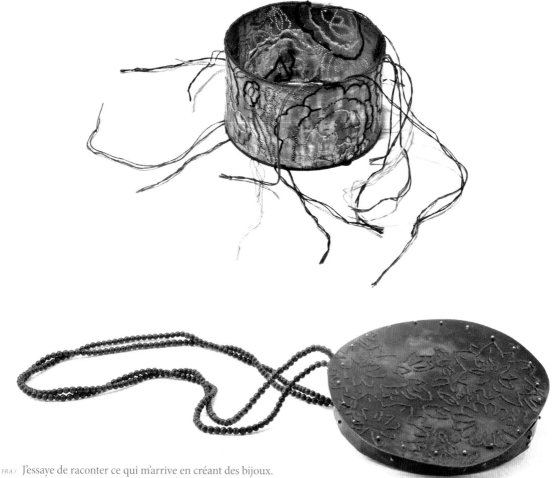

FRA / J'essaye de raconter ce qui m'arrive en créant des bijoux. Certains écrivent un journal, d'autres courent... moi je fais de la bijouterie. En général, je m'inspire de ce que je vois ou vis, des situations qui m'ont marquée d'une manière ou d'une autre. Je me laisse porter par mon instinct, par exemple, je travaille avec des objets que je trouve dans la rue. Peut-être que cette découverte n'est pas un hasard : cet objet qui possède une vie propre et que je viens de ramasser aurait-il quelque chose à me dire ?

En tant que créatrice de bijoux, mon expérience japonaise a marqué un tournant décisif dans ma carrière. Je crois que rien ne sera jamais plus comme avant. L'architecture, les techniques de bijouterie, le sumi e, l'ukiyo e, la reliure, les katanas, les kimonos... Le Japon est une source d'inspiration inépuisable. En ce moment, j'explore à fond cette expérience, et j'irais même jusqu'à dire qu'elle inspirera encore mon travail pendant des années et des années.

J'adore travailler avec du fil, et l'idée de coudre du métal m'enchante : faire des petits trous libère mon esprit. Les techniques que j'emploie varient suivant les besoins du bijou. J'aime travailler le métal, le bois et le tissu ; ils me renvoient à mes origines.

POR / Tento relatar o que me ocorre através das minhas peças. Alguns escrevem diários, outros correm... Eu faço joias. Principalmente me inspiro naquilo que vi ou vivi, situações que me marcaram de uma forma ou outra. Me deixo levar pelo meu instinto, por exemplo, trabalhar com objetos que encontro pela rua. Talvez o encontro não seja casual; este objeto com a sua própria vida que agora aparece diante de mim... Quer me contar algo?

Como joalheira, minha experiência no Japão marcou definitivamente um antes e um depois. Creio que nada voltará a ser igual. A arquitetura, as técnicas de joalheria, o *sumi-e*, o *ukiyo-e*, a encadernação, as *katanas*, os quimonos... Japão é uma fonte interminável de inspiração para mim. Agora exploro intensamente esta experiência e quase me arriscaria a dizer que isto me fornecerá anos e anos de trabalho.

Adoro utilizar o fio em meu trabalho, o fato de costurar metal me fascina e descubro que realizar furos libera a minha mente. As técnicas que uso sempre dependem do que cada peça necessita. Eu gosto de trabalhar com metais, madeiras e tecidos que me retornam às minhas origens.

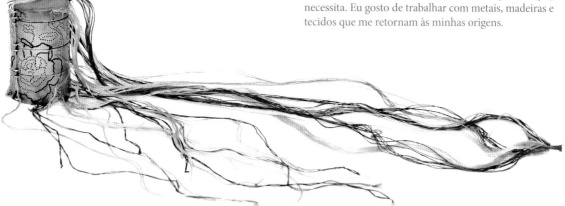

Hilde
de Decker

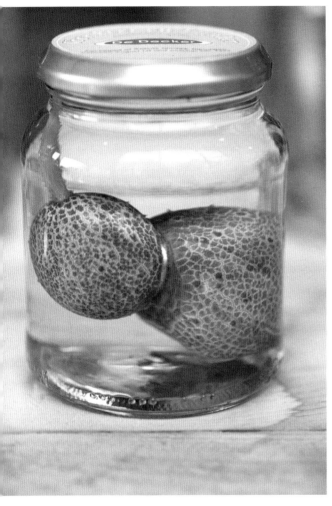

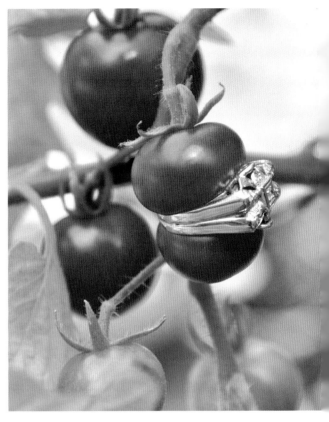

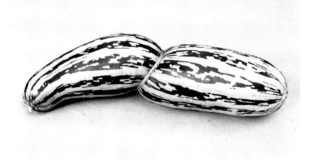

ENG / When a few years ago I was named Stadtgoldschmiede—goldsmith in residence—of the city of Hanau, I started thinking about what themes I could develop in my workshop. I wanted to offer completely new ideas that incorporated my own development. From this the idea of the Mobile Museum came about. Nowadays, technology leads us to constantly change our life and work spaces. We're global nomads. In contrast, museums represent stability and the past, which will not change. But imagine a nomadic Museum, in which we can show whatever we want, wherever we want. Three-dimensional objects are reduced to two dimensions. They are flexible, foldable, removable, they can be rolled up, and fastened together... But what historical objects deserve to be transported? Moving also means going and living elsewhere: presence and absence. On leaving a place, we leave traces of our presence. This makes us aware of the immense value of everyday life. And it also presents us with the question of *presentation* and *representation*: What is more important, the material object or what it suggests? Do we need the real thing to believe? To what extent can we make associations, up to what point can an object be reduced, and what is its essence? What generates images in our minds? In Hanau I was able to explore these topics by means of models, materials and techniques.

ESP / Cuando hace unos años fui nombrada Stadtgoldschmiede –orfebre invitada- de la ciudad de Hanau, empecé a pensar qué temas podría desarrollar en mi taller. Quería ofrecer una idea totalmente nueva que integrara mi propia evolución. Ahí nació la idea del Museo Móvil. Hoy en día, la tecnología nos lleva a cambiar constantemente nuestros espacios vitales y de trabajo. Somos nómadas globales. Por el contrario, el museo representa lo estable, el pasado que ya no cambiará. Pero imaginémonos un museo nómada, en el que podemos mostrar lo que queramos, donde queramos. Objetos tridimensionales se reducen a dos dimensiones. Son flexibles, plegables, desmontables, pueden enrollarse, encadenarse… Pero entonces ¿qué objetos históricos merecen ser transportados? Moverse significa también ir a vivir a otra parte: la presencia y la ausencia. Al abandonar un lugar dejamos rastros de nuestra presencia. Esto nos hace tomar consciencia del valor inmenso de lo cotidiano. Y también se nos presenta la cuestión de presentación y representación: ¿qué es más importante, el objeto material o lo que sugiere? ¿Necesitamos lo real para creer? ¿hasta qué punto podemos hacer asociaciones, hasta dónde se puede reducir un objeto, cuál es su esencia? ¿Qué genera imágenes en nuestra mente? En Hanau pude explorar estos temas mediante maquetas, materiales y técnicas.

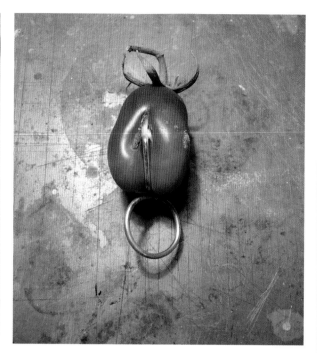

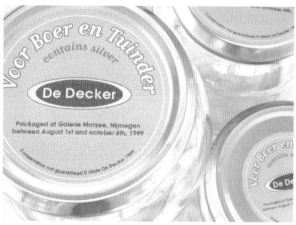

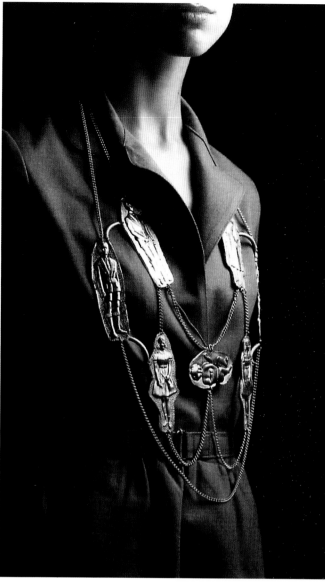

FRA / Lorsque j'ai été nommée, il y a quelques années, « Stadtgoldschmiede » ou orfèvre invitée de la ville allemande de Hanau, j'ai commencé à penser aux thèmes que je pourrais développer dans mon atelier. Je voulais proposer une idée complètement nouvelle qui intègrerait ma propre évolution artistique. C'est ainsi qu'est né le concept du Musée Mobile. Aujourd'hui, la technologie nous pousse à changer constamment de lieu de vie et de travail. Nous sommes devenus des nomades du monde. Le musée, au contraire, représente la stabilité, l'immuabilité du passé. Imaginons un musée nomade où nous pourrions présenter tout ce que l'on veut et où l'on veut. Les objets tridimensionnels se réduisent à deux dimensions. Ils sont malléables, pliables, démontables... on peut les enrouler, les enchaîner... Mais finalement, quels sont les objets historiques qui méritent d'être transportés ? Parce qu'être déplacés signifie aussi aller vivre ailleurs. C'est la présence et l'absence. Lorsque nous quittons un endroit où nous avons vécu, nous y laissons des traces de notre passage. Ceci nous permet de prendre conscience de la valeur immense du quotidien. Nous nous interrogeons alors sur la présentation et la représentation. Qu'est-ce qui est plus important : l'objet matériel ou ce qu'il nous suggère ? Avons-nous besoin du réel pour croire ? Jusqu'où peuvent nous mener les associations d'idées ? Jusqu'à quel point pouvons nous réduire un objet ? Quelle est son essence ? Qu'est-ce qui génère des images dans notre esprit ? À Hanau, j'ai pu explorer toutes ces voies à l'aide de maquettes, de matériaux et de techniques.

POR / Quando há alguns anos fui nomeada Stadtgoldschmiede – ourives convidada da cidade de Hanau, comecei a pensar sobre que assunto poderia desenvolver na minha oficina. Queria oferecer uma ideia totalmente nova que integraria minha própria evolução. Aí nasceu a ideia do Museu Móvel. Hoje em dia, a tecnologia nos leva a mudar constantemente nossos espaços vitais e de trabalho. Somos nômades globais. Pelo contrário, o museu representa o estável, o passado que já não mais se muda. Mas imaginemos um museu nômade, no qual podemos mostrar o que queremos, onde queremos. Objetos tridimensionais se reduzem a duas dimensões. São flexíveis, dobráveis, desmontáveis, podem enrolar-se, encadear-se... Mas então que objetos históricos merecem ser transportados? Mover-se significa também ir a viver em outra parte: a presença e a ausência. Ao abandonar um lugar deixamos rastros da nossa presença. Isto nos faz conscientizar do valor imenso do cotidiano. E também nos apresenta a questão de apresentação e representação: o que é o mais importante, o objeto material ou o que ele sugere? Precisamos do real para crer? Até que ponto podemos fazer associações, até onde se pode reduzir um objeto, qual é a sua essência? Quais imagens geram em nossa mente? Em Hanau pude explorar estes temas mediante maquetes, materiais e técnicas.

Katharina Dettar

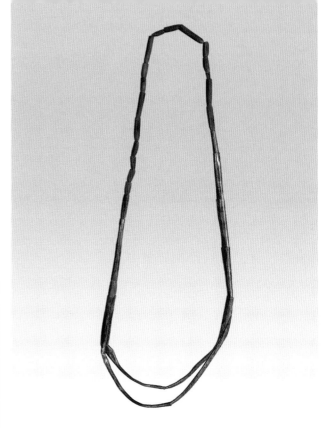

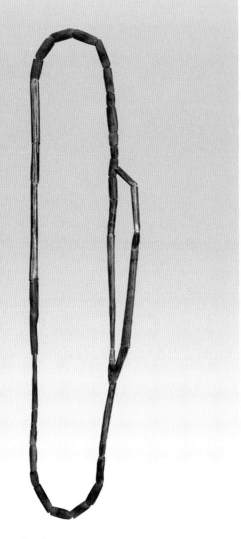

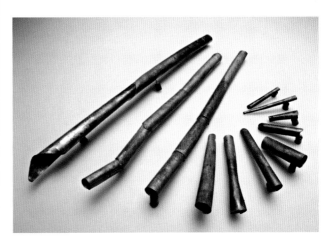

ENG / Is this jewellery?
Are these forms definitely jewellery, or just small sculptures/objects with a pin in the back?
Or perhaps suspended on a chain, so they become flexible structures for the human body?
Though the true origin of these beginnings is based on one question:
What does jewellery mean and what are the consequences of wearing it?

Ultimately I'm basically looking for the essence of jewellery for me, its importance and its values. I'm looking for that power, inherent in an object, which awakens in us the desire to have it, which causes a need in us: the power of attraction! It's the attraction of putting the necklace on over your head, feeling its weight on your skin and the satisfaction associated with all that, of displaying the piece and making it known to the people who see us, or even of the action of piercing an expensive piece of clothing with the needle of a brooch, just for the possibility of wearing it and having it on.

ESP / ¿Es esto joyería?
¿Son estás formas definitivamente joyería, o solo pequeñas esculturas/objetos con una aguja en la parte trasera?
¿O a lo mejor suspendidas de una cadena, por lo cual se transforman en estructuras flexibles aplicadas al cuerpo humano?
Aunque el verdadero origen de estos principios se basa en una pregunta:
¿Qué significa la joyería y qué consecuencias trae consigo el uso de joyas?

Al final, básicamente , estoy buscando la esencia de la joyería para mí, su importancia y sus valores. Estoy buscando ese poder, inherente a un objeto, que nos despierta el deseo de tenerlo, que provoca una necesidad en nosotros: ¡El poder de la atracción! Una atracción que implica tener que pasar el collar sobre la cabeza, sentir su peso en la piel y la satisfacción asociada a todo ello. Mostrar la joya y darla a conocer a quienes nos ven. Incluso la acción de perforar una costosa pieza de ropa con la aguja de un broche, tan solo por la posibilidad de poder sostenerlo y llevarlo.

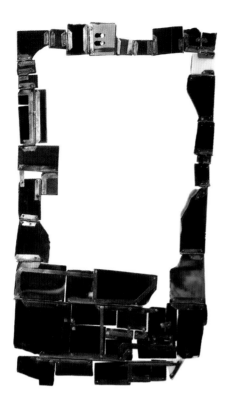
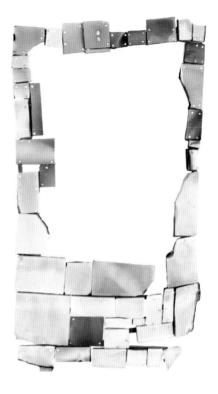
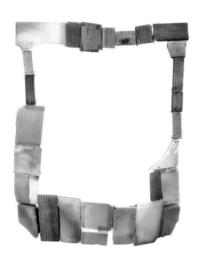
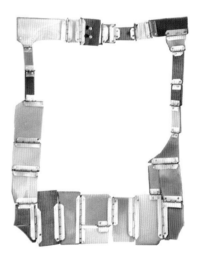

FRA / Est-ce un bijou ?

Ces formes sont-elles réellement des bijoux ou bien sont-elles des petites sculptures ou des objets équipés d'une épingle à l'arrière ?

Et si on les accroche à une chaîne, se transforment-elles en structures souples qui s'adaptent au corps humain ?

Une double question fondamentale est à la base de toutes ces interrogations :

Qu'est-ce qu'un bijou et qu'est-ce que son port implique ?

En fait, je cherche l'essence même du bijou, son importance et ses valeurs. Je m'intéresse au pouvoir inhérent de cet objet qui attise notre convoitise, qui crée en nous un besoin. La force d'attraction qu'il exerce ! Qui nous pousse à mettre un collier, à sentir son poids sur notre peau et à éprouver une réelle satisfaction à le faire. Arborer un bijou, le montrer à ceux qui nous voient. Aller jusqu'à perforer un vêtement coûteux pour y fixer une broche, simplement pour le plaisir de l'y accrocher et de la porter.

POR / Isto é joalheria?

Estas formas são definitivamente joalheria ou são pequenas esculturas/objetos com uma agulha na parte traseira?

Ou melhor, suspensas por uma corrente, pelo qual se transformam em estruturas flexíveis aplicadas ao corpo humano?

Ainda que a verdadeira origem destes princípios se baseie em uma pergunta:

O que significa a joalheria e que consequências traz o uso de joias?

No final, basicamente, estou buscando a essência da joalheria para mim, a sua importância e os seus valores. Estou buscando esse poder, inerente a um objeto, que nos desperte o desejo de tê-lo, que provoca uma necessidade em nós: O poder da atração! Uma atração que envolve ter que passar o colar sobre a cabeça, sentir o seu peso na pele e a satisfação associada a tudo isso. Mostrar a joia e torna-la conhecida para quem nos vê. Inclusive a ação de perfurar uma peça de roupa cara com a agulha de um broche, tão só pela possibilidade de poder mantê-lo e levá-lo.

Patricia Domingues

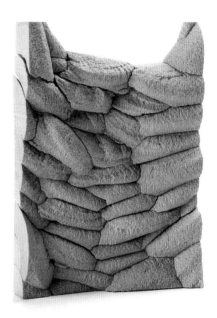

ENG / In the last three years I have tried to explore the idea of borders and limits as a value brought to the material. I work based on the idea of lines. When we draw them we create separate fields, but we also point out their unity. I question the idea of the different values that separate and unite. I am interested in the beginning and the end of things. Lines emerge as an expression of what unites the fields of space and material which, so distant in their immediate appearance, overlap and inhabit one another. Jewellery works for me as a reflection of human behaviour, and a material link between mind and body. Cutting, pasting, sculpting, composing, splitting up, breaking, joining... basic techniques allow me to express myself freely. I think my range of materials goes from wood, stone and resins to reconstituted material. In recent years I have worked with stone and reconstituted material. Stone is a material that involves many rules. Reconstituted material, however, works like a block of butter. Wherever you cut it, the material will be the same. I select resistant and bulky materials that I can sculpt, go through and transform.

ESP / En los últimos tres años he intentado explorar la idea de la frontera y del limite como un valor transportado hacia el material. Trabajo sobre la idea de la línea. Al trazarla separamos campos, pero también remarcamos su unión. Cuestiono la idea de los diferentes valores que separan y unen. Me interesa el principio y el final de las cosas. Las líneas surgen como expresión de lo que une los territorios espacio-materia que, tan distantes en su apariencia inmediata, se traspasan y se habitan. La joyería funciona para mí como un reflejo del comportamiento humano, y un vinculo material entre la mente y el cuerpo. Cortar, pegar, esculpir, componer, descomponer, romper, unir... Las técnicas básicas me permiten expresarme libremente. Creo que mi gama de materiales puede ir desde la madera, piedra y resinas hasta el material reconstituido. Los últimos años he trabajado con piedra y con material reconstituido. La piedra es un material formado por muchas reglas. El material reconstituido, en cambio, funciona como un bloque de mantequilla. Corte donde corte, el material será siempre el mismo. Selecciono materiales resistentes, y voluminosos para poder esculpirlos, atravesarlos y transformarlos.

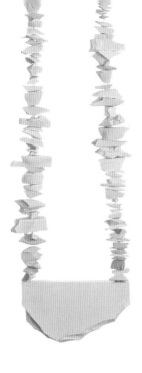

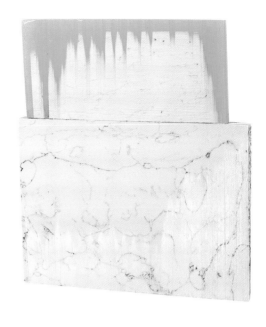

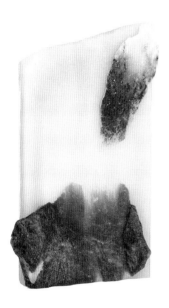

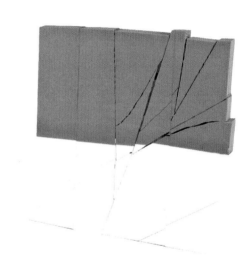

FRA / Je travaille depuis trois ans sur l'idée de frontière et
de limite, et sur l'application de cette notion à la matière.
Je me focalise sur le concept de ligne. Celle que l'on trace
marque la séparation entre deux camps, mais matérialise aussi
leur union. J'analyse les valeurs qui séparent et qui rassemblent.
Jc m'intéresse au commencement et à la fin des choses.
Les lignes sont l'expression concrète de ce qui relie les territoires
espace-matière, qui semblent tellement loin au premier abord,
mais que l'on peut traverser et habiter. Je considère que la
bijouterie est le reflet du comportement humain ; c'est le
véhicule matériel entre l'esprit et le corps. Découper, coller,
sculpter, orner, démonter, briser, assembler... Les techniques
de base me permettent de m'exprimer librement. La gamme
de matériaux que j'emploie va du bois à la pierre en passant
par les résines et le matériau reconstitué. Ces derniers temps
j'ai travaillé avec de la pierre et du matériau reconstitué.
La pierre est une matière qui obéit à différentes règles.
Le matériau reconstitué, en revanche, est un peu comme
une motte de beurre. Quel que soit l'endroit où l'on coupe,
il a toujours le même aspect. Je sélectionne des matériaux
résistants et volumineux pour pouvoir les sculpter, les
perforer et les transformer.

POR / Nos últimos três anos, tentei explorar a ideia da fronteira
e do limite como um valor transportado até o material.
Trabalho com a ideia da linha. Ao traçá-la separamos campos,
mas também remarcamos a sua união. Questiono a ideia dos
diferentes valores que separam e unem. Me interessa o princípio
e o fim das coisas. As linhas surgem como expressão do que une
os territórios espaço-matéria que, tão distantes da sua aparência
imediata, se ultrapassam e se habitam. A joia funciona para
mim como um reflexo do comportamento humano, e um
vínculo material entre a mente e o corpo. Cortar, colar,
esculpir, compor, descompor, romper, unir... As técnicas
básicas permitem expressar-me livremente. Creio que minha
gama de materiais pode ir desde a madeira, pedra e resinas até
o material reconstituído. A pedra é um material formado
por muitas regras. O material reconstituído, por outro lado,
funciona como uma barra de manteiga. Corte onde corte,
o material será sempre o mesmo. Seleciono materiais
resistentes e volumosos para poder esculpi-los, atravessá-los
e transformá-los.

Barbora Dzurakova

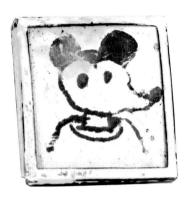

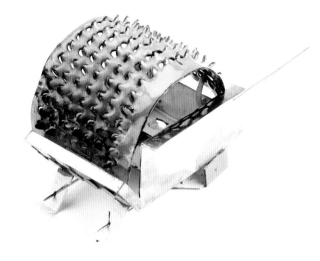

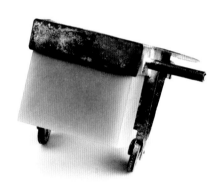

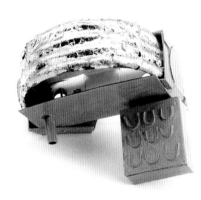

ENG / I am interested in investigating the various elements of the folk tradition of my country, Slovakia, and in exploring its artisanal techniques to try to find new applications that I can use in my work.

The basis of my artistic training is crystal: my speciality is glass-cutting techniques for a special type of vases. Making jewellery frees my mind and my hands: I freely choose a material and a technique, which is something I love. I like to go slowly, look closely at my work and decide what the next step will be.

Nature and artisanal objects are essential sources of inspiration to me. But I'm also inspired by everyday acts, like looking out the window of a train, climbing to the top of a hill, cycling through a new city, watching how the shelf stackers gradually put stock on the shelves of a supermarket, hearing a quiet conversation or taking pictures of a street, an iron gate, antique tools. I'm inspired by visiting a museum or an art gallery, or a design shop, or watching documentaries and reading books, or fashion or gardening magazines.

ESP/ Me interesa investigar los diversos elementos de la tradición folclórica de mi país, Eslovaquia, explorar sus técnicas artesanales para intentar encontrar nuevas aplicaciones que pueda usar en mi trabajo.

La base de mi formación artística es el cristal: mi especialidad, las técnicas de corte de cristal para un tipo especial de jarrones. Hacer joyas libera mi mente y mis manos; elijo libremente un material y una técnica y esto me encanta. Me gusta ir despacio, mirar de cerca mi trabajo y decidir cuál será el siguiente paso. La naturaleza y los objetos artesanales son para mí fuentes esenciales de inspiración. Pero también me inspiro en actos cotidianos, como mirar por la ventana de un tren, subir a lo alto de una colina, ir en bicicleta por una ciudad nueva, mirar como los reponedores colocan la mercancía poco a poco en las estanterías de un supermercado, escuchar una conversación tranquila o tomar fotos de una calle de una verja de hierro, de herramientas antiguas. Me inspira visitar un museo o una galería de arte, una tienda de diseño, ver documentales y leer libros, revistas de moda o de jardinería…

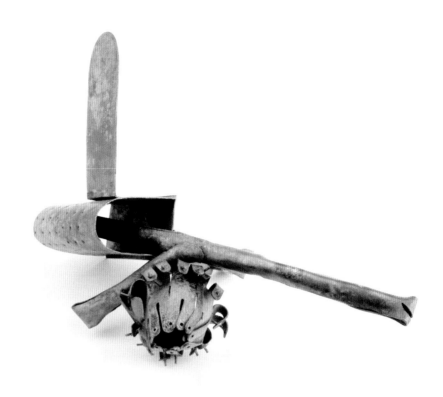

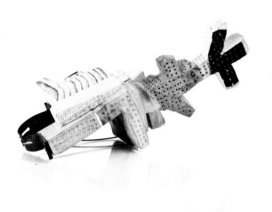

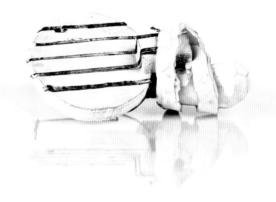

FRA / J'aime étudier tous les éléments du folklore de mon pays la Slovaquie et explorer ses techniques artisanales pour essayer de trouver de nouvelles applications qui me seraient utiles dans mon travail.

Ma formation de base est le verre. Ma spécialité est la découpe du verre pour la création d'un type particulier de vase suivant différentes méthodes. Le fait de fabriquer un bijou me libère l'esprit et les mains. Je choisis librement le matériau et la technique, et j'adore ça. J'aime procéder lentement et examiner de près mon travail avant de passer au détail suivant.

La nature et l'artisanat sont mes principales sources d'inspiration. Mais je puise également mes idées dans les actes de la vie quotidienne, comme regarder par la fenêtre d'un train, monter au sommet d'une colline, découvrir une nouvelle ville à bicyclette, observer les vendeurs ranger des articles sur les présentoirs des supermarchés, écouter une conversation tranquille ou prendre en photo une rue, une grille en fer, de vieux outils... Ce qui m'inspire aussi c'est de visiter un musée, une galerie d'art ou un magasin d'objets design, de voir des documentaires et de lire des livres, des magazines de mode ou de jardinage...

POR / Me interessa investigar os diversos elementos da tradição folclórica do meu país, Eslováquia, explorar as suas técnicas artesanais para tentar encontrar novas aplicações que eu possa usar no meu trabalho.

A base da minha formação artística é o vidro: minha especialidade, as técnicas de corte de vidro para um tipo especial de vaso. Fazer joias libera a minha mente e as minhas mãos, escolho livremente um material e uma técnica e isto me agrada. Eu gosto de ir devagar, olhar meu trabalho de perto e decidir qual será o passo seguinte.

A natureza e os objetos artesanais são para minhas fontes essenciais de inspiração. Mas também me inspiro em atos cotidianos, como olhar pela janela de um trem, subir no alto de um morro, andar de bicicleta por uma cidade nova, olhar como os reabastecedores colocam a mercadoria aos poucos nas prateleiras de um supermercado, escutar uma conversa tranquila ou tirar fotos de uma rua, uma grade de ferro, ferramentas antigas. Eu me inspiro ao visitar um museu ou uma galeria de arte, uma loja de *design*, ver documentários e ler livros, revistas de moda ou de jardinagem...

Iris Eichenberg

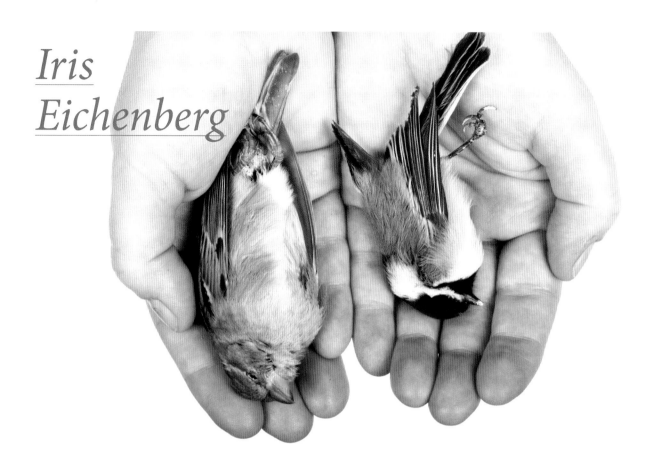

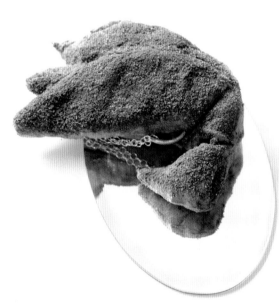

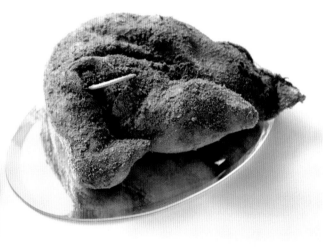

ENG / In my work I seek to understand and learn; it's a safe place, the part of my life where I do not fear being misunderstood. I'm not afraid to take risks that I would not take in other situations. It is both the most secure and the most insecure place, but a good place to be in. The most human and trivial things inspire me. Love, loss, longing, beauty: these are clichés that I want to transcend and abstract. Concepts repeat themselves, and I repeat myself constantly, but in different ways, in different and increasingly high voices inside me.

More than in terms of a technique, I like to think in terms of kinds of techniques: by hand, at human speed; adding more than taking away; simulating growth; coincidences. Depending on the moment, I use material that throws me, that awakens my senses in an indirect, unconscious, passing way.

ESP / En mi trabajo busco entender, aprender; es un lugar seguro, la parte de mi vida donde no temo ser malentendida. No temo asumir riesgos que no asumiría en otras situaciones. Es el lugar más seguro y el más inseguro, pero un buen lugar en el que estar. Me inspira lo más humano y trivial. El amor; la pérdida; la añoranza; la belleza: son clichés que quiero trascender y también abstraer. Los conceptos se repiten, yo misma me repito constantemente, pero de formas distintas, con voces diferentes y cada vez más altas en mi interior. Más que una técnica, me gusta pensar en especies de técnicas: trabajar a mano, a la velocidad humana; añadir, más que sustraer; simular el crecimiento; la casualidad…

Según el momento, uso el material que me proyecta, que despierta los sentidos de forma indirecta, cruzada, inconsciente.

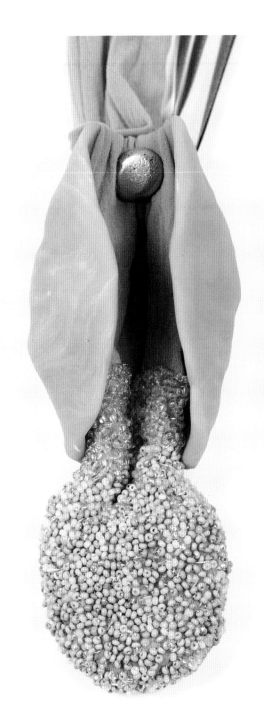

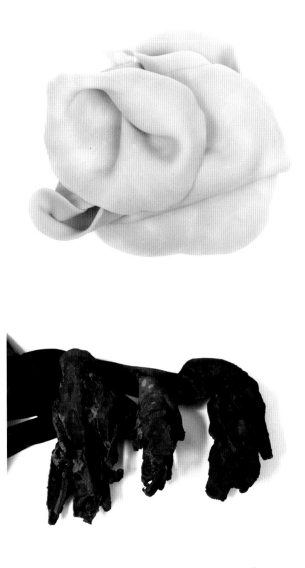

FRA / Dans mon travail, j'essaie de comprendre, d'apprendre. Je suis en lieu sûr, et je n'ai pas peur d'être incomprise ni de prendre des risques qu'en d'autres circonstances je refuserais d'assumer. En fait, c'est l'endroit le plus sûr et le plus dangereux à la fois, mais c'est un lieu où il fait bon être. Ce qui m'inspire est ce qui est typiquement humain, banal. Comme l'amour, la perte, la nostalgie, la beauté, tous ces clichés que je veux transcender et conceptualiser. Les mêmes notions se retrouvent toujours, je me répète moi-même tout le temps, mais d'une autre manière, avec des voix différentes et toujours plus hautes dans ma tête. Je n'applique pas une technique mais des types de techniques : travailler à la main, à une vitesse humaine ; ajouter plutôt que soustraire ; imiter la croissance, le hasard... Selon le moment, je vais utiliser un matériau qui me stimule, qui réveille mes sens de manière indirecte, croisée, inconsciente.

POR / No meu trabalho busco entender, aprender; é um lugar seguro, a parte da minha vida onde não tenho medo de ser mal-entendida. Não temo assumir risco que não assumiria em outras situações. É o lugar mais seguro e o mais inseguro, mas um bom lugar para se estar. Me inspira o mais humano e o trivial. O amor; a perda; a saudade; a beleza: clichês que quero transcender e também abstrair. Os conceitos se repetem, eu mesma me repito constantemente, mas de formas diferentes, com vozes diferentes e cada vez mais altas dentro de mim. Mais que uma técnica, eu gosto de pensar em tipos de técnicas: trabalho manual, a velocidade humana; somar, mais que subtrair; simular o crescimento; a casualidade... De acordo com o momento, uso o material que me estimula, que desperta os sentidos de forma indireta, cruzada, inconsciente.

Nicolas
Estrada

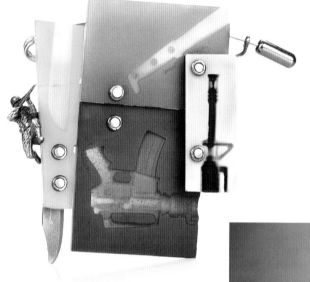

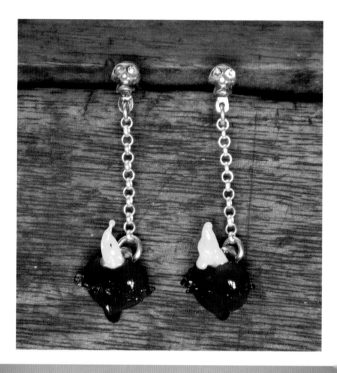

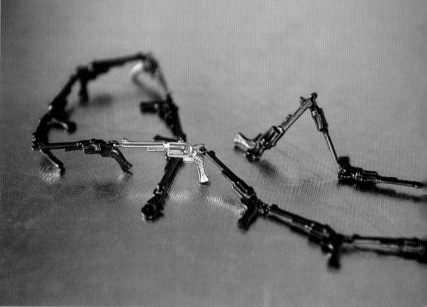

ENG/ I like my work to create surprise. My pieces are aimed at people who want to feel special: I like the executive who wears a pair of skulls or hearts, the delicate girl with a necklace of pistols.

Everyday emotions inspire me: sadness, joy, nostalgia, rage, tranquillity; I try to capture them in my pieces. I seek to convey a specific feeling in each collection: nonconformity, indignation or a certain sadness.

Some photos impress me so much that I head straight to the work table. I'm also inspired by seeing how architects manage to solve the problems of space and construction, and especially by the handling of light.

I try to learn one or two new techniques each year, but find it very difficult to be an expert in any particular one. I prefer to know a little bit of everything to apply it or evaluate it at the time it's needed.

I love yellow gold; its final shine makes other metals look pale. I really like stones as well, and I'm beginning to get a range of colours and reflections that before I didn't know.

ESP/ Me gusta que mi trabajo genere sorpresa. Mis piezas van dirigidas las personas que quieren sentirse especiales: me gusta el ejecutivo que lleva unos gemelos de calavera o de corazones, la chica delicada con un collar de pistolas...

Me inspiran las emociones cotidianas: tristezas, alegrías, nostalgia, recuerdos, rabia, tranquilidad, que trato de plasmar en mis piezas. Busco transmitir un sentimiento específico en cada colección: inconformidad, indignación, o una cierta tristeza.

La fotografía me inspira muchísimo. Algunas fotos me impresionan tanto que voy directo a la mesa de trabajo.

También me inspira ver como los arquitectos logran resolver los problemas de espacio y de construcción; y especialmente el manejo de la luz.

Intento aprender una o dos técnicas nuevas cada año, pero encuentro muy difícil ser experto en alguna en particular. Prefiero saber un poquito de todo para aplicarlo o evaluarlo en el momento en el que lo necesite.

Me encanta el oro amarillo, su brillo final hace palidecer a los demás metales. Con las piedras empiezo a conseguir una gama de colores y de reflejos que antes no conocía.

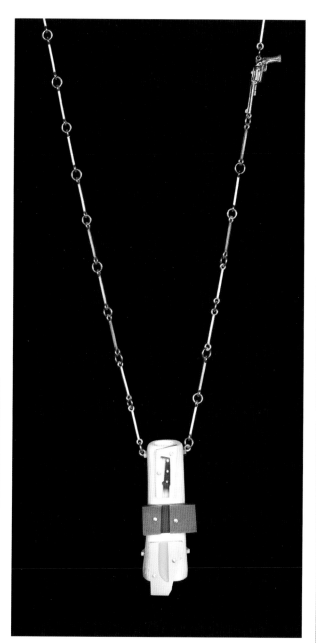

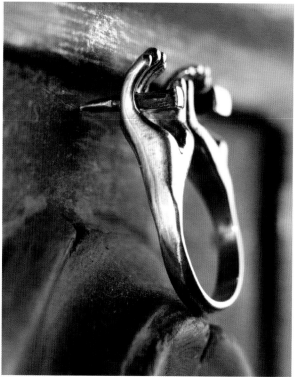

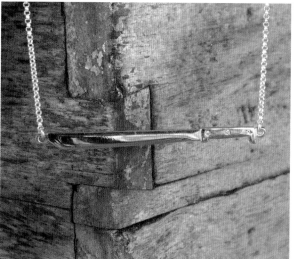

FRA / J'aime que mon travail étonne. Mes créations s'adressent aux personnes qui veulent sortir de l'ordinaire. J'adore le cadre qui porte des boutons de manchettes en forme de tête de mort ou de cœur, la jeune fille délicate qui arbore un collier décoré de pistolets...

Les émotions du quotidien m'inspirent : la tristesse, la joie, la nostalgie, le souvenir, la rage, la tranquillité. J'essaie de les intégrer à mes créations. Je cherche à transmettre un sentiment bien précis dans chacune de mes collections : l'anticonformisme, l'indignation ou bien une certaine tristesse.

La photographie m'inspire énormément. Certains clichés me stimulent tellement que je passe directement à ma table de travail. J'aime aussi voir comment les architectes résolvent les problèmes d'espace et de construction, et notamment comment ils gèrent la lumière.

J'essaie d'apprendre une ou deux techniques nouvelles par an, mais il m'est très difficile de devenir un expert dans une seule en particulier. Je préfère être un touche-à-tout, et choisir et appliquer celle qui me convient le mieux au moment où j'en ai besoin.

J'ai un faible pour l'or jaune, son éclat est si intense que les autres métaux paraissent ternes à côté. Avec les pierres, j'ai commencé à établir une gamme de couleurs et de reflets que je ne connaissais pas avant.

POR / Eu gosto que o meu trabalho cause surpresa. Minhas peças são dirigidas às pessoas que querem se sentir especiais: eu gosto quando um executivo leva um par de caveiras ou de corações, a moça delicada com um colar de pistolas...

Me inspiram as emoções cotidianas: tristezas, alegrias, nostalgia, recordações, raiva, tranquilidade, que trato de refletir nas minhas peças. Busco transmitir um sentimento específico em cada coleção: inconformidade, indignação ou certa tristeza.

A fotografia me inspira muitíssimo. Algumas fotos me impressionam tanto que vou direto à mesa de trabalho. Também me inspiro ao observar como os arquitetos conseguem resolver os problemas de espaço e de construção; e especialmente o manejo da luz.

Tento aprender uma ou duas técnicas novas a cada ano, mas acho muito difícil ser um perito em alguma em particular. Prefiro saber um pouco de tudo para aplicar ou avaliar no momento em que precise.

Eu adoro o ouro amarelo, seu brilho final faz empalidecer todos os outros metais. Com as pedras comecei a obter uma gama de cores e de reflexos que antes não conhecia.

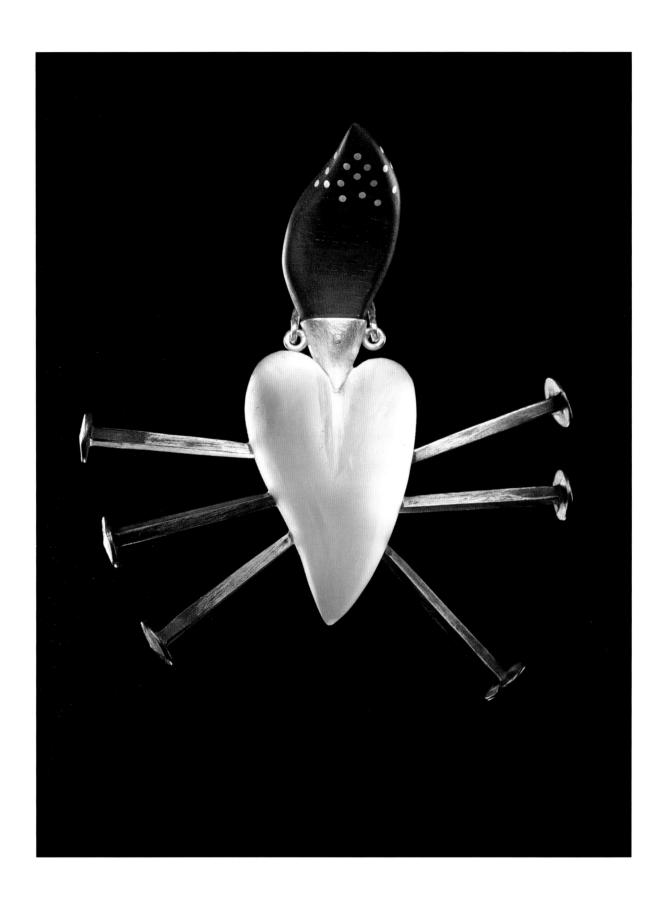

Everyday emotions inspire me: sadness, joy, nostalgia, rage, tranquillity; I try to capture them in my pieces.

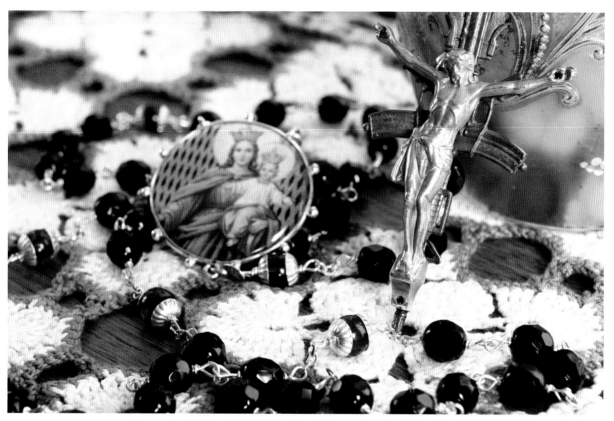

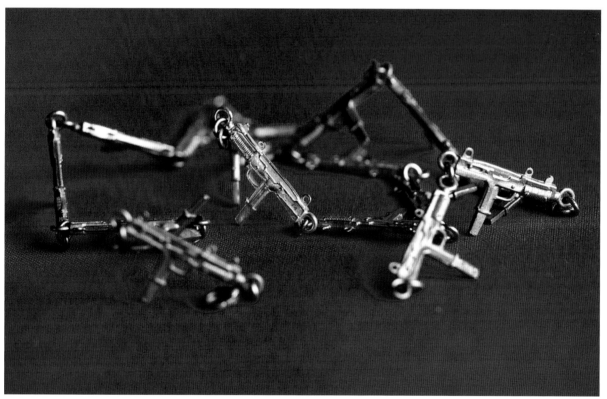

Benedikt
Fischer

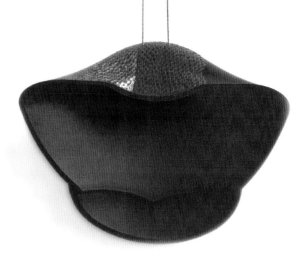

ENG / I want to create pieces that have an impact on the wearer and those who see them. I hope that my work prompts questions and arouses emotions. And I also want some of it to be kept from the viewer; I want it to retain some of its mystery. The meaning of jewellery itself is my greatest inspiration. The big question is: Why do humans need to wear jewellery? It doesn't have the same purpose as fashion, but however far we go back into the past, we find it in all eras and cultures. The most exciting thing for me is its beginnings, that primitive need to wear jewellery. For me, this question is the purest approach to this discipline. I like to use old methods and apply something to them that is really mine, but I also try to find new techniques. I love working with plastic; I think it is the most present material in our lives, and the one I touch the most each day.

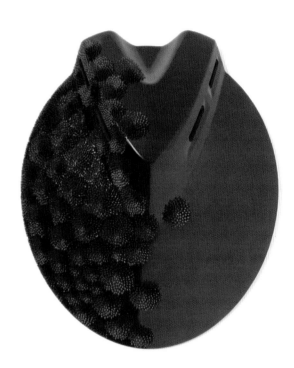

ESP / Quiero crear piezas que causen un impacto en quien las lleva y en quien las ve. Espero que mi trabajo despierte interrogantes y produzca emociones. Y también deseo que no se descubra del todo a quien lo contempla, que conserve parte de su misterio. El sentido de la joyería en sí mismo es mi mayor inspiración. La gran pregunta es, ¿por qué el ser humano necesita llevar joyas? No tiene el mismo propósito que la moda, pero por más lejos que nos remontemos en el pasado, seguimos encontrándolo en todas las épocas y culturas. Lo más emocionante para mí son sus inicios, la necesidad primaria de llevar joyas; para mí, este interrogante es el enfoque más puro hacia esta disciplina. Me gusta utilizar los procedimientos antiguos y aplicarles algo propiamente mío, pero también intento encontrar nuevas técnicas. Me encanta trabajar con el plástico, creo que es el material más presente en nuestra vida, el que más toco a diario.

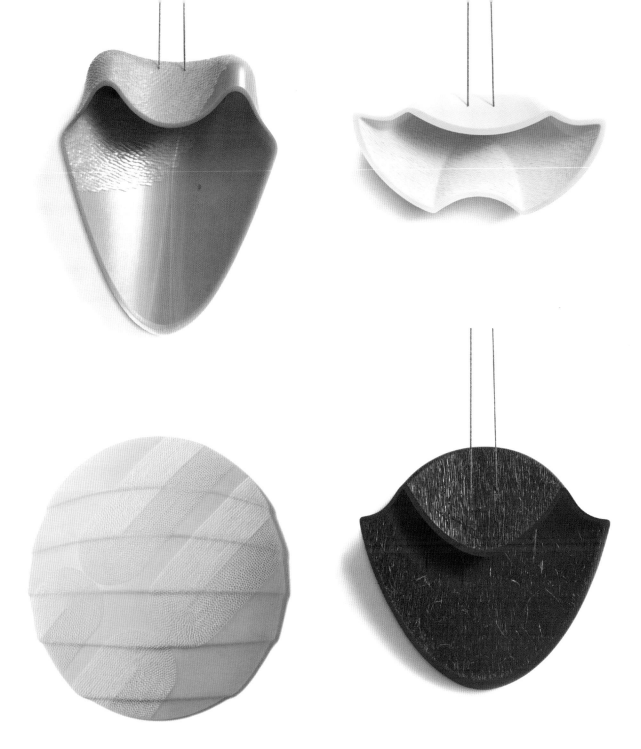

FRA / Je veux créer des bijoux qui émeuvent ceux qui les portent et ceux qui les voient. J'espère que mon travail interpelle et déclenche des émotions. Je souhaite aussi qu'ils ne se découvrent pas entièrement à ceux qui les contemplent, qu'ils gardent une part de leur mystère.

Le rôle même du bijou est ma plus grande source inspiration. La grande question est pourquoi les êtres humains ont-ils besoin de bijoux ? Ils n'ont pas la même fonction que la mode, et aussi loin que l'on remonte dans le passé, on en retrouve à toutes les époques et dans toutes les cultures. Ce qui me fascine le plus c'est le moment où il apparaît dans l'histoire de l'humanité, et où se manifeste ce besoin primitif de porter des bijoux. C'est cela qui m'a attiré vers cette discipline. J'aime utiliser des techniques anciennes et les appliquer à ma manière, mais j'essaie aussi de trouver de nouvelles méthodes. J'adore travailler avec le plastique ; je crois que c'est la matière la plus présente dans nos vies, celle avec laquelle je suis le plus en contact au quotidien.

POR / Quero criar peças que causem um impacto em quem as leva e em quem as vê. Espero que o meu trabalho desperte interrogações e produza emoções. E também desejo que ao contemplar, não se descubra tudo, que se conserve parte do seu mistério.

O sentido da joalheria em si mesmo é a minha maior inspiração. A grande pergunta é, por que o ser humano precisar usar joias? Não tem o mesmo propósito que a moda, mas por mais distante que voltemos ao passado, seguimos encontrando-as em todas as épocas e culturas. O mais emocionante para mim são seus inícios, a necessidade primária de usar joias; para mim, esta questão é o enfoque mais puro desta disciplina. Eu gosto de utilizar os procedimentos antigos e aplicá-los algo pessoal, mas também tento encontrar novas técnicas. Eu adoro trabalhar com o plástico, acredito que é o material mais presente em nossa vida, o que mais uso no dia a dia.

Karl
Fritsch

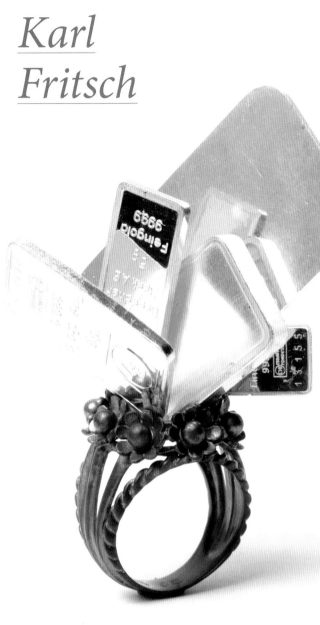

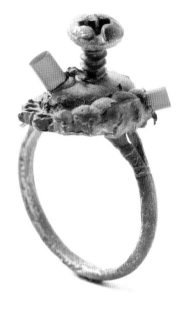

ESP / El principal propósito de mi trabajo es lograr que la
gente disfrute llevando mis anillos. El trabajo es lo que
realmente me motiva y prefiero que mis piezas hablen por
sí solas. Me gusta pensar cómo dar forma a un material
para que envuelva un dedo y hacer un buen anillo. Me gusta
moldear, engastar; me gusta el fuego, fundir y doblar. Mis
materiales favoritos son el plomo y, sobre todo, el oro por
su color, su peso, su fulgor amarillo, su suavidad. No puede
haber nada más elemental que yo, un martillo y un trozo
de oro, y cada uno expresa lo que quiere.
Me inspira el trabajo de Franz West, creo que es fantástico.
Hago únicamente anillos, por su escala. Siempre hay una
razón para hacer un anillo, pero también puedo hacer un
anillo sin ningún motivo en especial. A veces un anillo tiene
que salir muy deprisa. A veces quiere tener un aspecto
determinado y al momento siguiente, otro completamente
distinto. A veces se asusta, pierde el control; o, por el contrario,
se queda quieto sobre la mesa, como un niño bueno. Entonces
se trata de usar rápidamente una variedad de técnicas: soldar,
moldear, rellenar, encastar. El anillo no puede esperar, está
impaciente, quiere apresurarse y estar listo para un dedo.

ENG / The main purpose of my work is to ensure that people
enjoy wearing my rings. Doing the work itself is what really
motivates me and I prefer my pieces to speak for themselves.
I like to think about how to shape a material so that it
surrounds the finger and makes a good ring. I like
moulding, setting; I like heating, melting and bending.
My favourite materials are lead and, above all, gold, because
of its colour, its weight, its yellow glow, its softness. There
can be nothing more basic than myself, a hammer and a
piece of gold, each one expressing what it wants to. I'm
inspired by the work of Franz West, I think it's fantastic.
I do only rings, because of their size. There is always a reason
to make a ring, but I can also make a ring for no reason in
particular. Sometimes a ring has to be ready very fast.
Sometimes it wants a particular look, and the next moment,
a completely different one. Sometimes it takes fright or loses
control; or, on the contrary, it stays still on the table, like a
good boy. Then it's a question of using a variety of techniques:
welding, moulding, filling, setting. The ring cannot wait;
it's impatient and is in a hurry to be ready for a finger.

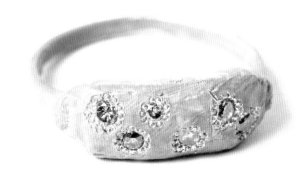

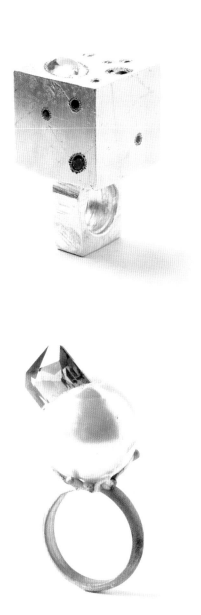

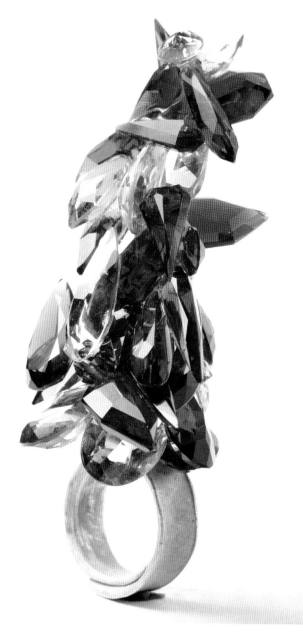

FRA / Le but principal de mon travail est que les gens aient du plaisir à porter mes bagues. C'est cela qui me motive, et je préfère que mes créations parlent à ma place. J'aime réfléchir à l'aspect façonnage du matériau pour qu'il enveloppe le doigt et se convertisse en une belle bague. Le moulage et le sertissage me captivent, mais le feu aussi me fascine avec la fonte et le pliage. Mes matériaux préférés sont le plomb et surtout l'or pour sa couleur, son poids, son éclat et sa douceur. Il n'y a rien de plus élémentaire qu'un morceau d'or, un marteau et moi, chacun de nous trois exprimant ce qu'il a envie de dire. Le travail de Franz West m'inspire, je trouve que ce qu'il fait est génial. Personnellement, je crée uniquement des bagues parce que c'est une échelle qui me convient. Il y a toujours une bonne excuse pour créer une bague, mais l'on peut aussi en fabriquer une comme ça, sans raison particulière. Parfois, la bague doit naître très rapidement. Pendant un instant, elle présente un certain aspect et puis brusquement elle change complètement de forme. Tantôt elle a peur et perd tout contrôle, ou alors elle reste sans bouger sur la table, comme un enfant sage. C'est à ce moment là qu'il faut enchaîner rapidement différentes techniques : soudure, moulage, fonte, sertissage. La bague ne peut pas attendre, elle est impatiente et veut être prête sans délai pour pouvoir garnir au plus vite la main qui l'attend.

POR / O principal propósito do meu trabalho é conseguir que as pessoas divirtam-se usando meus anéis. O trabalho é o que realmente me motiva e prefiro que as minhas peças falem por si mesmas. Eu gosto de pensar como dar forma a um material para que acomode um dedo e faça um bom anel. Eu gosto de moldar, engastar; eu gosto do fogo, derreter e dobrar. Meus materiais favoritos são o chumbo e, sobretudo, o ouro pela sua cor, seu peso, seu brilho amarelo, sua suavidade. Não pode existir nada mais básico que eu, um martelo e um pedaço de ouro, e cada um se expressa como quer.
Me inspira o trabalho de Franz West, acredito que é fantástico. Só faço anéis, por sua escala. Sempre existe uma razão para fazer um anel, mas também posso fazer um anel sem nenhum motivo especial. Às vezes um anel tem que sair muito rápido. Às vezes tem um aspecto determinado e no momento seguinte, outro completamente diferente. Às vezes se assusta, perde o controle; ou pelo contrário, permanece quieto pela mesa, como um bom menino. Então se trata de usar rapidamente uma variedade de técnicas: soldar, moldar, preencher, engastar. O anel não pode esperar, está impaciente e quer precipitar-se para estar pronto para um dedo.

Fabiana
Gadano

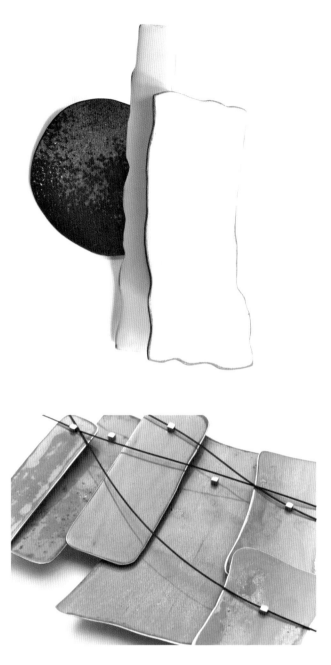

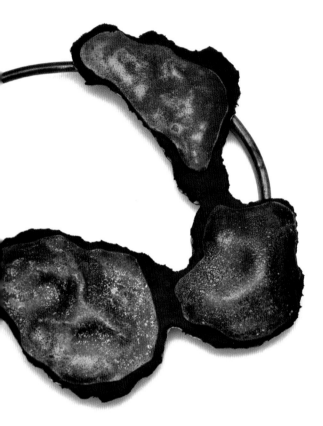

ENG / I want to communicate ideas and express my emotions and my experiences through jewellery. The materials I use always depend on this purpose. The pieces become messages that are broadcast when they are worn. Although I have experimented with many techniques, my themes have not changed: memories of the past, journeys, wishes for the future... For years, Padua's jewellery school has been a very important reference. Its experimentation with the fusion of metals and the application of pigments represented an important breakthrough in jewellery made from precious metals. I am inspired by contemporary art and, on the other hand, I find that jazz gives me a boost that helps me to communicate what I want to through my pieces. I listen to Miles Davis, John Coltrane or Stan Getz. And I also like authors like Murakami and Ishiguro because of their accuracy in describing feelings.

I enjoy building pieces, joining their different parts together. Often the materials that I put together cannot withstand the high temperatures of welding, so cold fasteners such as rivets are very useful for me.

ESP / Quiero comunicar ideas, expresar mis emociones y mi experiencia a través de la joyería. Los materiales que uso siempre van en función de este propósito. Al ser llevadas en el cuerpo, las piezas se convierten en mensajes que se difunden. A pesar de que he experimentado con muchas técnicas, mis temas no han cambiado: los recuerdos de tiempos pasados, viajes, deseos para el futuro... Desde hace años, la Escuela de Joyería de Pádua ha sido una referencia muy importante. Su experimentación con la fusión de metales y la aplicación de pigmentos supuso un gran avance en la joyería de metales preciosos. Me inspira el arte contemporáneo y, por otro lado, encuentro que el jazz me proporciona un impulso que me facilita comunicar lo que quiero con mis piezas. Escucho a Miles Davis, John Coltrane o Stan Getz. Y también me gustan autores como Murakami o Ishiguro, por su precisión al describir sentimientos.

Disfruto construyendo piezas, uniendo sus diferentes partes. A menudo, los materiales que uno no resisten altas temperaturas al soldarlos, de manera que las sujeciones en frío, como los remaches, son muy útiles para mí.

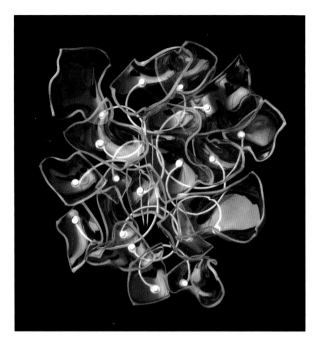

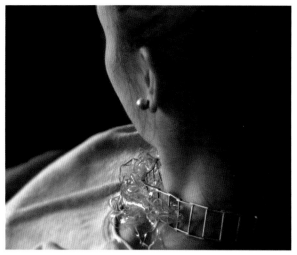

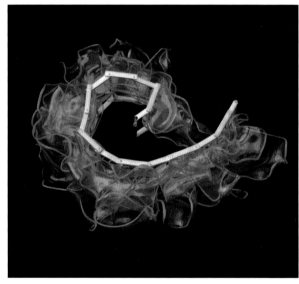

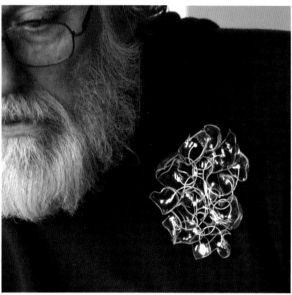

FRA / Je veux communiquer des idées, exprimer mes émotions et mon expérience par le biais de mes créations. Les matériaux que j'emploie servent toujours cet objectif. Les bijoux se transforment en messages que l'on diffuse lorsqu'on les porte. Bien que j'aie pratiqué de nombreuses techniques, mes thèmes de prédilection n'ont pas changé. Ce sont les souvenirs du temps passé, les voyages, des désirs pour l'avenir... l'école de Padoue est depuis longtemps une référence en matière de bijouterie-joaillerie. Ils ont travaillé sur la fusion des métaux et l'application de pigments, ce qui a constitué une réelle avancée dans le domaine de la fabrication de bijoux en métaux précieux. L'art contemporain m'inspire, et je trouve aussi que le jazz me communique une énergie qui m'aide à transmettre ce que je souhaite à mes créations. J'aime écouter Miles Davis, John Coltrane et Stan Getz. J'apprécie également des auteurs comme Murakami et Ishiguro qui savent si bien décrire les sentiments. J'adore fabriquer des bijoux, assembler leurs différentes pièces. Il arrive souvent que lors de la soudure, les matériaux ne résistent pas aux hautes températures. C'est pourquoi j'aime faire appel à des techniques d'assemblage à froid comme le rivetage.

POR / Quero comunicar ideias, expressar minhas emoções e minha experiência através da joia. Os materiais que uso sempre servem para este propósito. As peças se convertem em mensagens que se espalham ao ser levadas no corpo. Apesar de que experimentei muitas técnicas, meus temas não se modificaram: as memórias dos tempos passados, viagens, desejos para o futuro... Faz anos que a Escola de Joalheria de Padua tem sido uma referência muito importante. Sua experimentação com a fusão de metais e a aplicação de pigmentos supôs um grande avanço na joalheria de metais preciosos. A arte contemporânea me inspira e, por outro lado, percebo que o jazz me proporciona um impulso que me facilita comunicar o que quero com as minhas peças. Escuto Miles Davis, John Coltrane ou Stan Getz. E também gosto de autores como Murakami ou Ishiguro, pela sua precisão ao descrever sentimentos.
Gosto de construir peças, unindo suas diferentes partes. Com frequência os materiais que junto não resistem a altas temperaturas ao soldá-los, de maneira que, os elementos de fixação a frio, como os rebites, são muito uteis para mim.

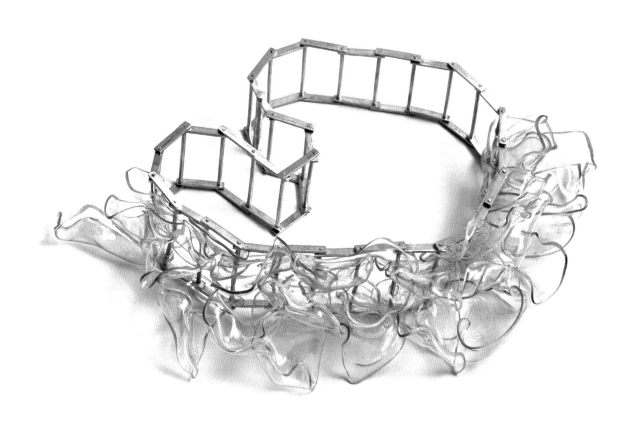

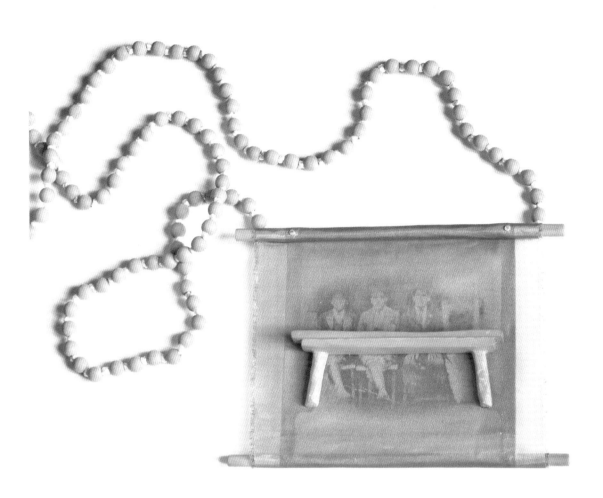

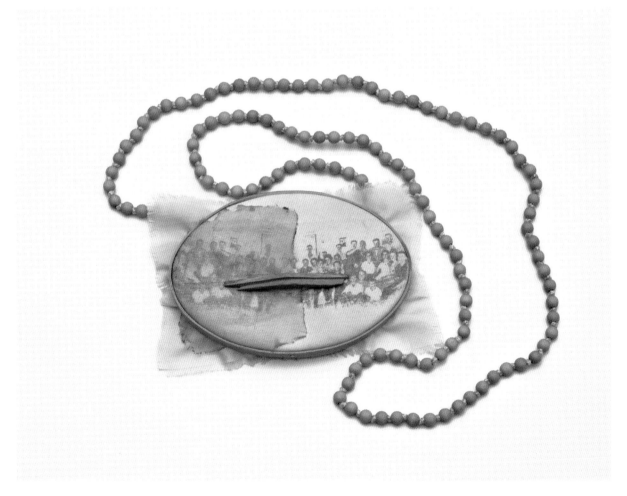

Carolina
Gimeno

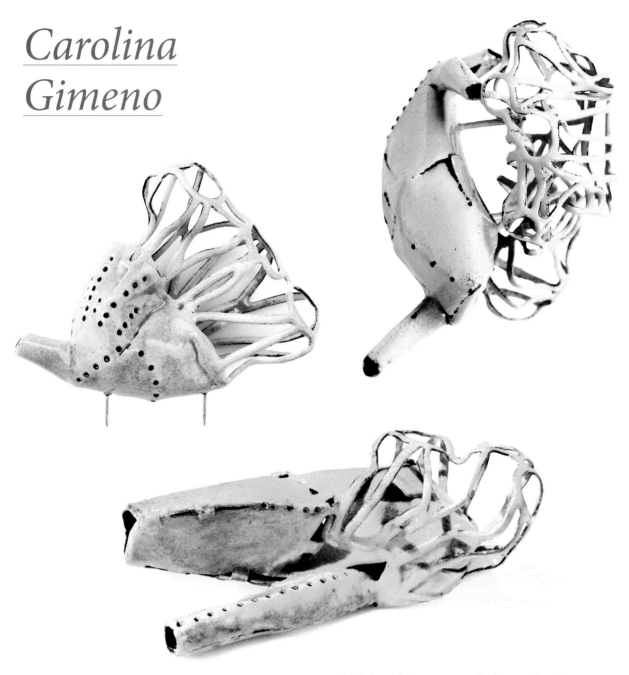

ENG / I am interested in jewellery as a means of communication, participation and connecting with society. Wearing jewellery entails a fascinating duality between a quite public act—an extension of one's own identity—and the intimacy of physical contact with the object. This drives me to continue investigating. I ask questions about the meaning of luxury, what it means to be a jeweller in such an unequal society and how to create a link between such different realities with my work. I'm attracted to pieces that can be held in the palm of your hand so you can look at them, but I do not think of a necklace, a brooch or ring during the process. Instead, in the end the object decides what it will become. I am interested in the work of artists from other disciplines, such as Marina Abramovic, Cornelia Parker and Sophie Calle. I feed my way of thinking and creating by reading authors such as Susan Noyes Platt, José Antonio Marina or Judith Butler, among others. When I have a clear idea of what I want to do the materials reveal themselves; I don't necessarily choose them, but rather I find them through a process of conceptual research.

ESP / Me interesa la joya como medio de comunicación, intervención y conexión con la sociedad. Llevar una joya comporta una dualidad fascinante, entre un acto absolutamente público, extensión de la propia identidad, y la intimidad del contacto físico con el objeto. Esto me impulsa a seguir investigando. Me interrogo acerca del sentido del lujo, qué significa ser joyera en una sociedad tan desigual y cómo crear con mi trabajo un nexo entre realidades tan distintas. Me atraen las piezas que se pueden contener en la palma de la mano para ser observadas, pero no pienso en un collar, un broche o un anillo durante el proceso, sino que al final el objeto decide en qué se convertirá. Me interesa el trabajo de artistas de otras disciplinas, como Marina Abramovic, Cornelia Parker o Sophie Calle. Alimento mi modo de pensar y crear leyendo autores como Susan Noyes Platt, José Antonio Marina o Judith Butler, entre otros. Cuando tengo una idea clara de lo que quiero hacer los materiales se revelan, no los elijo necesariamente sino que los descubro gracias a un proceso de investigación conceptual.

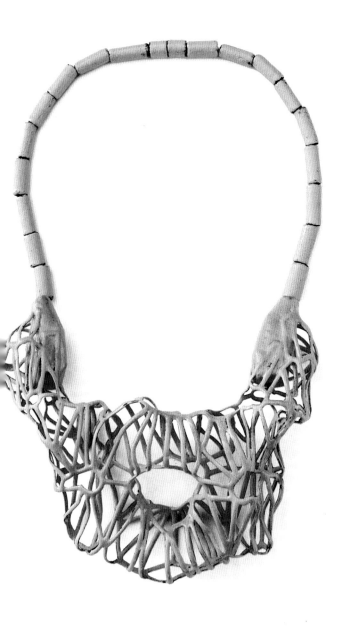
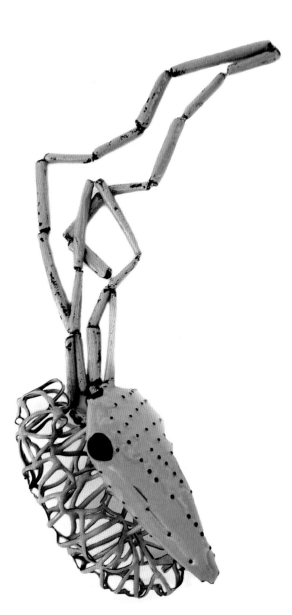

FRA / Je m'intéresse au bijou comme moyen de communication, d'intervention et de connexion avec la société. Le port d'un bijou renvoie à une dualité fascinante : c'est un acte totalement public qui est l'extension d'une identité personnelle et un accord intime caractérisé par le contact physique de l'objet. C'est ce qui me pousse à continuer mes recherches. Je m'interroge sur le sens du luxe, sur la place d'une joaillière dans une société où règnent les inégalités, et sur la manière d'établir un lien, par le biais de mon travail, avec des réalités aussi disparates. Je suis attirée par les bijoux que l'on peut tenir au creux d'une main pour les observer. Lorsque je travaille, je ne pense pas en terme de collier, de broche ou de bague ; c'est l'objet lui-même qui va choisir la forme à adopter. Les créations d'artistes d'autres disciplines m'interpellent, comme Marina Abramovic, Cornelia Parker ou Sophie Calle. Je nourris mon imagination et ma créativité en lisant des ouvrages d'auteurs tels que Susan Noyes Platt, José Antonio Marina et Judith Butler. Lorsque je sais exactement ce que je veux faire, les matériaux se présentent d'eux même. Je ne les choisis pas forcément : je les découvre par un travail de recherche conceptuelle.

POR / Me interessa a joia como meio de comunicação, intervenção e conexão com a sociedade. Usar uma joia envolve uma dualidade fascinante, entre um ato absolutamente publico extensão da própria identidade, e da intimidade do contato físico com o objeto. Isto me impulsiona a continuar investigando. Questiono o sentido do luxo, o que significa ser joalheira numa sociedade tão desigual e como criar com o meu trabalho um elo entre realidades tão diferentes. Me atraem as peças que podem caber na palma da mão para ser observadas mas não penso num colar, broche ou anel durante o processo, mas sim que no final o objeto decidirá no que se converterá. Me interessa o trabalho de artistas de outras disciplinas, como Marina Abramovic, Cornelia Parker ou Sophie Calle. Alimento o meu modo de pensar e criar lendo autores como Susan Noyes Platt, Jose Antonio Marina ou Judith Butler, entre outros. Quando tenho uma ideia clara do que quero fazer, os materiais se revelam não os escolho necessariamente, mas sim que os descubro graças a um processo de investigação conceitual.

Christine
Graf

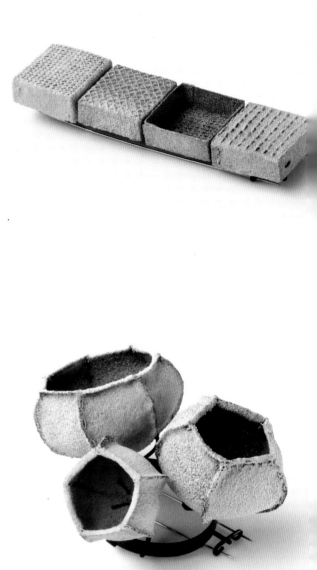

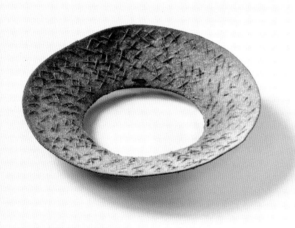

ENG / My work is characterised by my intuitive sense of
aesthetics and freedom in the creative process of perceiving,
understanding, creating and shaping an object.
I seek to convey sensations like stillness and dynamism,
fragility and transience, simplicity and lightness.
The material that I use for my pieces is manufactured industrial
copper mesh. Manipulating it like fabric or paper lets me
create forms directly with my hands, following my instincts.
I apply traditional textile techniques to metal and I try to change
the aesthetic qualities of the surface structure of the mesh.
This way I get a unique ornamentation created by rhythmic
repetition and its specific qualities of light and shadow.
I apply coloured enamel to round shapes with geometric
angles, which transforms the essential characteristics of the
object and creates a dialogue between space and boundaries.
The process requires many separate layers of enamel to be
applied. This allows me to create shades and subtle textures
and highlight the fragility and the ephemeral qualities of the
piece. The metal body, covered with enamel, acquires a new
visual and metaphorical identity.

ESP / Mi trabajo se caracteriza por mi sentido intuitivo
de la estética y la libertad en el proceso creativo de percibir,
comprender, crear y conformar un objeto.
Busco transmitir sensaciones como la quietud y el dinamismo,
la fragilidad y la fugacidad, la simplicidad y la ligereza.
El material que utilizo para mis piezas es de malla de cobre
industrial manufacturado. Manipularlo como el tejido o el
papel me permite dar formas directamente con las manos,
siguiendo mis instintos. Aplico técnicas textiles tradicionales
al metal y trato de cambiar las cualidades estéticas de la
estructura superficial de la malla. De este modo obtengo
una ornamentación única creada por la repetición rítmica
y sus cualidades específicas de luz y sombra.
Aplico esmalte de color a formas redondas con ángulos
geométricos, lo que transforma las características esenciales
del objeto y crea un diálogo entre el espacio y el límite.
El proceso requiere la aplicación de muchas capas separadas
de esmalte al fuego. Así consigo crear matices y texturas muy
sutiles y resaltar la fragilidad y las cualidades efímeras de la
pieza. El cuerpo de metal, cubierto por el esmalte, adquiere
una nueva identidad visual y metafórica.

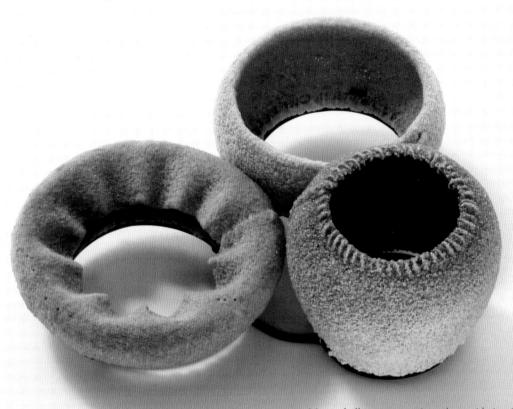

POR/ Meu trabalho se caracteriza pelo sentido intuitivo
da estética e da liberdade no meu processo criativo
de perceber, compreender, criar e configurar um objeto.
Busco transmitir sensações como a quietude e o dinamismo,
a fragilidade e a fugacidade, a simplicidade e a leveza.
O material que utilizo para as minhas peças é de malha de cobre
industrial manufaturado. Manipulá-lo como um tecido ou papel
permite dar formas diretamente com as minhas mãos, seguindo
meus instintos. Aplico técnicas têxteis tradicionais ao metal e
trato de mudar as qualidades estéticas da estrutura superficial
da malha. Deste modo consigo uma ornamentação única criada
pela repetição rítmica e as suas qualidades específicas de luz e
sombra. Aplico esmalte colorido a formas redondas com
ângulos geométricos, o que transforma as características
essenciais do objeto e cria um diálogo entre o espaço e o limite.
O processo requer a aplicação de muitas camadas separadas de
esmalte ao fogo. Assim consigo criar matizes e texturas bastante
sutis e ressalto a fragilidade e as qualidades efêmeras da peça.
O corpo de metal, coberto pelo esmalte, adquire uma nova
identidade visual e metafórica.

FRA/ Mon travail reflète mon sens viscéral de l'esthétique et la
liberté du processus créatif qui consiste à percevoir,
comprendre, créer et façonner un objet.
J'essaie de transmettre des sensations comme le calme et le
dynamisme, la fragilité et la fugacité, la simplicité et la légèreté.
Le matériau que j'utilise pour mes bijoux est la maille de cuivre
industrielle. Je la manipule comme du tissu ou du papier
pour lui donner une forme directement avec mes mains,
en me laissant guider par mon instinct. J'applique au métal
les techniques traditionnelles du textile, et j'essaie de modifier
les qualités esthétiques de la structure superficielle de la maille.
Ceci me permet de créer une pièce unique issue d'une
répétition rythmique qui possède ses qualités propres
d'ombre et de lumière.
J'applique de l'émail de couleur à des formes rondes dotées
d'angles géométriques, ce qui a pour effet de transformer
complètement les caractéristiques de base de l'objet et crée un
dialogue entre l'espace et ses limites. Le procédé requiert
plusieurs couches séparées d'émail cuit au feu. J'arrive ainsi à
créer des nuances et des textures très subtiles, et à faire ressortir
les qualités éphémères du bijou. Le corps de métal, recouvert
d'émail, acquiert une nouvelle identité visuelle et métaphorique.

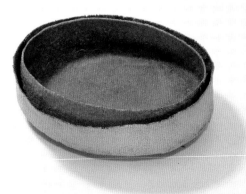

Adam
Grinovich

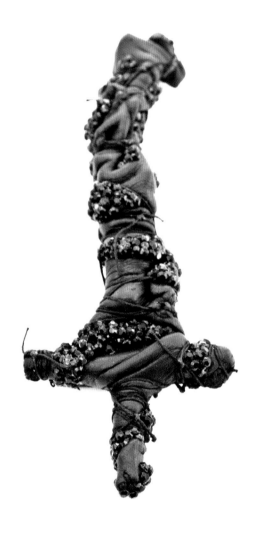

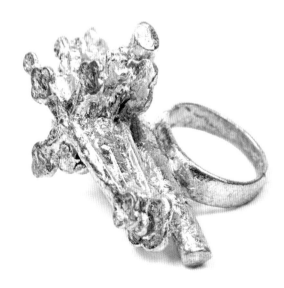

ESP / Con mi trabajo, quiero reflexionar sobre el mundo que me rodea, editarlo. Mi propósito es conectar y me fascinan los profundos vínculos culturales de este arte. Los mecanismos de transmisión cultural son mi gran fuente de inspiración. La droga, el lenguaje, el hip-hop, la cultura digital, el diseño gráfico…Nuestras elecciones nos definen. De joven cambiaba de gustos constantemente y me interesa mucho la identidad como concepto plástico y abierto al cambio. Creo que vivimos una época increíblemente inspiradora. Exploro conceptos a menudo contradictorios: el glamour, el valor, lo poético, las creencias, la blasfemia, los romántico y lo profano, lo sublime, el infinito, lo inmediato….Creo que es muy importante sentirte orgulloso de lo que haces, de la tradición de tu arte y de su futuro. Artistas como Otto Künzli, Ruudt Peters, Helena Lehtinen, Karen Pontoppidan o Celio Braga, entre muchos otros, contribuyen a este sentimiento.

Mi formación como orfebre me dio buen ojo para el detalle. Utilizo objetos encontrados, creo que porque me mueven ideales contemporáneos. Me encanta que casi todo ya esté inventado y yo tenga la oportunidad de manipularlo para expresarme. Y las piedras, ¡me encanta trabajar con piedras!

ENG / With my work, I want to reflect on and edit the world that surrounds me. My purpose is to connect, and I am fascinated by the deep cultural bonds of this art. The mechanisms of cultural transmission are my great source of inspiration. Drugs, language, hip hop, digital culture, graphic design... our choices define us. When I was young my tastes changed constantly, and I am really interested in identity as a malleable concept that is open to change. I think that we live in an incredibly inspiring age. I explore often-contradictory concepts: glamour, value, the poetic, beliefs, blasphemy, the romantic and the profane, the sublime, the infinite, the immediate... I think that it is very important to be proud of what you are doing, your artistic tradition and its future. Artists such as Otto Künzli, Ruudt Peters, Helena Lehtinen, Karen Pontoppidan and Celio Braga, among many others, contribute to this feeling.

My training as a goldsmith has given me good eye for detail. I use salvaged objects, I think because I'm driven by contemporary ideals. I love the way that almost everything has already been thought of and I have the opportunity to manipulate it to express myself. And stones: I love working with stones!

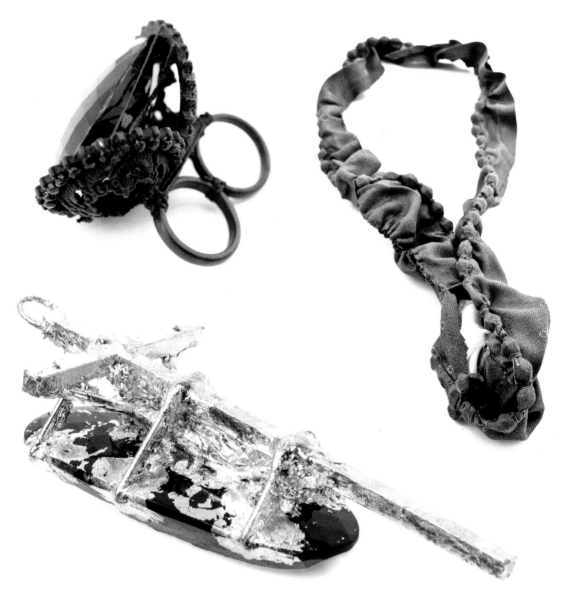

FRA / Mon travail me permet de réfléchir sur le monde qui m'entoure et de le modifier. Je cherche à établir des liens : les échanges culturels profonds de l'art de la joaillerie me fascinent. Les mécanismes de transmission culturelle sont ma plus grande source d'inspiration. Ma drogue : le langage, le hip-hop, la culture numérique, le graphisme… Les choix que nous faisons disent qui nous sommes. Lorsque j'étais jeune, mes goûts changeaient constamment et je m'intéressais beaucoup à l'identité en tant que concept plastique ouvert au changement. Je pense que nous vivons une époque incroyablement inspiratrice. J'explore des concepts contradictoires : le glamour, la valeur, la poésie, les croyances, le blasphème, le romantisme, le profane, le sublime, l'infini, l'immédiat… Je crois qu'il est très important d'être fier de ce que l'on fait, de la tradition de l'art que l'on pratique et de son avenir. Des artistes comme Otto Künzli, Ruudt Peters, Helena Lehtinen, Karen Pontoppidan et Celio Braga, entre autres, s'inscrivent dans cette lignée.

Ma formation d'orfèvre m'a donné le sens du détail. J'utilise des objets que je récupère, parce que je suis sensible aux idéaux contemporains. J'aime le fait que pratiquement tout soit déjà créé, et que je vais pouvoir m'exprimer en manipulant ces objets. Et que dire des pierres ! J'adore travailler avec des pierres !

POR / Com meu trabalho, quero reflexionar sobre o mundo que me rodeia, quero editá-lo. Meu propósito é conectar-me e me fascinam os profundos vínculos culturais desta arte. Os mecanismos de transmissão cultural são minha grande fonte de inspiração. A droga, a linguagem, o hip-hop, a cultura digital, o desenho gráfico… Nossas escolhas nos definem. Quando jovem, mudava de gostos constantemente e me interessa muito a identidade como conceito plástico e aberto a mudanças. Creio que vivemos numa época incrivelmente inspiradora. Exploro conceitos frequentemente contraditórios: o glamour, o valor, o poético, as crenças, a blasfêmia, o romântico e o profano, o sublime, o infinito, o imediato… Creio que é muito importante sentir-se orgulhoso do que se faz - da tradição da arte e do seu futuro. Artistas como Otto Künzli, Ruudt Peters, Helena Lehtinen, Karen Pontoppidan ou Celio Braga, entre muitos outros, contribuem para este sentimento.

A minha formação como ourives me proporcionou um bom olho para o detalhe. Utilizo objetos encontrados, acredito que me provocam ideais contemporâneos. Eu adoro que quase tudo já esteja inventado e eu tenha a oportunidade de manipulá-lo para expressar-me. E as pedras, adoro trabalhar com as pedras!

Ursula
Güttmann

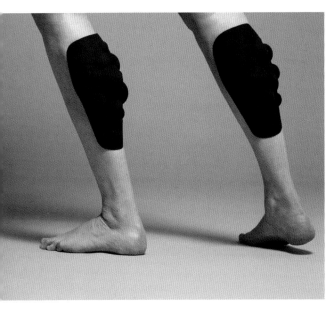

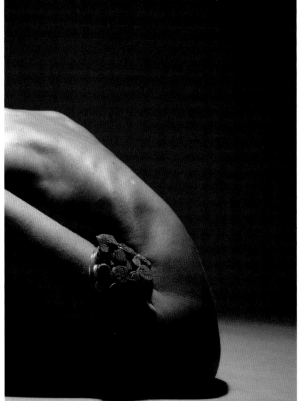

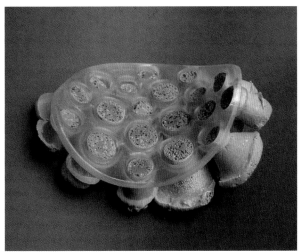

ENG / The body is not just a structure of flesh and blood; we are also the body. It is impossible to separate us from who we are. Because of this, any transformation of the body is a transformation of our being. For me jewellery is an extension of the body. It occurs on the border between my inside and outside. Energy comes from the personal and intimate me and is projected outward toward the public sphere. The idea of crossing that border—growing, extending, coming to the surface—fascinates me. Wearing jewellery breaks the body's contours and its limits, for the purpose of occupying space outside of it. Most of my works are based on exploring this relationship that definitely requires a reaction from the viewer and the courage of the wearer. Here is where my jewellery happens. I look for materials that have these special qualities. They should be elastic and flexible, like skin. This is why I work with silicone. I almost always mould shapes or make skins from forms that I have created before. My pieces provoke feelings, stimulate tactile intimacy and evoke wonder. They can repulse and attract at the same time.

ESP / El cuerpo no es solo una estructura de sangre y carne, el cuerpo somos también nosotros. Es imposible separarnos de lo que somos. Por eso, cualquier transformación del cuerpo es también una transformación de nuestro ser. Para mí la joyería es una extensión del cuerpo. Ocurre en esta frontera entre mi interior y el exterior. La energía viene de mi yo personal e íntimo y se proyecta hacia afuera, hacia lo público. Me fascina la idea de traspasar esa frontera: crecer, extenderse, salir a la superficie. Llevar una joya rompe el contorno del cuerpo, sus límites, con el propósito de ocupar espacio fuera de él. La mayoría de mis trabajos parten de la investigación sobre esta relación que exige sin duda una reacción del espectador y la valentía del portador. Aquí es donde ocurren mis joyas. Busco materiales que posean estas cualidades especiales. Deberían ser elásticos y flexibles, como la piel. Por eso trabajo con silicona. Casi siempre moldeo las formas o hago pieles de formas que he creado antes. Mis piezas provocan sensaciones, estimulan una intimidad táctil y evocan extrañeza. Pueden ser repulsivas y atrayentes a la vez.

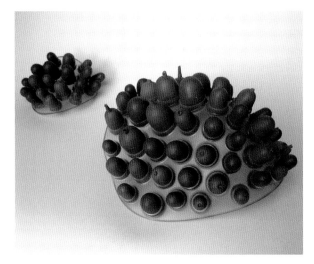

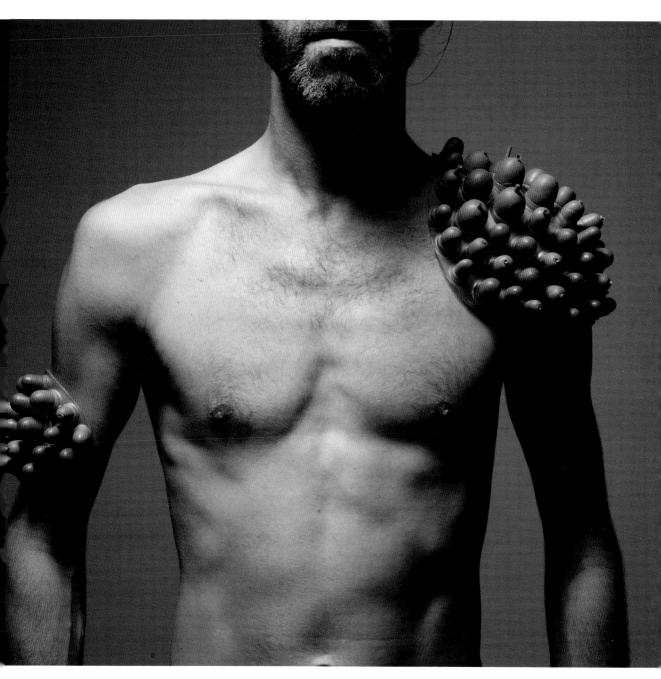

FRA / Le corps n'est pas simplement une structure de chair et de sang, c'est aussi nous-même. Il est impossible de nous séparer de ce que nous sommes. C'est pourquoi toute transformation de notre corps est aussi une transformation de nous-mêmes. Pour moi, la bijouterie est une prolongation du corps. Elle occupe la frontière entre mon intérieur et mon extérieur. L'énergie provient de mon moi intime et se projette vers l'extérieur, vers le public. J'adore l'idée de franchir cette frontière, de grandir, de s'étendre, de sortir à la surface. Un bijou que l'on porte brise le contour du corps, casse ses limites pour occuper l'espace qui l'environne. La plupart de mes œuvres reposent sur ce rapport qui a indubitablement besoin de la réaction du spectateur et de l'audace du porteur. C'est là que mes bijoux prennent vie. Je recherche des matériaux qui possèdent certaines qualités particulières. Ils doivent être souples et élastiques comme la peau. C'est pourquoi je travaille avec de la silicone. Le plus souvent, je moule des formes ou bien je crée des membranes à partir de moules que j'ai déjà. Mes bijoux produisent des sensations, stimulent l'intimité tactile et évoquent l'extravagance. Ils peuvent à la fois attirer et repousser.

POR / O corpo não é só uma estrutura de sangue e carne, nós também somos o corpo. É impossível separarmos do que somos. Por isso, qualquer transformação do corpo é também uma transformação do nosso ser. Para mim a joia é uma extensão do corpo. Ocorre nesta fronteira entre o meu interior e o exterior. A energia vem do meu íntimo pessoal e se projeta até o exterior, até o público. Me fascina a ideia de ultrapassar esta fronteira: crescer, estender-se, sair à superfície. Levar uma joia rompe o contorno do corpo, seus limites, com o propósito de ocupar espaço fora dele. A maioria dos meus trabalhos parte da investigação sobre esta relação que exige sem dúvida, da reação do espectador com a coragem do usuário. Aqui é onde as minhas joias ocorrem. Busco materiais que possuam estas qualidades especiais. Devem ser elásticos e flexíveis, como a pele. Por isso trabalho com silicone. Minhas peças provocam sensações, estimulam uma intimidade tátil e evocam estranheza. Podem ser repulsivas e atraentes ao mesmo tempo.

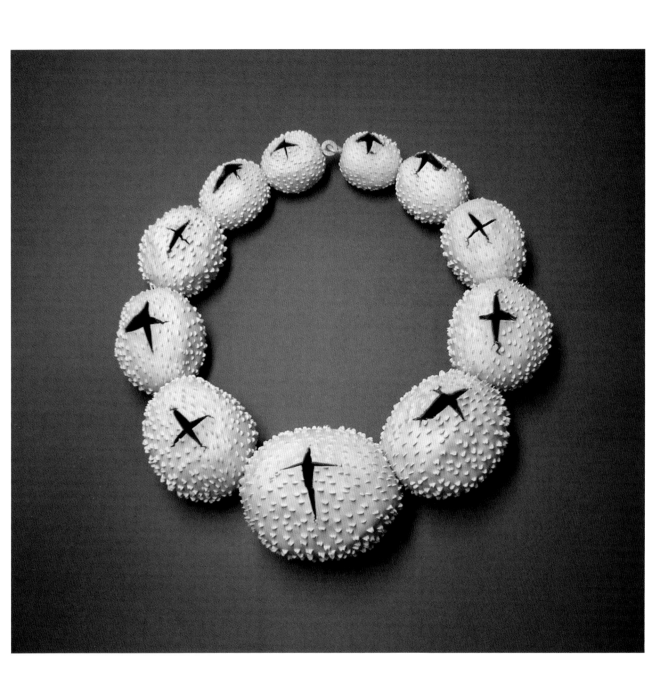

*Wearing jewellery breaks the body's
contours and its limits, for the purpose
of occupying space outside of it.*

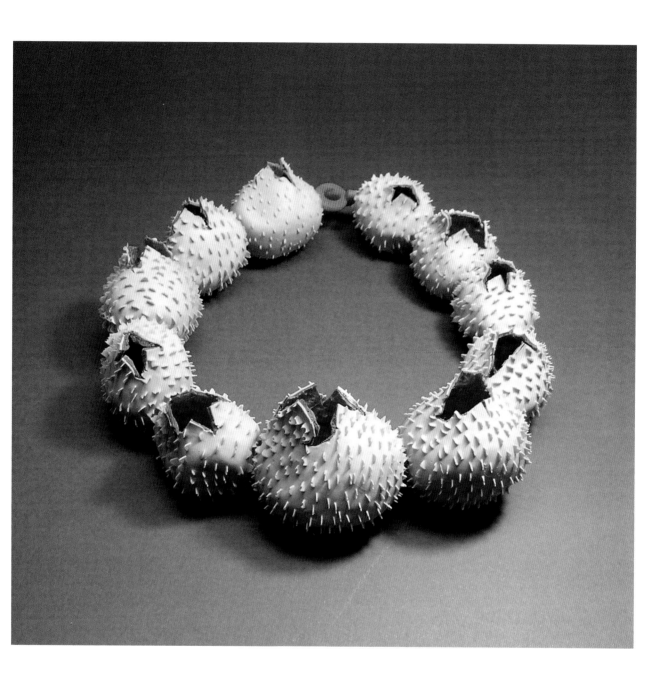

Dana
Hakim

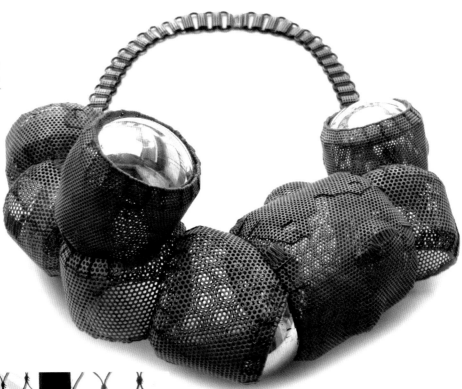

ENG / There's often a limit to expressing my feelings with words. However, my work allows me to express myself with a rich vocabulary. As an artist I want to be true to myself and my intuition, keeping my goals and desires during the creation process. Then, the piece will find people that connect with it, and not the other way round.

I'm inspired by the world, everything that happens and how I sense it. I analyse it rationally, but I play with it using my hands. I think that there are many points of view, many prisms of perception. I try to capture the revelatory experience that is discovering what is hidden under the surface.

My teachers—Karen Pontoppidan, Ruudt Peters, Yaron Ronen and Vered Kaminski—have been essential in my growth as a person and as an artist. My training was crucial for finding my own way.

I often use everyday objects and transform them; I give them a new meaning, a second life. I like them because they are charged with meaning and because of their powerful cultural presence. I get enthusiastic about making the tactile and material qualities the vehicle for the piece's essence. In this world full of mass-produced objects, for me it is a pleasure to give my pieces their own identity.

ESP / A menudo, expresar mis sentimientos con palabras supone un límite. En cambio, mi trabajo me permite expresarme con un vocabulario más rico. Como artista quiero serme fiel a mi misma y a mi intuición; conservar mis objetivos y mis deseos durante el proceso de creación. Luego, la pieza encontrará a quien conecte con ella, y no al revés.

Me inspira el mundo, todo lo que ocurre y cómo yo lo siento. Lo analizo de forma racional pero lo interpreto con mis manos. Creo que hay muchos puntos de vista, muchos prismas de percepción. Intento plasmar la experiencia reveladora que supone descubrir lo que se oculta bajo la superficie.

Mis profesores -Karen Pontoppidan, Ruudt Peters, Yaron Ronen, Vered Kaminski…- han sido esenciales en mi crecimiento como persona y como artista. Mi formación fue crucial a la hora de encontrar mi propio camino.

A menudo utilizo objetos cotidianos y los transformo, les doy un nuevo sentido, una segunda vida. Me gustan porque están cargados de significado y por su poderosa presencia cultural. Me entusiasma hacer que las cualidades táctiles y materiales sean el vehículo de la esencia de la pieza. En este mundo lleno de objetos de producción en masa, para mí es un placer darles a mis piezas su propia identidad.

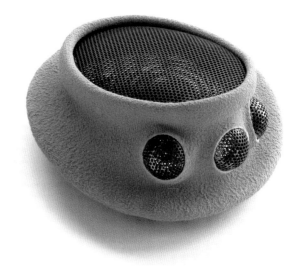

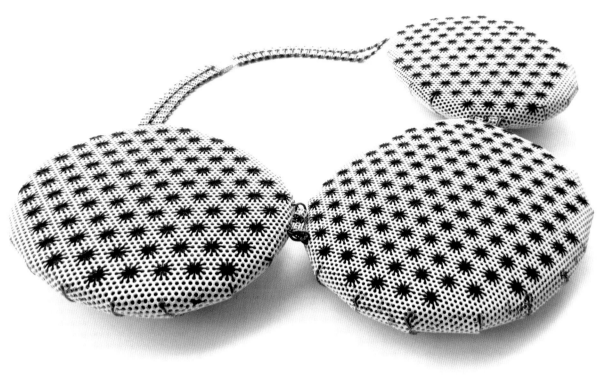

POR / Frequentemente, expressar meus sentimentos com palavras supõem um limite. No entanto, meu trabalho permite expressar-me com um vocabulário mais rico. Como artista, quero ser fiel a mim mesma e a minha intuição; conservar meus objetivos e meus desejos durante o processo da criação. Logo, a peça encontrará a quem se conecte com ela, e não o inverso. Me inspira o mundo, tudo o que ocorre e como eu o sinto. Analiso a tudo de forma racional, mas o interpreto com as minhas mãos. Acredito que há muitos pontos de vista, muitos prismas de percepção. Tento refletir a experiência reveladora que se supõe descobrir o que está oculto debaixo da superfície. Meus professores – Karen Pontoppidan, Ruudt Peters, Yaron Ronen, Vered Kaminski... – Foram essenciais no meu crescimento como pessoa e como artista. A minha formação foi crucial na hora de encontrar meu próprio caminho. Frequentemente utilizo objetos cotidianos e os transformo, dou um novo sentido, uma segunda vida. Eu gosto deles porque estão carregados de significados e uma presença cultural poderosa. Me entusiasmo em fazer com que as qualidades tácteis e materiais sejam o veículo essencial da peça. Neste mundo cheio de objetos de produção em massa, para mim é um prazer dar às minhas peças a sua própria identidade.

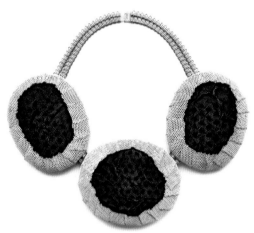

FRA / En général, les mots ne suffisent pas à traduire mes sentiments. À travers mon travail, en revanche, je m'exprime avec un vocabulaire plus riche. En tant qu'artiste, je veux être fidèle à moi-même et à mon intuition, et suivre mes objectifs et mes désirs au cours du processus de création. Ensuite, le bijou trouvera quelqu'un qui s'intéressera à lui et pas l'inverse. Le monde m'inspire, tout ce qui s'y passe et ce que je ressens. Je l'analyse de façon rationnelle, mais je l'interprète avec mes mains. Je pense qu'il existe de nombreux points de vue et modes de perception. J'essaie d'exprimer l'expérience révélatrice qui laisse entrevoir ce qui se cache au-dessous de la surface. Mes professeurs – Karen Pontoppidan, Ruudt Peters, Yaron Ronen et Vered Kaminski – ont eu une grande influence sur mon évolution aussi bien personnelle qu'artistique. Ma formation a été déterminante au moment de choisir ma propre voie. J'utilise souvent des objets de tous les jours que je transforme ; je leur donne un nouveau sens, une deuxième vie. Ils m'attirent parce qu'ils sont chargés de signification et qu'ils dégagent une très forte présence culturelle. Ce qui me passionne c'est le fait de transmettre l'essence d'un bijou à travers ses qualités tactiles et matérielles. Dans notre monde rempli d'objets de production de masse, c'est un réel plaisir de pouvoir conférer à mes bijoux une identité propre.

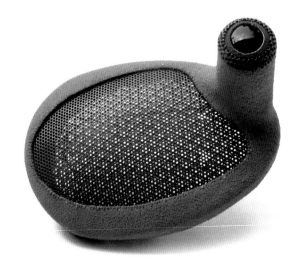

Sophie
Hanagarth

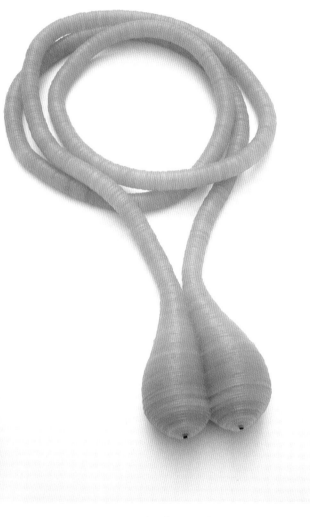

ESP / Quiero crear objetos populares con cualidades únicas: la simplicidad, el poder, la magia. Después de un día en el Louvre o un largo paseo por las calles de una gran ciudad, me siento inspirada. Los pintores simbolistas como Alfred Kubin, Arnold Böklin o Gustave Moreau, con sus atmósferas insólitas, me fascinan. La música, tanto si es jazz como electrónica, me ayuda a encontrar formas de expresar mis ideas. Pero también lo hacen la antropología, el arte o la literatura. El hierro, con su olor a sangre, es uno de mis materiales favoritos. El hierro simboliza la fuerza, pero también las cadenas, las ataduras. Armas, cadenas, joyas, todo está vinculado a los mismos mitos ancestrales. Desde la fragua de Vulcano al anillo de Prometeo, forjado con hierro de las montañas del Cáucaso, el hierro forjado puede entenderse como una forma radical de imaginar ornamentos. Joyas puras, en bruto. Al insertar la mano en un brazalete de hierro, esta queda cautiva, esposada. El brazalete es un arma. Me atrae la transformación directa de la materia a través de la presión y las flexiones. El hierro caliente pierde su estructura, puede ser modelado como la plastilina. Para mí, simboliza un despertar a la sensualidad.

ENG / I want to create popular objects with unique properties: simplicity, power and magic. After a day at the Louvre or a long walk through the streets of a big city I feel inspired. The Symbolist painters such as Alfred Kubin, Arnold Böklin or Gustave Moreau fascinate me with their unusual atmospheres. Music, whether it's jazz or electronic, helps me find ways to express my ideas. But so do anthropology, art or literature. Iron, with its smell of blood, is one of my favourite materials. Iron symbolises strength, but also chains and bonds. Weapons, chains and jewellery: all are linked to the same ancestral myths. From the Forge of Vulcan to Prometheus's ring, forged from iron from the Caucasus Mountains, wrought iron can be understood as a radical way of imagining ornamentation. It's pure jewellery in raw form. By putting your hand in an iron bracelet, it becomes captive, handcuffed. A bracelet is a weapon. What appeals to me is the direct transformation of the material through pressure and bending. Hot iron loses its structure and can be modelled like plasticine. To me, it symbolises an awakening of sensuality. ,

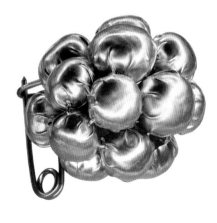

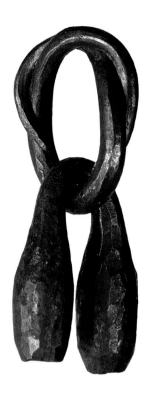

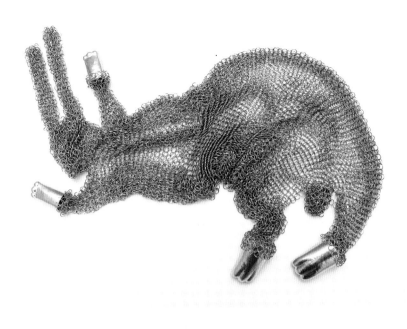

FRA / Je veux créer des objets populaires dotés de qualités uniques qui combinent simplicité, pouvoir et magie. Après une journée passée au Louvre ou une longue promenade dans les rues d'une grande ville, je sens venir l'inspiration. Les ambiances insolites créées par les peintres symbolistes comme Alfred Kubin, Arnold Böklin ou Gustave Moreau me fascinent complètement. La musique jazz et électronique m'aide à exprimer mes idées. Et aussi l'anthropologie, l'art ou la littérature. Le fer, avec son odeur de sang, est une de mes matières préférées. Il symbolise la force, mais aussi les chaînes et les attaches. Les armes, les chaînes, les bijoux, tout nous renvoie aux mêmes mythes anciens. De la forge de Vulcain à la bague de Prométhée faite avec le métal de ses chaînes et sertie d'une pierre du Caucase, nous voyons que le fer forgé est une forme radicale d'ornement. Des bijoux purs et bruts. Lorsque l'on enfile un bracelet en fer, on est capturé, menotté. Le bracelet est une arme. Ce qui me fascine, c'est la transformation directe du matériau sous la pression et la flexion. Le fer chaud perd sa structure et peut être modelé comme de la pâte. C'est pour moi comme un éveil de la sensualité.

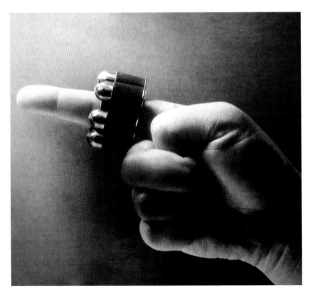

POR / Quero criar objetos populares com qualidades únicas: a simplicidade, o poder, a magia. Depois de um dia no Louvre ou um longo passeio pelas ruas de uma grande cidade eu me sinto inspirada. Os pintores simbolistas como Alfred Kubin, Arnold Böklin ou Gustave Moreau, com suas atmosferas insólitas, me fascinam. A música, tanto jazz como eletrônica, me ajudam a encontrar formas de como expressar as minhas ideias. Como também a antropologia, a arte ou a literatura. O ferro, com o seu cheiro de sangue, é um dos meus materiais favoritos. O ferro simboliza a força, mas também as correntes, as amarras. Armas, correntes, joias, tudo está vinculado aos mesmos mitos ancestrais. Desde a frágua de Vulcano ao anel de Prometeu, trabalhado com ferro das montanhas do Cáucaso, o ferro trabalhado pode ser entendido como uma forma radical de imaginar ornamentos. Joias puras, em bruto. Ao colocar na mão um bracelete de ferro, esta fica cativa, algemada. O bracelete é uma arma. O que me atrai é a transformação direta da matéria através da pressão e das flexões. O ferro quente perde a sua estrutura, pode ser modelado como a massinha. Para mim, simboliza um despertar da sensualidade.

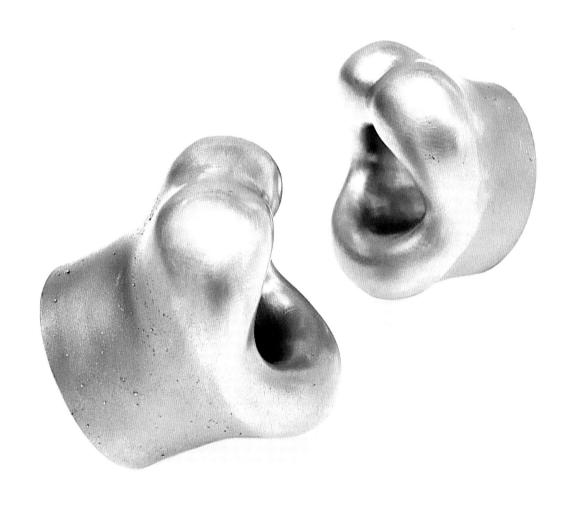

Iron, with its smell of blood,
is one of my favourite materials.

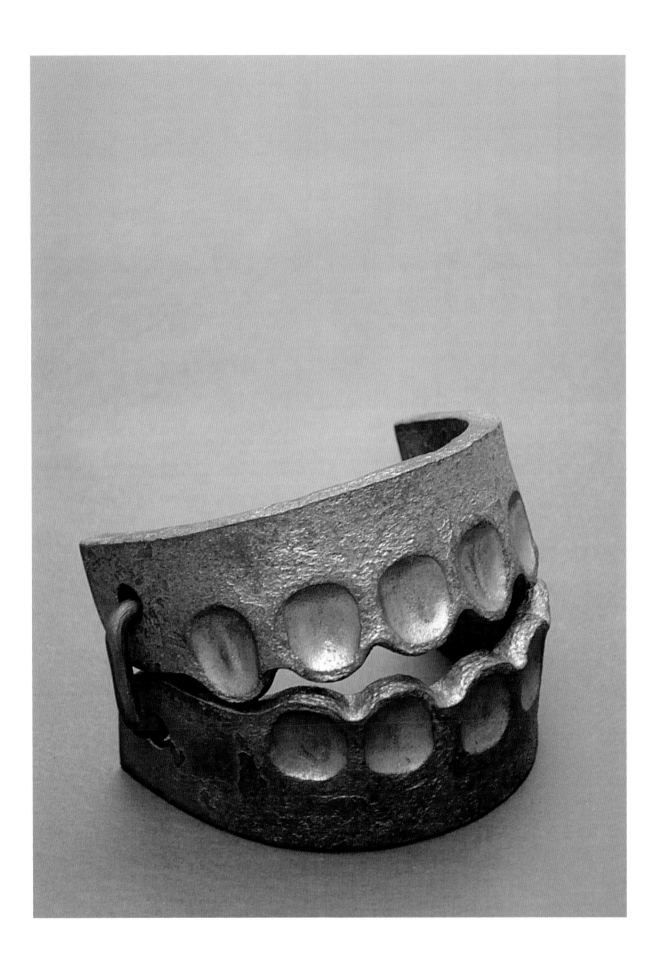

Hanna Hedman

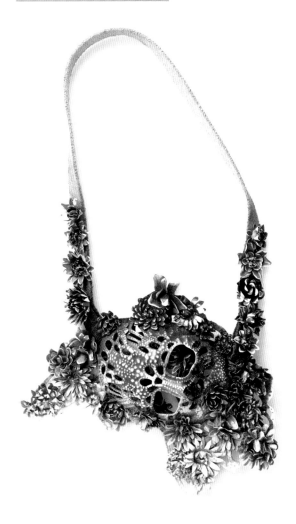

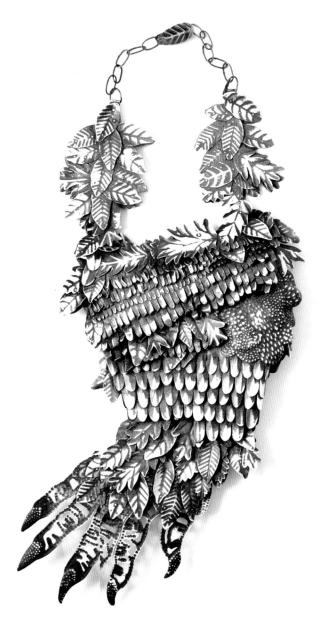

ENG / My work holds ornamental stories that suggest a complex world: beautiful, but also melancholic and malevolent.
I am interested in the the duality and struggle between beauty/good and fear/evil. The battle between light and dark. My pieces are not only isolated objects, they need a wearer and also a context. I am foremost a jeweller, an object maker, but I want to enhance the awareness of wearability and the relationship of the object with the human body. Photography, as a complement to my jewellery, reinforces the narrative of the stories I try to convey. The time I spent in New Zealand as well as my fascination with the art of the Victorian era have been a great influence. The long winters in Sweden, a country otherwise so safe and quiet, have brought elements of darkness and sadness to my work. I want to transmit the viewer, as well as myself, to a state of a certain melancholy. In my pieces you see beauty at first but, if you look closely, they also convey something unusual, frightening. I'm very intrigued by the process of shaping metal. I work with metal plaques, which I manipulate into three-dimensional objects. In the process, the objects transform organically, without me excessively planning the final result.

ESP / Mi trabajo consiste en ornamentos narrativos que sugieren un mundo complejo: hermoso, pero también melancólico y malévolo.
Me interesa la dualidad belleza/bondad-terror/maldad, las intersecciones y la lucha entre ambos. El combate entre la luz y la oscuridad. Mis piezas no son únicamente objetos aislados, necesitan quien las lleve y también un contexto. Soy sobre todo joyera y creadora de objetos, pero me interesa realzar la conciencia de la portabilidad y la relación de la joya con el cuerpo humano. La fotografía, como complemento a mis joyas, refuerza la narrativa de las historias que intento transmitir.
El tiempo que he pasado en Nueva Zelanda, así como mi fascinación por el arte de la era victoriana, me han influido mucho. Los largos inviernos de Suecia, un país por otra parte tan seguro y tranquilo, han aportado a mi trabajo un elemento de oscuridad y tristeza. Quiero transportar al observador, y a mí misma, a un estado de una cierta melancolía. En mis piezas se percibe belleza al principio pero de cerca transmiten algo inusual, siniestro.
Me intriga mucho el proceso de dar forma al metal.
Trabajo con placas metálicas que manipulo hasta convertirlas en objetos tridimensionales. En el proceso, las piezas se transforman en formas orgánicas, sin que yo planifique el resultado final.

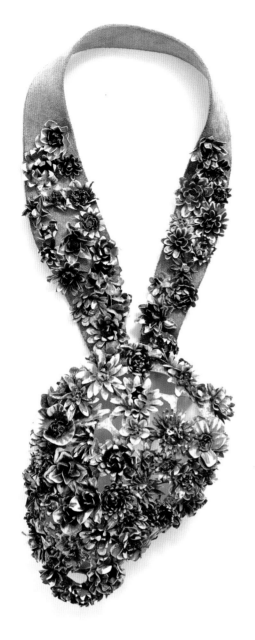

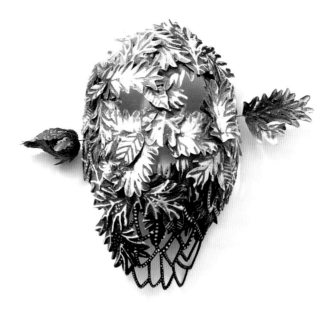

POR / Meu trabalho consiste em ornamentos narrativos que sugerem um mundo complexo: bonito, mas também melancólico e maléfico.

Me interesso pela dualidade beleza/bondade – terror/maldade, as interseções e a luta entre ambos. O combate entre a luz e a escuridão. Minhas peças não são unicamente objetos isolados, precisam de alguém para usá-las e também um contexto. Eu sou, sobretudo, joalheira e criadora de objetos, mas me interessa realçar a consciência da transferência e a relação da joia com o corpo humano. A fotografia, como complemento às minhas joias, reforça a narrativa das histórias que tento transmitir.

O tempo em que passei na Nova Zelândia, assim como a minha fascinação pela arte da era Vitoriana, me influenciaram muito. Os longos invernos da Suécia, um país por uma parte tão seguro e tranquilo, contribuíram para um elemento de escuridão e tristeza no meu trabalho. Quero transportar o observador e a mim mesma para um estado de certa melancolia. De início nas minhas peças nota-se a beleza, mas de perto transmitem algo incomum, sinistro.

Me intriga muito o processo de dar forma ao metal. Trabalho com placas metálicas que manipulo até convertê-las em objetos tridimensionais. No processo, as peças se transformam em formas orgânicas, sem que eu planeja o resultado final.

FRA / Mon travail consiste à créer des ornements narratifs qui évoquent un monde complexe à la fois beau, mélancolique et mauvais.

Je m'intéresse à la dualité beauté/bonté-laideur/méchanceté, aux points de convergence et de lutte entre les deux. Le combat entre la lumière et l'obscurité. Mes créations ne sont pas des objets isolés : elles ont besoin de quelqu'un pour les porter et d'un contexte pour exister. Je suis avant tout une bijoutière et créatrice d'objets, mais j'aime insister sur la notion de port et la relation entre le bijou et le corps humain. J'utilise les photos comme compléments de mes bijoux. Elles donnent plus de poids aux histoires que je veux raconter.

Le temps que j'ai passé en Nouvelle-Zélande et ma passion pour l'art de l'époque victorienne ont une grande influence sur mon travail. Les longs hivers de la Suède, qui est pourtant un pays sûr et tranquille, y ajoutent une pointe d'ombre et de tristesse. Je veux entraîner l'observateur et moi-même, dans un univers empreint de mélancolie. Au prime abord, il émane de mes bijoux de la beauté. Mais lorsqu'on les regarde de plus près, l'on ressent quelque chose d'étrange, de presque sinistre.

Le façonnage du métal est un processus fascinant. Je travaille avec des feuilles métalliques que je manipule jusqu'à les convertir en objets tridimensionnels. Au cours de cette transformation, ils deviennent des formes organiques, sans que j'aie décidé au préalable du résultat que je voulais obtenir.

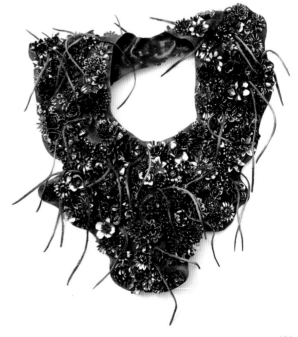

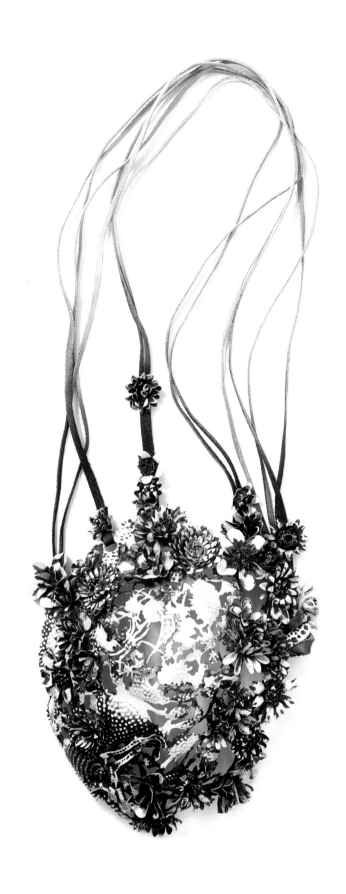

My world holds ornamental stories
that suggest a complex world: beautiful,
but also melancholic and malevolent.

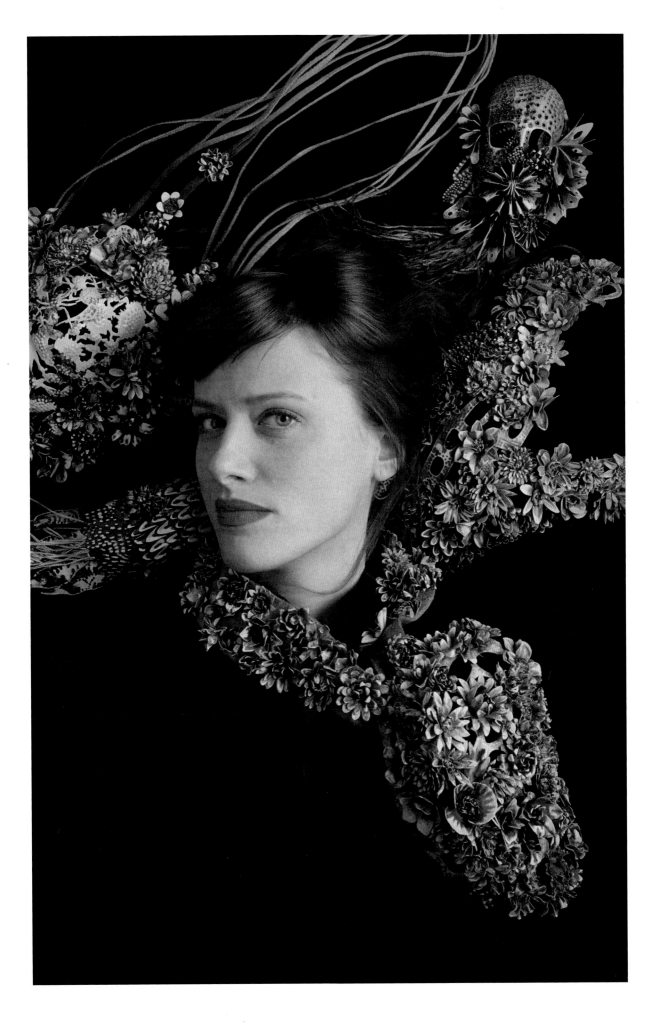

Gabriela
Horvat

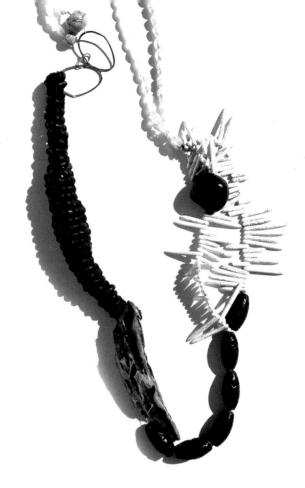

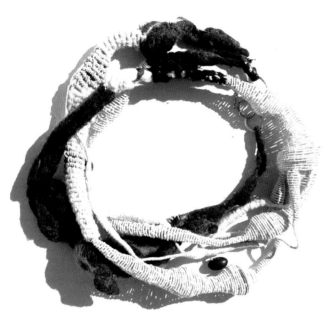

ENG / We work with the essence of the primitive, the ancestral: the essence of the object. We search for imperceptible and subtle balances but also for strong contrasts; in working with the scents and colours of the earth we appreciate human achievements. We are interested in what is hidden, implicit. We use superior materials that are natural and local, like silk, sheep and llama wool, metal, stone, wood and Argentinian leather.

I am devoted to fabrics. When I was little, my mum, who today is also my business partner, was an artist and used fabrics. A few years ago I participated in a fashion week and there I began to develop pieces with their own identity. It was winter and we used wool; when summer arrived we moved on to silks and we've continued in this way, mixing, discovering fabrics, incorporating wood, precious, semi-precious and rough stones: anything goes and it all says something. And in the search for equilibrium, in playing, we find ourselves working...

We almost always make necklaces; this probably has to do with hugging and being cared for, or that shield each one of us decides to use on a daily basis to confront the world with a feeling of strength.

ESP / Trabajamos con la esencia de lo primitivo, lo ancestral: la esencia del objeto. Buscamos equilibrios imperceptibles, sutiles y a su vez con fuertes contrastes; valoramos los logros humanos al trabajar con aromas y colores de la tierra. Nos interesa aquello que está oculto, implícito.

Usamos materiales nobles, naturales y locales, como la seda natural, la lana de oveja y llama, los metales, las piedras, las maderas y los cueros de la Argentina.

Siento devoción por los tejidos. Cuando yo era pequeña, mi mamá, hoy también mi socia, era artista plástica y utilizaba tejidos..

Hace unos años participé en una fashion week y ahí empecé a desarrollar piezas con identidad propia. Era invierno y usamos lanas; al llegar el verano pasamos a las sedas y así continuamos, mezclando, descubriendo tejidos, incorporando maderas, piedras preciosas, semipreciosas, toscas: todo vale, todo dialoga. Y en la búsqueda del equilibrio, en el juego, nos encontramos trabajando...

Casi siempre hacemos collares... probablemente tenga que ver con el abrazo, el cuidado, o ese escudo que cada uno decide ponerse a diario para enfrentarse al mundo, fortalecerse.

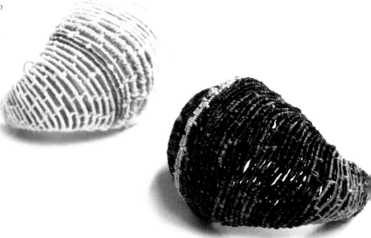

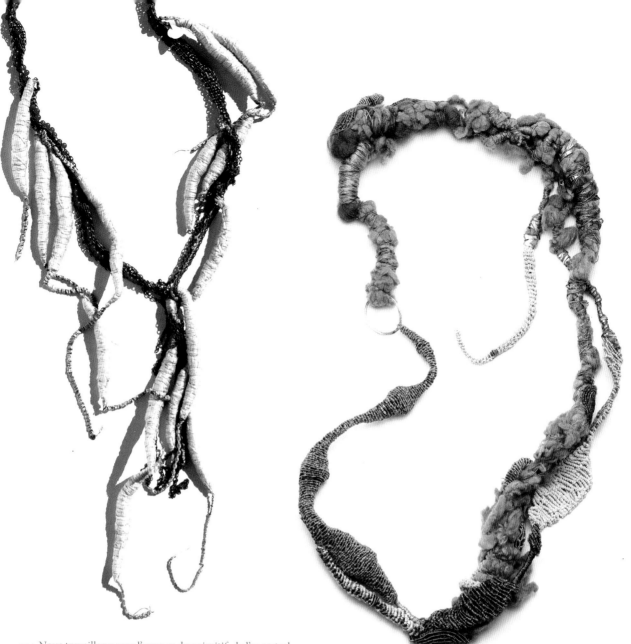

FRA / Nous travaillons avec l'essence du primitif, de l'ancestral :
la quintessence de l'objet. Nous recherchons à la fois des
équilibres imperceptibles, subtils et des contrastes marqués.
Lorsque nous travaillons avec des arômes et des couleurs
de terre, nous exaltons les réalisations humaines. Ce qui
nous intéresse est ce qui ne se voit pas, ce qui est implicite.
Nous utilisons des matières nobles, naturelles et locales,
comme la soie grège, la laine de mouton et de lama, les
métaux, les pierres, le bois et le cuir d'Argentine.
J'ai une vénération pour les tissus. Quand j'étais petite, ma
mère qui est aujourd'hui mon associée, était plasticienne,
et elle travaillait avec des tissus.
Il y a quelques années, j'ai participé à une semaine de mode.
C'est là que j'ai commencé à concevoir des créations possédant
une identité propre. C'était l'hiver et nous avons utilisé de la
laine. En été, nous sommes passés à la soie. Et nous avons
continué ainsi à mélanger les matières et à découvrir de
nouveaux tissus, à y intégrer des détails en bois, des pierres
précieuses et semi-précieuses non taillées. Tout a la même
valeur, tout est échange. Et dans notre recherche de l'équilibre
et du jeu, nous continuons à travailler sans relâche.
Nous réalisons presque toujours des colliers. C'est
probablement lié à la notion d'enlacement, d'affection
ou alors à cette armure que nous enfilons tous les matins
avant de sortir affronter le monde.

POR / Trabalhamos com a essência do primitivo, o ancestral:
a essência do objeto. Buscamos equilíbrios imperceptíveis,
sutis e ao mesmo tempo com fortes contrastes; valorizamos
as conquistas humanas de trabalhar com aromas e cores
da terra. Nos interessa aquilo que está oculto, implícito.
Usamos materiais nobres, naturais e locais, como a seda
natural, a lã de ovelha e da lhama, os metais, as pedras,
a madeira e o couro da Argentina.
Sinto uma devoção pelos tecidos. Quando eu era pequena,
minha mãe, hoje também a minha sócia, era artista plástica
e utilizava tecidos...
Há alguns anos participei de uma fashion week e lá comecei
a desenvolver peças com identidade próprias. Era inverno
e usamos lã; ao chegar o verão passamos às sedas e assim
continuamos, misturando, descobrindo tecidos, incorporando
madeira, pedras preciosas, semipreciosas, brutas: vale tudo,
tudo se dialoga. E na busca do equilíbrio, no jogo, nos
encontramos trabalhando...

Quase sempre fazemos colares... Provavelmente tem a ver
com o abraço, o cuidado, ou essa couraça que cada um decide
por no dia a dia para enfrentar o mundo, fortalecer-se.

Mari
Ishikawa

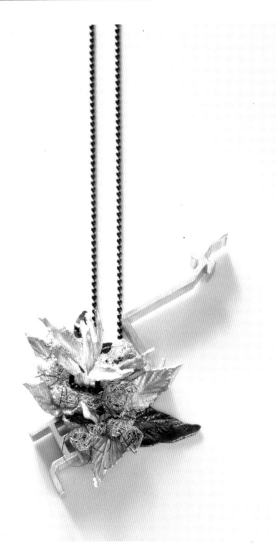

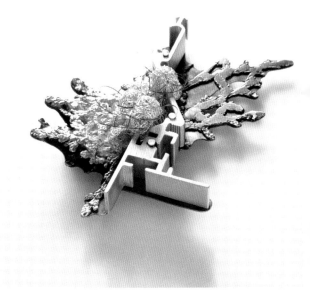

Para mí, lo más interesante es que la joyería escribe su propia historia; mientras estoy trabajando en una pieza, es mía, con mi propia historia. Pero cuando otra persona la lleva, empieza una nueva relación, una nueva historia.

Me interesan los paisajes naturales y los paisajes humanos, los edificios. Últimamente me atraen mucho los jardines antiguos, donde el tiempo se detiene, pero la vegetación sigue transformándose. Me gustaría mostrar la silenciosa revolución de las plantas.

El mundo que vemos es solo una parte de la realidad, que está compuesta de muchos mundos simultáneos que coexisten. Si abrimos nuestro corazón, podemos ver esos mundos paralelos. Siempre están con nosotros.

Me gusta mucho tomar fotos a la luz de la luna. En la fotografía y en la joyería encuentro dos formas distintas de aproximarme al tema de la realidad y la apariencia. Mis fotos captan, en la oscuridad, misteriosos colores, normalmente invisibles para el ojo humano que, a la luz de la luna, solamente percibe varias tonalidades de gris. Me gustaría poder mostrar estos matices de gris en mis joyas.

Mediante la técnica de la cera perdida hago moldes de flores naturales, tallos y hojas. Su perfección me sorprende. Intento congelar su belleza y preservar su esencia y su recuerdo.

For me, the most interesting thing is when jewellery writes its own story; while I'm working on a piece, it's mine, with my own story. But when someone else wears it, it's the start of a new relationship, a new story.

I'm interested in natural landscapes and human ones, buildings. Lately I have been really drawn to old gardens, where time stops, but the vegetation carries on changing. I'd like to be able to show the silent revolution of plants.

The world we see is only one part of reality, which is composed of many worlds that coexist simultaneously. If we open our hearts, we can see these parallel worlds. They are always with us.

I really like to take pictures by moonlight. In photography and jewellery I find two different ways to approach the theme of reality and appearance. My photos capture, in the darkness, mysterious colours that are normally invisible to the human eye, which in the light of the moon can only perceive different shades of grey. I'd like to be able to show these shades of grey in my jewellery.

Using the technique of lost-wax I make moulds of natural flowers, stems and leaves. Their perfection surprises me. I try to freeze their beauty and preserve their essence and memory.

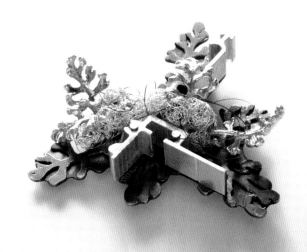

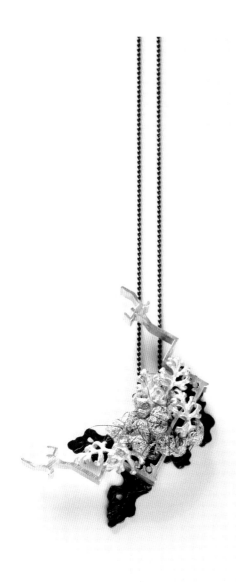

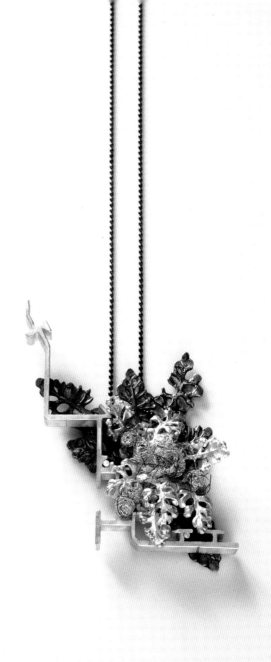

FRA / Ce que je trouve le plus fascinant dans la joaillerie, c'est qu'elle raconte sa propre histoire. Lorsque je travaille sur un bijou, il m'appartient, il fait partie de ma vie. Mais lorsqu'une autre personne le porte, il entame une nouvelle relation, une nouvelle histoire.

Les paysages naturels et aussi ceux créés par l'homme, comme les bâtiments, m'intéressent. Depuis quelques temps, je suis attirée par les jardins anciens, où le temps s'est arrêté mais où la végétation continue à se transformer. J'aimerais montrer la révolution silencieuse des plantes.

Le monde visible n'est qu'une partie de la réalité qui renferme plusieurs autres mondes parallèles. Nous pouvons les voir si nous ouvrons notre cœur. Ils sont en permanence à nos côtés. J'adore prendre des photos à la lumière de la lune. La bijouterie et la photographie me permettent toutes les deux d'aborder la réalité et les apparences. Mes photos captent dans la pénombre de mystérieuses couleurs qui sont normalement invisibles à nos yeux et qui sous l'éclat de la lune apparaissent comme différents tons de gris. J'aimerais pouvoir représenter ces nuances de gris dans mes bijoux.

J'utilise la technique de la cire perdue pour fabriquer des moules de fleurs naturelles, de tiges et de feuilles. Leur perfection m'étonne. J'essaie de fixer leur beauté et de conserver leur essence et leur souvenir.

POR / Para mim, o mais interessante é que a joia escreva a sua própria história; enquanto estou trabalhando numa peça, esta é minha, com a minha própria história. Mas quando outra pessoa a leva, começa uma nova relação, uma nova história.

Me interessam as paisagens naturais e as humanas, os edifícios. Ultimamente me atraem muito os jardins antigos, onde o tempo se detém, mas a vegetação segue se transformando. Eu gostaria de mostrar a silenciosa revolução das plantas.

O mundo que vemos é só uma parte da realidade, que está composta de muitos mundos simultâneos que se coexistem. Se abrirmos nosso coração, podemos ver esses mundos paralelos. Sempre estão conosco. Eu gosto muito de tirar fotos sob a luz da lua. Na fotografia e na joalheria, encontro duas formas diferentes de me aproximar ao tema da realidade e da aparência. Minhas fotos captam cores misteriosas na escuridão, normalmente invisíveis para o olho humano que, sob a luz da lua, só se percebe várias tonalidades de cinza. Eu gostaria de poder mostrar estas tonalidades de cinza em minhas joias. Usando a técnica da cera perdida faço moldes de flores naturais, galhos e folhas. Sua perfeição me surpreende. Tento congelar sua beleza e preservar a sua essência e sua memória.

Jiro
Kamata

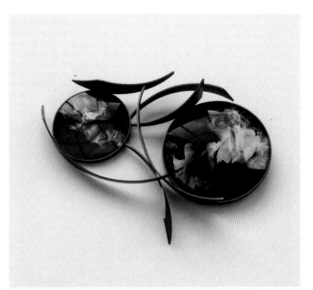

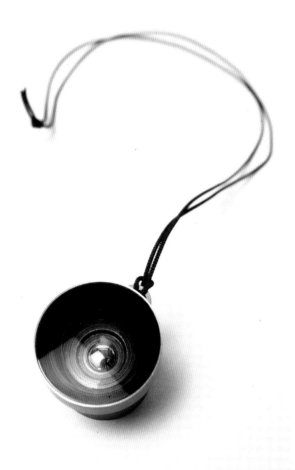

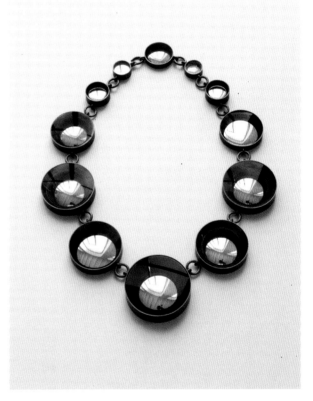

ENG / I wonder about what the real value of jewellery is.
And I think that memory is what makes a piece of jewellery
truly valuable. Any moment can be important, if I see, touch
or feel something that inspires me. It does not have to be
something special. I want to collect many different
experiences and store them in my mind. Suddenly they
appear without being called for, freely, and they combine
and become a single idea. It's like a chemical reaction.
I use old camera lenses for my works because they represent
the value of memory, with everything they have seen and
captured. My favourite technique is soldering, because I feel
like a goldsmith when I'm doing it!
Music, art, design, film and literature all fascinate me.
I think it's important to be curious!

ESP / Me pregunto cuál es el verdadero valor de la joyería.
Y creo que es la memoria lo que hace que una joya sea
realmente valiosa. Cualquier momento podría ser importante,
si veo, toco o siento algo que me inspira. No tiene que ser algo
especial. Quiero recoger muchas experiencias distintas y
conservarlas en mi mente. De repente aparecen sin buscarlas,
libremente, se unen y se convierten en una sola idea. Es como
una reacción química. Utilizo viejas lentes fotográficas para mis
obras porque representan el valor de la memoria, con todo lo
que han visto y capturado. Mi técnica favorita es la soldadura,
porque ¡me siento como un orfebre cuando estoy soldando!
Me fascina la música, el arte, el diseño, el cine, la literatura.
¡Creo que es importante ser curioso!

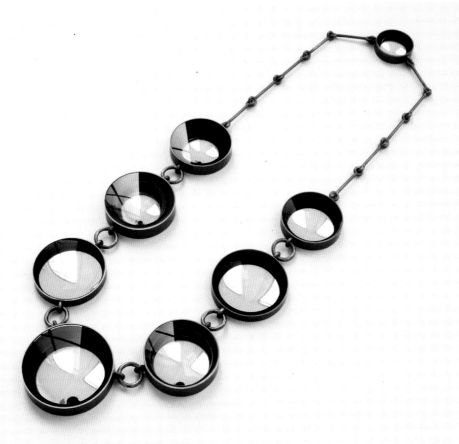

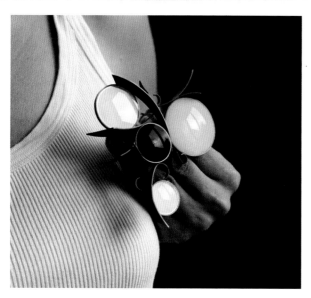

POR / Pergunto-me qual é o verdadeiro valor da joia. E creio que é a memória que faz com que uma joia seja realmente valiosa. Qualquer momento pode ser importante, se vejo, toco ou sinto algo que me inspira. Não tem que ser algo especial. Quero recolher muitas experiências diferentes e conservá-las na minha mente. De repente, elas aparecem livremente, sem buscá-las, se unem e se convertem em uma só ideia. É como uma reação química. Utilizo lentes fotográficas velhas para as minhas obras porque representam o valor da memória, com tudo o que já viram e capturaram. A minha técnica favorita é a soldagem, porque me sinto como um ourives quando estou soldando! Me fascina a música, a arte, o desenho, o cinema, a literatura. Acredito que é importante ser curioso!

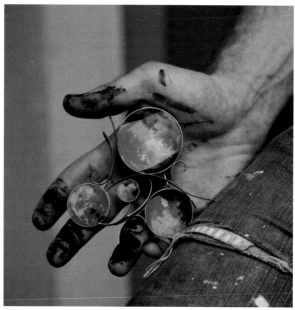

FRA / Je me demande quelle est la vraie valeur d'un bijou. Je crois que c'est la mémoire qui lui donne sa véritable force. N'importe quel moment peut revêtir de l'importance, si à cet instant là je vois, je touche, je ressens quelque chose qui m'inspire. Pas besoin que ce soit quelque chose de particulier. Je veux accumuler le plus grand nombre possible d'expériences diverses et les conserver dans ma mémoire. Elles refont surface ensuite librement, sans que je les cherche, et elles se rejoignent et se transforment en une idée unique. C'est comme une réaction chimique. J'utilise de vieux objectifs photo pour mes créations, parce qu'ils représentent la valeur de la mémoire, avec tout ce qu'ils ont vu et capturé. Ma technique préférée est la soudure, parce qu'elle me donne l'impression d'être un orfèvre !
Je suis un passionné de musique, d'art, de design, de ciné et de littérature. Je crois qu'il est important d'être curieux.

Agnes
Larsson

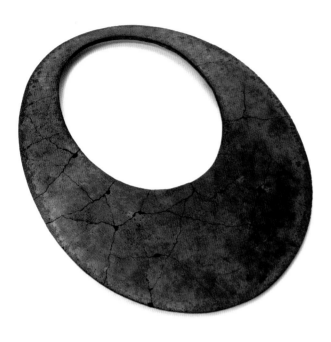

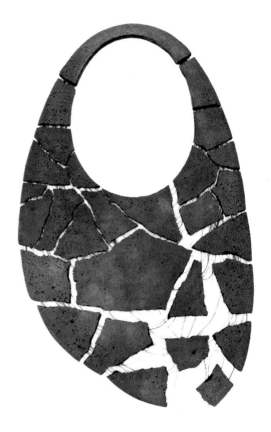

ENG / My work is always based on the materials. I am continually exploring materials such as coal, iron powder, deerskin or horse hair. I select the material carefully and it serves to guide me; I thoroughly explore its properties to reach the limits of its narrative capacity. I also try to process it to the fullest to transform it and give it a new life. I find inspiration in the power of the opposing forces that surround us and define our existence: life and death, light and darkness, the superficial and the deep, fragility and strength. And finally it is the body that truly inspires me; it takes all the decisions and transforms the material into a piece of jewellery. My work with coal has been hard and difficult, but thanks to its special qualities the result is something light and delicate. In the simplicity of the figures the raw material ceases to be recognizable. The broken pieces, with their polished surfaces and deep cracks, create a fragile protection against the outside world.

ESP / Mi trabajo parte siempre de los materiales. Continuamente estoy investigando materiales como el carbón, polvo de hierro, piel de ciervo, pelo de caballo. Selecciono un material cuidadosamente y me sirve como guía; exploro sus cualidades a fondo para llegar hasta el límite de su capacidad narrativa. También intento procesarlo al máximo hasta transformarlo y darle una nueva vida. Encuentro inspiración en el poder de las fuerzas opuestas que nos rodean y definen nuestra existencia: la vida y la muerte, la luz y la oscuridad, lo superficial y lo profundo, la fragilidad y la fuerza. Y finalmente es el cuerpo lo que me inspira en realidad, toma toda las decisiones y transforma el material en una pieza de joyería.
Mi trabajo con el carbón, por ejemplo, ha sido duro y difícil, pero gracias a sus especiales características el resultado es algo ligero, delicado. En la simplicidad de las figuras, la materia prima deja de ser reconocible. Las piezas rotas, con sus superficies pulidas y sus grietas profundas, crean una frágil protección contra el mundo exterior.

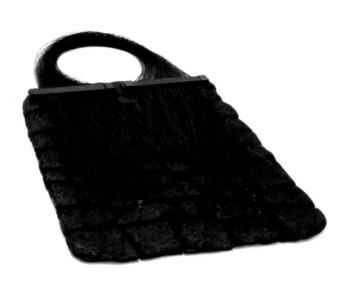

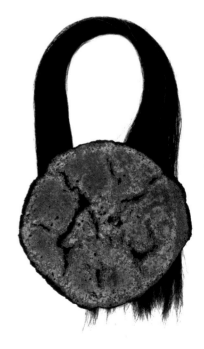

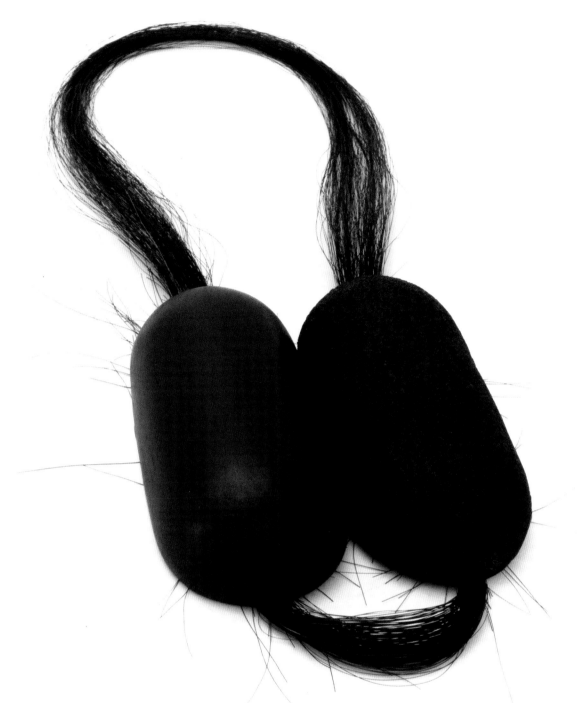

FRA / Mon travail part toujours de la matière. Je teste constamment des matériaux comme le charbon, la limaille de fer, la peau de chevreuil, le crin de cheval. Je choisis soigneusement la matière et je m'en sers de guide. J'explore à fond ses qualités jusqu'à atteindre les limites de sa capacité narrative. J'essaie aussi de la manipuler à l'extrême, jusqu'à la transformer et lui donner une nouvelle vie. Je trouve l'inspiration dans l'énergie des forces contraires qui nous entourent et donnent un sens à nos existences : la vie et la mort, la lumière et l'obscurité, la superficialité et la profondeur, la fragilité et la force. Mais au bout du compte, c'est le corps qui m'inspire vraiment. C'est lui qui prend toutes les décisions et qui transforme la matière en bijou.

Mon travail sur le charbon, par exemple, a été dur et difficile, mais grâce à ses caractéristiques particulières, le résultat final est une matière légère et délicate. À travers la simplicité des formes, la matière première n'est plus reconnaissable. Les bijoux brisés, qui combinent surfaces polies et fractures profondes, créent un fragile rempart contre le monde extérieur.

POR / Meu trabalho parte sempre dos materiais. Continuamente estou investigando materiais como o carvão, pó de ferro, pele de cervo, pelo do cavalo. Seleciono um material cuidadosamente que me serve como guia; exploro suas qualidades a fundo para chegar até o limite da sua capacidade narrativa. Também tento processá-lo ao máximo até transformá-lo e dar-lhe uma nova vida. Encontro inspiração no poder das forças opostas que nos rodeiam e definem a nossa existência: a vida e a morte, a luz e a escuridão, o superficial e o profundo, a fragilidade e a força. E finalmente é o corpo o que me inspira de verdade, tomando todas as decisões e transformando o material em uma peça de joia.

Meu trabalho com o carvão, por exemplo, tem sido duro e difícil, mas graças às suas características especiais, o resultado é algo leve, delicado. Na simplicidade das figuras a matéria-prima deixa de ser reconhecida. As peças quebradas, com as suas superfícies polidas e as suas fissuras profundas, criam uma proteção frágil contra o mundo externo.

Hyorim
Lee

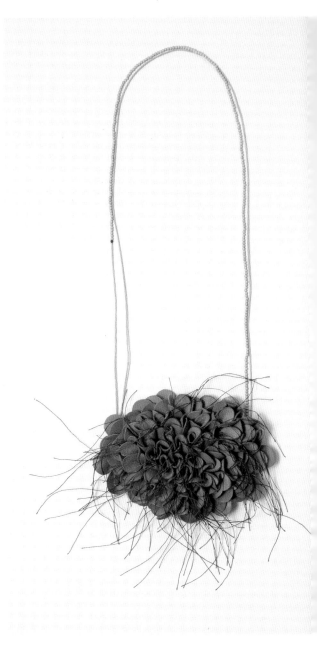

ENG / Reptiles and insects undergo different ecdyses and metamorphoses until they become adults. They leave behind their own epidermis. In a new environment, human beings also grow and become stronger every day.

Flowers, grass and trees grow in the ground. Collectively they cover the desolate land. Natural elements may be small, but sometimes, when they're connected, they look entirely different: intertwined branches that look like a strong tree, hundreds of tiny flowers that look like a single one. A huge package making a new form, rather than several pieces together.

In a similar way, my appearance and my life are made up of fragments of memory. Memory is confusing, but it is vividly coloured. Memory fragments are connected by a piece of string: they become a new piece, which continues to grow. To express this, I am very interested in leather. It comes from an animal, but is dyed in beautiful colours, like flowers. When you wear it as a necklace, it feels like a second skin (located in a place between your skin and clothes). If I sew the pieces together with a fine thread (lines), I can connect the various stages of growth. Small parts become one through growth.

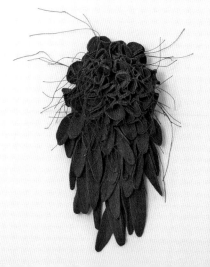

ESP / Los reptiles y los insectos sufren distintas ecdisis y metamorfosis hasta llegar a adultos. Dejan atrás su propia epidermis. También el ser humano, en un nuevo entorno, crece y se fortalece día a día.

Las flores, la hierba y los árboles crecen en la tierra. Todos juntos cubren la tierra desolada. Los elementos de la naturaleza pueden ser pequeños, pero en ocasiones, conectados, ofrecen una visión totalmente distinta: ramas entrelazadas que parecen un fuerte árbol; cientos de diminutas flores que parecen una sola. Un enorme envoltorio de una forma nueva, en lugar de varias piezas unidas.

Del mismo modo, mi aspecto y mi vida están hechos de fragmentos de memoria. La memoria es confusa, pero tiene un color vivo. Los fragmentos de memoria están conectados por un trozo de cuerda: se convierten en una pieza nueva que sigue creciendo.

Para expresar esto me interesa mucho el cuero. Viene de un animal pero está teñido de hermosos colores, como las flores. Cuando la llevas como un collar, la sientes como tu otra piel (en algún lugar entre la piel y la ropa). Si coso las piezas con un hilo fino (líneas), conecto las distintas etapas del crecimiento. Pequeñas piezas que son una: creciendo.

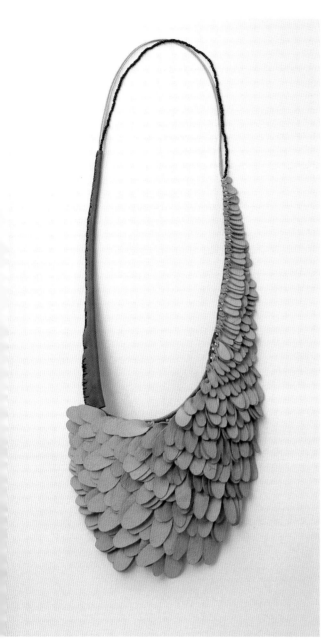
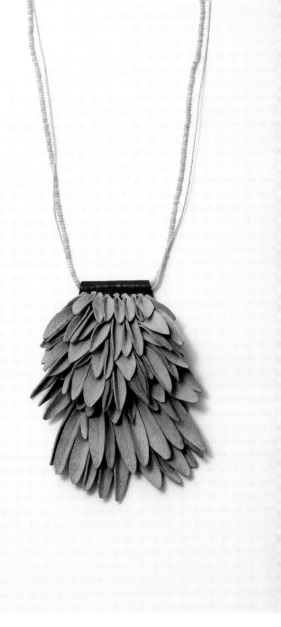

FRA / Les reptiles et les insectes subissent plusieurs mues et métamorphoses avant de devenir adultes. Ils laissent derrière eux leur ancien épiderme. L'être humain, placé dans un nouvel environnement, évolue et devient chaque jour un peu plus fort. Les fleurs, l'herbe et les arbres poussent dans la terre. Ensemble, ils recouvrent le sol aride. Les éléments de la nature, même de petite taille, changent parfois complètement d'aspect lorsqu'on les associe : des branches enlacées deviennent un arbre solide ; des centaines de fleurs minuscules ont l'air d'être une seule grande fleur. Une énorme enveloppe produit une nouvelle forme unique au lieu de multiples morceaux rassemblés. De même, mon apparence et ma vie sont constituées de fragments de mémoire. Celle-ci est confuse, mais elle est d'une couleur vive. Ces fragments de mémoire sont reliés par un bout de corde. Ils se transforment en un nouvel élément qui ne cesse de grandir.

Pour exprimer tout cela, je m'intéresse en particulier au cuir. Il a une origine animale, mais il peut être teint de jolies couleurs, comme les fleurs. Lorsqu'on le porte autour du cou sous forme de collier, c'est comme une deuxième peau (entre vêtements et peau). Si je couds plusieurs pièces de cuir avec un fil très fin (lignes), je relie différentes étapes de croissance. Les petits morceaux en forment un plus grand qui ne cesse de grandir.

POR / Os répteis e os insetos sofrem diferentes ecdises e metamorfoses até chegarem à fase adulta. Deixam para trás a sua própria epiderme. Também o ser humano, num novo ambiente, cresce e se fortalece dia a dia. As flores, a grama e as árvores crescem no solo. Todos juntos cobrem a terra desolada. Os elementos da natureza podem ser pequenos, mas quando conectados, oferecem uma visão totalmente diferente: galhos entrelaçados que parecem uma árvore forte; centenas de flores miúdas que parecem uma só. Um enorme revestimento com uma forma nova, em lugar de várias peças unidas.

Do mesmo modo, meu aspecto e a minha vida estão feitos de fragmentos de memória. A memória é confusa, mas tem uma cor viva. Os fragmentos de memória estão conectados por um pedaço de corda: se convertem em uma peça nova, que segue crescendo.

Para expressar isto, me interesso muito pelo couro. Vem de um animal, mas está tingido de belas cores, como as flores. Quando se usa como um colar, sente-se como uma segunda pele (em algum lugar entre a pele e a roupa). Se costuro as peças com um fio fino (linhas), conecto as diferentes etapas do crescimento. Pequenas peças que são uma: um crescer.

Beth Legg

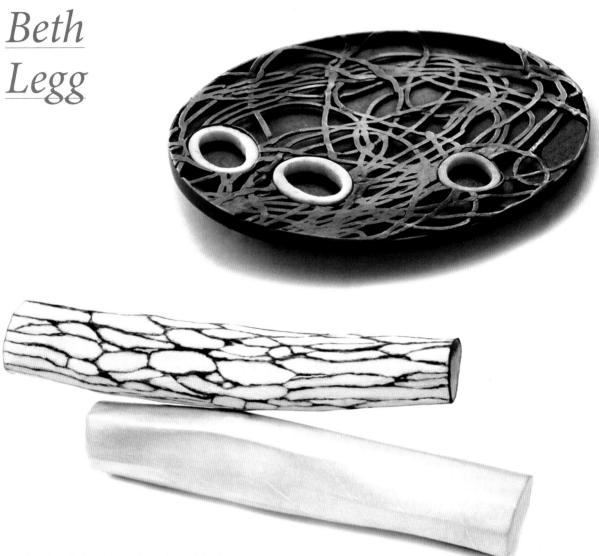

ENG / I explore feelings about places through landscape and memory in my creations. My work has been very much influenced by the area that I come from, namely Scotland's isolated northern coast. These origins have made me fascinated by the idea of unexplored places, as well as the silence and calm of places that exist out on the fringes and have a beautiful and melancholy sense of isolation to them. My instinct is to go straight to working with my primary materials rather than starting out making designs at the drawing board. I love working with traditional tools, and also interacting with the materials. The process of investigating their properties unlocks their hidden potential to me. On both an intellectual and emotional level I get a real sense of satisfaction from designing while I make pieces.

I like to think of the body as a landscape, and when a person wears a piece of jewellery they incorporate its own landscape narrative and also develop their own associations through the piece, which itself is transformed when it is worn. I think of my pieces as still lives through a contemplative and sensitive interpretation of the sense of place. My work could be considered a moving dialogue, with each piece exploring elements relating to landscape and memory and ultimately reflecting the bleak and fragile nature of the environment I come from.

ESP / Mis piezas exploran el sentido del lugar a través del paisaje y de la memoria. El entorno remoto del que provengo, en el extremo norte de la costa de Escocia, ha influido inmensamente en mi trabajo. Siempre me han fascinado las tierras recónditas y el silencio y la quietud de las zonas fronterizas: lugares cuya desolación puede ser a un tiempo bella y melancólica. Instintivamente tiendo a trabajar con materiales antes que diseñar piezas de antemano. Me gustan mucho los métodos de trabajo con herramientas tradicionales, establecer un diálogo con una serie de materiales mediante la exploración de sus cualidades innatas y descubrir sus posibilidades inherentes. Para mí, diseñar mientras se hace es una satisfacción, tanto intelectual como emocional.

Me gusta pensar en el cuerpo como un paisaje: las joyas se transforman y quien las lleva incorpora esa narrativa del paisaje que contienen y crea sus propias asociaciones mediante la pieza. Alejadas de quien las lleva, me gustaría que mis piezas tuvieran las cualidades de los bodegones, mediante una interpretación sensible y contemplativa del sentido del lugar. Mi trabajo podría definirse como un diálogo en movimiento: cada pieza como una exploración de elementos compositivos que giran alrededor del paisaje y la memoria y que finalmente reflejan la desolación y la fragilidad del entorno del que procedo.

POR / Minhas peças exploram o sentido do lugar através da paisagem e da memória. O ambiente remoto de onde venho, no extremo norte da costa da Escócia, influenciou imensamente o meu trabalho. Sempre me fascinaram as terras recônditas e o silêncio e a quietude das zonas fronteiriças: lugares cuja desolação pode ser ao mesmo tempo bela e melancólica. Instintivamente tendo a trabalhar com materiais antes de desenhar peças de antemão. Gosto muito dos métodos de trabalho com ferramentas tradicionais, estabelecer um diálogo com uma série de materiais através da exploração das suas qualidades inatas e descobrir suas possibilidades inerentes. Para mim, desenhar enquanto se faz é uma satisfação, tanto intelectual como emocional.

Eu gosto de pensar no corpo como uma paisagem: as joias se transformam e quem as usa incorpora esta narrativa da paisagem que contem e cria as suas próprias associações através da peça.

Fora quem as usa, eu gostaria que as minhas peças tivessem a qualidade da natureza-morta, através de uma interpretação sensível e contemplativa do sentido do lugar. Meu trabalho poderia definir-se como um diálogo em movimento: cada peça como uma exploração de elementos compostos que giram ao redor da paisagem e da memória e que finalmente refletem a desolação e a fragilidade do ambiente que procedo.

FRA / Mes créations explorent l'esprit du lieu par le biais du paysage et de la mémoire. Le pays lointain d'où je viens, la côte à l'extrême nord de l'Écosse, a une énorme influence sur mon travail. J'ai toujours été fascinée par les endroits reculés, et le silence et le calme des zones frontalières. Se sont des lieux où la désolation peut être à la fois belle et mélancolique. Par instinct, j'ai tendance à travailler directement avec les matériaux plutôt que de commencer par dessiner mes créations. J'aime bien utiliser des outils traditionnels et établir un dialogue avec différents matériaux, afin d'explorer leurs qualités intrinsèques et découvrir les possibilités qu'ils recèlent. Pour moi, le fait de concevoir un bijou à mesure que je le façonne est une profonde satisfaction intellectuelle et émotionnelle. L'idée que le corps est un paysage me plaît beaucoup. Les bijoux se transforment, et ceux qui les portent intègrent leur histoire dans le paysage qui les renferme. Les gens créent leurs propres associations par l'intermédiaire du bijou.

J'aimerais que mes bijoux, lorsqu'ils ne sont pas portés, aient la qualité des natures mortes, et qu'ils traduisent l'aspect délicat et contemplatif de l'esprit du lieu. Je pourrais définir mon travail comme un dialogue en mouvement : chaque bijou explore les éléments constitutifs qui tournent autour du paysage et de la mémoire. Ils reflètent finalement la désolation et la fragilité du milieu d'où je viens.

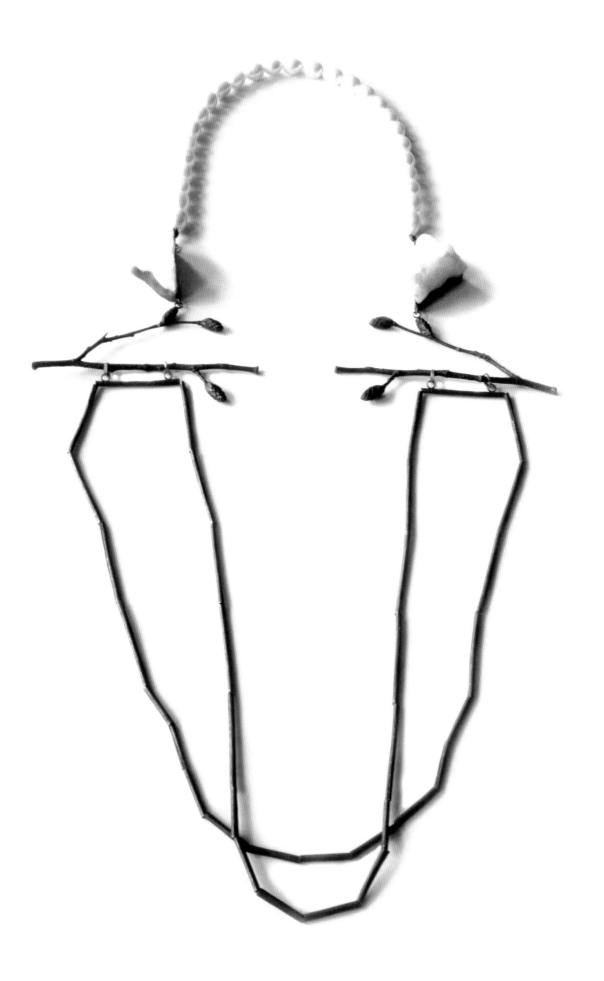

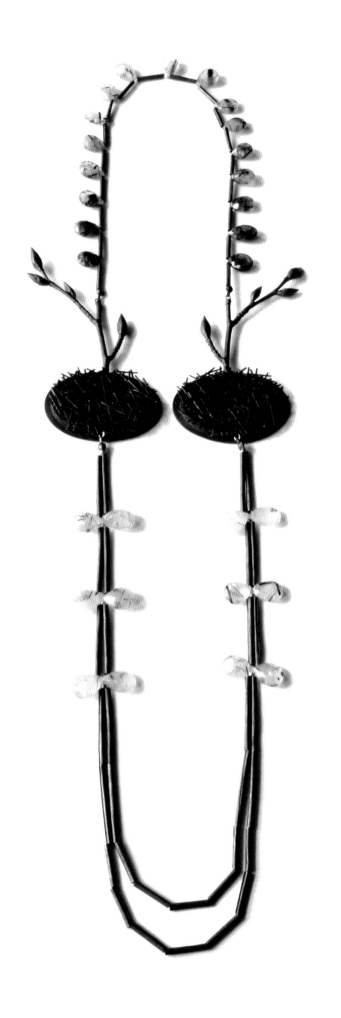

Helena
Lehtinen

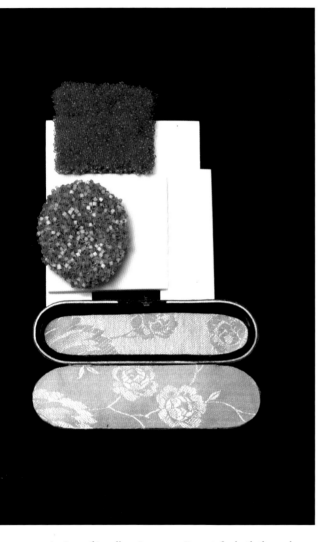

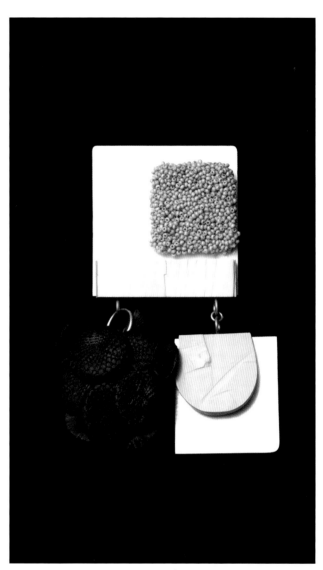

ENG / A piece of jewellery is a commitment, for both the maker
and the wearer. It follows you, wherever you go. Our jewellery
has an audience, not only in galleries and exhibitions, but also
in the supermarket and on the street. It's always with you,
attached to your body. It's small in size, but not in meaning.
The mutability of gardens fascinates me. In the north, in winter,
the landscape is almost black and white, or rather, white mixed
with grey shadows. Everything is covered by layer after layer of
snow. I wonder about what is hiding under those white hills.
What is a blooming garden like in the middle of winter? What
were the daffodils like: yellow or a delicate shade of blue? How
do the colours stay in our memory, and what feelings remain
there? Perhaps we can almost smell the perfume of these
gardens that elude us?
I'm also intrigued by what it means to belong to a family.
My starting point is an ordinary object, like a mobile phone,
a computer, a credit card. They share features like rounded
corners, and they're practical and easy to handle. But if you start
playing with the object it changes, displaying its own particular
characteristics. Similarly, members of a family have much in
common, but are also very different.

ESP / Una joya es un compromiso. Para quien la hace y también
para quien la lleva. Te sigue, allá donde vayas. Nuestras joyas
tienen espectadores, no solo en galerías y exposiciones, también
en el supermercado, en la calle. Siempre está contigo, conectada
a tu cuerpo. Pequeña en tamaño, pero no en significado.
Me fascina la mutabilidad de los jardines. En el norte, en
invierno, el paisaje es casi blanco y negro o, mejor dicho, blanco
mezclado con sombras grises. Todo está cubierto por capas
y capas de nieve. Me pregunto qué se oculta bajo esas blancas
colinas. ¿Cómo es un jardín en flor en pleno invierno?
¿Cómo era el narciso, amarillo o de un delicado tono azul?
¿Cómo se mantienen los colores en nuestra memoria, qué
sentimientos permanecen? ¿Acaso no podemos casi oler
el perfume de los jardines que nos eluden?
También me intriga el significado de pertenecer a una familia.
Mi punto de partida es un objeto corriente: como un teléfono
móvil, un ordenador, una tarjeta de crédito. Comparten
características como sus esquinas redondeadas, son
prácticos, fáciles de manejar. Pero si empiezas a jugar
con el objeto, cambia, adopta detalles propios: del mismo
modo, los miembros de una familia tienen mucho en
común, pero también son muy distintos.

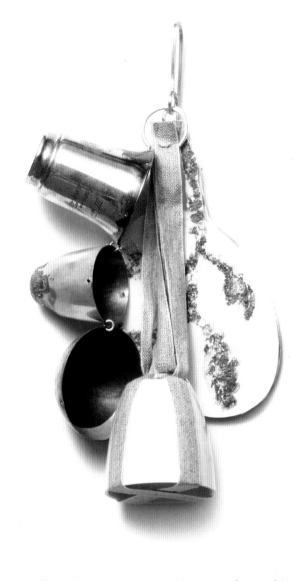

FRA / Un bijou est un engagement. Aussi bien pour celui qui le fabrique que pour celui qui le porte. Il te suit partout où tu vas. Il a des spectateurs, non seulement dans les galeries et les expositions, mais aussi au supermarché et dans la rue. Il te suit partout, relié à ton corps. Il a une petite taille, mais une grande importance.

La métamorphose des jardins me fascine. Au nord, en hiver, le paysage est presque noir et blanc, ou plutôt blanc avec des ombres grises. Tout est recouvert de multiples couches de neige. Je me demande ce qui se cache sous ces collines blanches. À quoi ressemble un jardin en fleurs en plein hiver ? Le narcisse était-il jaune ou d'un ton bleu tendre ? Comment préservons-nous les couleurs dans notre mémoire, quels sentiments demeurent ? Ne peut-on pas sentir le parfum de ces jardins qui nous échappent ?

Je m'intéresse aussi à la notion d'appartenance à une famille. Mon point de départ est un objet courant, comme un téléphone portable, un ordinateur, une carte de crédit. Tous les trois possèdent des angles arrondis, sont pratiques et faciles à utiliser. Mais si tu commences à jouer avec l'objet, il change, il affiche des détails qui lui sont propres. C'est comme les membres d'une famille : ils ont beaucoup de choses en commun mais ils sont aussi tous très différents.

POR / Uma joia é um compromisso. Para quem a faz e também para quem a usa. Ela te segue mais além. Nossas joias têm espectadores, não só em galerias e exposições, mas também no supermercado, nas ruas. Sempre está contigo, conectada ao seu corpo. Pequena em tamanho, mas não em significado. Me fascino pela mutabilidade dos jardins. No norte, durante o inverno, a paisagem é quase branca e preta, ou melhor, branca misturada com sombras cinza. Tudo está coberto por camadas e camadas de neve. Me pergunto o que se oculta embaixo dessas colinas brancas. Como é um jardim florido em pleno inverno? Como seria o narciso, amarelo ou de um delicado tom azul? Como se mantém as cores na nossa memória, que sentimentos permanecem? Por acaso não podemos quase cheirar o perfume dos jardins que nos escapam?

Também me intriga o significado de pertencer a uma família. Meu ponto de partida é um objeto corrente: como um celular, um computador, um cartão de crédito. Dividem características em comum, como seus cantos arredondados, são práticos, fáceis de usar. Mas se você começar a jogar com o objeto, ele muda, adota detalhes próprios: do mesmo modo, os membros de uma família têm muito em comum, mas também são muito diferentes.

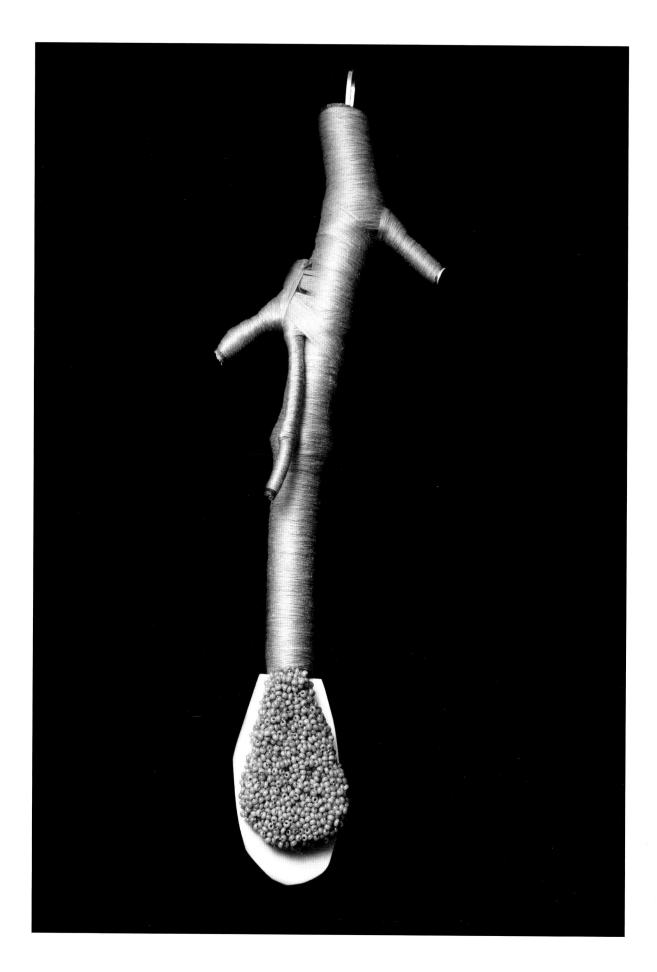

The mutability of gardens fascinates me.

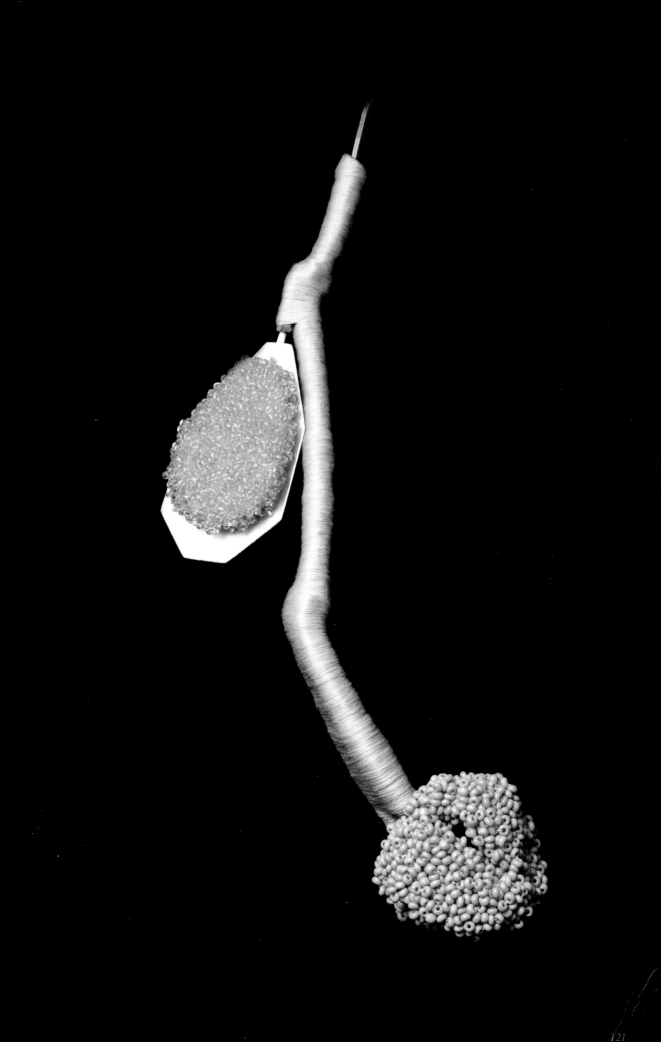

Jens-Rüdiger Lorenzen

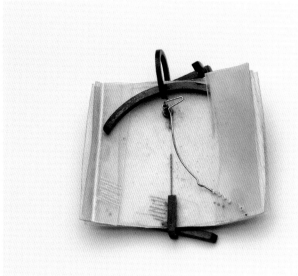

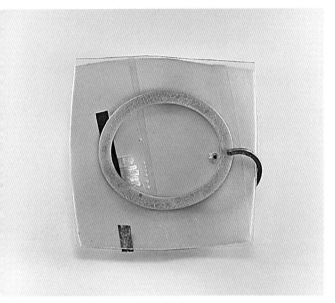

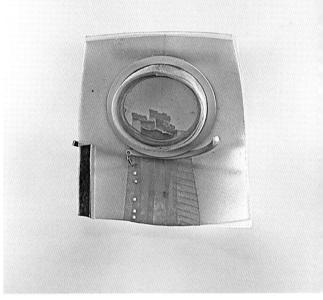

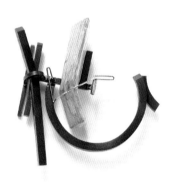

ENG / For me the charm of making jewellery lies in the fact that I can create objects that make a particular statement when they're worn on the human body. You can also think of them as miniature sculptures. I am inspired especially by cultures or parts of a cultural concept, such as Shakerism or Zen Buddhism. But some individual artists also inspire me, for example the architect Tadao Ando or the writer Arno Schmidt. I often combine different materials by screwing them together, otherwise I wouldn't be able to join the individual pieces in the way I had in mind.
In recent years I have worked in depth with different varieties of parchment. I'm amazed by the lightness of this material, its transparency, the possibilities for painting on it and its extraordinary importance throughout history.
I love brooches because they are a direct visual statement aimed at the viewer, without taking the human body into account too much; and rings, because they can always be seen from different perspectives and offer different sculptural qualities because of hand movements.

ESP / Para mí el encanto de hacer joyas reside en el hecho de que puedo crear objetos que realizan una afirmación específica al llevarse sobre el cuerpo humano. También pueden verse como esculturas en miniatura. Me inspiro sobre todo en culturas o partes de un concepto cultural, como por ejemplo el shakerismo o el budismo zen. Pero algunos artistas, de manera individual, también me inspiran: por ejemplo el arquitecto Tadao Ando o el escritor Arno Schmidt. Suelo combinar los más diversos materiales a base de atornillarlos juntos, de otra forma no sería capaz de unir las piezas individuales de la manera que imagino.
En los últimos años he trabajado en profundidad con diferentes variedades de pergamino. Me fascina la ligereza de este material y también su transparencia, las posibilidades que ofrece de pintar en él, y su extraordinaria importancia a lo largo de la historia.
Me gustan los broches porque son una declaración visual directa, destinada al espectador, sin tomar demasiado en cuenta el cuerpo humano; y los anillos, porque siempre pueden verse desde perspectivas distintas y ofrecen diferentes cualidades escultóricas, gracias a los movimientos de la mano.

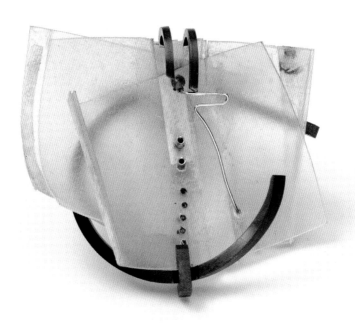

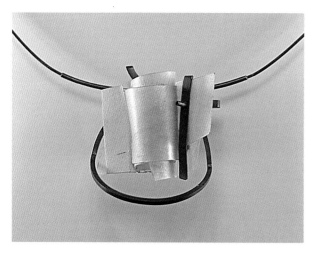

POR / Para mim o encanto de fazer joias reside na possibilidade de se criar objetos que realizam uma afirmação específica quando usadas sobre o corpo humano. Também se podem ver como esculturas em miniatura. Me inspiro sobretudo nas culturas ou partes de um conceito cultural, como por exemplo o shakerismo ou o budismo zen. Mas alguns artistas, de maneira individual, também me inspiram: por exemplo, o arquiteto Tadao Ando ou o escritor Arno Schimdt.
Eu costumo combinar os mais diversos materiais a base de parafusá-los juntos, de outra forma não seria capaz de unir as partes individuais da forma que eu imagino.
Nos últimos anos trabalhei a fundo com diferentes variedades de pergaminho. Me fascina a leveza deste material e também a sua transparência, as possibilidades de pintá-lo e a sua extraordinária importância ao longo da história.
Eu gosto dos broches porque é uma declaração visual direta, destinada ao espectador, sem tomar muito em conta o corpo humano; e os anéis, porque sempre se podem ver em distintas perspectivas e oferecem distintas qualidades esculturais, graças aos movimentos da mão.

FRA / Ce qui m'attire dans la bijouterie, c'est le fait de créer des objets capables de transmettre un message lorsqu'ils sont portés. Je les vois aussi comme des sculptures en miniature. Je tire mon inspiration notamment de diverses cultures ou de certains aspects culturels, par exemple, la secte des Shaking Quakers ou le bouddhisme zen. Mais certains artistes aussi m'inspirent, comme l'architecte Tadao Ando ou l'écrivain Arno Schmidt.
En général, j'associe les matériaux les plus divers. Je les assemble à l'aide de vis, sinon je ne pourrais pas combiner les différentes pièces exactement comme je veux.
Ces dernières années, j'ai beaucoup travaillé avec de nombreuses variétés de parchemin. J'adore la légèreté de cette matière et sa transparence, la possibilité de peindre sur ce support et son extraordinaire importance au cours de l'histoire.
J'aime les broches parce qu'elles sont une affirmation visuelle directe qui s'adresse au spectateur, et qu'elles sont assez loin du corps. Les bagues aussi me fascinent parce qu'on peut les regarder sous divers angles : elles sont comme des sculptures changeantes qui naissent du mouvement de la main.

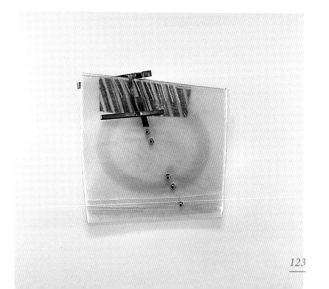

Jorge Manilla

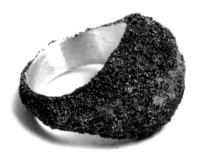

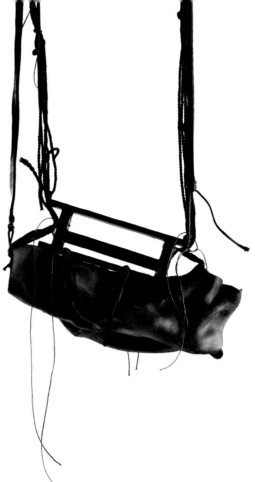

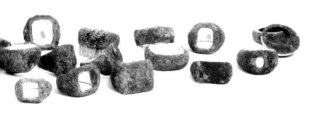

ENG/ I am interested in the human being and I get inspiration from the body and illness, from rituals and their interaction with the body, and from forms of protection like charms or symbols. Or from the Catholic religion, in its Latin American interpretation. I am interested in exploring the concept of the physically and psychologically fragmented body, and its use in history. I look to reuse and translate this concept in my current working methodology. The body is full of emotions and thoughts, and it is on this I have focused in recent years. Contemporary art is a great influence, especially artists like Jannis Kounelis, Diana Al Hadid, or Berlinde de Bruyckere or Gabriel Orozco. I respect and admire the work of jewellers like Hanna Hedman, Iris Eichenberg or Alexander Blank. I am a classically trained jeweller, and one day I discovered that by playing with established techniques I could achieve interesting things. On the other hand, I have training as a sculptor and that allows me the freedom to play and experiment with materials to the fullest extent, transforming them and letting them speak in a new way. I like to take risks with techniques, and feel the touch, temperature and plasticity of new materials. And above all, I'm interested in transforming them as much as possible.

ESP/ Me interesa el ser humano y me inspiro en el cuerpo, la enfermedad, en los rituales y su interacción con el cuerpo, en formas de protección como fetiches o símbolos. O en la religión católica, en su interpretación latinoamericana. Me interesa explorar el concepto del cuerpo fragmentado, física y psicológicamente, y el uso del cuerpo en la historia. Busco reutilizar y traducir este concepto a mi metodología de trabajo actual. El cuerpo es una caja de emociones y pensamientos y en esto me he centrado en los últimos años. El arte contemporáneo es una gran influencia: sobre todo artistas como Jannis Kounelis, Diana Al Haddid, Berlinde de Bruykere o Gabriel Orozco. Respeto y admiro el trabajo de joyeros como Hanna Hedman, Iris Eichenberg o Alexander Blank. Soy un joyero formado clásicamente, y un día descubrí que jugando con técnicas establecidas podía lograr algo interesante. Por otro lado, tengo formación como escultor y eso me permite la libertad de jugar y experimentar al máximo con materiales, transformándolos y dejándolos hablar de otra manera. Me gusta arriesgarme en las técnicas, sentir el tacto, la temperatura, la plasticidad de nuevos materiales. Y, sobre todo, me interesa transformarlos al máximo.

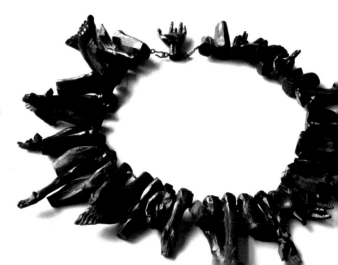

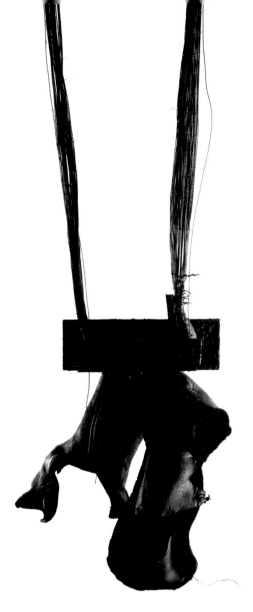

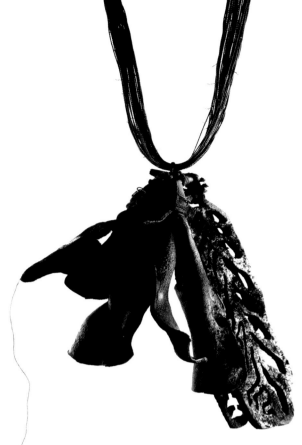

FRA / L'être humain me fascine et je puise mon inspiration dans le corps, la maladie, et les rituels qui interagissent avec ce corps pour le protéger en faisant appel à des fétiches ou des symboles. Et aussi dans la religion catholique et son interprétation latino-américaine. J'aime explorer le concept du corps fragmenté, aussi bien au niveau physique que psychologique, et l'utilisation du corps dans l'histoire de l'humanité. Je cherche à réutiliser et à traduire cette notion à travers la méthodologie que j'emploie aujourd'hui. Le corps est un réservoir d'émotions et de pensées, et c'est sur cet aspect que je travaille depuis plusieurs années. L'art contemporain m'influence énormément, surtout des artistes comme Jannis Kounelis, Diana Al Haddid, Berlinde de Bruykere et Gabriel Orozco. Je respecte et j'admire le travail de bijoutiers tels que Hanna Hedman, Iris Eichenberg et Alexander Blank. J'ai suivi une formation classique de bijoutier, et j'ai découvert un jour que l'on pouvait obtenir des résultats intéressants en jouant avec les techniques traditionnelles. J'ai également étudié la sculpture, ce qui me permet d'expérimenter avec les matériaux et de les transformer pour qu'ils s'expriment d'une autre manière. J'adore prendre des risques sur le plan technique et sentir le contact, la température et la plasticité de nouveaux matériaux. Ce qui m'intéresse par dessus tout, c'est de les transformer au maximum.

POR / O ser humano me interessa e me inspiro no corpo, na enfermidade, nos rituais e a sua interação com o corpo, nas formas de proteção como fetiches ou símbolos. Ou na religião católica, na sua interpretação latina americana. Explorar o conceito do corpo fragmentado me interessa, física e psicologicamente, e o uso do corpo na história. Busco reutilizar e traduzir este conceito na metodologia de meu trabalho atual. O corpo é uma caixa de emoções e pensamentos e nisto me enfoquei nos últimos anos. A arte contemporânea é uma grande influência: sobretudo artistas como Jannis Kounelis, Diana Al Haddid, Berlinde de Bruykere ou Gabriel Orozco. Respeito e admiro o trabalho de joalheiros como Hanna Hedman, Iris Eichenberg ou Alexander Blank. Sou um joalheiro formado classicamente, e um dia descobri que jogando com técnicas estabelecidas podia alcançar algo interessante. Por outro lado, tenho formação como escultor e isso me permite a liberdade de jogar e experimentar ao máximo com materiais, transformando-os e deixando-os falar de outra maneira. Eu gosto de me arriscar nas técnicas, sentir o tato, a temperatura, a plasticidade de novos materiais. E, sobretudo, me interessa transformá-los ao máximo.

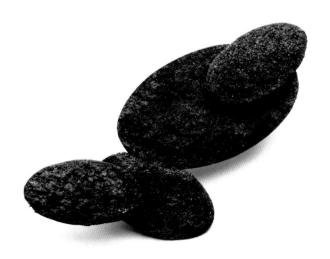

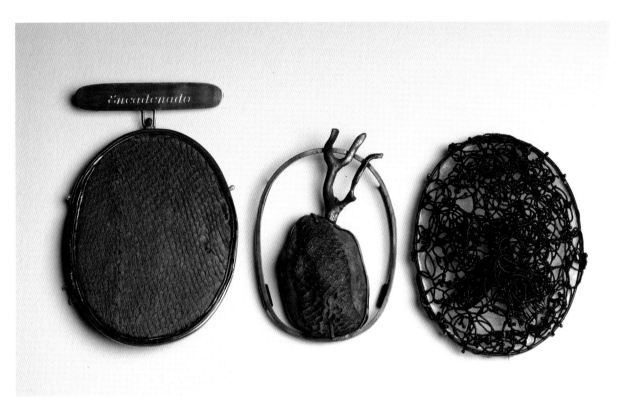

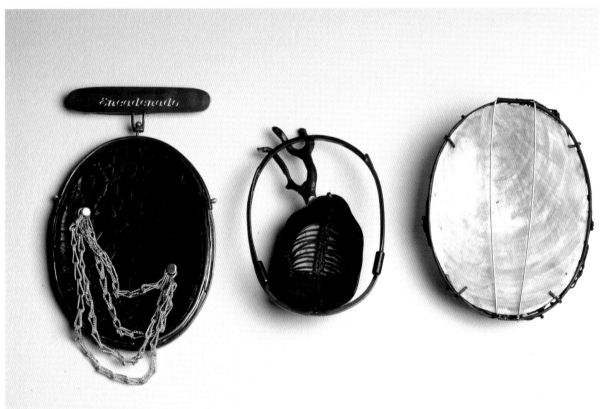

*I like to take risks with techniques,
and feel the touch, temperature
and plasticity of new materials.*

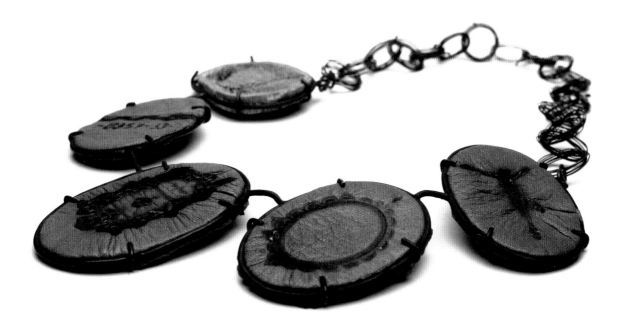

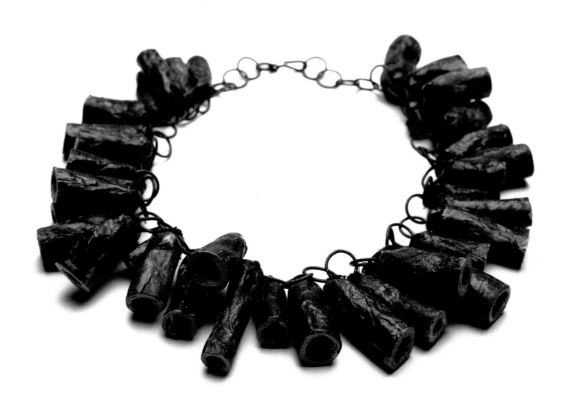

Stefano Marchetti

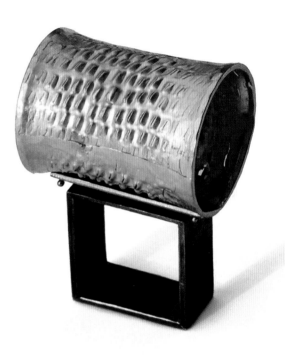

ENG / In the late eighties I was fascinated by Venetian glass and mosaics. I tried to convert the technical processes of these disciplines to make them appropriate for goldsmithing. As time has gone by, my output has become more heterogeneous; ideas have come about following persistent thoughts, such as my desire to hammer gold into extremely fine threads to create very precise forms. The meaning of this work coincides with the need to solve a problem. Using intuition, strategies and errors to find a solution are, in fact, what I wanted to show. At other times I have sought out poetic challenges using only established processes: hammer work, welding, niello. I have searched for shapes that evoke simultaneous feeling of asymmetry and improbability, like the Rorschach test. Often poetic references come from elements of nature, like clouds, tree foliage, maps... I explore the interpretation of jewellery, in an attempt to establish to what extent pieces can be understood without their external cultural context, or how a contemporary piece can awaken pleasure independently of the world of contemporary jewellery's protective wrapping.

ESP / A finales de los años ochenta me fascinaban los vidrios y mosaicos de Venecia. Intentaba traducir los procesos técnicos propios de estas disciplinas en técnicas apropiadas para la orfebrería. Con el paso del tiempo, mi producción se ha hecho más heterogénea, las ideas surgen a partir de pensamientos insistentes, como el deseo de trabajar a martillo finísimos hilos de oro para crear formas muy precisas. El significado de este trabajo coincide con la necesidad de resolver un problema. La intuición, las estrategias, los errores para alcanzar una solución son, en realidad, lo que quería mostrar. En otros momentos he buscado el desafío poético usando solamente procedimientos ya conocidos: trabajo con martillo, soldaduras, el nielado. He buscado formas, evocando atmósferas a un tiempo asimétricas e improbables, como los tests de Rochard. A menudo las referencias poéticas provienen de elementos de la naturaleza, como nubes, el follaje de árboles, mapas geográficos…
Investigo acerca de la interpretación de la joya, en un intento de establecer en qué medida un objeto de orfebrería puede entenderse sin su soporte cultural exterior, o de qué manera una pieza contemporánea puede despertar placer independientemente del envoltorio protector del mundo de la joyería contemporánea.

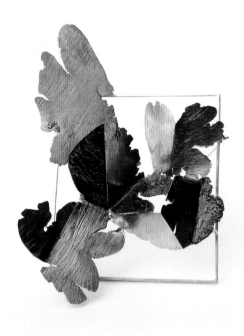

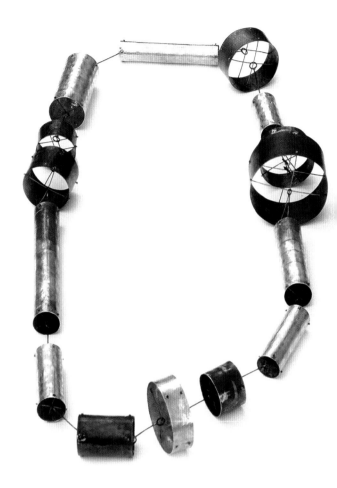

FRA / À la fin des années 80, j'étais attiré par le verre et les mosaïques de Venise. J'essayai d'adapter les méthodes propres à ces disciplines aux techniques de l'orfèvrerie. Au fil du temps, ma production est devenue plus hétérogène. Mes idées sont inspirées par des pensées impérieuses, comme le désir de travailler au marteau des fils d'or extrêmement fins pour créer des formes minutieuses. Le sens profond de ce travail se combine au besoin de résoudre un problème. L'intuition, les stratégies, les erreurs commises avant de trouver la solution sont en réalité ce que je souhaitais montrer. À d'autres moments, j'ai voulu relever un défi poétique en utilisant exclusivement des procédés connus : travailler au marteau, souder ou nieller. J'ai recherché des formes évoquant des atmosphères, parfois aussi asymétriques et improbables que les tests de Rorschach. Souvent les références poétiques dérivent des éléments de la nature, comme les nuages, la cime des arbres, les cartes géographiques...
J'étudie l'interprétation des bijoux pour voir si un objet d'orfèvrerie peut être compris en dehors de son contexte culturel extérieur ou si une création moderne est capable de susciter du plaisir en dehors de la couche protectrice du monde de la bijouterie contemporaine.

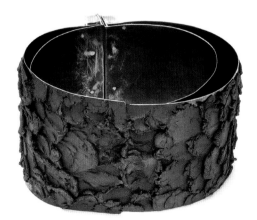

POR / Ao final dos anos oitenta me fascinavam os vidros e mosaicos de Veneza. Tentava traduzir os processos técnicos próprios destas disciplinas em técnicas apropriadas para a ourivesaria. Com o passar do tempo, minha produção foi-se fazendo mais heterogênea, as ideias surgindo a partir de pensamentos insistentes, como o desejo de trabalhar finíssimos fios de ouro com martelo para criar formas muito precisas. O significado deste trabalho coincide com a necessidade de resolver um problema. A intuição, as estratégias, os erros para alcançar uma solução são, na realidade, o que eu queria mostrar. Em outros momentos, busquei o desafio poético usando somente procedimentos já conhecidos: trabalho com martelo, soldagem ou niello. Busquei formas, invocando atmosferas ao mesmo tempo assimétricas e improváveis, como os testes de Rochard. Com frequência as referências poéticas provêm de elementos da natureza, como nuvens, folhagem das árvores, mapas geográficos...
Investigo sobre a interpretação da joia, tentando estabelecer em qual medida um objeto de ourivesaria pode ser entendido sem seu suporte cultural exterior, ou de que maneira uma peça contemporânea pode despertar prazer independentemente do involucro protetor do mundo da joia contemporânea.

José Marín

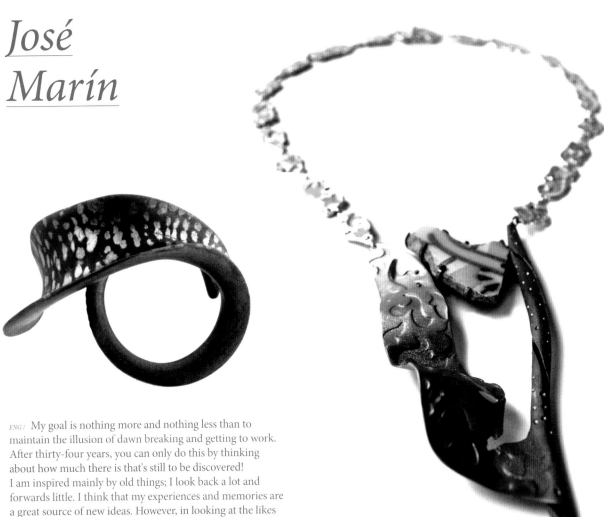

ENG/ My goal is nothing more and nothing less than to maintain the illusion of dawn breaking and getting to work. After thirty-four years, you can only do this by thinking about how much there is that's still to be discovered!

I am inspired mainly by old things; I look back a lot and forwards little. I think that my experiences and memories are a great source of new ideas. However, in looking at the likes of Michael Zobel, with his mastery over mixing metals and textures, I have discovered that there is always much to learn. I am fascinated by the art of the Renaissance and Modernism, but when I work purely around form, very organic, plant-inspired forms emerge from my hands.

The techniques that I enjoy the most are forging, embossing, engraving, and especially riveting; it's like going back to basics. It allows me the immediacy of starting and finishing a piece in a single session and I feel like I am transforming the raw material into jewellery.

If I had to choose a material, it would be titanium. Its lightness makes it possible to work with on a large scale and offers a vast colour range through the controlled oxidation of the surface. Although brooches give you creative freedom, I like the challenge of producing other parts that require taking into account and respecting ergonomic parameters. The creative process is completely in reverse; first I think about how to adapt it to the body and then I make the piece.

ESP/ Mi objetivo es nada más ni nada menos que mantener la ilusión de que amanezca para ponerme a trabajar. ¡Después de 34 años, eso solo se consigue pensando que queda mucho por descubrir!

Me inspiro principalmente en lo antiguo, miro mucho hacia atrás y poco hacia delante. Creo que mis propias experiencias y mis recuerdos son una gran fuente de nuevas ideas. Sin embargo, observando a artistas como Michael Zobel, con su maestría en la mezcla de metales y texturas, descubrí que siempre queda mucho por aprender. Me fascinan el arte del Renacimiento y el Modernismo, pero cuando trabajo desde lo más puramente formal, de mis manos salen formas muy orgánicas, de inspiración vegetal.

Las técnicas que más me divierten son la forja, el repujado, el grabado y, especialmente, el remachado: es como volver a los orígenes. Me permite la inmediatez absoluta de empezar y terminar una pieza en una sola sesión y puedo sentir como transformo la materia prima en una joya.

Si tuviera que elegir un material, sería el titanio. Su ligereza hace posible abordar grandes formatos y ofrece un inmenso abanico cromático a través de la oxidación controlada de la superficie.

Aunque el broche permite crear sin censura, me gusta el reto de producir otras piezas que exigen tener en cuenta y respetar unos parámetros de ergonomía. El proceso creativo es completamente a la inversa, primero reflexiono sobre cómo adaptarlo al cuerpo y luego hago la pieza.

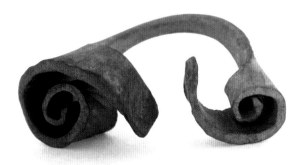

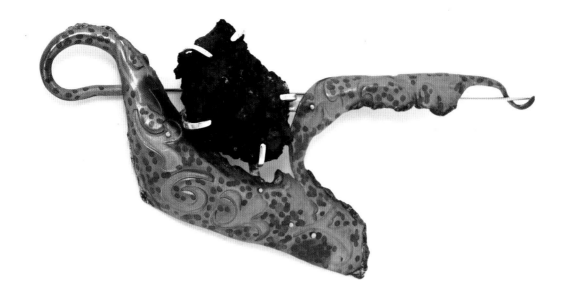

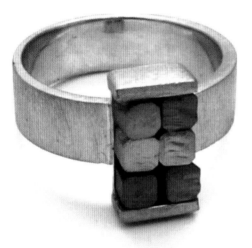

FRA / Mon objectif est ni plus ni moins de me lever tous les matins pour me mettre directement au travail. Si je fais cela depuis 34 ans, c'est parce que je sais qu'il me reste encore tant de choses à découvrir.

Le passé est ma plus grande source d'inspiration. Je regarde plus souvent en arrière que vers l'avenir. Je pense que mes propres expériences et souvenirs sont une mine d'idées nouvelles. Toutefois, face à un artiste comme Michael Zobel qui maîtrise parfaitement le mélange des métaux et des textures, je me rends compte qu'il me reste encore beaucoup à apprendre. Je suis attiré par l'art de la Renaissance et le Modernisme, mais lorsque je travaille au niveau de la création pure, mes mains élaborent des formes très organiques d'inspiration végétale. Les techniques que j'apprécie le plus sont la forge, le repoussage, la gravure et surtout le rivetage. C'est comme un retour aux origines. Je bascule dans l'immédiateté qui me permet de commencer et de finir un bijou en une seule session. Je peux ainsi vivre la transformation de la matière première en bijou. Si je devais choisir une matière, je nommerais le titane. Sa légèreté se prête à l'élaboration de pièces de grand format, et il offre une large gamme tonale grâce à l'oxydation contrôlée de sa surface.

La création d'une broche ne pose aucune contrainte, mais je préfère relever des défis et créer des bijoux qui doivent respecter certains critères ergonomiques. Le processus créatif est complètement inversé, dans le sens où je commence par réfléchir à la façon d'adapter le bijou au corps et ensuite seulement je passe à sa fabrication.

POR / Meu objetivo não é nada mais nada menos que manter a ilusão de que amanheça para começar a trabalhar. Depois de 34 anos, isso só se consegue pensando que falta muito por descobrir!

Me inspiro principalmente no antigo, observo muito o passado e pouco o futuro. Creio que as minhas próprias experiências e minhas lembranças são uma grande fonte de novas ideias. No entanto, observando artistas como Michael Zobel, com a sua maestria na mistura de metais e texturas, descobri que sempre falta muito para aprender. Me fascina a arte do Renascimento e o Modernismo, mas quando trabalho desde formal mais puro, das minhas mãos saem formas bastante orgânicas, de inspiração vegetal. As técnicas que mais me divertem são a forja, o relevo, o gravado e, especialmente, a rebitagem: é como voltar às origens. Permite o imediato absoluto de começar e terminar uma peça numa só sessão e posso sentir a transformação da matéria-prima numa joia.

Se tivesse que escolher um material, seria o titânio. Sua leveza faz possível abordar grandes formatos e oferece um imenso leque cromático através da oxidação controlada da sua superfície.

Ainda que o broche permita criar sem censura, eu gosto do desafio de produzir outras peças que exigem o ter em conta e o respeito aos parâmetros de ergonomia. O processo criativo é completamente invertido, primeiro reflexiono sobre como adaptá-lo ao corpo e depois faço a peça.

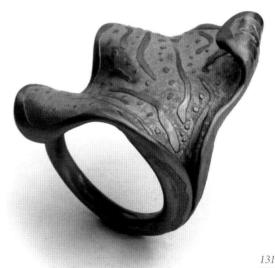

Xavier Monclús

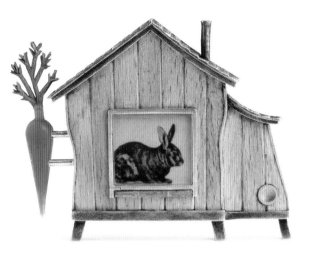

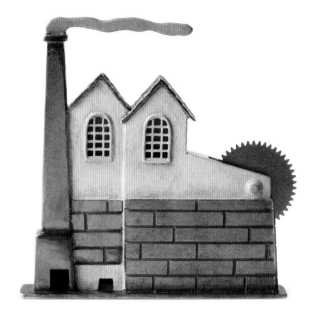

ENG/ I seek to express myself as an artist and encourage reflection from the viewer. I am inspired by nature, especially by the textures of rocks and trees, and by animals. At the moment I'm interested in vernacular architecture, especially Menorca's. Any artist that evokes nature and architecture through their own originality is a source of inspiration. I really like the *embatado* technique because it allows me to create lots of hollow forms in metal. I'm attracted to the great expressive power of colour. The assembly of small objects in my pieces evokes that surreal, primal spirit in my work, a decontextualisation of images and objects. I like silver for its ductile quality and its fine appearance, traditionally linked to jewellery. I also like the colour of bronze. And woods, for their textures and because they are easy to handle. Although until now I have almost always made brooches because of the freedom they allow you, now I want to explore other types of jewellery such as rings, pendants or earrings and adapt my technique and expressiveness to their demands.

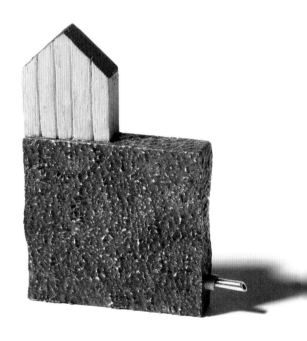

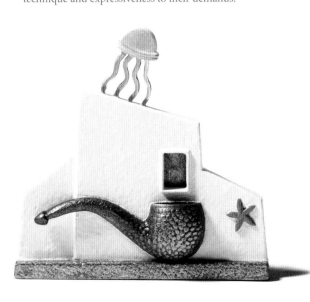

ESP/ Busco expresarme como artista e incitar la reflexión en el espectador. Me inspiro en la naturaleza, sobre todo en las texturas de rocas y árboles, y en los animales. Ahora me interesa la arquitectura popular, especialmente la menorquina. Cualquier artista que evoque la naturaleza y la arquitectura bajo su particular originalidad es una fuente de inspiración. Me gusta mucho el embatado porque me permite crear muchas formas huecas en metal. Me atrae el gran poder expresivo del color. El ensamblaje de pequeños objetos en mis piezas evoca ese espíritu primigenio surrealista de mi obra, la descontextualización de imágenes y objetos. Me gusta la plata por su calidad dúctil y por su apariencia noble ligada tradicionalmente a la joyería. También me gusta el color del bronce. Y las maderas, por sus texturas y su fácil manipulación. Aunque hasta ahora he realizado casi siempre broches por la libertad que permiten, ahora quiero explorar otras tipologías de joyas como anillos, colgantes o pendientes, adaptando mi técnica y expresividad a sus exigencias.

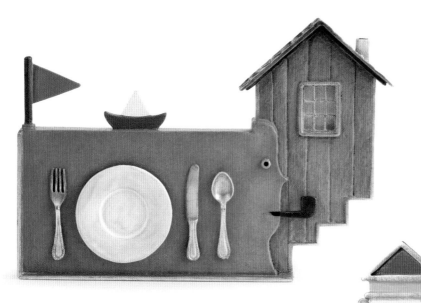

FRA / Je cherche à m'exprimer en tant qu'artiste et à inciter le spectateur à la réflexion. La nature est ma source d'inspiration, notamment les textures de pierres et d'arbres, et les animaux. En ce moment, je m'intéresse à l'architecture populaire, en particulier, celle de Minorque. Tout artiste qui présente sa propre vision de la nature et de l'architecture m'intéresse. J'aime la technique de l'emboutissage parce qu'elle permet de créer toutes sortes de formes creuses dans du métal. Je suis attiré par la grande force d'expression de la couleur. L'assemblage de petits éléments qui caractérise mes bijoux évoque l'esprit surréaliste à la base de toutes mes créations, c'est-à-dire la décontextualisation des images et des objets. L'argent me plaît en raison de sa ductilité et de son côté noble associé depuis toujours à la bijouterie. J'ai aussi un faible pour la couleur du bronze. Et pour le bois parce qu'il offre de belles textures et qu'il est facile à travailler. Jusqu'à présent, j'ai surtout fabriqué des broches, car elles représentent peu de contraintes, mais aujourd'hui je souhaite explorer d'autres typologies de bijoux, comme les bagues, les pendentifs et les boucles d'oreilles, et adapter ma technique et mon expressivité à leurs exigences.

POR / Busco expressar-me como artista e incitar a reflexão no espectador. A natureza me inspira, especialmente as texturas das rochas e árvores e os animais. Agora me interessa a arquitetura popular, especialmente a minorquina. Qualquer artista que evoque a natureza e a arquitetura sob sua particular originalidade é uma fonte de inspiração. Eu gosto muito da técnica do *embatado* porque me permite criar muitas formas ocas no metal. Me atrai o grande poder expressivo da cor. A montagem de pequenos objetos nas minhas peças evoca este espírito primitivo surrealista da minha obra, a descontextualização de imagens e objetos. Eu gosto da prata pela sua qualidade dúctil e pela sua aparência nobre ligada tradicionalmente à joalheria. Também gosto da cor do bronze. E a madeira, pela sua textura e a sua fácil manipulação. Ainda que até agora realizasse quase sempre broches pela liberdade que permitem, agora quero explorar outros tipos de joias como anéis, pingentes ou brincos, adaptando a minha técnica e expressividade a suas exigências.

Marc
Monzó

ENG/ When I was very young I visited the Escola Massana in Barcelona. I wanted to study arts and crafts, but I did not know what to choose, so I visited all of the classes. I will never forget the feeling of entering a jewellery studio and seeing all those people concentrating on small objects, with their precision tools. My uncertainty evaporated. I later saw pieces by Karl Fritsch and Ruudt Peters, which completely changed me; I learned that the jewellery was a vehicle for freely expressing myself. My jewellery speaks of jewellery, its materials. My work is not narrative but purely autobiographical. I try not to think of the wearer as a specific person; my pieces can be worn by men, women, adults and children. I feel comfortable with exploring small objects and with the precision they require. The idea of living on a planet floating in the middle of the universe scares me, and I think that my obsession with small things is a reaction to this fear.
I don't like the expression *contemporary jewellery*, and in fact I don't know what it means. I am a jeweller; I do not think there is much difference between me and a jeweller from the nineteenth century, apart from the context. There are things about plastic that I like—its colours, its strength and lightness, the heat produced when it's in contact with the skin. I like its banality and how commonplace it is. I learnt the flute and trumpet, and music is a major influence in my work. I like its intangible nature. It helps me to concentrate.

ESP/ Cuando era muy joven visité la Escuela Massana de Barcelona. Quería estudiar artes y oficios pero no sabía qué elegir, así que visité todas las clases. Nunca olvidaré la sensación de entrar en el taller de joyería y ver a toda esa gente concentrada en objetos pequeños, con sus herramientas de precisión. Mis dudas se disiparon. Más adelante vi las piezas de Karl Fritsch y de Ruudt Peters y esto me transformó, aprendí que la joyería es un soporte para expresarme libremente. Mi joyería habla sobre joyería, sobre la materia. Mi trabajo no es narrativo sino puramente autobiográfico. Intento no pensar en el portador como una persona específica, mis piezas pueden ser llevadas por hombres, mujeres, adultos, niños. Me siento cómodo explorando objetos pequeños y también con la precisión que requieren. La idea de vivir en un planeta que flota en medio del universo me asusta, y creo que mi obsesión con lo pequeño es una reacción a este miedo. No me gusta la expresión *joyería contemporánea*, y en realidad no sé qué significa. Soy joyero, no creo que haya mucha diferencia entre yo y un joyero del S XIX, aparte del contexto. Hay cosas del plástico que me gustan mucho, sus colores, su fuerza y también su ligereza, el calor que produce en contacto con la piel. Me gusta su banalidad, su cotidianeidad. Estudié flauta y trompeta y la música es una influencia importante en mi trabajo. Me gusta su naturaleza inmaterial. Me ayuda a concentrarme.

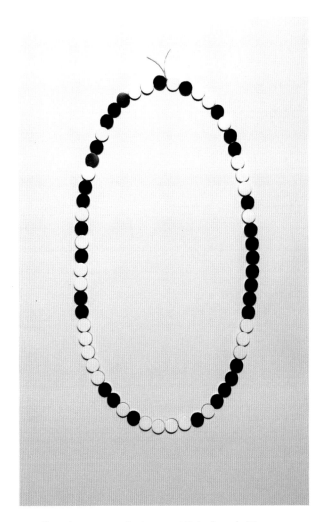

FRA / Lorsque j'étais jeune, j'ai visité la Escuela Massana de Barcelone. Je voulais étudier l'art et l'artisanat, mais comme je ne savais pas quoi choisir, j'ai assisté à toutes les classes proposées. Je n'oublierai jamais la sensation que j'ai eue lorsque je suis entré dans l'atelier de bijouterie et que j'ai vu tous ces gens concentrés en train de travailler sur des objets minuscules avec des outils de précision. Mes doutes en un instant se sont dissipés. Plus tard, j'ai découvert les créations de Karl Fritsch et de Ruudt Peters, et cela m'a transformé. J'ai compris que le bijou était un support qui me permettait de m'exprimer librement. Mes bijoux parlent d'eux-mêmes, de la matière. Mon travail n'est pas narratif, il est purement autobiographique. J'essaie de ne pas penser au porteur comme à une personne précise. Mes créations peuvent être portées par des hommes, des femmes, des adultes, des enfants. Le travail sur de petits objets et la précision qu'il requiert est tout à fait ce qui me convient. L'idée de vivre sur une planète qui flotte en suspension dans l'univers me terrorise, et je crois que mon obsession pour les choses de petite taille est une réaction face à cette angoisse. Je n'aime pas l'expression « bijouterie contemporaine ». En fait, je ne sais pas ce que cela veut dire. Je suis bijoutier, et je ne crois pas qu'il y ait une grande différence entre moi et un artisan du XIX°, hormis le contexte.

J'adore certains aspects du plastique, comme ses couleurs, sa résistance et aussi sa légèreté, la chaleur qu'il produit au contact de la peau. Son côté banal et quotidien me plaît. J'ai étudié la flûte et la trompette, et la musique a une grande influence sur mon travail. J'aime sa nature immatérielle. Elle m'aide à me concentrer.

POR / Quando eu era muito jovem, visitei a Escuela Massana de Barcelona. Queria estudar artes e ofícios, mas não sabia o que escolher, assim que visitei todas as aulas. Nunca me esquecerei da sensação de entrar na oficina de joalheria e ver toda aquela gente concentrada em pequenos objetos, com suas ferramentas de precisão. Minhas dúvidas se dissiparam. Mais adiante vi as peças de Karl Fritsch e de Ruudt Peters e isso me transformou, aprendi que a joalheria é um suporte para me expressar livremente. Minhas joias falam sobre joias, sobre a matéria.

Meu trabalho não é narrativo senão puramente autobiográfico. Tento não pensar no usuário como uma pessoa específica, minhas peças podem ser usadas por homens, mulheres, adultos, crianças. Sinto a vontade explorando objetos pequenos e também com a precisão que requerem. A ideia de viver em um planeta que flutua no meio do universo me assusta e acredito que a minha obsessão com o pequeno é uma reação a este medo.

Não gosto da expressão joalheria contemporânea e na realidade, não sei o que significa. Sou joalheiro, não acredito que haja muita diferença entre mim e um joalheiro do século XIX, à parte do contexto.

Há coisas do plástico de que gosto muito, suas cores, sua força e também sua leveza, o calor que se produz em contato com a pele. Eu gosto da sua banalidade, sua cotidianidade.

Estudei flauta e trompete e a música é uma influência importante no meu trabalho. Eu gosto da sua natureza não material. Me ajuda a me concentrar.

Choonsun
Moon

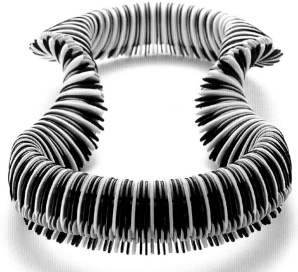

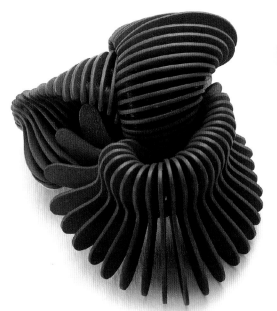

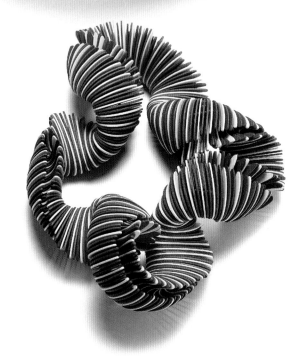

ENG / In my jewellery colours are set free through intuition, instinct. The colours twinkle and escape out of the pieces, clear for all to see. Simple, repeated geometric shapes let us see the colour before it is formed. My pieces twist and turn with body movement and seem to curl even more because of their intense colours. The colour and shape fool our imperfect eyes, leading us to an imaginary world, paralysing our mind and will. It's an optical illusion that exalts colours. My pieces are fun objects. I started with scrap paper and now use solid plastic to create firmer shapes and more solid colours. I also use rubber bands to provide both smoothness and tension.

My creations have no metaphorical or philosophical meaning, but instead try to be playful and light. The visual effect of colours and shapes is essential and is my inspiration. In the visual arts, the artist communicates through fusing different sensory experiences.

I only work by hand. As I observe the progress of a piece, I decide on the next step. My favourite pieces are necklaces because I get the best results with them.

ESP / En mis joyas los colores se liberan a través de la intuición, del instinto. Los colores centellean y escapan de las piezas, saltan a la vista. Simples figuras geométricas que se repiten para que veamos el color antes que la forma. Mis piezas serpentean con el movimiento del cuerpo y parecen ondularse todavía más a causa de sus intensos colores. El color y la forma engañan al ojo imperfecto, nos llevan a un mundo imaginario, paralizan nuestra mente, nuestra voluntad. Una ilusión óptica que exalta los colores.

Mis piezas son objetos divertidos. Empecé con papel de deshecho y ahora utilizo plástico sólido para que la forma sea más firme y los colores más sólidos. También utilizo gomas elásticas para obtener suavidad y también tensión.

Mi trabajo no tiene un significado metafórico o filosófico, sino que quiere ser lúdico y ligero. El efecto visual de colores y figuras es esencial y es mi fuente de inspiración. En las artes visuales, el artista se comunica mediante la fusión de distintas experiencias sensoriales.

Trabajo únicamente a mano. Cuando observo el progreso de una pieza, decido el siguiente paso. Mis piezas favoritas son los collares porque con ellos consigo los mejores resultados.

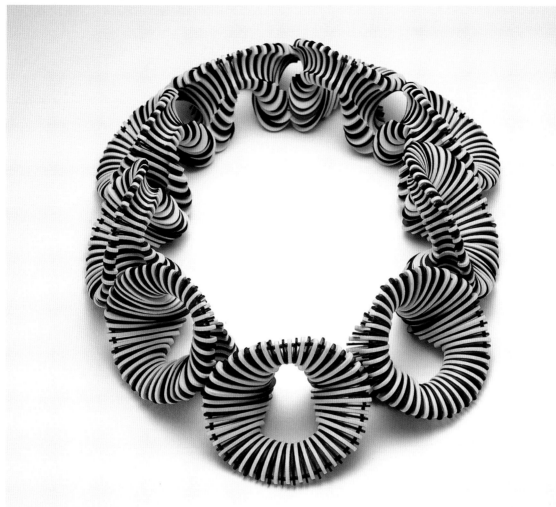

POR / Nas minhas joias as cores se liberam através da intuição, do instinto. As cores cintilam e escapam das peças, saltam à vista. Simples figuras geométricas que se repetem para que vejamos a cor antes da forma. Minhas peças serpenteiam com o movimento do corpo e parecem ondular-se ainda mais por causa das suas cores intensas. A cor e a forma enganam o olho imperfeito, nos levam a um mundo imaginário, paralisam nossa mente e nossa vontade. Uma ilusão ótica que exalta as cores.

Minhas peças são objetos divertidos. Comecei com papel desfeito e agora utilizo plástico solido para a forma seja mais firme e as cores mais sólidas. Também utilizo borrachas elásticas para obter suavidade e também tensão.

Meu trabalho não tem um significado metafórico ou filosófico, senão o de querer ser lúdico e leve. O efeito visual de cores e figuras é essencial e é a minha fonte de inspiração. Nas artes visuais, o artista se comunica mediante a fusão de diferentes experiências sensoriais.

Trabalho unicamente com as mãos. Quando observo o progresso de uma peça, decido o passo seguinte. Minhas peças favoritas são os colares porque com eles consigo os melhores resultados.

FRA / Les couleurs qui animent mes bijoux se libèrent par intuition, par instinct. Elles brillent et s'échappent pour nous sauter aux yeux. De simples figures géométriques répétitives nous font découvrir la couleur avant la forme. Mes bijoux serpentent en suivant le mouvement du corps et semblent onduler encore davantage sous l'effet de ces couleurs intenses. La couleur et la forme sont trompeuses pour un œil non exercé : elles nous transportent dans un monde imaginaire, paralysent notre esprit et annihilent notre volonté. C'est une illusion optique qui exalte les couleurs.

Mes créations sont des objets amusants. J'ai commencé à travailler avec des vieux papiers et aujourd'hui j'utilise du plastique rigide pour que les formes paraissent plus fermes et les couleurs plus profondes. J'emploie également des gommes élastiques qui ajoutent de la douceur et de la tension. Mon travail n'a aucune signification métaphorique ou philosophique. Il a simplement la prétention d'être ludique et léger. L'effet visuel des couleurs et des formes est ce qui m'importe. Et c'est ce qui m'inspire. Dans le monde des arts visuels, l'artiste communique en fusionnant différentes expériences sensorielles.

Je travaille exclusivement à la main. À mesure que j'avance dans l'élaboration d'une pièce, je décide de l'étape suivante. Je préfère les colliers parce que c'est eux qui produisent le plus bel effet.

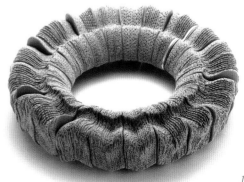

Eija
Mustonen

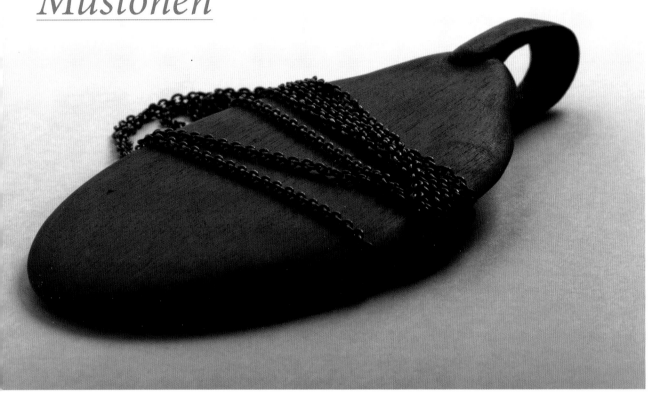

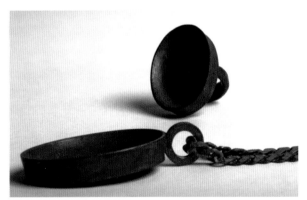

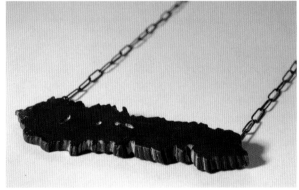

ENG / A few years ago I spent some time in Holland, in a place where everything had been touched by man. I felt homesick. I missed having space around me, and open views before my eyes. I started to think again about jewellery, and also stones: something unique, beautiful, unheard-of. I swap these general qualities for ones of my own, my own values. The scenery around me in Finland, with its lakes and islands, is unique, beautiful and incredible.

In recent years some of my family and friends have died. I continued reflecting on the landscape, and I introduced the idea of mourning jewellery. The connection with my own environment and my space has been the starting point in my work process. Arbitrariness and order, like in nature. The theme is always the landscape, not only as a physical but also an emotional state.

I'm inspired by everyday life, and what happens around us. And I'm influenced by what happens in art, architecture and contemporary dance.

ESP / Hace algunos años pasé una temporada en Holanda, en un lugar en el que todo ha sido intervenido por el hombre. Sentía nostalgia. Echaba de menos el espacio a mi alrededor, las vistas abiertas frente a mis ojos. Empecé a reflexionar de nuevo sobre la joyería y también sobre las piedras: algo único, hermoso, inaudito. Intercambio estas cualidades generales por las mías propias, mis propios valores. Único, hermoso e inaudito es el el paisaje que me rodea en Finlandia, sus lagos y sus islas.

En los últimos años algunos familiares y amigos han muerto. Continué con mi reflexión acerca del paisaje e introduje la idea de la joyería de duelo. La conexión con mi propio entorno y mi espacio ha sido el punto de partida en mi proceso de trabajo. Arbitrariedad y orden, como ocurre en la naturaleza. El tema siempre es el paisaje, no solamente físico sino también como estado emocional.

Me inspira la vida cotidiana, lo que sucede a nuestro alrededor. Y me influye lo que ocurre en el arte, la arquitectura o la danza contemporánea.

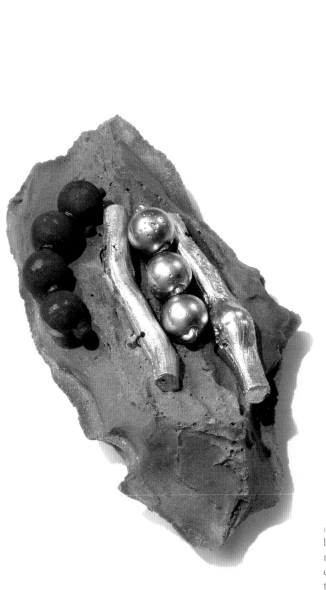

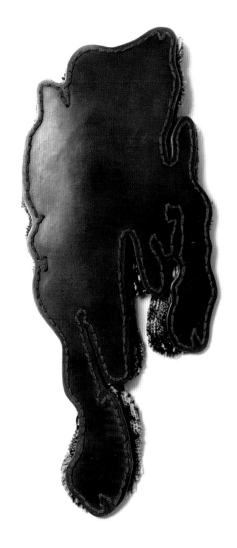

FRA / J'ai vécu pendant un temps en Hollande, dans un endroit où tout avait été modifié par l'homme. J'avais la nostalgie de la nature. Je regrettais les grands espaces et les paysages ouverts à l'infini. C'est là que j'ai recommencé à réfléchir aux bijoux et aux pierres : je cherchai quelque chose d'unique, de beau, d'inédit. Je voulais échanger ces qualités avec les miennes, avec mes propres valeurs. Unique, beau et inédit est le paysage qui m'entoure en Finlande, avec ses lacs et ses îles. Ces dernières années, j'ai perdu des membres de ma famille et des amis. J'ai poursuivi ma réflexion sur le paysage et j'y ai introduit la notion de bijou de deuil. La relation avec mon environnement et mon espace a été le point de départ de mon travail. Arbitraire et ordonné, comme dans la nature. Le sujet est toujours le paysage, pas seulement physique, mais aussi comme état émotionnel.

La vie quotidienne m'inspire, tout ce qui se déroule autour de moi. Et aussi ce qui se passe dans le monde de l'art, de l'architecture et de la danse contemporaine.

POR / Há alguns anos, passei uma temporada na Holanda, num lugar em que tudo havia sido interferido pelo homem. Sentia nostalgia. Sentia falta do espaço ao meu redor, das vistas abertas diante de mim. Comecei a reflexionar de novo sobre a joia e também sobre as pedras: algo único, belo, inédito. Troco estas qualidades generais pelas minhas próprias, meus próprios valores. Único, belo e inaudito é a paisagem que me rodeia na Finlândia, seus lagos e suas ilhas.

Nos últimos anos, alguns familiares e amigos morreram. Continuei com a minha reflexão sobre a paisagem e introduzi a ideia da joia de duelo. A conexão com meu próprio ambiente e meu espaço tem sido o ponto de partida no meu processo de trabalho. Arbitrariedade e ordem como ocorrem na natureza. O tema sempre é a paisagem, não somente física senão também como estado emocional.

Me inspira a vida cotidiana, o que acontece ao nosso redor. E me influencia o que ocorre na arte, na arquitetura ou na dança contemporânea.

Kazumi Nagano

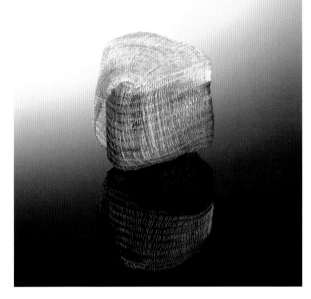

ESP / Durante mi formación artística me especialicé en el arte tradicional japonés, lo que sin duda tiene una clara influencia en mi trabajo actual.

Mi obra gira en torno a los conceptos de calma y belleza. A partir de aquí aspiro a conseguir algo que no sea una simple copia del arte occidental; me gustaría que la gente, al ver mis piezas, conectara con las cualidades más íntimas y profundas del espíritu japonés.

Desde hace cientos de años, el arte del plegado está muy arraigado en la tradición japonesa. Mediante las técnicas propias del origami pliego láminas de oro, papel japonés o cinta de bambú, y las transformo en piezas tridimensionales. A través de mi trabajo busco transmitir paz, tranquilidad. El oro de mis piezas no refleja la fuerza y el dinamismo del sol, sino el brillo de la luna. *Nieve, luna y flores* son motivos que aparecen a menudo en la pintura japonesa clásica y tiendo a usarlos también en mis joyas.

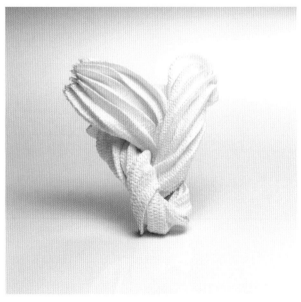

ENG / During my training to be an artist I specialised in traditional Japanese art, which certainly has had a clear influence on my current work.

My work revolves around the concepts of calm and beauty. From these, I hope to produce something other than a simple copy of Western art. I'd like it if people, on seeing my pieces, connected with the most intimate and profound qualities of the Japanese spirit.

For hundreds of years, the art of folding has been deeply rooted in Japanese tradition. Using origami techniques I fold gold leaf, Japanese paper or bamboo ribbon, transforming them into three-dimensional pieces.

Through my work I seek to convey peace and tranquility. The gold in my pieces does not reflect the strength and dynamism of the sun, but the brightness of the moon. *Snow, moon* and *flowers* are motifs that often appear in classical Japanese painting, and I also tend to use them in my jewellery.

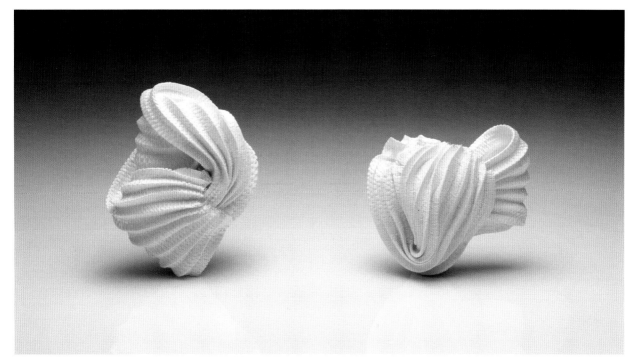

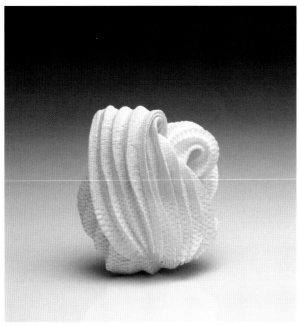

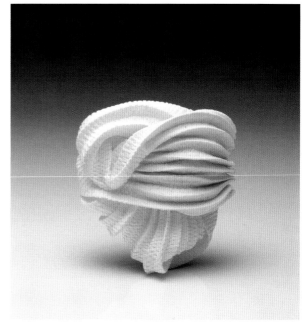

FRA / Au cours de ma formation artistique, je me suis spécialisée dans l'art traditionnel japonais, ce qui a clairement une grande influence sur ce que je fais actuellement.

Mon œuvre tourne autour des notions de calme et de beauté. À partir de là, j'essaie d'obtenir quelque chose qui ne soit pas une copie de l'art occidental. J'aimerais que les gens puissent, à travers mes créations, sentir une connexion avec les aspects les plus intimes et les plus profonds de l'esprit japonais.

L'art du pliage fait partie depuis des siècles de la tradition japonaise. J'applique les techniques de l'origami à des feuilles d'or, à du papier japonais ou à du placage de bambou pour les transformer en objets tridimensionnels.

Avec mon travail, je cherche à transmettre un sentiment de paix et de tranquillité. L'or de mes bijoux ne reflète pas l'énergie ou la force du soleil, mais l'éclat de la lune. La *neige*, la *lune* et les *fleurs* sont des sujets qui reviennent souvent dans la peinture japonaise classique, et j'aime bien aussi les utiliser dans mes créations.

POR / Durante a minha formação artística me especializei na arte tradicional japonesa, o que sem dúvida tem uma clara influência no meu trabalho atual.

Minha obra gira em torno dos conceitos de calma e beleza. A partir daqui aspiro em conseguir algo que não seja uma simples cópia da arte ocidental, eu gostaria que as pessoas, ao verem as minhas peças, conectassem-se com as qualidades mais íntimas e profundas do espírito japonês.

Desde centenas de anos, a arte da dobradura está muito enraizada na tradição japonesa. Mediante das técnicas próprias do origami, dobro lâminas de ouro, papel japonês ou cinta de bambu e as transformo em peças tridimensionais.

Através do meu trabalho busco transmitir paz, tranquilidade. O ouro das minhas peças não reflete a força e o dinamismo do sol, senão o brilho da lua. *Neve, lua e flores* são motivos que aparecem com frequência na pintura japonesa clássica e tendo a usá-los também nas minhas joias.

Lena
Olson

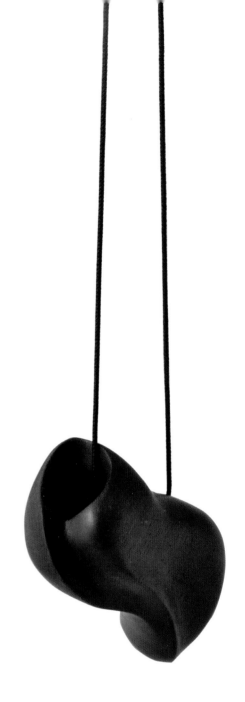

ENG / More than being something visual, for me jewellery is
a feeling on the skin, a texture, a shape. Jewellery that cannot
be touched misses the point. I use different varieties of wood
because it is an infinite source of inspiration, both because
of its physical qualities and its cultural content. I work in quite
an intuitive way. When I have a piece of wood in my hands,
often something unexpected happens that takes me in a new
direction. This makes me constantly alert, and the whole
process is very exciting. I prefer pieces that come into direct
contact with the wearer, such as rings or bracelets. I'm
fascinated by what happens when a piece is transformed
through body movement. My creations often become pendants,
so they can be viewed from all angles. Each of my pieces of
jewellery is born from an idea, from a form hidden within the
material that I have to discover and explore. I am inspired in an
instant, by what I see when I'm walking: a line that grows, an
architectural form, the legs of a running dog or the angle
of the person next to me's arm.

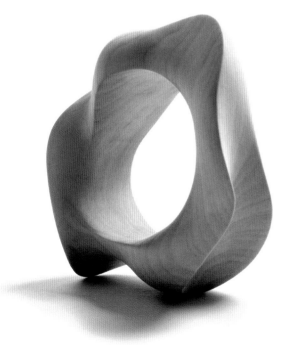

ESP / Más que una imagen, las joyas son para mí una sensación
en la piel, una textura, una forma. Una joya que no puede
tocarse, pierde el sentido. Utilizo distintas variedades de
madera porque es una fuente infinita de inspiración tanto
por sus cualidades físicas como por su contenido cultural.
Trabajo de forma bastante intuitiva. Cuando tengo un trozo
de madera entre las manos, a menudo ocurre algo inesperado
que me lleva en una nueva dirección. Ello me hace estar
continuamente alerta y todo el proceso es muy excitante.
Prefiero las piezas que entran en contacto directo con quien
las lleva, como los anillos o los brazaletes. Me fascina lo que
ocurre cuando una pieza se transforma con el movimiento
del cuerpo. Mis obras a menudo se convierten en colgantes,
de manera que pueden verse desde todos los ángulos. Cada
una de mis joyas nace de una idea, de una forma oculta dentro
del material, que tengo que descubrir y explorar. Me inspiro en
un instante, en lo que observo mientras camino: una línea que
crece, una forma arquitectónica, las patas de un perro que corre
o el ángulo que forma el brazo de la persona que está a mi lado.

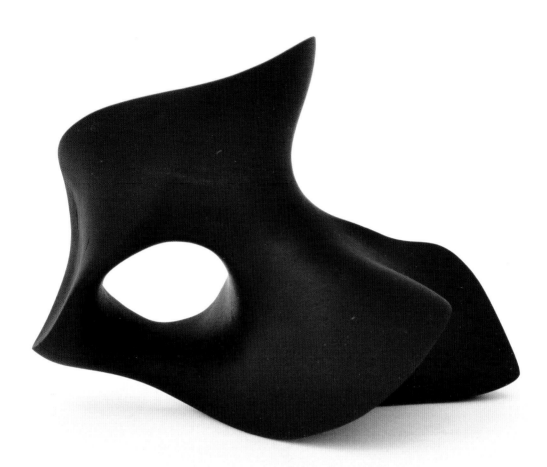

POR / Mais que uma imagem, as joias são para mim uma
sensação na pele, uma textura, uma forma. Uma joia que não
se pode tocar perde o sentido. Utilizo diferentes variedades
de madeira porque é uma infinita fonte de inspiração tanto
pelas suas qualidades físicas como pelo seu conteúdo cultural.
Trabalho de forma bastante intuitiva. Quando tenho um
pedaço de madeira entre as mãos, com frequência ocorre algo
inesperado que me leva a uma nova direção. Isto me faz estar
continuamente alerta e todo o processo é muito emocionante.
Prefiro as peças que entram em contato direto com quem as
usa, como os anéis e os braceletes. Me fascina o que ocorre
quando uma peça se transforma com o movimento do corpo.
Minhas obras com frequência se convertem em pendentes,
de maneira que podem ser vistas em todos os ângulos.
Cada uma das minhas joias nasce de uma ideia, de uma forma
oculta dentro do material, que tenho que descobrir e explorar.
Me inspiro num instante, no que observo enquanto caminho:
uma linha que cresce, uma forma arquitetônica, as patas
de um cachorro que corre ou o ângulo que forma o braço
da pessoa que está ao meu lado.

FRA / Plus qu'une image, un bijou est pour moi une sensation
sur la peau, une texture, une forme. Un bijou que l'on ne
pourrait pas toucher n'aurait aucun sens. J'utilise différentes
variétés de bois parce que c'est une source infinie d'inspiration,
tant pour ses qualités physiques que pour sa dimension
culturelle. Je travaille plutôt de façon intuitive. Lorsque j'ai
un morceau de bois entre les mains, je me retrouve souvent
entraînée vers une nouvelle direction. C'est pour cela que
je dois être constamment à l'affût : vivre un tel processus
est une véritable aventure. Je préfère les bijoux qui sont
en contact direct avec leur porteur, comme les bagues
et les bracelets.
Je suis fascinée par ce qui se passe lorsqu'un bijou se
transforme en suivant le mouvement du corps. Mes œuvres
finissent souvent en pendentifs ; on peut les voir ainsi sous
tous les angles. Chacun de mes bijoux part d'une idée,
d'une forme occulte contenue dans le matériau et que je dois
découvrir et explorer. L'inspiration me vient en un instant,
au cours d'une promenade ou dans la vie courante : une
ligne qui monte, une forme architecturale, les pattes d'un
chien qui coure ou l'angle que forme le bras de la personne
qui est à côté de moi

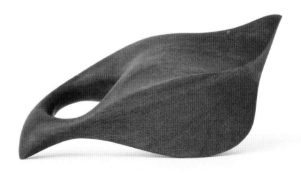

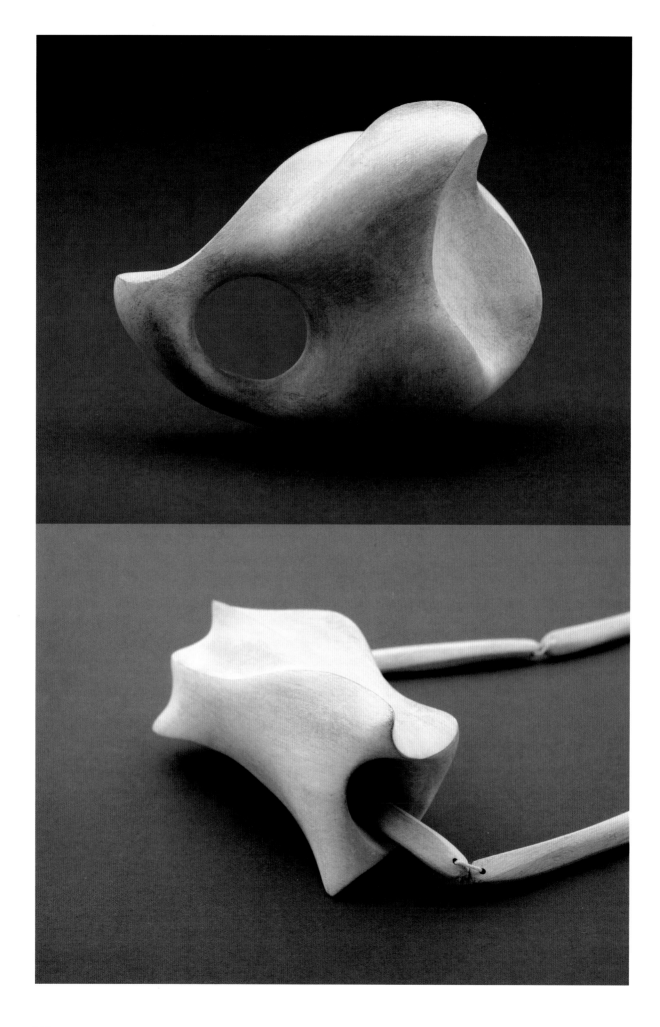

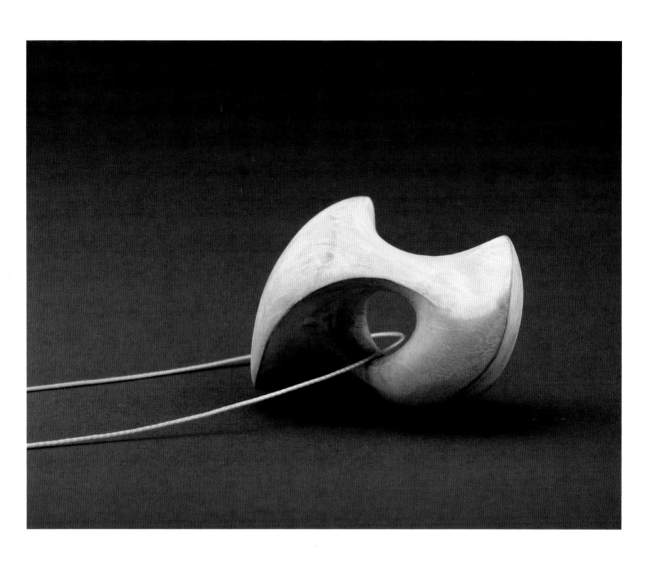

When I have a piece of wood in my hands,
often something unexpected happens
that takes me in a new direction.

Tomàs Palos

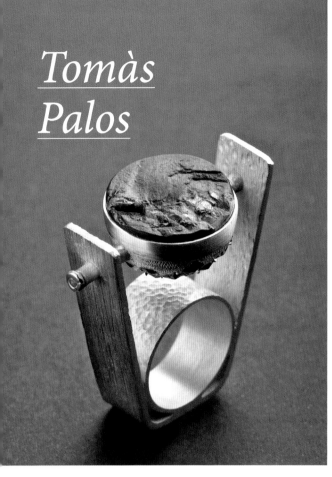

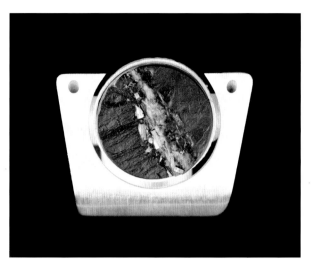

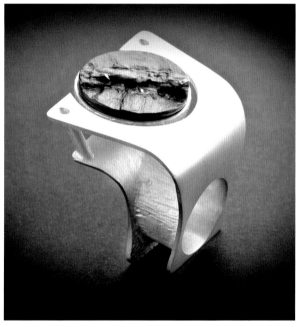

ENG / As an artist, what interests me the most is experimenting with all the materials that can be manipulated with the tools of a jewellery studio. I enjoy working by hand, so I use a variety of techniques to give to my pieces textures, colour, movement and, above all, volume: welding, rivets, hammering, inlaying metal in wood or enamelling gold and silver using a blowtorch. I used a variety of objects for my works, from a clock mechanism or chips and electronic parts to a camera. And I also experiment with lots of materials, for example iron, acrylic, ebony, ivory and alabaster.

Through my work I want to convey my feelings and my experience: love, sex, procreation and the miracle of the universe. In my understanding jewellery is an art, not simply pure ornamentation. Through my creative freedom I like to give my pieces a strong symbolic and even narrative content that reflects my experiences, through an approach that is close to painting, sculpture or even architecture, so that they are sometimes poetic or very bold.

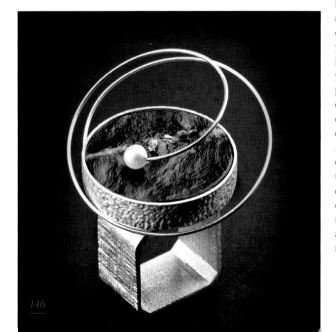

ESP / Como artista, lo que más me interesa es experimentar con todos los materiales que pueda manipular con las herramientas de un taller de joyería. Disfruto trabajando artesanalmente, por ello empleo un amplia variedad de técnicas para dar a mis piezas texturas, color, movimiento y sobre todo, volumen: soldaduras, remaches, martelés, incrustación de metales en maderas o el esmaltado sobre oro y plata con el soplete. He utilizado una gran variedad de objetos para mis obras, desde una máquina de reloj o chips y piezas electrónicas, hasta una máquina fotográfica. Y también experimento con gran cantidad de materiales, como el hierro, el metacrilato, el ébano, el marfil o el alabastro.

A través de mi obra quiero transmitir mis sentimientos y mi experiencia: el amor, el sexo, la procreación y el milagro del universo. Entiendo la joyería como Arte, no simplemente como puro ornamento. A través de mi libertad creativa busco dotar a mis piezas de un fuerte contenido simbólico e incluso narrativo que refleje mis vivencias, en una actitud cercana a la pintura, a la escultura o incluso a la arquitectura, de manera que a veces resultan poéticas o muy atrevidas.

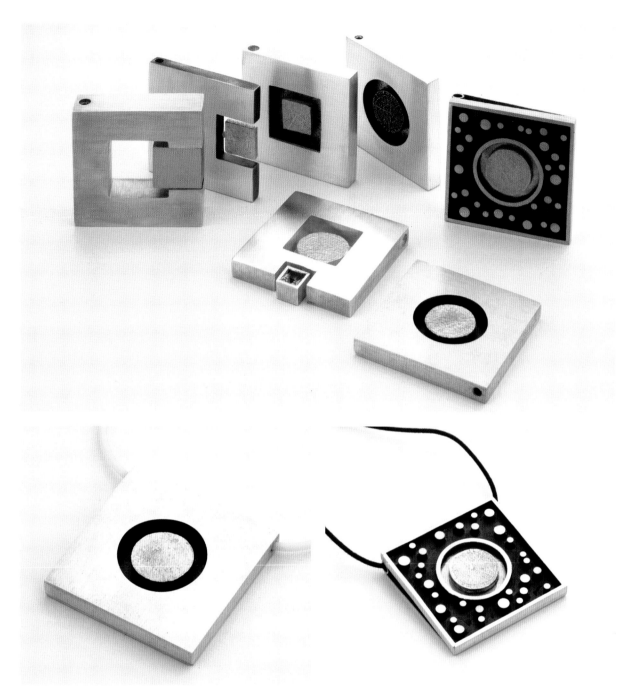

FRA/ Ce qui m'intéresse en tant qu'artiste, c'est d'expérimenter avec tous les matériaux que je peux façonner avec des outils de joaillerie. J'aime ce travail d'artisan. Je fais appel à un large éventail de techniques pour conférer de la texture, de la couleur et du mouvement à mes créations, et surtout du volume : soudure, rivetage, martelé, incrustation de métal dans du bois ou d'émail sur de l'or ou de l'argent à l'aide d'un chalumeau. J'ai utilisé toutes sortes d'objets dans mes créations, du mécanisme de montre à la puce électronique en passant par un appareil photo. J'ai aussi employé une grande variété de matériaux comme le fer, le méthacrylate, l'ébène, l'ivoire ou l'albâtre.

Je veux que mon œuvre puisse transmettre mes sentiments et mon expérience sur l'amour, le sexe, la procréation et le miracle de l'univers. Pour moi la joaillerie est un art à part entière, et un bijou n'est pas un simple ornement. Ma liberté de création me donne la possibilité de charger mes bijoux d'un fort contenu symbolique, y compris narratif, qui reflète mes expériences. C'est une approche qui s'apparente plus à la peinture, à la sculpture, voire à l'architecture, et qui explique que mes créations sont parfois poétiques ou provocantes.

POR/ Como artista, o que mais me interessa é experimentar todos os materiais que se possam manipular com as ferramentas de uma oficina de joias. Me divirto trabalhando artesanalmente, por isso utilizo uma grande variedade de técnicas para dar às minhas peças texturas, cores, movimento e, sobretudo, volume: soldagem, rebitagem, martelés, incrustações de metais na madeira ou o esmaltado sobre ouro e prata com o maçarico. Utilizei uma grande variedade de objetos para as minhas obras, desde uma máquina de relógio ou chips e peças eletrônicas, até uma máquina fotográfica. E também experimento com grande quantidade de materiais, como o ferro, o metacrílico, o ébano, o marfim ou o alabastro.

Através da minha obra quero transmitir meus sentimentos e a minha experiência: o amor, o sexo, a procriação e o milagre do universo. Entendo a joia como Arte, não simplesmente como um puro ornamento. Através da minha liberdade criativa busco dotar às minhas peças um forte conteúdo simbólico e incluso narrativo que reflita as minhas vivências, numa atitude próxima a da pintura, da escultura ou inclusive da arquitetura, de maneira que, às vezes resultam poéticas ou muito atrevidas.

Ruudt Peters

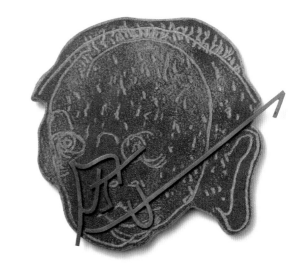

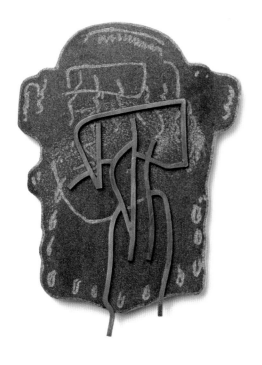

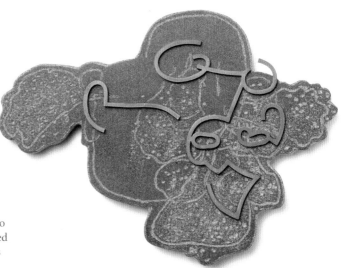

ENG/ I studied medical instrument manufacturing, which requires extreme precision. Then I realised I didn't want to grow old in a laboratory. I had to get out of there! I decided to study art and jewellery seemed a logical path, but I was never interested in making adornments. I am a very bad jeweller, in the sense that I'm not interested in the symbiotic relationship between the jewellery and the body, but in confronting it. Jewellery is a valid artistic medium, but to do something relevant, it is essential to leave conventional ideas behind, to feel the vibrations of our time, to have a clear message and strongly defend it. If a piece has no soul, I'm not interested in it.

There's a Dutch word "bezieling," which means something like "giving soul to an object." I try to create favourable circumstances for that. And it happens when someone really connects with a piece, when they know there is something beyond the material.

I feel love for the body, but I seek to reverse the order, showing what is hidden and making it into jewellery. I use body language to communicate my spiritual experience, not my relationship with the environment. My hands reflect my inner life and my mind does not fully control the process.

ESP/ Estudié fabricación de instrumental médico, que requiere una precisión extrema. Luego me di cuenta de que no quería envejecer en un laboratorio. ¡Tenía que salir de ahí! Decidí estudiar arte y la joyería parecía un camino lógico, pero nunca me interesó hacer adornos. Soy muy mal joyero, en el sentido de que no me interesa la relación simbiótica entre una joya y el cuerpo, sino enfrentarse a él. La joyería es un medio artístico válido, pero para hacer algo relevante es esencial dejar atrás ideas convencionales, sentir las vibraciones de nuestro tiempo, tener mensaje claro y defenderlo con firmeza.

Si una pieza no tiene alma, no me interesa. Hay una palabra holandesa "bezieling", que significa algo como "infundir alma a un objeto". Intento crear las circunstancias favorables para ello. Y ocurre cuando alguien conecta realmente con una pieza, cuando saben que hay algo más allá de lo material.

Siento amor por el cuerpo pero busco invertir el orden, mostrar lo oculto convirtiéndolo en una joya. Uso el cuerpo como lenguaje para comunicar mi experiencia espiritual, no mi relación con el entorno. Mis manos reflejan mi vida interior y mi mente no controla mucho el proceso.

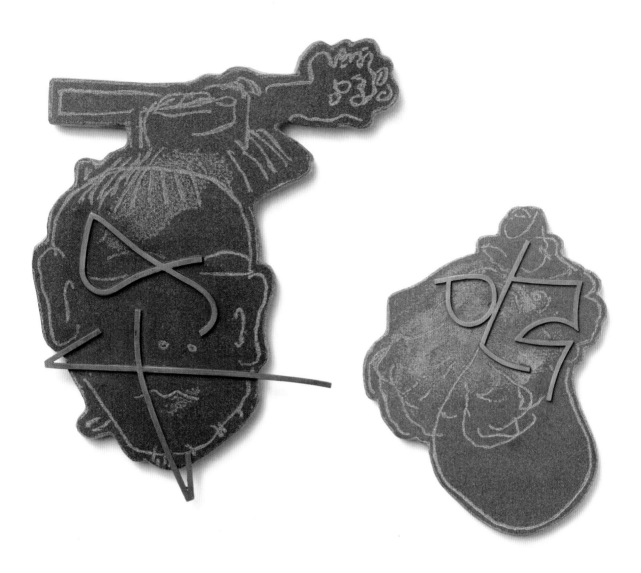

FRA / J'ai étudié la fabrication d'instruments médicaux, ce qui demande une précision extrême. Mais je me suis rendu compte ensuite que je ne voulais pas passer ma vie dans un laboratoire. Il fallait que je choisisse un autre métier ! Je me suis dirigé vers les arts, et la joaillerie me paraissait un choix logique, bien que la notion d'ornement ne m'avait jamais intéressée. Je ne suis pas un bijoutier classique dans le sens où je ne suis absolument pas concerné par la relation symbiotique entre le bijou et le corps. Ce que je cherche c'est l'affrontement entre les deux. La bijouterie est un art à part entière, mais pour créer quelque chose de valable, encore faut-il oublier les idées reçues et percevoir les vibrations de notre époque, transmettre un message clair et le défendre jusqu'au bout.

Si un bijou n'a pas d'âme, il ne m'intéresse pas. Le mot « bezieling » en hollandais signifie « insuffler une âme à un objet ». J'essaie de créer les conditions propices à cette conjoncture. Elle se produit lorsqu'un rapport s'établit entre une personne et un bijou, et qu'elle se rend compte qu'il y a autre chose derrière la matière visible.

J'aime le corps, mais j'essaie d'inverser l'ordre des choses, de montrer sa face cachée en le transformant en bijou. J'utilise le corps comme un moyen de communiquer mon expérience spirituelle et non pas ma relation avec ce qui m'entoure. Mes mains reflètent ma vie intérieure, et mon esprit n'a pratiquement aucun contrôle sur le processus de création.

POR / Estudei fabricação de instrumento médico, que requer uma precisão extrema. Logo me dei conta de que não queria envelhecer num laboratório. Tinha que sair de lá! Decidi estudar arte e a joalheria parecia um caminho lógico, mas nunca me interessei em fazer adornos.Sou um péssimo joalheiro, no sentido que não me interessa a relação simbiótica entre uma joia e o corpo, senão confrontar-se com ele. A joalheria é um meio artístico válido, mas para fazer algo relevante é essencial deixar para trás ideias convencionais, sentir as vibrações do nosso tempo, ter uma mensagem clara e defendê-la com firmeza.

Se uma peça não tem alma, não me interessa. Há uma palavra holandesa "bezieling", que significa algo como "infundir alma a um objeto". Tento criar as circunstâncias favoráveis para isso. E isso ocorre quando alguém se conecta realmente com uma peça, quando sabe que há algo mais além do material.

Sinto amor pelo corpo, mas busco inverter a ordem, mostrar o oculto convertendo-lhe numa joia. Uso o corpo como linguagem para comunicar a minha experiência espiritual, não minha relação com o ambiente. Minhas mãos refletem minha vida interior e minha mente não controla muito o processo.

Katja
Prins

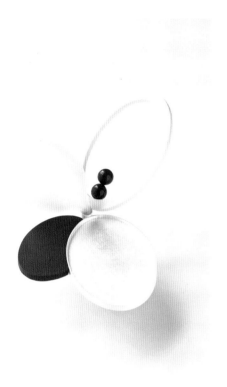

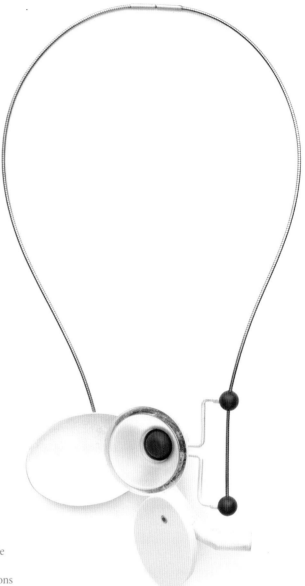

ENG / I consider my work to be art, an expression of my
way of seeing things. I hope to be able to intrigue people
with my work, to arouse questions from them.
Astonishment is one of the most beautiful of the emotions
we lose as we grow older. Art is the best way to keep me
questioning myself.
I'm really intrigued by the intimacy established between
the human body and mechanical devices: medical technology
and industry. I'm inspired by everything related to this subject.
With my work I want to tell stories about the body, as an object
of manipulation, as a machine-instrument. And about
machines-instruments as extensions of our body. It fascinates
me that today our body is something that we can change,
sculpt. It is an extension of our mind, always in relation to
the environment. Ultimately man, and especially his body,
is the measure of all things.
For me the technique is just the vehicle to go where I want,
a tool that helps me to tell my story. But I prefer to master
it well, this way I discover things while working; the unexpected
can be a gift, a treasure. As can materials, and for that reason
I prefer them not to be precious, because I want to fill them
with my own meaning.

ESP / Considero mi trabajo un arte, una expresión de mi
manera de ver las cosas. Espero ser capaz de intrigar a otras
personas con mi trabajo, despertarles preguntas. Maravillarse
es una de las emociones más hermosas que perdemos al hacernos
mayores. El arte es el mejor medio para seguir cuestionándome.
Me intriga mucho la intimidad que se establece entre el cuerpo
humano y los artefactos mecánicos: la tecnología médica
y la industria. Me inspira todo lo relacionado con este tema.
Con mi trabajo quiero contar historias sobre el cuerpo: como
objeto de manipulación, como máquina-instrumento. Y sobre
las máquinas-instrumentos como extensiones de nuestro
cuerpo. Me fascina que hoy nuestro cuerpo es algo que
podemos cambiar, esculpir. Es una extensión de nuestra mente,
siempre en relación con el entorno. Al fin y al cabo, el hombre,
especialmente su cuerpo, es la medida de todas las cosas.
Para mí la técnica es simplemente el vehículo para ir a donde
quiero, una herramienta que me ayuda a contar mi historia.
Pero prefiero dominarla bien, de esta manera mientras trabajo
descubro cosas; lo inesperado puede ser un regalo, un tesoro.
Los materiales también, y por eso prefiero que no sean
preciosos, pues quiero cargarlos de mi propio significado.

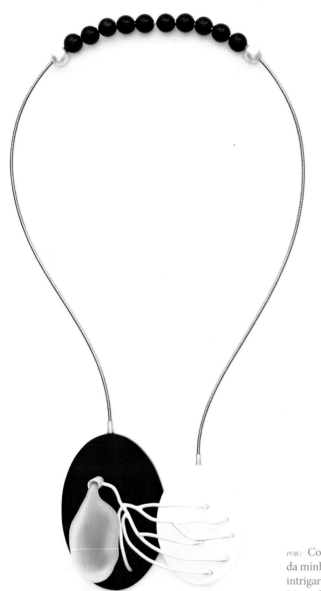

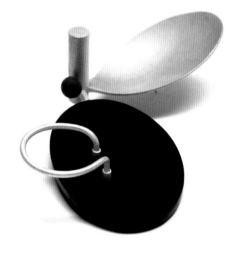

FRA / Je considère que mon travail est un art qui exprime ma manière de voir les choses. J'espère que mes œuvres sont capables de susciter de l'intérêt chez les gens et de les interpeller. En grandissant nous perdons notre capacité d'émerveillement, qui est une des plus belles émotions qui soient. L'art est le moteur qui me pousse à aller voir plus loin.

Je suis intriguée par l'intimité qui s'établit entre le corps humain et les objets mécaniques issus des technologies médicales et de l'industrie. Tout ce qui tourne autour de ce sujet m'inspire. À travers mon travail, je raconte des histoires sur le corps qui est objet de manipulation ou machine-instrument. Je suis fascinée par l'idée qu'il est possible de nos jours de changer notre corps, de le sculpter. Il est une extension de notre esprit, et est en contact permanent avec notre environnement. Après tout, le corps est pour l'être humain la mesure de toutes choses. Pour moi, la technique est simplement le moyen d'arriver à mes fins : c'est un outil qui m'aide à raconter mon histoire. Mais je veux la dominer complètement pour pouvoir découvrir quelque chose de nouveau en travaillant, comme un cadeau, un trésor inattendu. Comme j'aime aussi contrôler les matériaux, je préfère qu'ils ne soient pas précieux pour pouvoir les investir de mes propres significations.

POR / Considero meu trabalho uma arte, uma expressão da minha maneira de ver as coisas. Espero ser capaz de intrigar outras pessoas com meu trabalho, fazê-las questionar. Maravilhar-se é uma das emoções mais bonitas que perdemos ao envelhecermos. A arte é o melhor meio para seguir questionando-me.

Me intriga muito a intimidade que se estabelece entre o corpo humano e os artefatos mecânicos: a tecnologia médica e a indústria. Me inspira tudo o que está relacionado com este tema. Com meu trabalho quero contar histórias sobre o corpo: como objeto de manipulação, como máquina-instrumento. E sobre as máquinas-instrumentos como extensões de nosso corpo. Me fascina que hoje nosso corpo é algo que se pode mudar, esculpir. É uma extensão da nossa mente, sempre em relação com o ambiente. Ao final das contas, o homem, especialmente o seu corpo, é a medida de todas as coisas.

Para mim a técnica é simplesmente o veículo para ir aonde eu quero, uma ferramenta que me ajuda a contar a minha história. Mas prefiro dominá-la bem, desta maneira, enquanto trabalho descubro coisas; o inesperado pode ser um presente, um tesouro. Os materiais também, e por isso, prefiro que eles não sejam preciosos, pois quero carregá-los com meu próprio significado.

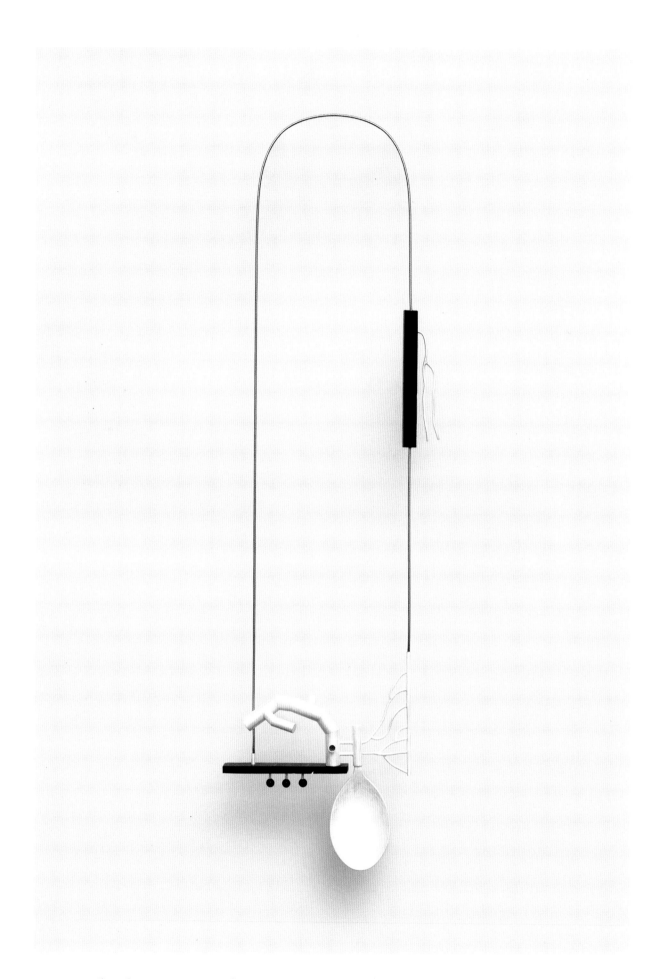

Art is the best way to keep questioning myself.

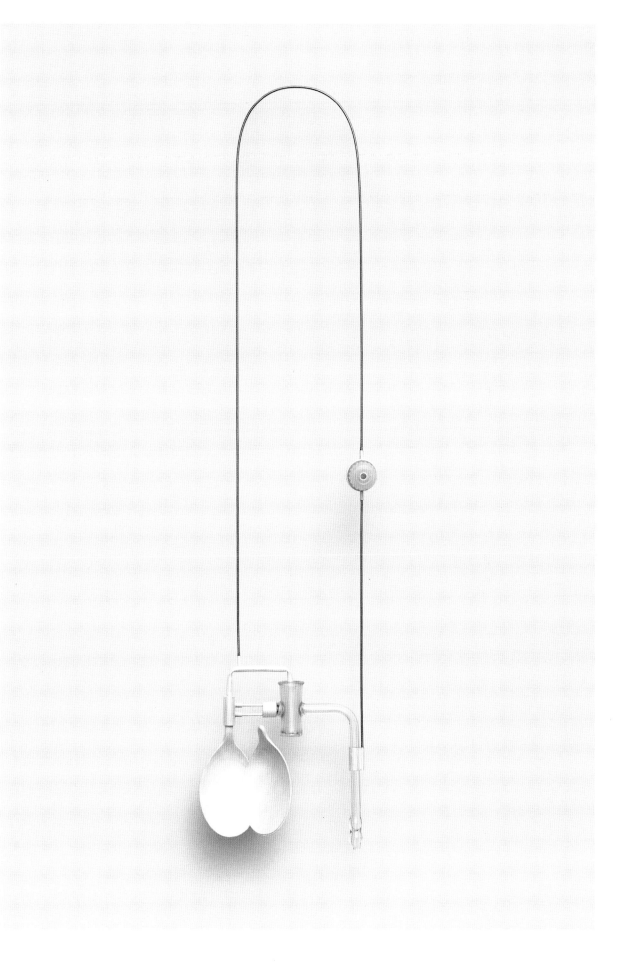

Ramón
Puig Cuyàs

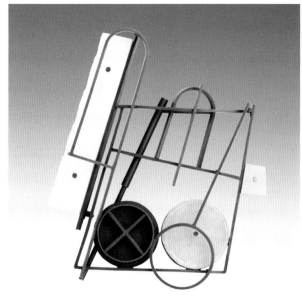

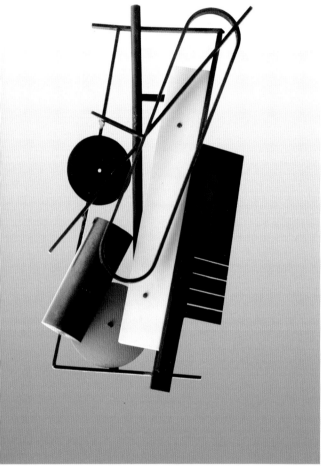

ENG / What drives me is the need to establish a small measure of order in our chaotic universe, to reach both perfection and clarity in the structure of a piece and also the depth of its mystery, like the music of Bach. Creation always moves within the boundary between light and darkness.

I like to consider myself to be that craftsman that Walter Gropius dreamed of when he said that the artist is a craftsman who, during rare moments of clarity, transcends his will and art flourishes unconsciously out of his hands. I continuously work to reconnect with such moments, when everything seems to flow effortlessly from a deep spring. I think that artisanal creation contributes to the well-being of our world, as William Morris and Richard Sennett have said. I have tried to make extra-ordinary objects that are charged with a symbolic function, to retain some of the magic of putting on a piece of jewellery.

Making jewellery is an adventure which as time passes transforms the world of uncertainty in which I make my works into a world of certainties which, no matter how provisional pose new questions and keep up the tension and energy of artistic evolution.

ESP / Me impulsa la necesidad de instaurar una pequeña fracción de orden en nuestro universo de caos, de alcanzar la perfección y la claridad en la estructura de una pieza pero también la profundidad de su misterio, como la música de Bach. La creación siempre se mueve en el límite entre la luz y la oscuridad.

Me gusta considerarme como aquel artesano con el que soñaba Walter Gropius cuando decía que el artista es un artesano que, en escasos momentos de claridad, se sitúa mas allá de su voluntad y el arte florece inconscientemente de sus manos. Trabajo continuamente para reencontrarme con estos momentos, cuando todo parece fluir sin esfuerzo de un manantial profundo. Creo que la creación artesanal contribuye al bienestar de nuestro mundo como ya decían William Morris o Richard Sennett. He intentado hacer objetos extra-ordinarios, cargados de función simbólica, recuperar parte del gesto mágico de ponerse una joya.

Hacer joyas es una aventura que, con el transcurrir del tiempo, va transformando el mundo de incertidumbres en el que realizo mis obras en un universo de certezas, por bien que siempre provisionales, que despiertan nuevos interrogantes y mantienen la tensión y la energía de la evolución artística.

FRA / Je suis poussé par le besoin d'instaurer un peu d'ordre dans notre univers chaotique, d'atteindre la perfection et la précision dans la structure d'un bijou et de découvrir la profondeur de son mystère, comme la musique de Bach. La création évolue toujours dans les limites entre l'ombre et la lumière.

J'aime à penser que je suis comme cet artisan auquel rêvait Walter Gropius. Il disait que l'artiste est un artisan qui, en de rares moments de lucidité, perd le contrôle de sa volonté et produit inconsciemment de l'art avec ses mains. Je travaille sans relâche pour essayer de trouver ces moments où tout semble jaillir sans effort d'une source profonde. Je pense que la création artisanale contribue au bien-être de l'humanité, comme l'ont dit avant moi, William Morris et Richard Sennett. J'ai essayé de fabriquer des objets extraordinaires, chargés de fonction symbolique, et de récupérer une partie du geste magique qui consiste à se parer d'un bijou.

La création de bijoux est une aventure qui au fil du temps transforme un monde plein de doutes – celui où je fabrique mes œuvres – en un univers de certitudes, toujours éphémères, qui posent de nouvelles questions, et entretiennent la tension et l'énergie de l'évolution artistique.

POR / Me impulsiona a necessidade de estabelecer uma pequena fração de ordem no nosso universo de caos, de alcançar a perfeição e a claridade na estrutura de uma peça mas também a profundidade do seu mistério, como a música de Bach. A criação sempre se move no limite entre a luz e a escuridão. Eu gosto de me considerar como aquele artesão com que sonhava Walter Gropius, quando dizia que o artista é um artesão que, em escassos momentos de claridade, se situa mais além da sua vontade e a arte floresce inconscientemente de suas mãos. Trabalho continuamente para reencontrar-me com estes momentos, quando tudo parece fluir sem esforço de um manancial profundo. Creio que a criação artesanal contribui ao bem-estar do nosso mundo como já diziam William Morris ou Richard Sennett.

Intentei fazer objetos extraordinários, carregados de função simbólica, recuperando parte do gesto mágico de pôr uma joia. Fazer joias é uma aventura que no transcorrer do tempo vai transformando o mundo de incertezas no qual realizo minhas obras num universo de certezas, ao menos que sempre provisionais, que despertam novas perguntas e mantem a tensão e a energia da evolução artística.

Anthony Roussel

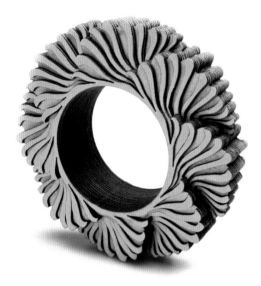

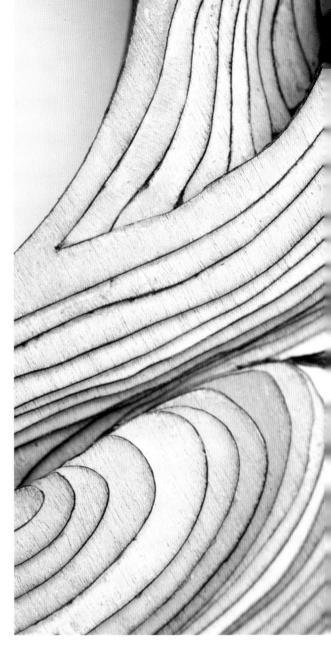

ENG / In my studio I have a photo of Matisse drawing on the wall from his bed. This image of a dedicated artist, whose weak body is not an obstacle to his passion, inspires me a lot. My technique focuses on creating complex sequences from sheets to achieve flowing 3D figures. I love the challenge posed by bringing different pieces together to create a big final structure. I want to achieve the same feeling as when you look at an Impressionist painting for the first time and discover that it is made from thousands of tiny brush strokes.
For guiding and cutting I use CNC technology. At university I came into contact with the world of 3D technologies, which back then were still fairly exclusive, but thanks to them I was able to solve the problems that workbenches presented me with, since I have a spinal impairment that restricts my mobility. I work by hand, but with a different system of tools. Wood, with its warmth, its smell, its textures, is my favourite material. There's something natural and basic about working with it that inspires a lot of respect in me. I grew up in an urban area of London, where the colour grey and cement dominated. I think that wood is a reaction to that. People forget that such a humble material forged empires. I'm really motivated by challenging the general attitude towards wood by pushing its potential through new technologies.

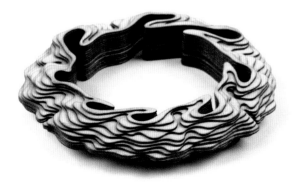

ESP / En mi estudio tengo una fotografía de Matisse dibujando en la pared desde su cama. Me inspira muchísimo esta imagen del artista entregado, cuyo débil cuerpo no es un obstáculo para su pasión.
Mi técnica se centra en crear secuencias complejas a partir de láminas para conseguir figuras fluidas en 3D. Me encanta el reto que supone unir distintas piezas para crear una gran estructura final. Quiero obtener la misma sensación que cuando miramos un cuadro impresionista por primera vez, y descubrimos que está hecho a base de miles de diminutas pinceladas.
Para guiar y cortar uso tecnología CNC. En la universidad entré en contacto con el mundo de tecnologías 3D que entonces eran aún bastante exclusivas, pero gracias a ellas pude solucionar el problema que me suponía el banco de trabajo, pues tengo un impedimento vertebral que restringe mi movilidad. Trabajo a mano, pero con un sistema distinto de herramientas. La madera, con su calidez, su olor, sus texturas, es mi material favorito. Trabajar con ella tiene algo de básico y natural y me produce un gran respeto. Crecí en una zona urbana de Londres, donde reinaban el color gris y el cemento. Creo que la madera es una reacción a esto. La gente olvida que un material tan humilde forjó imperios. Me motiva mucho desafiar la actitud general hacia la madera forzando sus posibilidades con nuevas tecnologías.

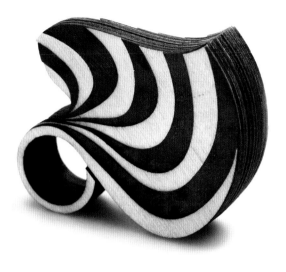

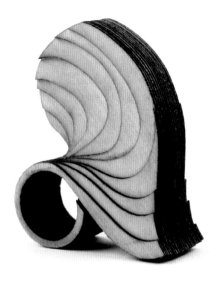

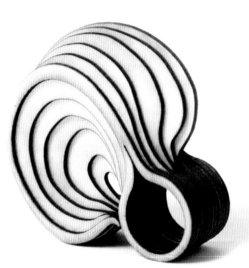

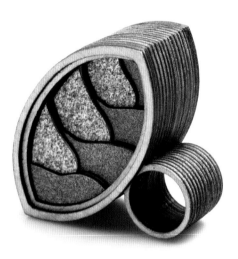

FRA / Dans mon studio, j'ai une photo de Matisse malade dessinant sur le mur depuis son lit. Cette image de l'artiste acharné pour qui la faiblesse du corps n'est pas un obstacle à sa passion m'inspire beaucoup.

Ma technique consiste à élaborer des séquences complexes à partir de lamelles empilées afin de produire des formes fluides en relief. J'aime le défi que pose la réunion de différentes pièces pour créer une seule grande structure. Mon objectif est de générer la même sensation que lorsque l'on regarde un tableau impressionniste pour la première fois et que l'on se rend compte qu'il est composé d'une myriade de touches de couleur minuscules.

Pour me guider et découper les pièces, je fais appel à la FAO. À l'université, j'ai découvert le monde des technologies 3D qui étaient à l'époque réservées à l'élite. Elles m'ont permis de résoudre le problème que me posait l'établi car j'ai une mobilité réduite à cause de mon dos. Je travaille à la main mais avec des outils adaptés.

De toutes les matières, c'est le bois que je préfère pour sa chaleur, son odeur et ses textures. Son façonnage représente pour moi quelque chose de fondamental et de naturel pour lequel j'éprouve le plus profond respect. J'ai grandi dans une zone urbaine de Londres où régnaient la couleur gris et le ciment. Je crois que le bois est une réaction à tout cela. Les gens oublient qu'un matériau aussi humble a bâti des empires. J'aime aller à contre-courant et prouver aux gens que le bois est bien autre chose, en optimisant ses possibilités à l'aide des nouvelles technologies.

POR / No meu estúdio tenho uma fotografia de Matisse desenhando na parede da sua cama. Me inspira muitíssimo esta imagem do artista entregado, cujo corpo fraco não é um obstáculo para a sua paixão.

Minha técnica centraliza em criar sequências complexas a partir de lâminas para conseguir figuras fluidas em 3D. Eu adoro o desafio onde se supõe unir diferentes peças para criar uma grande estrutura final. Quero obter a mesma sensação quando observamos um quadro impressionista pela primeira vez e descobrimos que está feito a partir de mil pinceladas minúsculas.

Para guiar e cortar uso tecnologia CNC. Na universidade entrei em contato com o mundo de tecnologias 3D que até então era ainda bastante restrita, mas graças a elas pude solucionar o problema da minha bancada de trabalho, pois tenho um impedimento vertebral que restringe a minha mobilidade. Trabalho com as mãos, com um sistema diferente de ferramentas.

A madeira, com o seu calor, seu cheiro, suas texturas, é o meu material favorito. Trabalhar com ela tem algo de básico e natural e me causa um grande respeito. Cresci numa zona urbana de Londres, onde reinava a cor cinza e o cimento. Acredito que a madeira é uma reação a isto. Esquecemos que um material tão humilde conquistou impérios. Me motivo muito a desafiar a atitude geral em relação à madeira forçando as suas possibilidades com novas tecnologias.

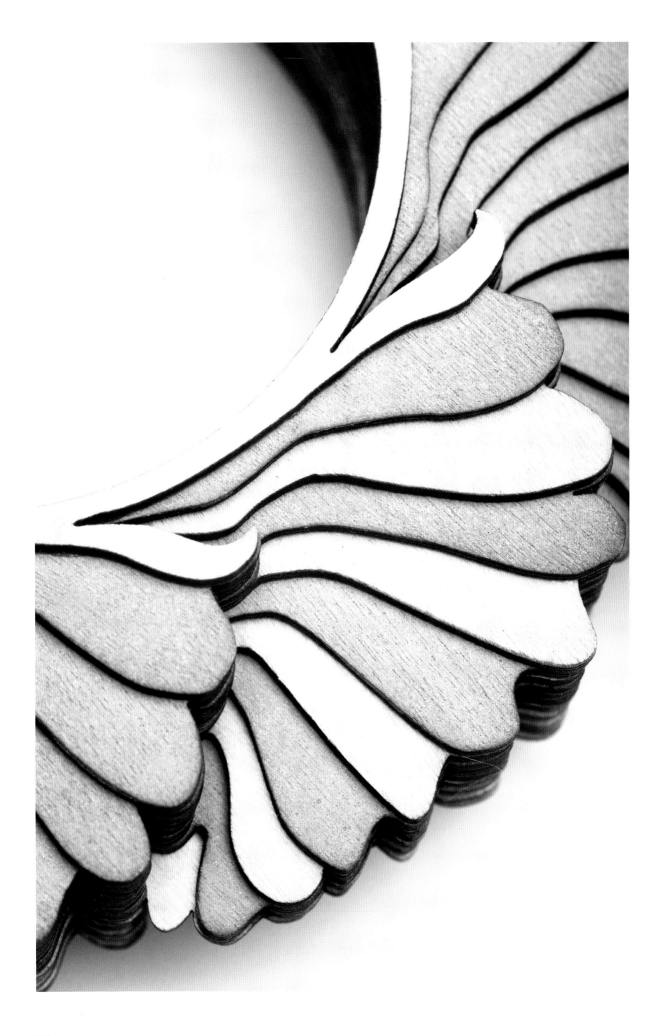

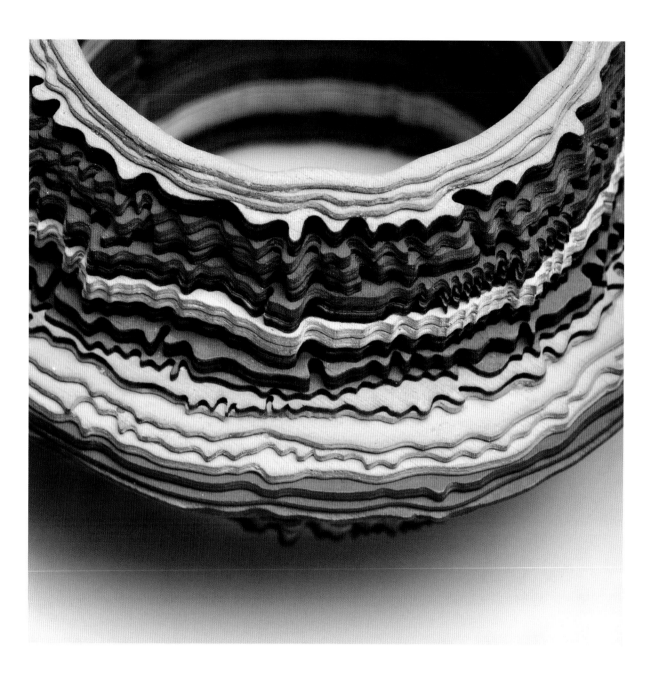

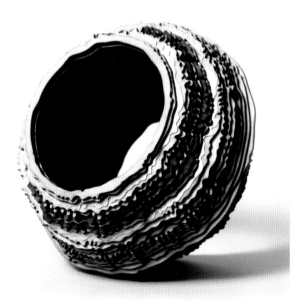

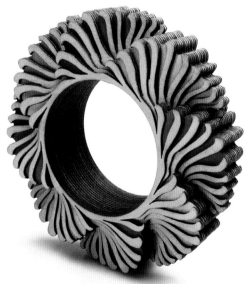

Jacqueline Ryan

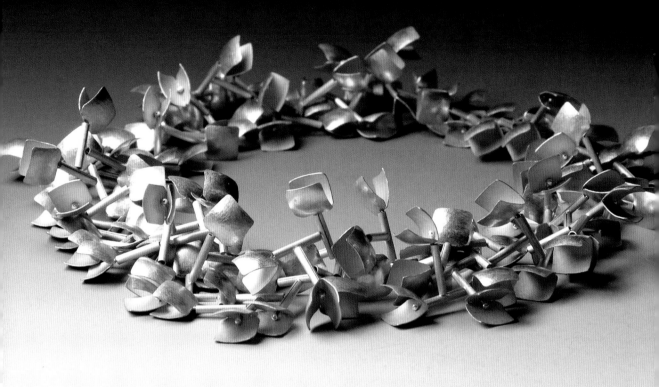

ENG / I am fascinated by the plant world, in all its states and on all scales: transformation, order and chaos, decomposition, almost imperceptible details. I want to celebrate the extraordinary coincidence that has allowed nature to exist.

From the essence of what I draw I build a paper structure in miniature that will become a gold object. Paper is an unpredictable material and the creation of models awakens dozens of ideas that connect the space between a drawing and a three-dimensional piece.

When I was child my father took me to the London museums and since then I have been fascinated by precious objects from ancient civilisations, and the mystery that is hidden behind the timelessness of their powerful spell.

I always use eighteen-carat gold, often combined with vitreous enamel. Nothing can compare to the qualities of gold, its colour. All steps of my work are done by hand; I love the mark the human hand leaves on each object.

I decide on the type of jewellery I make based on what the original layout suggests to me.

I'm attracted to the challenge of complex pieces, for example necklaces. To make a necklace, it is necessary to take into account not just the shape of the neck and shoulders, but also versatility, comfort, flexibility, movement and, above all, the challenge of thinking about the human body as the piece's final environment.

ESP / Me fascina el mundo vegetal, en todas sus escalas y estados vitales: la transformación, el orden y el caos, la descomposición, detalles casi imperceptibles. Quiero celebrar la extraordinaria coincidencia que hace que la naturaleza exista.

Desde la esencia de lo que dibujo, construyo una estructura de papel en miniatura que se convertirá en un objeto de oro. El papel es un material impredecible y la creación de las maquetas despierta docenas de ideas que conectan el espacio entre un dibujo y una pieza tridimensional.

Cuando era niña mi padre me llevaba a los museos de Londres y desde entonces me fascinan los objetos preciosos de las antiguas civilizaciones, el misterio que se oculta tras la intemporalidad de su poderoso hechizo.

Utilizo siempre oro de 18 quilates, a menudo combinado con esmalte vítreo. Nada se puede comparar a las cualidades del oro, a su color. Trabajo todos los procesos a mano, amo la huella que la mano humana deja en cada objeto.

Decido la tipología de una joya a partir del lo que me sugiere la maqueta original.

Me atrae el desafío de las piezas complejas, como los collares. Para hacer un collar es necesario tener en cuenta desde la forma del cuello y los hombros hasta la versatilidad, la comodidad, la flexibilidad, el movimiento y, sobre todo, el reto de pensar en el cuerpo humano como su entorno final.

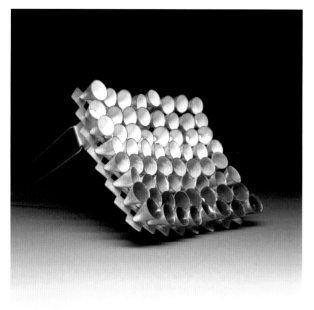
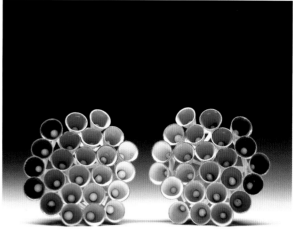
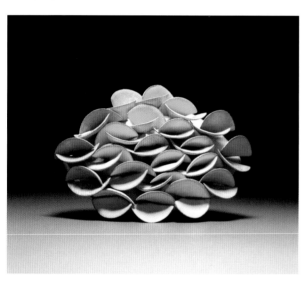
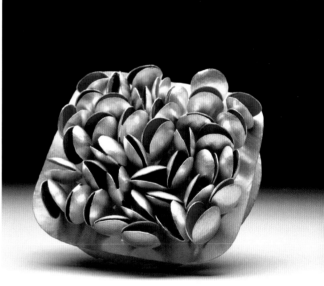

FRA / Je suis fascinée par le monde végétal, dans toutes ses échelles et toutes ses formes : la transformation, l'ordre, le chaos, la décomposition, les détails presque imperceptibles. Je veux célébrer l'extraordinaire coïncidence qui fait que la nature existe. Depuis l'essence de ce que je dessine, je construis une structure miniature en papier d'où jaillira un objet en or. Le papier est un matériau imprévisible, et la création de maquettes déclenche d'innombrables idées qui relient l'espace séparant un dessin d'une pièce en trois dimensions.

Quand j'étais petite à Londres, mon père m'emmenait aux musées. C'est à cette époque que remonte ma fascination pour les objets précieux des anciennes civilisations, pour le mystère qui se cache derrière l'intemporalité de leur puissant pouvoir de séduction.

J'utilise toujours de l'or 18 carats, que j'associe souvent à de l'émail vitrifié. Les qualités et la couleur de l'or sont incomparables. Je travaille les différentes techniques à la main : j'aime la trace que laisse la main dans les objets que l'on fabrique. Je décide de la typologie d'un bijou à partir de ce que me suggère la maquette originale.

J'aime relever le défi que posent les pièces complexes, comme les colliers. Pour fabriquer un collier, il faut prendre en compte la forme du cou et des épaules, et aussi la variabilité, le confort, la flexibilité, le mouvement, sans oublier que le corps humain sera son « présentoir ».

POR / Me fascina o mundo vegetal, em todas as suas escalas e estados vitais: a transformação, a ordem e o caos, a decomposição, detalhes quase imperceptíveis. Quero celebrar a extraordinária coincidência que faz com que a natureza exista. A partir da essência do que desenho, construo uma estrutura de papel em miniatura que se converterá num objeto de ouro. O papel é um material imprescindível e a criação das maquetes desperta dezenas de ideias que conectam o espaço entre um desenho e uma peça tridimensional.

Quando eu era menina, meu pai me levava aos museus de Londres e desde então me fascinam os objetos preciosos das antigas civilizações, o mistério que se oculta após a eternidade de seu poderoso encanto.

Utilizo sempre ouro de 18 quilates, frequentemente combinado com esmalte vítreo. Nada se pode comparar às qualidades do ouro, a sua cor. Trabalho todos os processos manualmente, amo a marca que a mão humana deixa em cada objeto. Decido a tipologia de uma joia a partir do que me sugere a maquete original. Me atrai o desafio das peças complexas, como os colares. Para fazer um colar é necessário ter em conta desde a forma do pescoço e dos ombros até a versatilidade, a comodidade, a flexibilidade, o movimento e, sobretudo, o desafio de pensar no corpo humano como a sua embalagem final.

Estela
Sàez

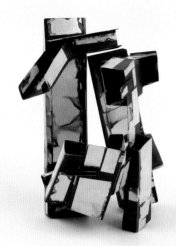

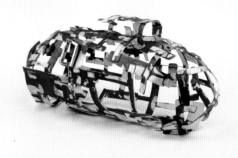

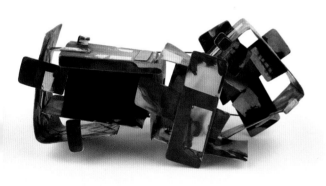

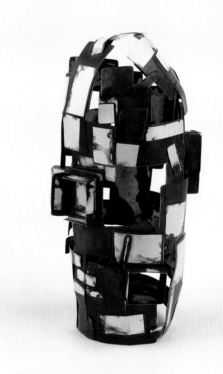

ENG / During my last trip I met lots of people, yet in spite of this I felt very alone, faced with the universal loneliness that we all have inside of us. We are born alone, we die alone, and we spend half of our lifetime trying to find someone. Along the way, some people develop intellectual mechanisms to combat this angst. Recognising the destruction of our cultural roots to be part of the purely human has not been easy. I transfer this state of mind to my pieces of jewellery: it balances my thoughts. The material chooses me and I, intuitively, follow it; I let myself be carried away by how my body, my touch, react to it. I have spent many hours in the studio looking for a new language: the *re-crystallisation* of stones and the strength of silver. And I've rediscovered how fleeting and fragile our existence is and how what happens on the outside influences me on the inside. I wonder about how my pieces will age.

ESP / Durante mi ultimo viaje he conocido a muchísima gente y, aún así, me he sentido muy sola, enfrentada a la soledad universal que todos llevamos dentro. Nacemos solos, morimos solos y pasamos media vida intentando encontrar a alguien. Durante el recorrido, algunas personas desarrollan mecanismos intelectuales para luchar contra esta angustia. Reconocer la destrucción de nuestras raíces culturales para formar parte de lo puramente humano no ha sido fácil. Transfiero este estado mental a mis piezas de joyería: esto equilibra mis pensamientos. El material me elige y yo, intuitivamente, lo sigo; me dejo llevar por cómo mi cuerpo, mi tacto, reaccionan a él. He pasado muchas horas en el taller buscando un nuevo lenguaje: la *re-cristalización* de las piedras y la fuerza de la plata. Y he descubierto de nuevo cuán fugaz y frágil es nuestra existencia y de qué manera lo que ocurre en el exterior influye en mi interior. Me pregunto cómo envejecerán las piezas.

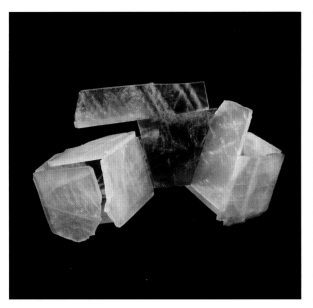

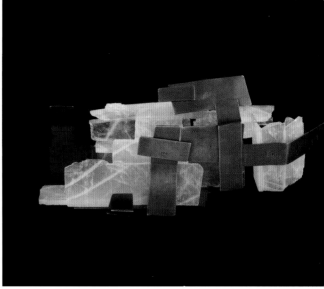

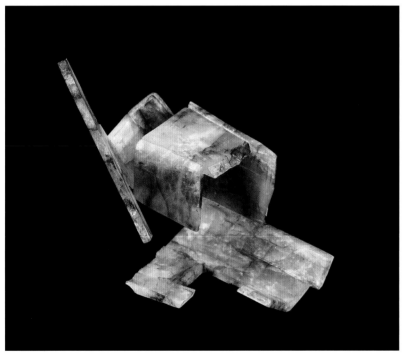

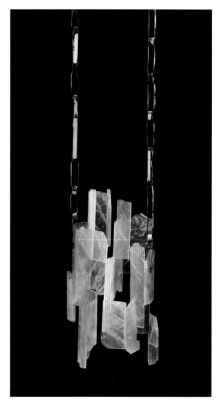

FRA / Lors de mon dernier voyage, j'ai rencontré énormément de monde, mais malgré tout je me suis sentie seule face à la solitude universelle que nous portons tous au fond de nous. Nous naissons seuls, nous mourons seuls et nous passons la moitié de notre vie à essayer de rencontrer l'autre. En chemin, certaines personnes développent des mécanismes intellectuels pour lutter contre cette angoisse. Ce n'est pas facile de reconnaître la destruction de nos racines culturelles pour n'appartenir qu'à ce qui est purement humain. Je transmets mon état mental à mes créations : ceci équilibre mes pensées. La matière me choisit, et moi je la suis intuitivement. Je me laisse porter par les réactions de mon corps et par mon sens du toucher. J'ai passé beaucoup de temps dans mon atelier à chercher un nouveau langage : la « *recristallisation* » des pierres et la force d'un métal comme l'argent. Et j'ai redécouvert la fugacité et la fragilité de nos existences et la façon dont l'extérieur influence mon monde intérieur. Je me demande comment mes bijoux vont vieillir.

POR / Durante minha última viagem conheci muitas pessoas e ainda assim, me senti muito sozinha, enfrentando a solidão universal que todos levamos dentro. Nascemos sozinhos, morremos sozinhos e passamos metade da vida tentando encontrar alguém. Durante este percurso, algumas pessoas desenvolvem mecanismos intelectuais para lutar contra esta angústia. Reconhecer a destruição de nossas raízes culturais para formar parte do puramente humano não tem sido fácil. Transfiro este estado mental às minhas peças de joias: isto equilibra meus pensamentos. O material me escolhe e eu, intuitivamente, o sigo; me deixo levar por como meu corpo, meu tato, reagem a ele. Passei muitas horas na oficina buscando uma nova linguagem: a *recristalização* das pedras e a força da prata. E descobri de novo o quão fugaz e frágil é a nossa existência e de que maneira o que ocorre no exterior influencia no meu interior. Me pergunto como envelheceriam as peças.

Philip Sajet

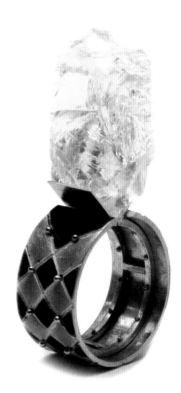

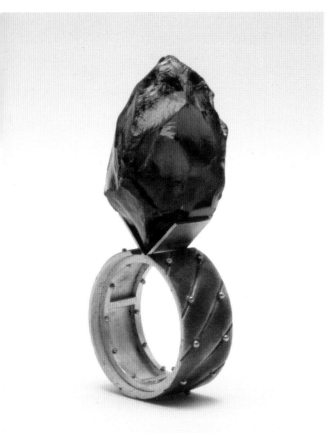

ENG / At the beginning of my career, I went through a stage of total laziness. I even thought about becoming a money forger. The gallery owner Louise Smit asked me for some pieces for an exhibition and I prepared twenty-five very different ones. At that time my lack of consistency seemed like a weakness to me, so I decided to exaggerate it and turn it into my distinguishing feature. A piece of jewellery has a strange power that allows the person that possesses it to feel different from everyone else, to gain a certain uniqueness. Why is this? I don't know, but it's what happens. For me life is sacred; it shocks me when I hear people say that violence inspires me. I have a series called *Broken Blood*, which sounds very good, but it is a theatrical exaggeration, conjuring up images, tragic symbols: something that should not have occurred. A cry against injustice. There is much at stake when a piece is in contact with the skin. The union between the wearer and the jewellery is total, and this is why I like small necklaces that surround the throat and protect it. I have complex feelings toward gold; I feel like it's mine and I get jealous when I see other people with it! I also use colours: transparent enamel on white silver or huge pieces of jewellery made with delicate translucent stones. Rusted things that we find on the street also offer beautiful shades of brown. The idea of beauty, to be able to make an absolutely beautiful object, increasingly captivates me. Sometimes I manage it, in some ways. And sometimes, when it works, unexpected shapes appear, which is fascinating.

ESP/ Al principio de mi carrera pasé por una etapa de absoluta desidia. Incluso pensé en dedicarme a la falsificación de monedas. La galerista Louise Smit me pidió piezas para una exposición y preparé veinticinco muy distintas. En ese momento mi falta de coherencia me pareció una debilidad, así que decidí exagerarla y convertirla en mi elemento diferencial. Una joya tiene un extraño poder que permite a quien la posee sentirse distinto de los demás, apoderarse de una cierta singularidad. ¿Por qué es así? No lo sé, pero ocurre. Para mí la vida es sagrada, me choca cuando oigo decir que me inspira la violencia. Tengo una serie llamada *Sangre rota*, que suena muy bien, pero es una exageración teatral, evoca imágenes, símbolos trágicos: algo que no debería haber ocurrido. Un grito contra la injusticia. Hay mucho en juego cuando una pieza está en contacto con la piel. La unión entre el portador y la joya es completa, por eso me gustan los collares cortos que rodean la garganta y la protegen. Tengo sentimientos complejos hacia el oro, ¡siento que es mío y tengo celos cuando lo veo en otras manos! También uso colores: esmalte transparente sobre plata blanca o joyas enormes hechas con delicadas piedras translúcidas. Las piezas oxidadas que encontramos en la calle ofrecen también hermosas tonalidades de marrón. Cada vez me cautiva más la idea de belleza, poder ser capaz de hacer un objeto absolutamente bello. En ocasiones lo consigo, en cierto modo. Y a veces, cuando funciona, aparecen formas inesperadas, lo que es fascinante.

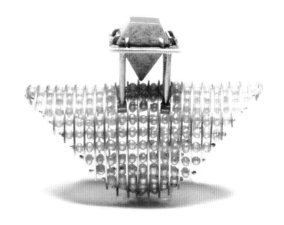

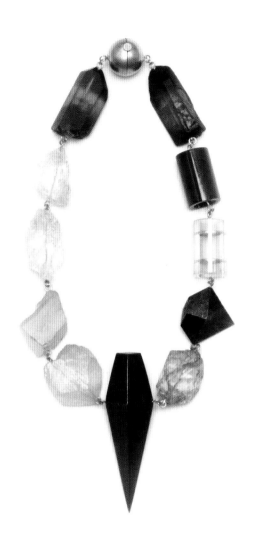

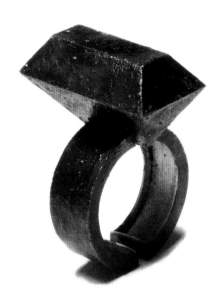

POR / A princípio de minha carreira passei por uma etapa de absoluta apatia. Inclusive pensei em me dedicar à falsificação de moedas. A galerista Louise Smit me pediu peças para uma exposição e preparei vinte e cinco muito diferentes. Neste momento, a minha falta de coerência me pareceu uma fraqueza, assim que decidi exagerá-la e convertê-la em meu elemento diferencial. Uma joia tem um estranho poder que permite a quem a use a sentir-se diferente dos demais, apoderar-se de certa singularidade. Por que é assim? Não sei, mas ocorre. Para mim a vida é sagrada, eu me choco quando escuto algo que me inspira a violência. Tenho uma série chamada *Sangue roto*, que soa muito bem, mas é uma exageração teatral, invocando imagens, símbolos trágicos: algo que não deveria ter ocorrido. Um grito contra a injustiça. Há muito em jogo quando uma peça está em contato com a pele. A união entre o usuário e a joia está completa, por isso eu gosto dos colares curtos que rodeiam a garganta e a protegem. Tenho sentimentos complexos em relação ao ouro, sinto que é meu e tenho ciúmes quando o vejo em outras mãos! Também uso cores: esmalte transparente sobre a prata branca ou joias enormes feitas com delicadas pedras translúcidas. As peças oxidadas que encontramos nas ruas oferecem também belas tonalidades de marrom. Cada vez mais me cativa a ideia de beleza, poder ser capaz de fazer um objeto absolutamente belo. Em algumas ocasiões eu consigo, de certa maneira. E às vezes, quando funciona, aparecem formas inesperadas, o que é fascinante.

FRA / Au début de ma carrière, j'ai eu une période de démotivation totale. J'ai même envisagé de me consacrer à la fabrication de fausses pièces de monnaie. La galeriste Louise Smit m'a demandé de créer des bijoux pour une exposition, et j'en ai préparé vingt-cinq très différents les uns des autres. À l'époque, j'ai pris ce manque de cohérence pour une faiblesse et puis j'ai décidé d'accentuer ce défaut pour en faire une force, une marque de fabrique. Tout bijou possède un pouvoir étrange : celui de donner à son porteur l'impression d'être différent des autres, de sortir du lot. Pourquoi ? Je n'en sais rien, mais c'est ainsi. Pour moi, la vie est sacrée et je m'insurge lorsque certaines personnes prétendent qu'elle m'inspire de la violence. J'ai créé une série qui s'appelle *Sang brisé*. C'est un nom qui sonne bien, mais c'est une exagération théâtrale qui évoque des images et des symboles tragiques : quelque chose qui n'aurait jamais dû arriver. En fait c'est un cri contre l'injustice. Il se passe beaucoup de choses lorsqu'un bijou est en contact avec la peau. L'union entre le porteur et le bijou est totale. C'est pour cela que j'aime les colliers ras de cou qui entourent la gorge et la protègent. J'entretiens avec l'or une relation complexe. J'estime qu'il m'appartient, et je deviens jaloux lorsque je le vois entre d'autres mains. J'utilise également des couleurs : de l'émail transparent sur de l'argent blanc ou bien des bijoux énormes composés de délicates pierres translucides. Les pièces oxydées que nous trouvons dans la rue présentent de jolis tons marron. La notion de beauté me fascine chaque jour davantage, le fait d'être capable de créer quelque chose de vraiment beau. J'y arrive parfois. Et dans ces moments-là, des formes inattendues naissent sous mes doigts. C'est complètement envoûtant.

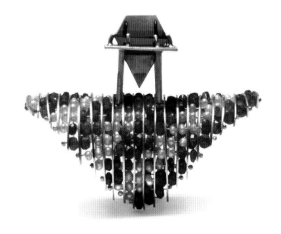

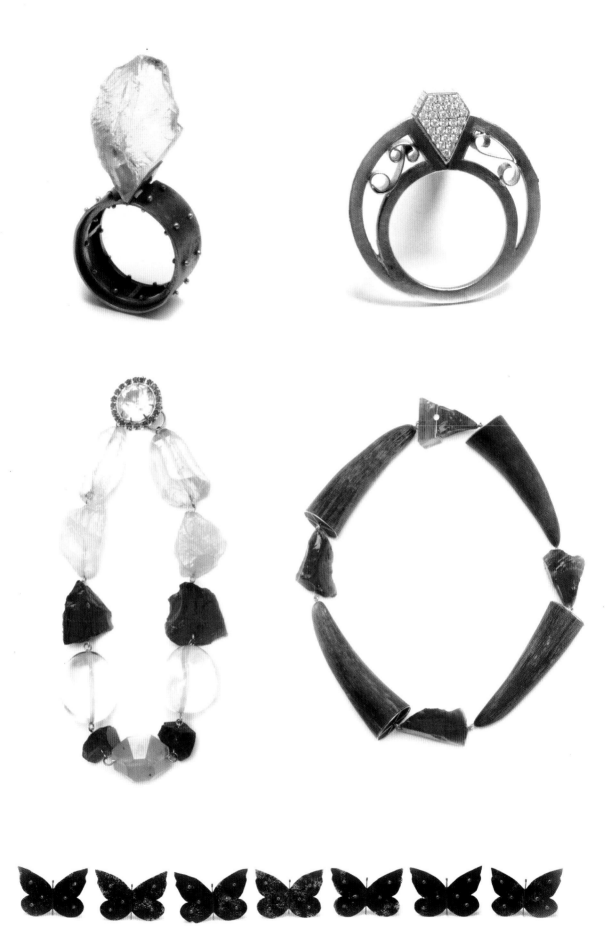

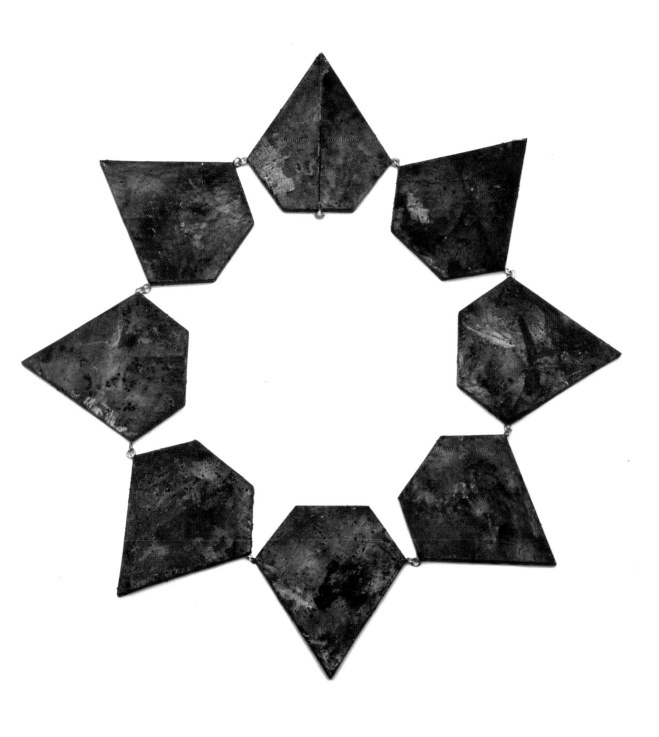

A piece of jewellery has a strange power that allows the person that possesses it to feel different from everyone else, to gain a certain uniqueness.

Ezra
Satok-Wolman

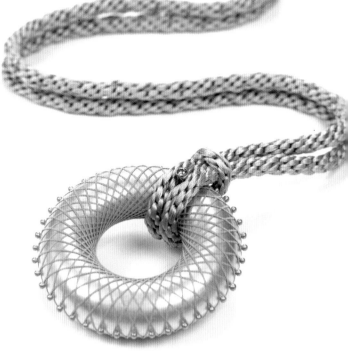

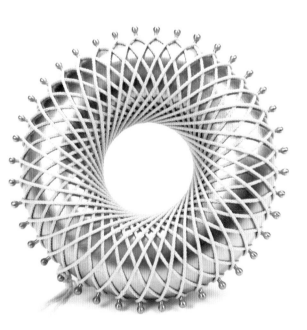

ESP/ Me fascina la precisión geométrica constante tanto en la naturaleza terrestre como en el universo, por eso exploro temas relacionados con la cosmología, las matemáticas y las dinámicas estructurales del mundo natural. Trabajo sobre los orígenes de esta ciencia, el número áureo como una constante del diseño y la idea de las matemáticas como el *lenguaje universal*. Científicos como Pitágoras, Platón o más tarde Galileo y Copérnico, que contribuyeron con sus descubrimientos a nuestra comprensión del mundo, son fuente de inspiración para mí. Como orfebre y joyero, siento gran admiración por Giovanni Corvaja. La música también es una parte integral de mi proceso de trabajo, sobre todo Phish, que para mí constituyen el equilibrio perfecto entre la composición calculada y la improvisación. Mis piezas están hechas a mano y el proceso empieza con una aleación de metales elementales. Siempre me ha encantado fabricar y construir piezas con múltiples componentes y mecanismos. Paso mucho tiempo trabajando con el martillo. Mis materiales preferidos son el oro, el paladio y el platino, sobre todo por la amplia gama de colores que permiten al ser aleados. Ya antes de ser joyero y gemólogo coleccionaba piedras y minerales y elijo siempre cristales naturales o piedras cortadas que tengan una geometría interesante.

ENG/ I'm fascinated by the constancy of geometric precision, both in nature here on Earth and in the universe, and so I explore topics related to cosmology, mathematics, and the structural dynamics in the natural world. I work on the origins of this science, the golden ratio as a constant of the design and the idea of mathematics as the *universal language*. Scientists like Pythagoras, Plato or later Galileo and Copernicus, who contributed with their discoveries to our understanding of the world, are a source of inspiration for me. As a goldsmith and jeweller, I feel a great admiration for Giovanni Corvaja. Music is also an integral part of my work process, especially Phish, who for me represent the perfect balance between calculated composition and improvisation. My pieces are made by hand and the process begins with an alloy of metallic elements. I have always loved manufacturing and building pieces with multiple components and mechanisms. I spend a lot of time working with a hammer. My favourite materials are gold, palladium and platinum, above all because of the wide range of colours that they allow once in alloy form. Before becoming a jeweller and gemologist I collected stones and minerals and I always choose natural crystals or cut stones that have interesting geometry.

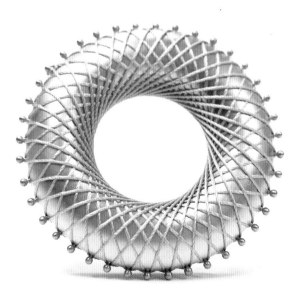

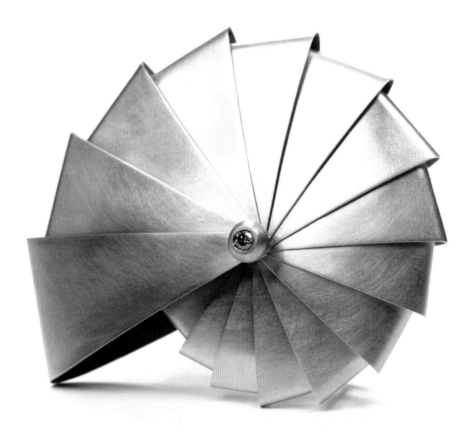

FRA / Je suis en admiration devant la précision géométrique
qui existe dans la nature terrestre et dans l'univers. C'est
pour cela que j'explore des sujets liés à la cosmologie, aux
mathématiques et aux dynamiques structurelles du monde
naturel. Je travaille sur les origines de cette science, sur le
nombre d'or qui est une constante de la création et sur les
mathématiques qui sont un *langage universel*. Des savants
comme Pythagore et Platon, ainsi que Galilée et Copernic
plus tard, ont contribué grâce à leurs découvertes à une
meilleure compréhension du monde. Ils sont pour moi une
source d'inspiration. En tant qu'artisan orfèvre et joaillier, j'ai
une grande admiration pour Giovanni Corvaja. La musique
fait également partie intégrante de mon processus créatif,
surtout Phish qui selon moi symbolise l'équilibre parfait
entre la composition calculée et l'improvisation. Mes bijoux
sont façonnés à la main, et leur fabrication commence
toujours par un alliage de métaux de base. J'ai toujours aimé
élaborer et construire des bijoux comportant de multiples
éléments et mécanismes. Je passe beaucoup de temps à
travailler la pièce au marteau.
Mes matériaux préférés sont l'or, le palladium et le platine,
car leur alliage permet d'obtenir une vaste gamme de couleurs.
Avant d'être joaillier et gemmologue, je collectionnais les
pierres et les minéraux. Je choisis toujours des cristaux
naturels ou des pierres taillées qui présentent une
géométrie intéressante.

POR / Me fascina a precisão geométrica constante tanto da
natureza terrestre como do universo, por isso exploro temas
relacionados com a cosmologia, a matemática e a dinâmica
estrutural do mundo natural. Trabalho sobre as origens desta
ciência, o número áureo como uma constante do desenho
e a ideia da matemática como Linguagem Universal.
Cientistas como Pitágoras, Platão ou mais tarde Galileu
e Copérnico, que contribuíram com seus descobrimentos
à nossa compreensão do mundo, são fontes de inspiração
para mim. Como ourives e joalheiro, sinto grande admiração
por Giovanni Corvaja. A música também é uma parte integral
do meu processo de trabalho, sobretudo Phish, que para mim
constituiem o equilíbrio perfeito entre a composição calculada
e a improvisação. Minhas peças são feitas à mão e o processo
começa com uma liga de metais elementares. Sempre adorei
fabricar e construir peças com múltiplos componentes e
mecanismos. Passo muito tempo trabalhando com o martelo.
Meus materiais preferidos são o ouro, o paládio e a platina,
sobretudo pela ampla gama de cores que permitem ao serem
ligados. Já antes de ser joalheiro e gemólogo colecionava
pedras e minerais e escolho sempre cristais naturais ou
pedras cortadas que tenham uma geometria interessante.

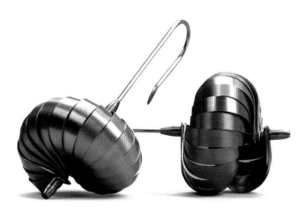

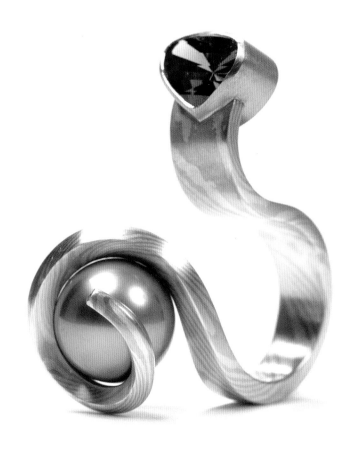

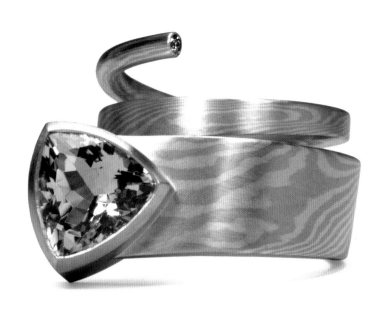

I work on the origins of this science, the golden ratio as a constant of the design and the idea of mathematics as the universal language.

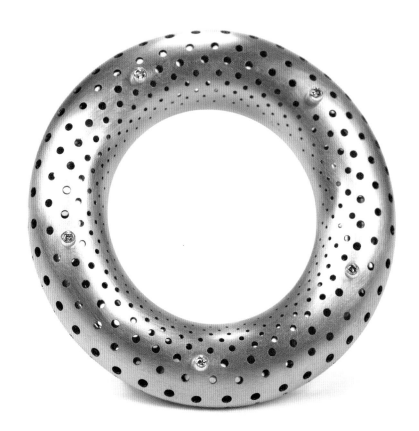

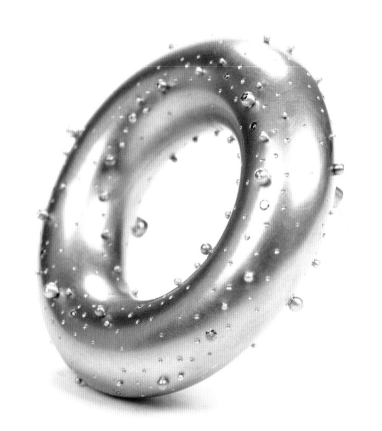

Karin
Seufert

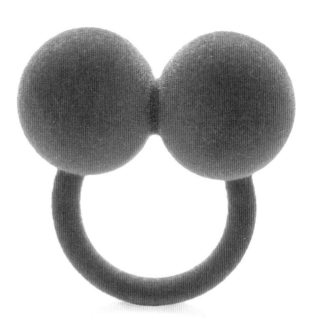

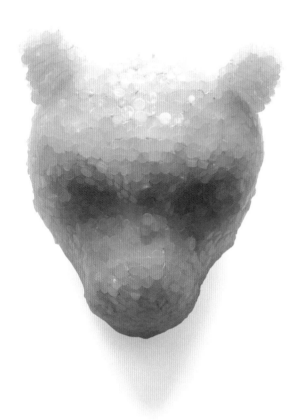

ENG / It fascinates me to question the value of things, and to change and manipulate their appearance. Making something recognizable and also changing our perceptions are the themes that keep me busy. I am inspired by anything, from architecture to a piece of art, a film, consumer society, advertising... everything around me can be a direct or subliminal inspiration. Years ago I needed to investigate religion, consumption and mass phenomena, and I used the Coca-Cola logo or ones belonging to sports brands, which are like modern fetishes, and allude to a new religion. I have also reconstructed emblematic pieces of jewellery out of unusual materials. Right now I am fascinated by the beauty of the plastic corks, with their perfect blend of colour, pattern, shape and size, and which go straight into the bin.
My favourite material is PVC because of its amazing transformational ability and its ability to be adapted to the techniques I use. I don't think that I've discovered all the possibilities it offers yet. Recently I have been using textile techniques such as sewing, backstitching or crocheting when working with plastics. I like the processes that take time.

ESP / Me fascina cuestionar el valor de las cosas, cambiar y manipular su aspecto. Hacer que algo sea reconocible y también transformar nuestra percepción, son temas que me mantienen ocupada. Me inspira cualquier cosa: desde la arquitectura hasta una pieza de arte, una película, la sociedad de consumo, la publicidad...todo a mi alrededor puede ser inspiración, directa o subliminal. Hace años necesitaba investigar la religión, el consumo y los fenómenos de masas y usé el logo de Coca-Cola o los logos de marcas deportivas, que son como fetiches modernos y aluden a una nueva religión. También he reconstruido piezas emblemáticas de joyería en materiales inusuales. Ahora mismo me fascina la belleza de los tapones de plástico, con su perfecta fusión de color, dibujo, forma y tamaño, que se va directa a la basura. Mi material favorito es el PVC, por sus increíble capacidad de transformación y su adaptabilidad a las técnicas que uso. Creo que todavía no he descubierto todas sus posibilidades. Últimamente utilizo técnicas textiles como la costura, los pespuntes o el ganchillo al trabajar con mis plásticos. Me gustan los procesos que requieren tiempo.

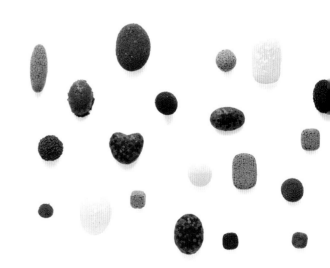

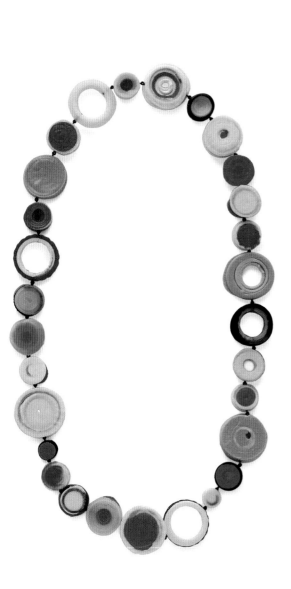

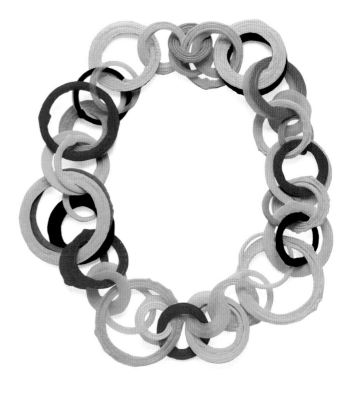

FRA / J'aime m'interroger sur la valeur des choses, transformer et manipuler leur aspect. Je cherche à fabriquer un objet qui soit reconnaissable, mais qui en même temps modifie notre perception. Tout m'inspire, de l'architecture à une œuvre d'art en passant par un film, la société de consommation, la publicité... Tout ce qui m'entoure peut servir de source d'inspiration directe ou subliminale. Autrefois, j'avais besoin d'étudier la religion, la consommation et les phénomènes de masse. À l'époque, j'ai utilisé le logo de Coca-Cola et de marques de sport qui sont des fétiches modernes évoquant une nouvelle religion. J'ai aussi reconstruit des bijoux emblématiques dans des matériaux inhabituels. Aujourd'hui, c'est la beauté des bouchons en plastique qui m'attire, avec la fusion parfaite de la couleur, du dessin, de la forme et de la taille, et que l'on jette directement à la poubelle.

Ma matière de prédilection est le PVC en raison de son incroyable capacité de transformation et de son adaptabilité aux techniques que j'emploie. Je pense que je n'ai pas encore découvert toutes ses possibilités. Depuis peu, j'utilise des techniques textiles, comme la couture, la piqûre ou le crochet, pour travailler le plastique. J'aime les procédés qui prennent du temps.

POR / Me fascina questionar o valor das coisas, mudar e manipular seu aspecto. Fazer com que algo seja reconhecível e também transformar nossa percepção é um tema que me deixa ocupada. Me inspira qualquer coisa: desde a arquitetura até uma peça de arte, um filme, a sociedade de consumo, a publicidade...tudo ao meu redor pode ser inspiração, direta ou subliminar. Há anos precisava investigar a religião, o consumo e os fenômenos das massas e então usei o logotipo da Coca-Cola ou das marcas esportivas, que são como fetiches modernos e que fazem alusão a uma nova religião. Também reconstruí peças emblemáticas de joia em materiais incomuns. Agora mesmo me fascinam a beleza das tampas de plástico, que vão direto para o lixo, com a sua perfeita fusão de cor, desenho, forma e tamanho. Meu material favorito é o PVC, por sua incrível capacidade de transformação e a sua adaptação às técnicas que uso. Acredito que ainda não descobri todas as suas possibilidades. Ultimamente utilizo técnicas têxteis como a costura, os pespontos ou o crochê ao trabalhar com meus plásticos. Eu gosto dos processos que requerem tempo.

Jiří
Šibor

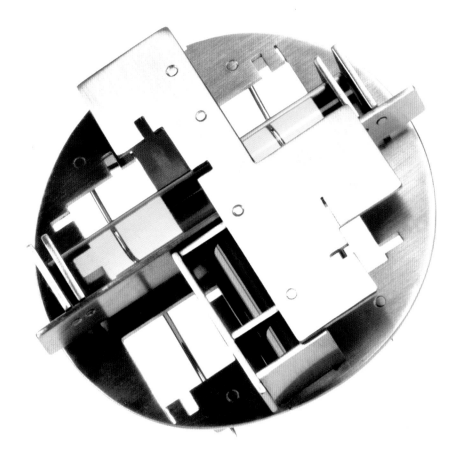

ENG/ I make small sculptural figures that could be defined as jewellery. I love the fact that the visual characteristics of works of art can cross the limits of our perception. As artists, everything we do is the result of an influence. For me, Richard Serra and his work into the symbols of balance and human frailty is a fundamental influence. And so is James Turrell, with his wonderful studies of light and space and non-verbal communication as a part of our perception. My favourite material is metal, especially stainless steel. I like the way that when you work with it it responds with toughness. And by chance it is also one of the key metals in my zodiac sign. The process that I like most in my work is riveting, a limited, old-fashioned technique. The past and the future are connected.

ESP/ Hago pequeñas figuras esculturales que podrían definirse como joyería. Me fascina el hecho de que las características visuales de las obras de arte pueden atravesar los límites de nuestra percepción. Como artistas, todo lo que hacemos es el resultado de una influencia. Para mí, Richard Serra, con su trabajo sobre los símbolos de equilibrio y fragilidad humana es una influencia fundamental. Y también James Turrell, con su maravilloso estudio de la luz, el espacio y la comunicación no verbal como parte de nuestra percepción. Mi material favorito es el metal, sobre todo el acero inoxidable. Me gusta cómo, al trabajarlo, responde con dureza. Y casualmente también es uno de los metales dominantes en mi signo del zodíaco. El proceso que más me gusta en mi trabajo es el remache, una técnica limitada, antigua. El pasado y el futuro se conectan.

FRA / Je fabrique de petits objets structurels que l'on peut qualifier de bijoux. J'adore le fait que les caractéristiques visuelles des œuvres d'art dépassent les limites de notre perception. En tant qu'artistes, tout ce que nous faisons est le résultat d'une influence quelconque. Personnellement, je dois beaucoup à Richard Serra et à son travail sur les symboles de l'équilibre et de la fragilité humaine. Et je m'appuie aussi sur James Turrell et sa merveilleuse étude de la lumière, de l'espace et de la communication non verbale qui font partie de notre perception. Mon matériau préféré est le métal, surtout l'acier inoxydable. J'aime voir comment il durcit au cours du processus de façonnage. C'est aussi un des métaux dominants de mon signe du zodiaque. La technique que j'affectionne le plus est le rivetage, qui est ancienne et plutôt limitée. Elle relie le passé et le futur.

POR / Faço pequenas figuras esculturais que poderiam se definir como joalheria. Me fascina o fato de que as características visuais das obras de arte podem atravessar os limites da nossa percepção. Como artistas, tudo o que fazemos é o resultado de uma influência. Para mim, Richard Serra, com seu trabalho sobre os símbolos de equilíbrio e fragilidade humana é uma influência fundamental. E também James Turrell, com seu maravilhoso estúdio da luz e do espaço e comunicação não verbal como parte da nossa percepção. Meu material favorito é o metal, sobretudo o aço inoxidável. Eu gosto como, ao trabalhá-lo, ele responde com dureza. E casualmente também é um dos metais dominantes do meu signo do zodíaco. O processo que mais gosto no meu trabalho é a rebitagem, uma técnica limitada, antiga. O passado e o futuro se conectam.

Vera
Siemund

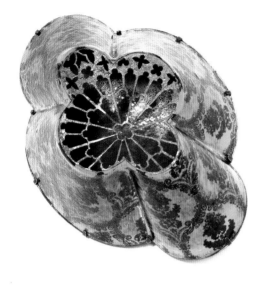

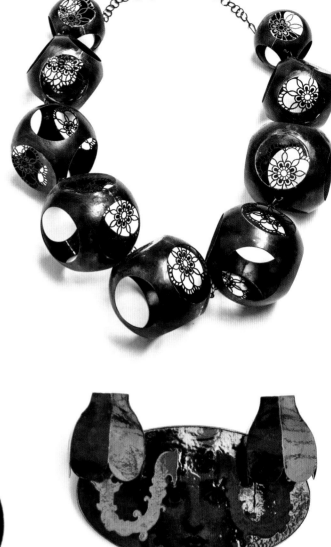

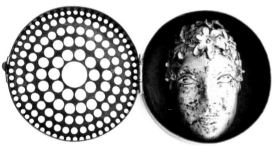

ENG / True beauty is something that has to be discovered. I'm eclectic, I explore art forms from other eras. Not only high culture and canonical design, but also the trivial: what is seen as ugly can be my object of interest. Sometimes I find incredibly moving things in these excerpts of *low culture,* in the trash. I love diving into the past, going into a particular time and trying to understand its creations. But I then need to transform the objects that I admire into something new, something that is relevant to me, today.

My sources of inspiration change. For quite a while I was very influenced by classicism, for example the architecture of Karl Friedrich Schinkel. I take steps back and forward in the history of art, and this may seem arbitrary, but for me it is not a game. I have a predilection for traditional goldsmithing techniques, which provide very different results. I love metals like iron and steel because of their hardness and colour. When I want to include colour, enamel is for me the most honest, though difficult material.

I'm not interested in producing a large number of copies of the same piece, and I often lose interest after making a prototype.

ESP / La verdadera belleza tiene algo que hay que descubrir. Soy ecléctica, exploro formas artísticas de otras épocas. Pero no sólo la alta cultura y el diseño canónico, sino también lo trivial: aquello que se ve como feo puede ser mi objeto de interés. A veces descubro cosas increíblemente conmovedoras en estos extractos de la *baja cultura,* en la basura. Me encanta bucear en el pasado, adentrarme en un tiempo concreto y tratar de entender sus creaciones. Pero luego necesito transformar los objetos que admiro en algo nuevo, algo que sea relevante para mí, hoy.

Mis fuentes de inspiración cambian. Durante bastante tiempo estuve muy influida por el clasicismo, por ejemplo la arquitectura de Karl Friedrich Schinkel. Doy pasos hacia atrás y hacia adelante en la historia del arte, y ello puede parecer arbitrario, pero para mí no es un juego. Siento predilección por las técnicas tradicionales de orfebrería, que proporcionan resultados muy diferentes. Me encantan los metales como el hierro o el acero, debido a su dureza y su color. Cuando quiero incluir color, el esmalte para mí es el material más honesto, aunque difícil.

No me interesa producir un gran número de copias de la misma pieza y a menudo pierdo el interés después de hacer un prototipo.

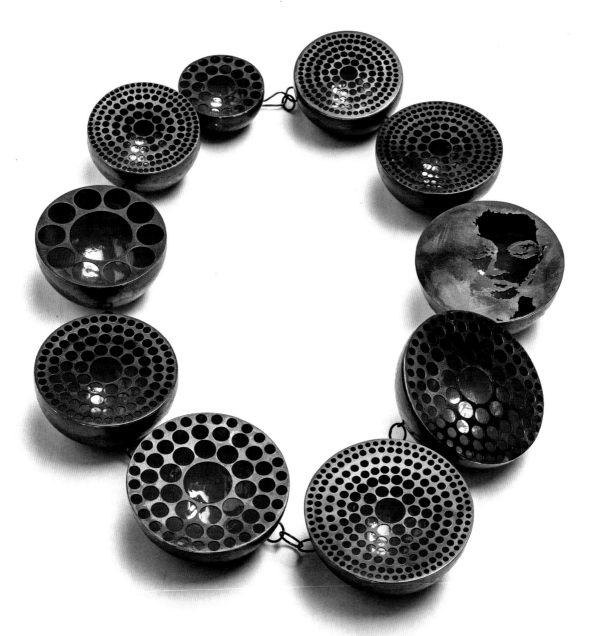

FRA / La vraie beauté cache quelque chose qu'il convient de découvrir. Je suis éclectique, j'explore des formes artistiques d'autres époques. Je ne m'intéresse pas seulement à la grande culture et à l'art officiel, mais aussi à des objets banals, voire moches. Je découvre parfois des choses très émouvantes dans les recoins de la culture *de bas étage*, dans les ordures. J'aime me plonger dans le passé, m'immerger dans une époque précise et essayer de comprendre les créations de cette période. Mais ensuite, j'ai besoin de transformer les objets que j'admire en quelque chose de nouveau qui ait un sens pour moi aujourd'hui.

Mes sources d'inspiration changent. Pendant un temps, j'ai été très influencée par le classicisme, par exemple, par l'architecture de Karl Friedrich Schinkel. Je fais quelques pas en arrière et puis en avant dans l'histoire de l'art. Je sais que cela peut paraître arbitraire, mais pour moi ce n'est pas un jeu. J'ai une prédilection pour les techniques traditionnelles d'orfèvrerie, qui produisent des résultats très originaux. J'aime les métaux comme le fer ou l'acier, à cause de sa dureté et de sa teinte. Lorsque je veux ajouter de la couleur, je préfère l'émail qui est à mon avis la matière la plus honnête, bien qu'elle soit difficile à travailler.

Produire de multiples copies d'un même bijou ne m'intéresse pas. La plupart du temps, je n'ai pas envie de refaire la même chose une fois que j'ai créé un prototype.

POR / A verdadeira beleza tem algo a descobrir. Sou eclética, exploro formas artísticas de outras épocas. Mas não só a alta-costura e o desenho canônico, como também o trivial: aquilo que se vê como feio pode ser meu objeto de interesse. Às vezes eu descubro coisas incrivelmente comovedoras nestes extratos da *baixa cultura*, no lixo.

Eu adoro mergulhar no passado, aprofundar-me num tempo concreto e tratar de entender as suas criações. Mas logo preciso transformar os objetos que admiro em algo novo, algo que seja relevante para mim hoje.

Minhas fontes de inspiração mudam. Durante bastante tempo estava muito influenciada pelo classicismo, por exemplo, a arquitetura de Karl Friedrich Schinkel. Dou passos para trás e para frente na história da arte, e isto pode parecer arbitrário, mas para mim não é um jogo.

Sinto predileção pelas técnicas tradicionais de ourivesaria, que proporcionam resultados muito diferentes. Eu adoro os metais como o ferro ou o aço, devido à sua dureza e a sua cor. Quando quero incluir cor, o esmalte para mim é o material mais honesto, ainda que difícil.

Não me interessa produzir um grande número de cópias da mesma peça e com frequência perco o interesse depois de fazer um protótipo.

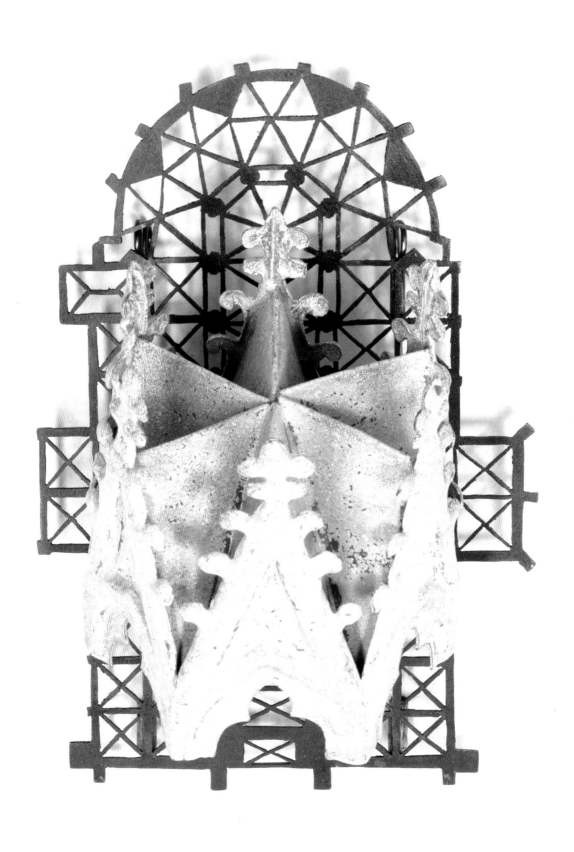

I'm eclectic, I explore art forms from other eras.

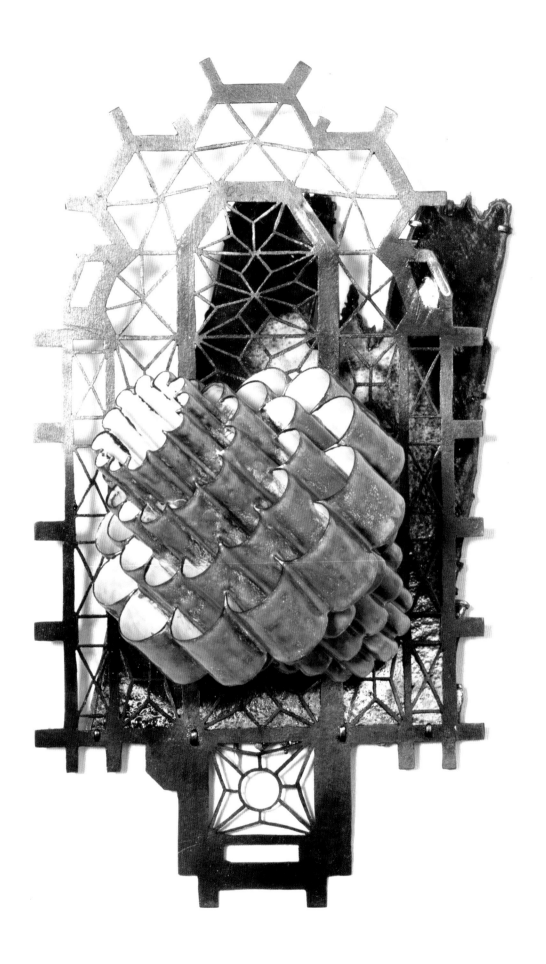

Peter Skubik

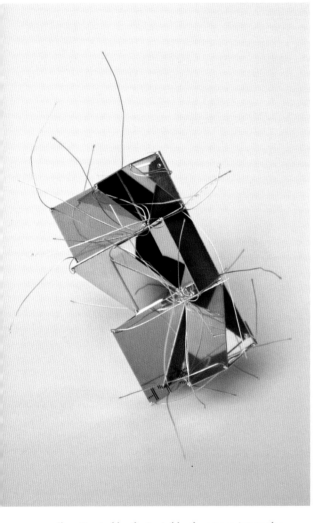

ENG / I'm attracted by the invisible, the non-existent, the imagined, the transitory, everything that is behind what we see. I like to get to the bottom of things.

I have been working for a few years with mirror pieces made from stainless steel. The surfaces reflect their surroundings, confronting the viewer with changing appearances; they are invisible, like mirrors. Our vision is only a small part of our senses.

I love stainless steel because it allows me to create large pieces that are beyond the conventional limits of the jewellery. The concept of tension is something that I explore continuously. Often it is my state of mind, and I project it by connecting pieces together using compression and fixing them with springs or magnets.

Proportion is essential for calibrating both feelings and art. It delimits good and evil, as well as the optical tension in the visual arts.

I'm also interested in secrets. In jewellery these can be amulets, photos, hair or an object locked away in a locket. I like to create jewellery pieces that are codes or use coded language, like Morse code or Fibonacci numbers, to get accidental proportions or sequences of colours.

ESP / Me atrae lo invisible, lo no-existente, lo imaginado, lo transitorio, todo aquello que está detrás de lo que vemos. Me gusta llegar al fondo de las cosas.

Desde hace unos años trabajo con piezas de espejo de acero inoxidable. Las superficies reflejan su entorno, confrontando al espectador con las apariencias cambiantes; son invisibles, como los espejos. La vista es solo una pequeña parte de nuestros sentidos.

Me encanta el acero inoxidable, porque me permite crear grandes piezas, más allá de los límites convencionales de la joyería. El concepto de tensión es algo que exploro continuamente. A menudo es mi estado mental y lo proyecto uniendo piezas mediante compresión y fijándolas con muelles o imanes.

La proporción es fundamental para calibrar tanto los sentimientos como el arte. Delimita el bien y el mal, pero también la tensión óptica en las artes visuales.

También me interesan los secretos. En la joyería pueden ser amuletos, fotos, cabello o un objeto encerrado en un medallón. Me gusta crear joyas que sean códigos o usar lenguaje cifrado, como el código Morse o los números Fibonacci, para obtener proporciones accidentales o secuencias de colores.

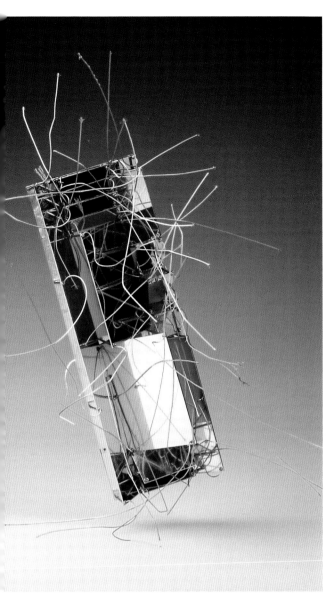

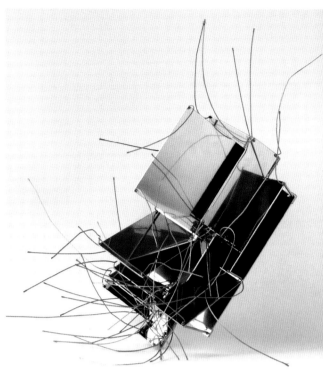

POR / Me atrae o invisível, o não existente, o imaginado, o transitório, tudo aquilo que está atrás do que vemos. Eu gosto de chegar ao fundo das coisas. Há alguns anos, trabalho com peças de espelho de aço inoxidável. As superfícies refletem o seu redor, confrontando o espectador com as aparências mutáveis; são invisíveis, como os espelhos. À primeira vista, é só uma pequena parte dos nossos sentidos. Eu adoro o aço inoxidável, porque me permite criar grandes peças, mais além dos limites convencionais da joalheria. O conceito de tensão é algo que exploro continuamente. Com frequência é o meu estado mental e o projeto unindo peças mediante compressão e fixando-as com molas ou ímãs. A proporção é fundamental para calibrar tanto os sentimentos como a arte. Delimita o bem e o mal, mas também a tensão ótica nas artes visuais. Também me interessam os segredos. Na joalheria podem ser amuletos, fotos, cabelos ou um objeto preso num medalhão. Eu gosto de criar joias que sejam códigos ou usar linguagem cifrada, como o código Morse ou os números Fibonacci, para obter proporções acidentais ou sequencia de cores.

FRA / Je suis attiré par l'invisible, l'inexistant, l'imaginaire, le transitoire, par tout ce qui se cache derrière ce que nous voyons. J'aime aller au fond des choses. Depuis plusieurs années je travaille avec des morceaux de miroir en acier inoxydable. Les surfaces renvoient l'environnement et confrontent le spectateur avec le reflet changeant des apparences qui sont invisibles comme les miroirs. La vue n'est qu'une infime partie de nos sens. J'ai une préférence pour l'acier inoxydable parce qu'il me permet de réaliser des pièces de grand format qui vont au-delà des limites de la bijouterie traditionnelle. J'explore en permanence le concept de tension. Comme cela correspond souvent à mon état mental, je projette cette tension en assemblant des pièces par compression et en les fixant à l'aide de ressorts ou d'aimants. Le sens de la mesure est ce qui compte par dessus tout, aussi bien en art qu'en amour. Il permet de tout calibrer. Il délimite le bien et le mal ainsi que la tension optique entre les arts visuels. Je suis aussi fasciné par les secrets. En joaillerie, il peut s'agir d'amulettes ou d'une photo, une mèche de cheveux ou un objet conservés dans un médaillon. J'aime créer des bijoux qui fonctionnent à la manière des codes secrets, ou utiliser un langage chiffré comme le morse ou les nombres de Fibonacci pour obtenir des proportions accidentelles ou des suites de couleurs.

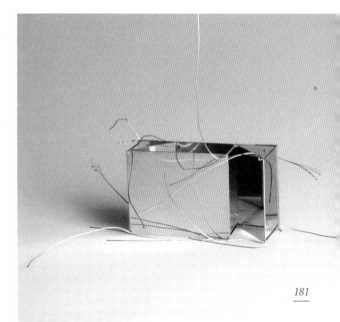

Despo
Sophocleus

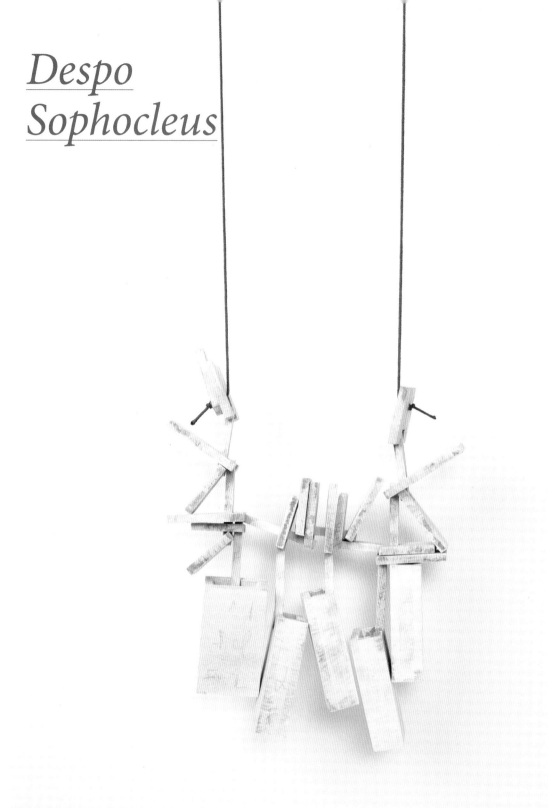

ENG / There was a movement in the place
And a change of direction
That led you to a point between two others
And to another place in time

ESP / Hubo un movimiento en el lugar
Y un cambio de dirección
Que te condujo a algún punto entre otros dos
Y a otro lugar en en tiempo

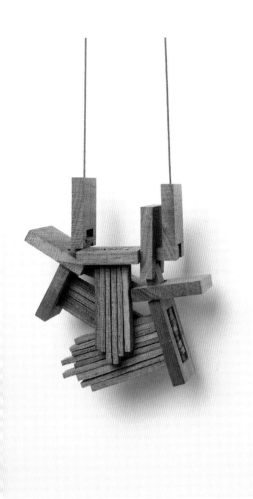
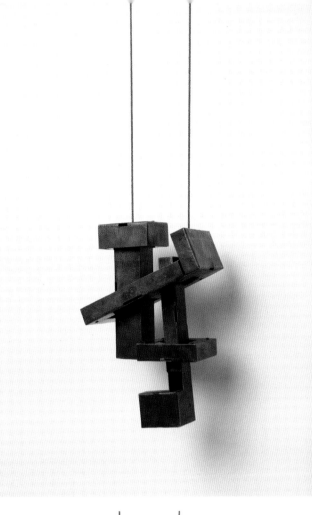
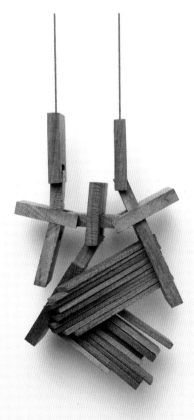
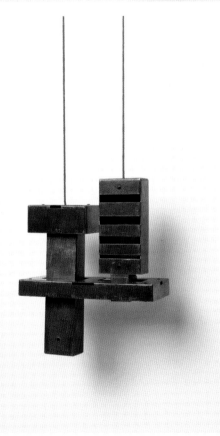

FRA / Il y a eu un mouvement ici
Et un déplacement dans l'autre sens là
Qui t'a conduit à un point situé entre toi et moi
Vers un autre lieu dans le temps

POR / Houve um movimento no lugar
E uma mudança de direção
Que te conduz a algum ponto entre outros dois
E a outro lugar no tempo.

Bettina
Speckner

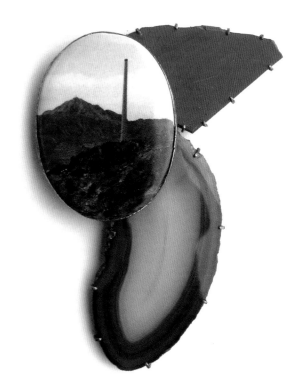

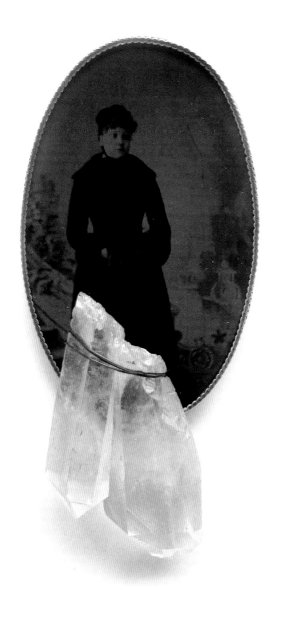

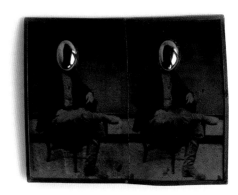

ENG / There is inspiration in everything. Max Beckmann, the great German expressionist painter, said: "I am seeking for the bridge which leans from the visible to the invisible through reality. It may sound paradoxical, but it is in fact reality which forms the mystery of our existence." This sentence sums up my search, what I want to explore as a jeweller. This is why I like to integrate images into my pieces; for me they have the same function as stones, gold or shells. Each material, just like each image, tells a story. My images, rather than narrating a situation, allow a story to be captured. Before becoming a jeweller I was a painter, and I think that's why my favourite pieces are brooches: they're the closest thing to a painter's canvas. I like to play with the two-dimensionality of the brooch (mine are almost always flat) and the three-dimensionality implied in a photograph.

ESP / La inspiración está en todo. Max Beckmann, el gran pintor expresionista alemán, dijo: "Mi objetivo es hacer visible lo invisible a través de la realidad. Aunque suene paradójico, es de hecho la realidad lo que conforma el misterio de nuestra existencia". En esta frase se encuentra resumida mi búsqueda, aquello que deseo explorar como joyera. Por eso me gusta integrar imágenes en mis piezas, para mí tienen la misma función que las piedras, el oro o las conchas. Cada material, como cada imagen, cuenta una historia, Mis imágenes, más que narrar una situación, permiten apropiarse de una historia. Antes de ser joyera era pintora y creo que por eso mis piezas favoritas son los broches: son lo más parecido al lienzo del pintor. Me gusta jugar con la bidimensionalidad del broche (los míos son casi siempre planos) y la tridimensionalidad que lleva implícita una fotografía.

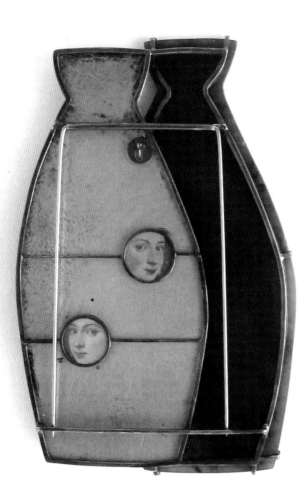

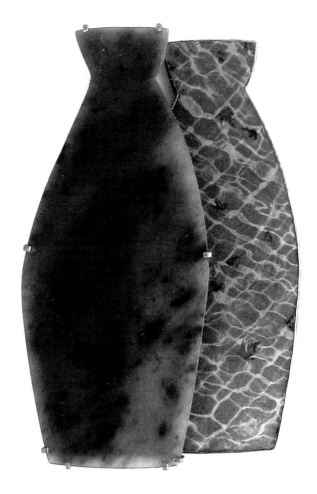

POR / A inspiração está em tudo. Max Beckmann, o grande pintor expressionista alemão, disse: "Meu objetivo é fazer visível o invisível através da realidade. Ainda que pareça paradoxo, é de fato a realidade que configura o mistério da nossa existência". Nesta frase se encontra resumida a minha busca, aquilo que desejo explorar como joalheira. Por isso eu gosto de integrar imagens nas minhas peças, para mim têm a mesma função que as pedras, o ouro ou as conchas. Cada material, como cada imagem, conta uma história. Minhas imagens, mais que narrar uma situação, permitem apropriar-se de uma história. Antes de ser joalheira eu era pintora e creio que por isso, minhas peças favoritas são os broches: é o mais parecido à tela do pintor. Eu gosto de jogar com o bidimensional do broche (os meus são quase sempre planos) e a tridimensionalidade que uma fotografia leva implícita.

FRA / L'inspiration est partout. Max Beckmann, le grand peintre expressionniste allemand a dit : « Je cherche à rendre l'invisible visible au moyen de la réalité. Cela peut paraître contradictoire, mais c'est un fait que la réalité constitue le mystère de notre existence. » Cette phrase résume ce que je recherche et la mission que je me suis fixée en tant que bijoutier. C'est pour cela que j'aime intégrer des images dans mes bijoux, parce qu'elles revêtent pour moi la même fonction que les pierres, l'or et les coquillages. Chaque matériau, comme chaque image, raconte une histoire. Mes images font bien plus que narrer une situation : elles permettent de s'approprier une histoire. J'étais peintre avant de devenir joaillière, et je crois que c'est pour cela que je préfère les broches, parce qu'elles se rapprochent de la toile. J'aime jouer avec les deux plans d'une broche (les miennes sont presque toujours planes) et la tridimensionnalité implicite d'une photographie.

Gisbert Stach

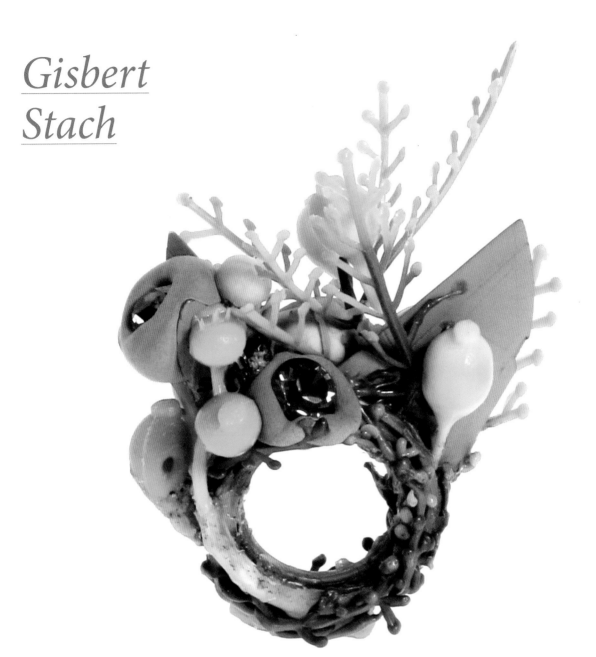

ENG / I want to find a middle path between creating pieces of jewellery, acting with pieces of jewellery and making films about jewellery. I'm fascinated by the phenomena that take place in materials (plastics melting, metal dissolving in acid); images of destruction like car or plane crashes; natural phenomena (a diamond burning at high temperatures); powerful symbols (a heart, a cross or a diamond); the emotions connected to jewellery (addictions to buying wearing and consuming it) .

This is why I want to show how time affects materials—deformation and destruction, but also imitation, for example making a piece of amber that looks edible.

Any story regarding jewellery attracts me, from Greek mythology to articles or police reports. Or, for example, the Paul Simon song Diamonds on the Soles of Her Shoes.

I am interested in all types of materials: plastics, amber, silicone, asphalt, acid, alabaster, electronic parts, industrial jewellery...

I like to melt, dissolve, glue, assemble, destroy, burn... and also film pieces of jewellery and act with them.

ESP / Quiero encontrar un camino medio entre crear joyas, actuar con joyas y hacer películas sobre la joyería. Me fascinan los fenómenos que tiene lugar en los materiales (fundir plásticos, disolver metal en ácido), imágenes de destrucción como coches o aviones accidentados; fenómenos de la naturaleza –un diamante que se quema a altas temperaturas-; símbolos poderosos, como un corazón, una cruz, o un diamante; las emociones conectadas a la joyería, como la adicción a comprarla, llevarla, consumirla.

Por eso me interesa mostrar cómo el tiempo afecta a los materiales: la deformación, la destrucción o también la imitación: hacer de una pieza de ámbar algo que parezca comestible.

Cualquier historia relacionada con la joyería me atrae: desde la mitología griega hasta artículos o informes de la policía. O, por ejemplo, la canción de Paul Simon: Diamonds on the Soles of Her Shoes.

Me interesan todo tipo de materiales; plásticos, ámbar, silicona, asfalto, ácido, alabastro, piezas electrónicas, la joyería industrial…

Me gusta fundir, disolver, pegar, ensamblar, destruir, quemar….Y también filmar las joyas, actuar con ellas.

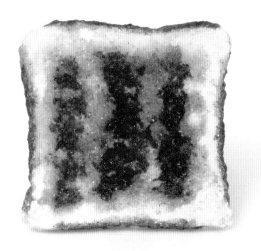

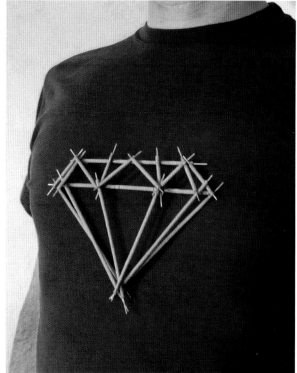

POR / Quero encontrar um caminho médio entre criar joias, atuar com joias e fazer filmes sobre a joalheria. Me fascinam os fenômenos que ocorrem com os materiais (derreter plásticos, dissolver metal no ácido), imagens de destruição como acidentes de carros ou aviões; fenômenos da natureza – um diamante que se queima em altas temperaturas; - símbolos poderosos, como um coração, uma cruz ou um diamante; as emoções conectadas à uma joia, como o vício em comprá-la, usá-la, consumi-la.

Por isso me interessa mostrar como o tempo afeta os materiais: a deformação, a destruição ou também a imitação: fazer de uma peça de âmbar algo que se pareça comestível.

Qualquer história relacionada com a joia me atrai: desde a mitologia grega até artigos ou relatos da polícia. Ou, por exemplo, a canção de Paul Simon: Diamonds on the Soles of Her Shoes.

Me interessa todo tipo de material: plástico, âmbar, silicone, asfalto, ácido, alabastro, peças eletrônicas, joia industrial...

Eu gosto de derreter, dissolver, colar, montar, destruir, queimar... E também filmar as joias, atuar com elas.

FRA / Je veux trouver un moyen terme entre les trois facettes de ma passion pour les bijoux : la création, l'interaction et le documentaire. Je suis fasciné par les phénomènes liés aux matériaux (fonte du plastique, dissolution du métal dans de l'acide), images de destruction qui rappellent les véhicules ou les avions accidentés ; par les péripéties de la nature (diamant brûlant à haute température) ; par les symboles forts comme un cœur, une croix ou un diamant ; par les émotions associées aux bijoux tel que l'achat, le port et la consommation compulsifs.

C'est pour cela que j'aime montrer l'effet du temps sur les matériaux, la déformation, la destruction et aussi l'imitation, par exemple, créer un bijou en ambre qui ressemble à quelque chose de comestible.

Toutes les histoires qui ont un lien avec les bijoux me passionnent, de la mythologie grecque aux articles de presse en passant par les rapports de police. Ou la chanson de Paul Simon « Diamonds on the Soles of Her Shoes ».

Tous les types de matériaux m'intéressent : les plastiques, l'ambre, la silicone, l'asphalte, l'acide, l'albâtre, les composants électroniques, la joaillerie industrielle...

J'aime fondre, dissoudre, coller, assembler, détruire, brûler... Et aussi filmer les bijoux, interagir avec eux.

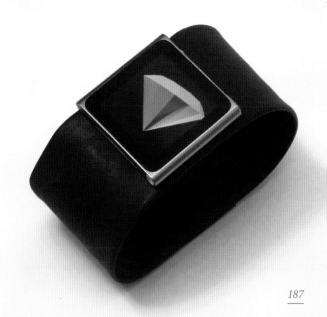

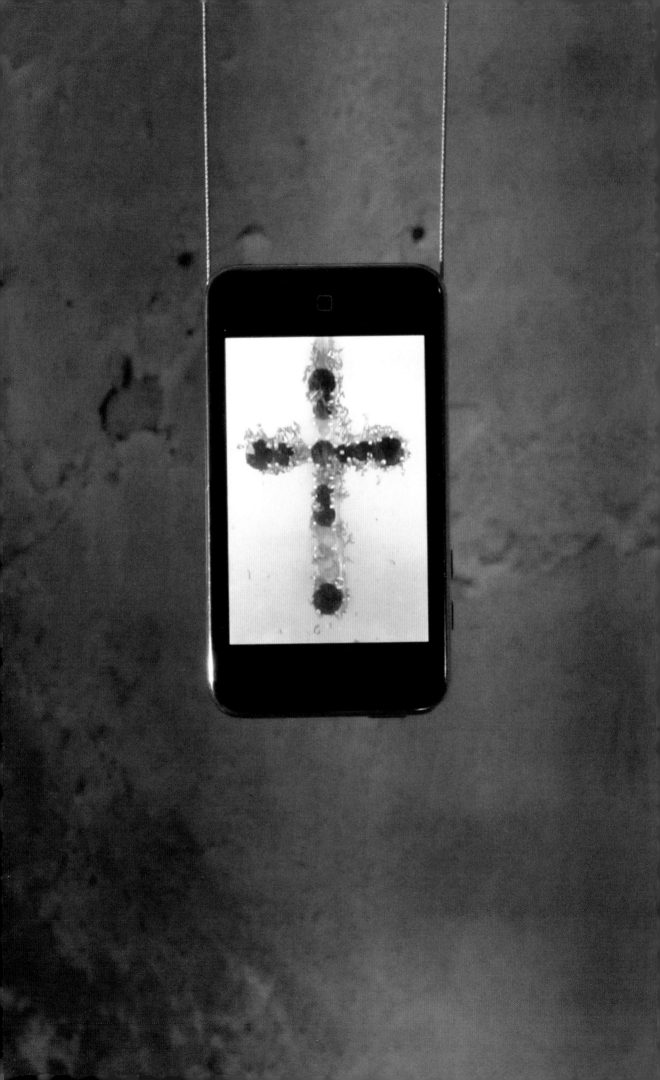

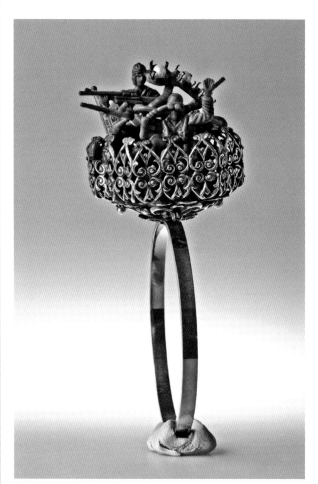

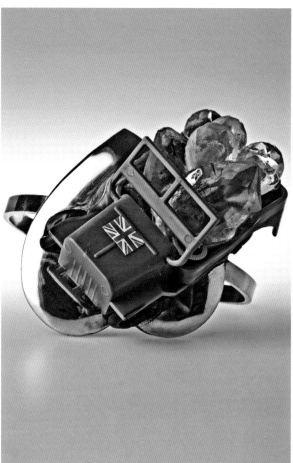

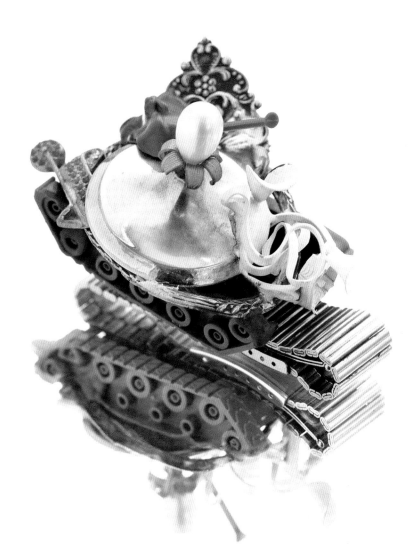

Antje Stolz

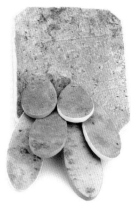

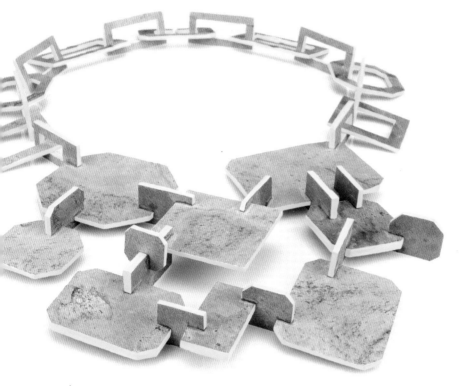

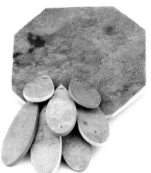

ENG / In my work I like to play with the perception, associations, illusion. In my edges and etchings I look for the contrast between the subtle gradations of natural slate and the bright colours of neon lights. For me, stones contain an element of pragmatism. They come from nature and each one of them is unique. I like the idea that neither the wearer nor the viewer can see all the steps of the process at a glance, because it appears to be made from a single block. People are always surprised by how little my pieces weigh, and they never expect them to be so comfortable. I love that moment. Slate layers allow me to build big and exuberant pieces that weigh very little. The classical forms of faceted stones are an essential element of jewellery.

For this reason I like to play with these images and create a certain confusion. The observer expects to know what is in front of them, but just by looking at them closely or touching them they realise their mistake. Plastic and artificial materials are very important in my work. They let me make my own mark from the outset. I can mix materials, dye them, put them into moulds, join bits together, cut jagged layers or imitate crystal's perfect shapes.

ESP / En mi trabajo me gusta jugar con la percepción, las asociaciones, la ilusión. Busco el contraste entre las gradaciones sutiles de la pizarra natural y los colores brillantes de las luces de neón en los bordes y en los grabados. Para mí, las piedras contienen un elemento de pragmatismo. Provienen de la naturaleza y cada una de ellas es única. Me gusta la idea de que tanto el portador como el espectador no puedan ver todos los pasos del proceso a simple vista, porque parece hecha de un único bloque. La gente siempre se sorprende de lo poco que pesan mis piezas y nunca se esperan que resulten tan cómodas. Me encanta ese momento. Las capas de pizarra me permiten construir grandes y exuberantes piezas que pesan muy poco. Las formas clásicas de las piedras facetadas son un elemento esencial de la joyería. Por eso me gusta jugar con estas imágenes y crear una cierta confusión. El observador espera saber qué tiene delante, pero solo al verlas de cerca o al tocarlas se da cuenta del error. Los materiales plásticos y artificiales son muy importantes en mi trabajo. Me permiten dejar mi propia marca desde el principio. Puedo mezclar los materiales, teñirlos, ponerlos en moldes, unir fragmentos, cortar capas irregulares o imitar formas perfectas de cristal.

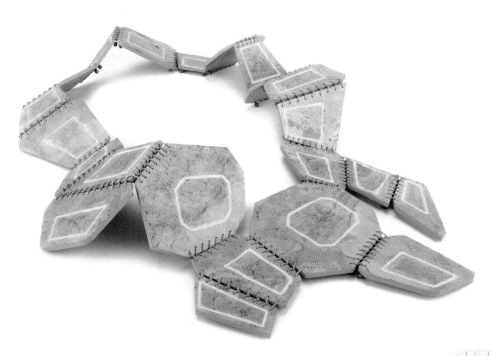

FRA / Dans mon travail, j'aime jouer avec la perception, les associations, l'illusion. Je recherche le contraste entre les dégradés subtils de l'ardoise naturelle et les couleurs vives des lumières de néon sur les contours et dans les creux des gravures. Je pense que les pierres ont un côté pragmatique. Elles sont issues de la nature et chacune d'elle est unique. Je me réjouis que ni le porteur ni le spectateur ne puisse noter toutes les étapes du processus au premier coup d'œil, parce que le bijou a l'air taillé d'une seule pièce. Les gens sont souvent surpris de constater que mes bijoux ne pèsent presque rien et sont si commodes à porter. J'adore ce moment de la découverte. Les couches d'ardoise me permettent de construire de grandes pièces exubérantes d'une légèreté aérienne. Les formes classiques des pierres à facettes font partie intégrante de la joaillerie. J'aime jouer avec cette idée et créer une surprise : l'observateur pense savoir de quoi il s'agit, mais lorsqu'il regarde le bijou de plus près ou le saisit, il se rend compte de sa méprise. Les matières plastiques et artificielles occupent une place importante dans mon travail. Elles me permettent de prendre mes marques dès le départ. Je peux mélanger les matériaux, les teindre, les couler dans des moules, assembler différents fragments, découper des couches irrégulières ou imiter les formes parfaites des cristaux.

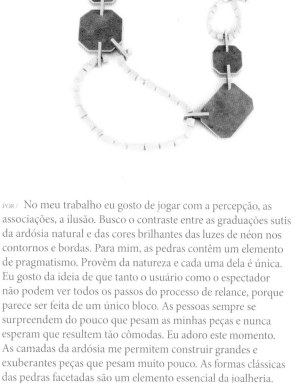

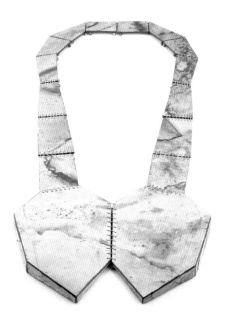

POR / No meu trabalho eu gosto de jogar com a percepção, as associações, a ilusão. Busco o contraste entre as graduações sutis da ardósia natural e das cores brilhantes das luzes de néon nos contornos e bordas. Para mim, as pedras contêm um elemento de pragmatismo. Provêm da natureza e cada uma dela é única. Eu gosto da ideia de que tanto o usuário como o espectador não podem ver todos os passos do processo de relance, porque parece ser feita de um único bloco. As pessoas sempre se surpreendem do pouco que pesam as minhas peças e nunca esperam que resultem tão cômodas. Eu adoro este momento. As camadas da ardósia me permitem construir grandes e exuberantes peças que pesam muito pouco. As formas clássicas das pedras facetadas são um elemento essencial da joalheria. Por isso eu gosto de jogar com estas imagens e criar certa confusão. O observador espera para saber o que tem adiante, mas só ao vê-las de perto ou ao tocá-las se dá conta do equívoco. Os materiais plásticos e artificiais são muito importantes no meu trabalho. Me permitem deixar minha própria marca desde o princípio. Posso misturar os materiais, tingi-los, pô-los em formas, unir fragmentos, cortar camadas irregulares ou imitar formas perfeitas de cristal.

Tore
Svensson

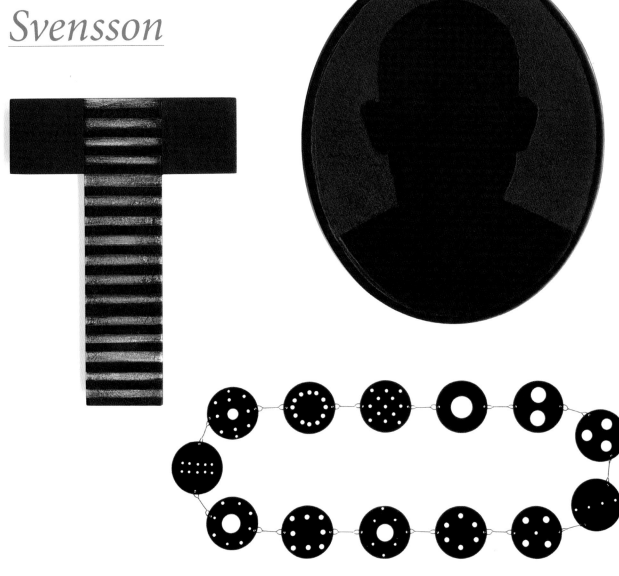

ENG / I try to explore myself and also my surroundings through geometry and mathematics, which are very much present in my work. I am fascinated by the contemplative expression of minimalist art, especially artists such as Donald Judd and Richard Serra. But I have also been influenced by artists from other disciplines, such as Nick Cave and Haruki Murakami. After seeing an exhibition, a film or a play I always look forward to getting to work.

Before training as a silversmith and jeweller, I became interested in painting and graphic arts. When I started working with metal I soon adopted the technique of engraving; the surfaces of my pieces are very important to me. My interest in painting has subsequently been revived and now I use a lot of colour in my works.

For years steel has been my favourite material. It helps me to achieve the result I'm looking for. I like to work in series and my projects tend to go on for a long time. A new idea will emerge from my current work and the beginning and the end become difficult to tell apart. My series allow me to make small changes in expression and content.

ESP / Intento explorarme a mí mismo y también mi entorno mediante la geometría y las matemáticas, que están muy presentes en mi trabajo. Me fascina la expresión contemplativa del arte minimalista, sobre todo de artistas plásticos como Donald Judd o Richard Serra. Pero también me han influido artistas de otras disciplinas como Nick Cave o Haruki Murakami. Después de ver una exposición, una película o una obra de teatro siempre estoy deseando ponerme a trabajar. Antes de formarme como platero y joyero me interesé por la pintura y las artes gráficas. Cuando empecé a trabajar con el metal enseguida adopté la técnica del grabado; las superficies de mis piezas son muy importantes para mí. Posteriormente he recuperado mi interés por la pintura y ahora uso mucho el color en mis obras

Desde hace años el acero es mi material favorito, me ayuda a alcanzar el resultado que busco. Me gusta trabajar con series y mis proyectos suelen prolongarse en el tiempo. Una nueva idea emerge de mi trabajo actual y el principio y el final se hacen difíciles de discernir. Con las series consigo formular pequeños cambios de expresión y contenido.

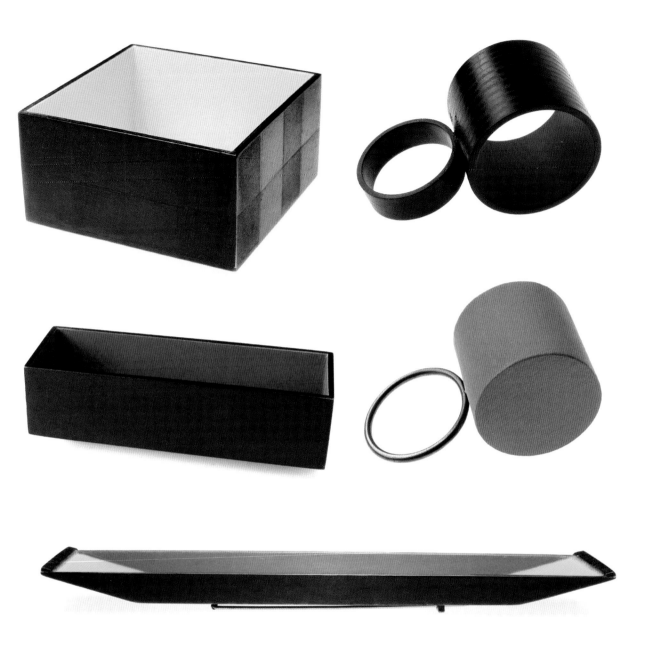

FRA / Je cherche à explorer mon moi intérieur ainsi que
mon environnement par le biais de la géométrique et des
mathématiques qui sont très présents dans mes créations.
L'expression contemplative de l'art minimaliste me fascine,
surtout les œuvres de plasticiens comme Donald Judd et
Richard Serra. Mais des artistes d'autres disciplines m'ont aussi
influencée, dont Nick Cave et Haruki Murakami. Après avoir
vu une exposition, un film ou une pièce de théâtre, j'ai
toujours envie de me mettre à travailler.
Avant de me former au métier d'orfèvre, je me suis intéressée
à la peinture et aux arts graphiques. Lorsque j'ai commencé
à travailler le métal, j'ai tout de suite adopté la technique de
la gravure : les surfaces de mes bijoux ont pour moi une
importance capitale. Par la suite, je suis revenue à la peinture
et aujourd'hui j'utilise beaucoup la couleur dans mes créations.
L'acier est depuis longtemps mon matériau de choix : il me
permet d'atteindre le résultat que je vise. J'aime travailler sur des
séries, et mes projets courent souvent sur une longue période.
Lorsqu'une réalisation m'inspire une nouvelle idée, il m'est
difficile d'en visualiser le début et la fin. Avec les séries, j'arrive à
formuler de légères variations au niveau de la forme et du fond.

POR / Tento explorar a mim mesmo e também o meu redor
mediante a geometria e a matemática, que estão muito presentes
no meu trabalho. Me fascina a expressão contemplativa da arte
minimalista, sobretudo os artistas plásticos como Donald Judd
ou Richard Serra. Mas também me influenciaram artistas de
outras disciplinas como Nick Cave ou Haruki Murakami.
Depois de ver uma exposição, um filme ou uma peça de teatro
sempre desejo voltar ao trabalho.
Antes de me formar como ourives e joalheiro, me interessei
pela pintura e as artes gráficas. Quando comecei a trabalhar
com o metal em seguida adotei a técnica da gravação; as
superfícies das minhas peças são muito importantes para mim.
Posteriormente recuperei meu interesse pela pintura e agora
uso muito as cores nas minhas obras.
Há anos o aço é o meu material favorito, me ajuda a alcançar
o resultado que busco. Eu gosto de trabalhar com séries e meus
projetos costumam prolongar-se no tempo. Uma nova ideia
emerge do meu trabalho atual e o início e o fim se fazem
difíceis de distinguir. Com as séries consigo formular
pequenas mudanças de expressão e conteúdo.

Edu
Tarín

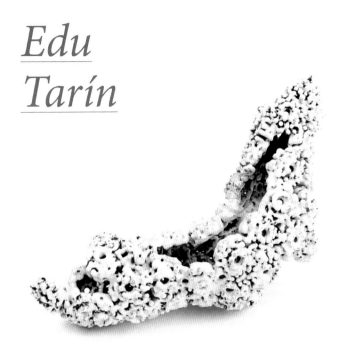

ENG / The weapon that keeps me going and alert during my creative process is the search for the unexpected within the familiar, without forgetting origins and paths previously travelled. Our perception is intimately related to learning life lessons and I am interested in exploring what new associations our subconscious is capable of establishing from the objects that we define as jewellery, which possess a specific aesthetic. For me, it is a reflection on how society processes its environment and how the art of jewellery is perceived in the collective memory.

Music influences me a lot when I am creating. Composers like Ottorino Respighi, Aram Khachaturian, Mussorgski and Falla manage to make the unknown take shape in my hands. I grew up in the world of commercial jewellery and I like the freedom to be able to use both traditional and industrial techniques, from lost-wax casting and enamelling to electroforming and electroplating. I have a special relationship with wax. I'm fascinated by the endless possibilities it offers and how easy it is to adapt it and capture the essence of a moment to then express its legacy in another material later on.

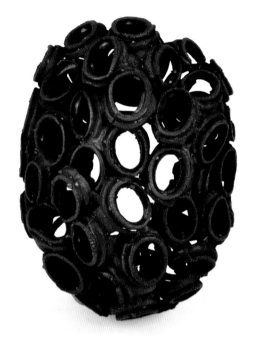

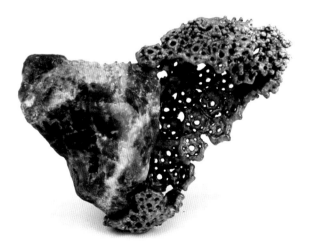

ESP / El arma que me incentiva y me mantiene alerta durante mi proceso creativo es la búsqueda de lo inesperado dentro de lo conocido, sin olvidar los orígenes y los senderos ya recorridos. Nuestra percepción está íntimamente relacionada con nuestro aprendizaje vital y a mí me interesa explorar qué nuevas asociaciones es capaz de establecer nuestro subconsciente a partir de esos objetos que definimos como joyería, que poseen una estética concreta. Para mí, es una reflexión sobre cómo la sociedad procesa el entorno y de qué manera el arte de la joyería es percibido en la memoria colectiva.

La música me influye mucho a la hora de crear. Compositores como Ottorino Respighi, Aram Khachaturian, Mussorgski o Falla consiguen hacer que lo desconocido vaya tomando forma en mis manos.

Crecí en el mundo de la joyería comercial y me gusta la libertad de poder usar técnicas tanto tradicionales como industriales, desde la fundición a la cera perdida, el esmaltado, el electroformado o la galvanoplastia. Tengo una relación especial con la cera. Me fascinan las infinitas posibilidades que ofrece, su facilidad de adaptarse y capturar la esencia de un momento para después plasmar su herencia en otro material.

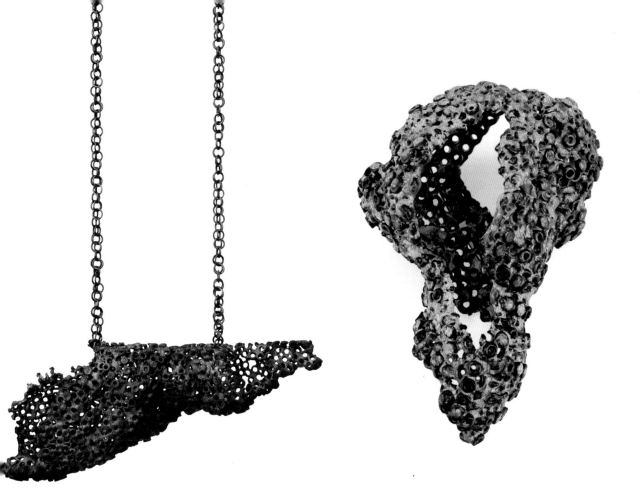

POR / A arma que me incentiva e me mantém alerta durante o meu processo criativo é a busca do inesperado dentro do conhecido, sem esquecer as origens e os caminhos já recorridos. Nossa percepção está intimamente relacionada com nossa aprendizagem vital e me interesso em explorar que novas associações são capazes de estabelecer nosso subconsciente a partir destes objetos que definimos como joia, que possuem uma estética concreta. Para mim, é uma reflexão sobre como a sociedade processa o ambiente e de que maneira a arte da joalheria é percebida na memória coletiva.

A música me influencia muito na hora de criar. Compositores como Ottorino Respighi, Aram Khachaturian, Mussorgski ou Falla conseguem fazer com que o desconhecido vá tomando formas em minhas mãos.

Cresci no mundo da joalheria comercial e gosto da liberdade de poder usar técnicas tanto tradicionais como industriais, desde o derretimento da cera perdida, o esmaltado, a eletroformação ou a galvanização. Tenho uma relação especial com a cera. Me fascinam as infinitas possibilidades que oferece, sua facilidade de adaptar-se e capturar a essência de um momento para depois refletir sua herança num outro material.

FRA / Ce qui me motive et me garde en alerte tout au long du processus créatif, c'est la recherche de l'inattendu dans le champ du connu, même si je n'oublie pas pour autant les origines ni les chemins déjà parcourus. Notre perception est intimement liée à notre apprentissage de la vie, et je m'intéresse aux nouvelles associations que notre inconscient est capable d'établir à partir de ces objets que nous appelons bijoux et qui possèdent une esthétique concrète. Pour moi, c'est une réflexion sur la manière dont la société traite l'environnement et sur la façon dont l'art de la joaillerie est perçu dans la mémoire collective.

La musique a une grande influence sur ma créativité. Des compositeurs comme Ottorino Respighi, Aram Khachaturian, Mussorgski et Falla poussent mes mains à donner une forme à ce fragment d'inconnu.

J'ai grandi dans le milieu de la bijouterie commerciale, et j'apprécie la liberté de pouvoir mélanger des techniques traditionnelles et industrielles allant de la cire perdue à l'émail, en passant par l'électroformage et la galvanoplastie. J'ai un rapport à la cire particulier. Je suis émerveillé par ses possibilités infinies, sa facilité d'adaptation et sa manière de capturer l'instant pour le traduire ensuite dans une autre matière.

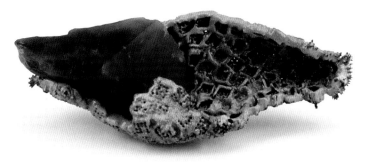

Fabrizio Tridenti

ENG / My goal is to be able to create a relationship, an exchange between a work and its audience. More than the jewellery itself, I'm interested in the reactions it provokes.

A piece of jewellery cannot stay within the limits of its function. When it is released infinite fields for experimentation that can result in productive artistic experiences are opened up; when the importance of the intangible is affirmed, the piece acquires a new perspective, and a whole set of values is reconstructed.

I'm interested in provoking reactions, debates, shifting the focus from an aesthetic experience to an intellectual one, or, rather, joining the two.

My father worked in construction, and I often helped him out when I was a child. I like places that are supposedly unattractive, and the big, colourful machines used in construction.

I am inspired by abandoned spaces and contemporary society's leftovers. I especially like waste material, items for recycling and industrial paint: I analyse chaotic structures and convert them into jewellery that can have an aesthetic function but at the same time get us mixed up in architectural chaos.

I am interested in the energy produced by chaos. For me, waste and disorder are very vibrant and expressive, the essence of our reality.

ESP / Mi objetivo es ser capaz de crear una relación, un intercambio entre obra y público. Más que la joya, me interesa las reacciones que provoca.

Una joya no puede permanecer dentro de los límites de su función. Al liberarla se abren infinitos campos de experimentación que pueden dar lugar a experiencias artísticas productivas: al afirmar la importancia de lo intangible, la joya adquiere una nueva perspectiva, se reconstruye una entera escala de valores.

Me interesa provocar reacciones, debates, cambiar el enfoque desde la experiencia estética a la experiencia intelectual o, mejor dicho, unirlas.

Mi padre trabajaba en la construcción y de niño a menudo le ayudaba. Me gustan estos lugares supuestamente poco atractivos y las grandes máquinas de colores que se usan en la construcción.

Me inspiro en los espacios abandonados y en los residuos producidos por la sociedad contemporánea. Especialmente me gusta el material de desecho, los artículos para reciclar y pintura industrial: analizo sus estructuras caóticas y los reconvierto en joyas que pueden tener una función estética pero que a la vez nos involucran en el caos arquitectónico.

Estoy interesado en la energía producida por el caos. Para mí, los residuos y el desorden son algo muy vibrante y expresivo, la esencia de nuestra realidad.

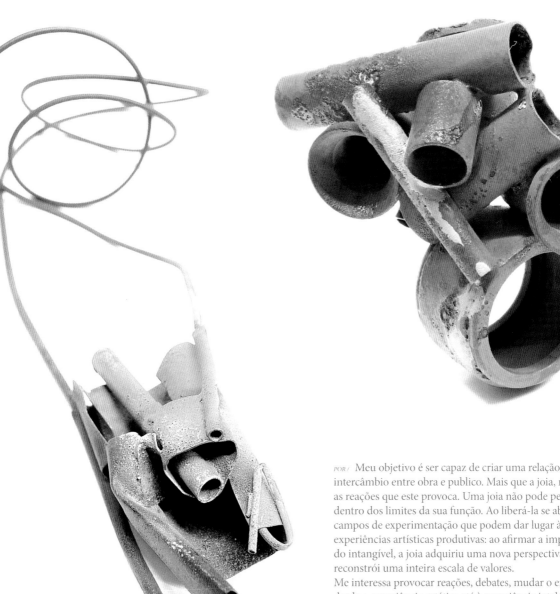

POR / Meu objetivo é ser capaz de criar uma relação, um intercâmbio entre obra e publico. Mais que a joia, me interessa as reações que este provoca. Uma joia não pode permanecer dentro dos limites da sua função. Ao liberá-la se abrem infinitos campos de experimentação que podem dar lugar às experiências artísticas produtivas: ao afirmar a importância do intangível, a joia adquiriu uma nova perspectiva, se reconstrói uma inteira escala de valores.

Me interessa provocar reações, debates, mudar o enfoque desde a experiência estética até à experiência intelectual ou, em outras palavras, uni-las. Meu pai trabalhava na construção e de criança, com frequência eu o ajudava. Eu gosto dos lugares supostamente pouco atrativos, e das grandes maquinas coloridas que se usam na construção.

Me inspiro nos espaços abandonados e nos resíduos produzidos pela sociedade contemporânea. Especialmente gosto do material de resíduo, os artículos para reciclar e a pintura industrial: analiso suas estruturas caóticas e os reconverto em joias que podem ter uma função estética, mas ao mesmo tempo, nos envolvem no caos arquitetônico.

Estou interessado na energia produzida pelo caos. Para mim, os resíduos e a desordem são algo muito vibrante e expressivo, a essência da nossa realidade.

FRA / Mon objectif est d'établir un rapport, un échange entre une œuvre et un public. Ce n'est pas tant le bijou qui m'intéresse que les réactions qu'il suscite.

Un bijou ne peut pas se cantonner à sa fonction. Une fois libéré de son carcan, plus rien ne freine les velléités d'expérimentation, les expériences artistiques productives : en affirmant l'importance de l'intangible, le bijou acquiert une autre perspective et donne naissance à une nouvelle échelle de valeurs.

J'aime provoquer des réactions, lancer des débats, passer du ressenti esthétique à l'expérience intellectuelle, ou plutôt combiner les deux.

Mon père travaillait dans la construction et je l'aidais souvent quand j'étais petit. J'aime les chantiers qui n'ont soi-disant rien de beau et les grands engins de terrassement aux couleurs vives. Les terrains vagues m'inspirent, ainsi que les résidus produits par notre société contemporaine. J'aime tout particulièrement les matériaux de rebut, les objets à recycler et la peinture industrielle : j'analyse leur structure chaotique et je les transforme en bijoux qui auront une fonction esthétique tout en nous renvoyant au chaos architectural.

En fait, je m'intéresse à l'énergie née du chaos. Pour moi, les résidus et le désordre sont des manifestations vibrantes et expressives qui représentent l'essence même de notre réalité.

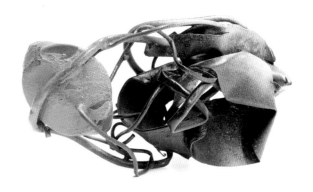

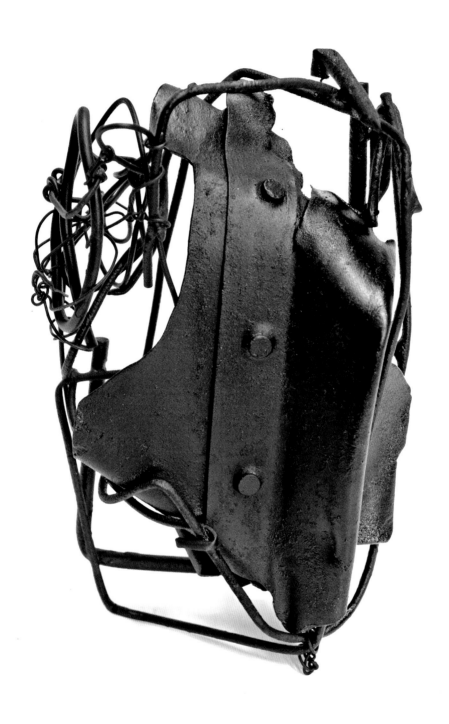

I like places that are supposedly unattractive, and the big, colourful machines used in construction.

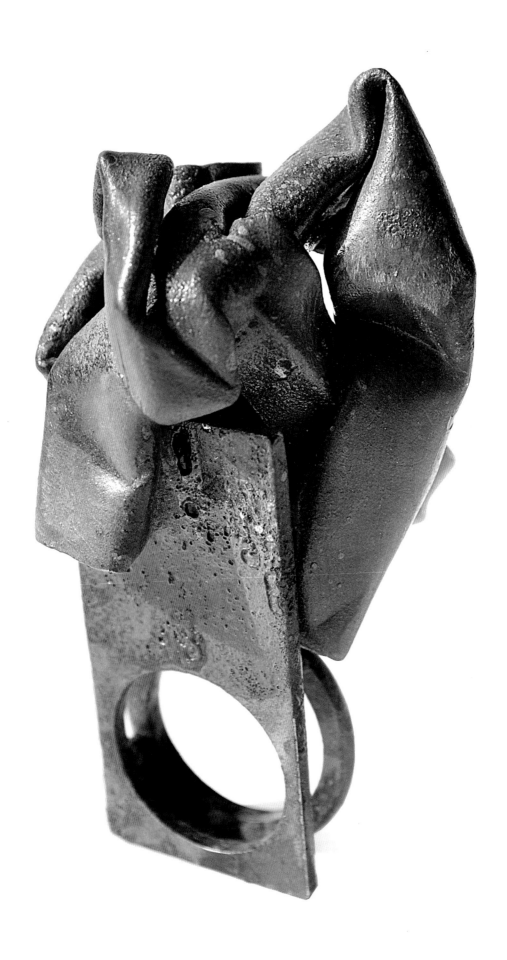

Tarja Tuupanen

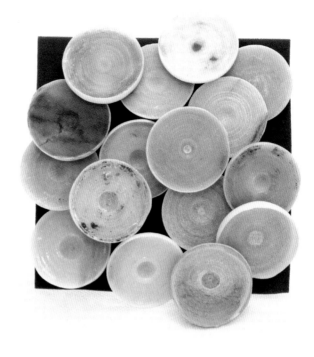

ENG / For ten years I've been working primarily with stone. My relationship with it is so intense that it has become more than a material I use. Besides stone, traditional techniques for working with it are my most precious tool: both things are my fetish and my sustenance.

In my latest works I have wanted to address my work with stone. I am asking myself what it means to me. *Why, how?* What happens when I see marble crockery in a second-hand store? Instead of raw materials, I see vulgar candelabras, salt shakers from the eighties—mass-produced objects. What's the outcome of this surprising encounter? Through my work I explore how historical and cultural references influence my work, my values and my handling of my artistic technique.

ESP / Desde hace diez años trabajo esencialmente con piedra. Mi relación con ella es tan intensa que se convierte en más que un material de trabajo. Además de la piedra, las técnicas tradicionales de trabajarla son mi herramienta más preciosa: ambas cosas son mi fetiche y también mi sustento.

En mis últimos trabajos he querido enfrentarme a mi trabajo con la piedra. Me pregunto qué quiere decirme. *¿Por qué, cómo?* ¿Qué ocurre cuando veo una vajilla de mármol en una tienda de segunda mano? En lugar de materia prima, candelabros vulgares, saleros de los años ochenta, todos ellos objetos producidos en masa. ¿Qué sale de este sorprendente encuentro? A través de mi trabajo exploro cómo la historia y las referencias culturales influyen en mi trabajo, mis valores y el control de mi técnica artística.

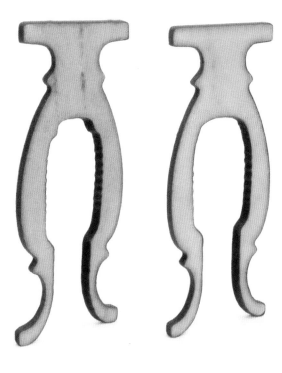

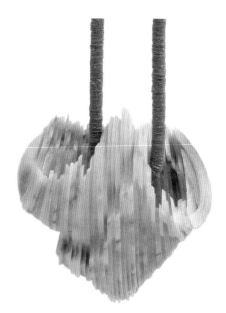

FRA / Voilà une dizaine d'années que je travaille presque exclusivement avec de la pierre. Mon rapport avec elle est si intense qu'elle est pour moi beaucoup plus qu'un simple matériau. La pierre et les outils traditionnels que j'utilise pour la façonner sont tout aussi précieux : ils sont à la fois un trésor et mon gagne-pain.

Avec mes dernières créations, j'ai décidé de pousser plus loin mon rapport avec le travail de la pierre. Je me demande ce qu'elle veut me dire : *pourquoi ? comment ?* Qu'est-ce que je ressens lorsque je vois une paillasse en marbre dans la devanture d'un brocanteur ou que j'aperçois des chandeliers vulgaires et des salerons des années 80 et tous ces objets produits en masse ? Qu'est-ce qui ressort de cette rencontre ? À travers mes créations j'explore leur influence sur mon travail et mes valeurs, et j'analyse le contrôle de ma technique artistique sur l'histoire et les références culturelles.

POR / Há dez anos trabalho essencialmente com pedra. Minha relação com ela é tão intensa que se converte em mais que um material de trabalho. Além da pedra, as técnicas tradicionais de trabalho são minhas ferramentas mais preciosas: ambas são meu fetiche e também o meu sustento.

Nos meus últimos trabalhos quis enfrentar o meu trabalho com a pedra. Pergunto-me o que me quer dizer. Por quê? Como? O que ocorre quando vejo uma vasilha de mármore numa tenda de segunda mão? No lugar de matéria-prima, candelabros vulgares, saleros dos anos oitenta, todos estes objetos produzidos em massa. O que sai deste surpreendente encontro? Através das minhas criações exploro como a história e as referências culturais influenciam meu trabalho, meus valores e o controle da minha técnica artística.

Nelly Van Oost

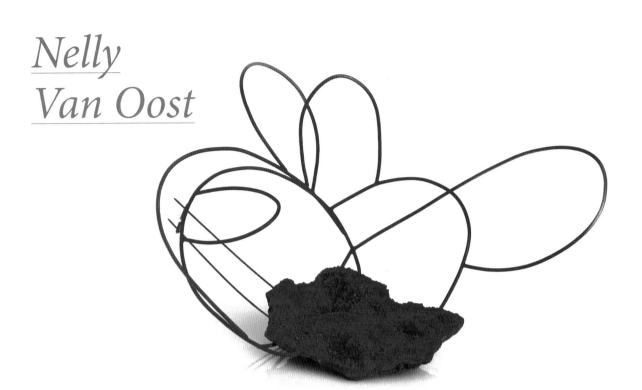

ENG / When I conceive a piece, I draw in the space around the body, I tell a story, I think about my connection with others. This connection with others is what I truly seek to express with my work. I often wonder about the connection between other people, especially those for whom I design my jewellery. These bodies, these people, are my inspiration. During my creative process these links are always present, greatly influencing what I do.

Each person makes his or her own journey and this journey constructs our identity. I've heard so many stories about these journeys! I have no doubt that they influence my own; they give me new perspectives about the world, about my past. I very carefully treasure these encounters. They help me to look to the future with absolute confidence.

Some artists influence me a lot, especially photographers like Diane Arbus or Sophie Calle, and also sculptors such as Louise Bourgeois, Annette Messager and Antony Gormley. I like to discover new techniques and materials and play with them. Right now I'm in a long and intense conversation with metal cable, but this could change at any time!

ESP / Cuando concibo una pieza, dibujo en el espacio alrededor del cuerpo, cuento una historia, pienso en mi conexión con los demás. Esta conexión con los otros es lo que verdaderamente busco expresar con mi trabajo. A menudo me pregunto sobre la conexión entre las otras personas, especialmente aquellos para quienes diseño mis joyas. Estos cuerpos, estas personas, son mi inspiración. Durante mi proceso creativo estos vínculos están siempre presentes, influyen mucho en lo que hago.

Cada persona hace su viaje y este viaje construye nuestra identidad. ¡He escuchado tantas historias sobre estos viajes! No tengo duda de que influyen en el mío propio, me dan nuevas perspectivas sobre el mundo, sobre mi pasado. Atesoro estos encuentros con esmero, me ayudan a mirar el futuro con absoluta confianza.

Algunos artistas me influyen mucho, sobre todo algunas fotógrafas, como Diane Arbus o Sophie Calle, y también escultores, como Louise Bourgeois, Annette Messager o Antony Gormley.

Me gusta descubrir nuevas técnicas y materiales y jugar con ellos. En estos momentos estoy teniendo una larga e intensa conversación con el cable de metal, ¡pero esto podría cambiar en cualquier momento!

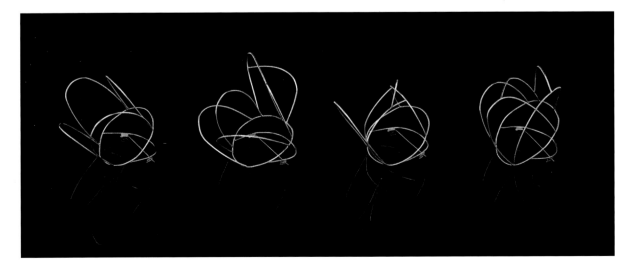

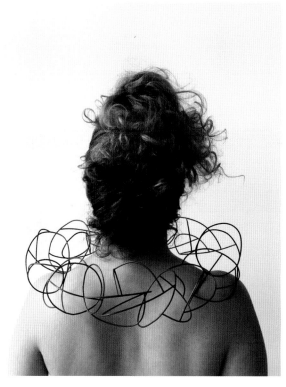

FRA / Lorsque je conçois un bijou, je dessine dans l'espace qui entoure le corps, je raconte une histoire, je pense à mon lien avec les autres. C'est cette connexion que je cherche à exprimer dans mon travail. Je me pose souvent des questions sur ce qui relie les gens, surtout les personnes pour lesquelles je crée des bijoux. Tous ces corps, tous ces êtres sont ma source d'inspiration. Au cours du processus créatif, ils sont très présents dans mon esprit et influencent beaucoup ce que je fais. Chaque personne réalise son propre voyage, et c'est en voyageant que se forge son identité. J'ai entendu tant d'histoires sur ces voyages ! Je ne doute pas une seconde qu'ils influencent aussi ma vie, qu'ils m'ouvrent de nouvelles perspectives sur le monde et sur mon passé. Je chéris ces rencontres qui me donnent une confiance totale en l'avenir.

Certains artistes m'influencent beaucoup, surtout des photographes comme Diane Arbus et Sophie Calle, et aussi des sculpteurs dont Louise Bourgeois, Annette Messager et Antony Gormley.

J'aime découvrir des techniques et des matières nouvelles, et jouer avec elles. Actuellement, j'ai une certaine affinité avec les fils en métal, mais cela peut changer à tout moment.

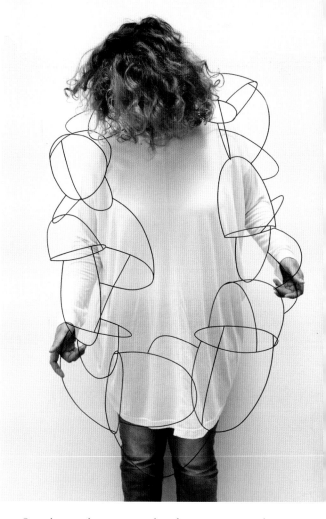

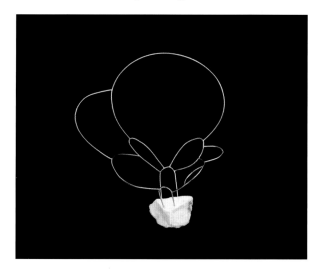

POR / Quando concebo uma peça, desenho no espaço ao redor do corpo, conto uma história, penso na minha conexão com os demais. Esta conexão com os outros é o que verdadeiramente busco expressar com o meu trabalho. Com frequência me pergunto sobre a conexão entre as outras pessoas, especialmente aqueles para quem desenho as minhas joias. Estes corpos, estas pessoas, são a minha inspiração. Durante o meu processo criativo estes vínculos estão sempre presentes, influenciam muito o que faço.

Cada pessoa faz sua viagem e esta viagem constrói nossa identidade. Escutei tantas histórias sobre estas viagens! Não tenho dúvida de que me influenciam e me dão novas perspectivas sobre o mundo, sobre meu passado. Guardo estes encontros com esmero, me ajudam a encarar o futuro com absoluta confiança.

Alguns artistas me influenciam muito, sobretudo algumas fotógrafas, como Diane Arbus ou Sophie Calle, e também escultores, como Louise Bourgeois, Annette Messager ou Antony Gormley.

Eu gosto de descobrir novas técnicas e materiais e jogar com eles. No momento tenho uma longa e intensa conversa com o cabo de metal, mas isto pode se alterar a qualquer momento!

Tanel
Veenre

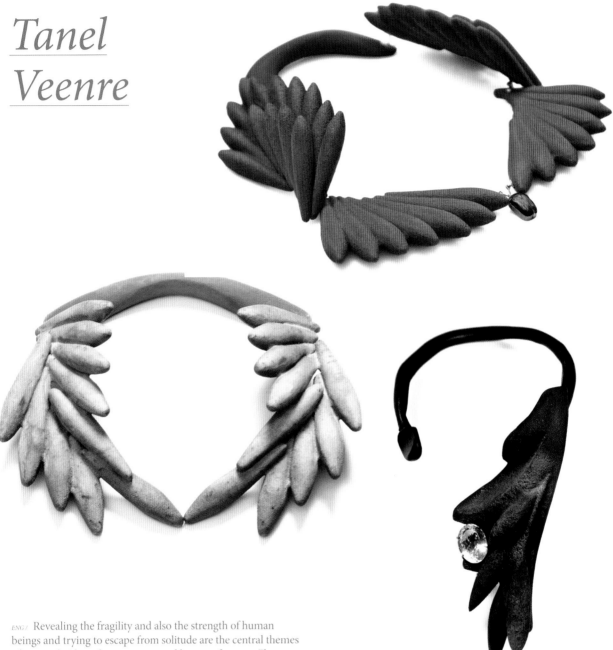

ENG / Revealing the fragility and also the strength of human beings and trying to escape from solitude are the central themes of my work. I love the symmetry and beauty of nature. Flowers, especially orchids, birds, insects. The sky, poetry, the elements, the unexpected. I am fascinated by people with enormous talent and strong and determined spirit: my teachers, Kadri Mälk and Ruudt Peters. I've been greatly influenced by medieval art and also the Pre-Raphaelites, the Victorian era, Modernism and Art Deco. But contemporary artists have influenced me as well. Fashion: Balenciaga, McQueen, Pugh, Owens, Victor & Rolf… And literature: Marcel Proust, Oscar Wilde…
I think the artist should be 100% responsible for processes. I love engraving: the incredible purity of digging out shapes from materials. I love organic materials: wood, bone, jet, faceted and rough stones.
Big necklaces allow me to express myself to the fullest, and I also like headbands and wreaths.

ESP / Revelar la fragilidad y también la fuerza del ser humano y como intenta escapar de la soledad, son los temas centrales de mi trabajo. Me encanta la simetría y la hermosura de la naturaleza. Las flores, especialmente las orquídeas, los pájaros, los insectos. El cielo, la poesía, los elementos, lo inesperado. Me conmueven las personas con enorme talento y espíritu fuerte y decidido: mis profesores, Kadri Mälk y Ruudt Peters. Me ha influido mucho el arte medieval y también los prerrafaelitas, la era victoriana, el modernismo y el art decó. Pero también los artistas contemporáneos. La moda: Balenciaga, McQueen, Pugh, Owens, Víctor&Rolf… Y la literatura, Marcel Proust, Oscar Wilde…
Creo que el artista debería ser 100% responsable de los procesos. Me apasiona el grabado: la pureza increíble de excavar formas de los materiales. Me encantan los materiales orgánicos: la madera, el hueso, el azabache; las piedras facetadas y en bruto.
Los collares grandes me permiten expresarme al máximo, y también me gustan las coronas y los pendientes.

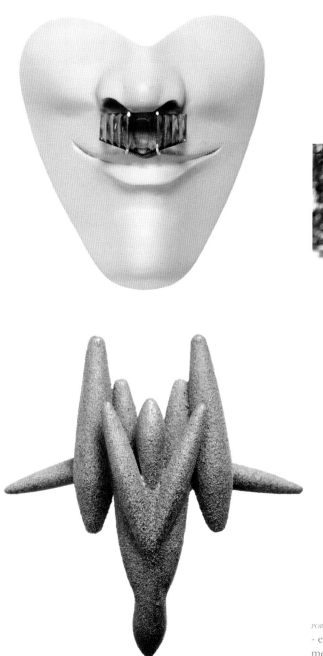

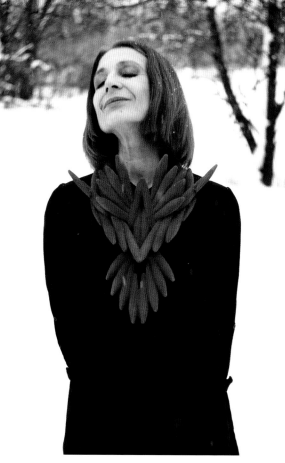

FRA / Mes créations sont axées sur trois grands thèmes : montrer la faiblesse et la force de l'être humain, et comment tenter d'échapper à la solitude. Je suis émerveillé par la symétrie et la beauté de la nature. Les fleurs, et tout particulièrement les orchidées, les oiseaux, les insectes. Le ciel, la poésie, les éléments, l'insolite. Je suis fasciné par les gens qui ont du talent à revendre et les idées claires, comme mes professeurs Kadri Mälk et Ruudt Peters. L'art médiéval m'a beaucoup influencé, ainsi que les préraphaélites, le style victorien, le modernisme et l'art déco. Mais aussi les artistes contemporains. Sans oublier la mode : Balenciaga, McQueen, Pugh, Owens, Victor&Rolf. Ni la littérature : Marcel Proust, Oscar Wilde. Je crois qu'un artiste doit maîtriser à 100 % tous les processus qu'il utilise. J'adore la gravure, l'incroyable pureté du geste qui cisèle la matière pour y tracer des formes. Tous les matériaux organiques me passionnent : le bois, l'os, le jais, les pierres taillées et brutes.

Les grands colliers me permettent de m'exprimer au maximum, et j'aime aussi créer des couronnes et des pendentifs.

POR / Revelar a fragilidade e também a força do ser humano - e como tenta escapar da solidão, são os temas centrais do meu trabalho. Amo a simetria e a formosura da natureza. As flores, especialmente as orquídeas, os pássaros, os insetos. O céu, a poesia, os elementos, o inesperado. Me fascinam as pessoas com enorme talento e espírito forte e decidido: meus professores, Kadri Mälk e Ruudt Peters. A arte medieval me influenciou muito e também os Pré-Rafaelitas, a era Vitoriana, o Modernismo e a Arte Decô. Mas também os artistas contemporâneos. A moda: Balenciaga, McQueen, Pugh, Owens, Víctor&Rolf... E a literatura, Marcel Proust, Oscar Wilde...

Acredito que o artista deveria ser 100% responsável pelos processos. Eu adoro o gravado: a pureza incrível de escavar formas nos materiais. Eu adoro os materiais orgânicos: a madeira, o osso, o azeviche; as pedras facetadas e brutas. Os colares grandes permitem expressar-me ao máximo, e também gosto das coroas e dos pingentes.

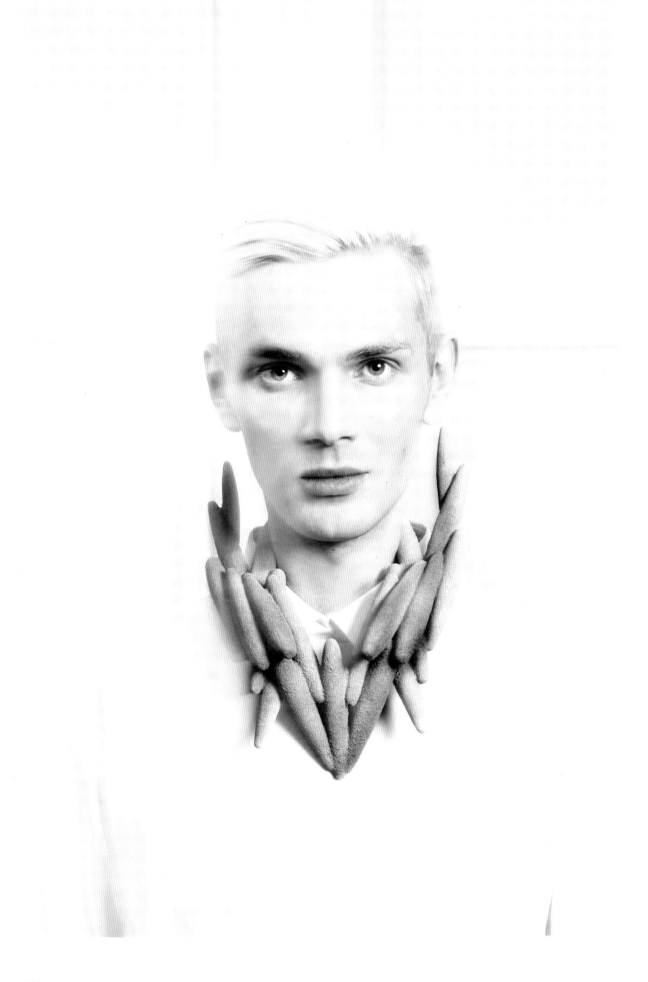

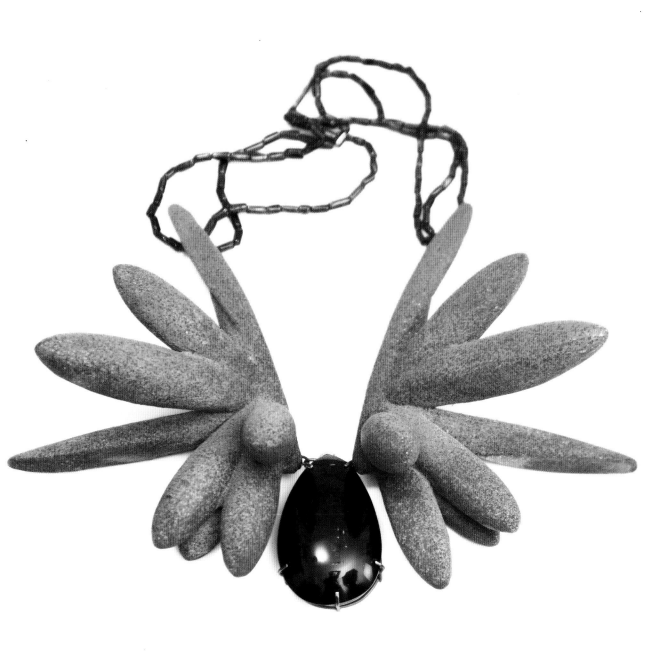

I love the symmetry and beauty of nature.
Flowers, especially orchids, birds, insects.
The sky, poetry, the elements, the unexpected.

Peter
Vermandere

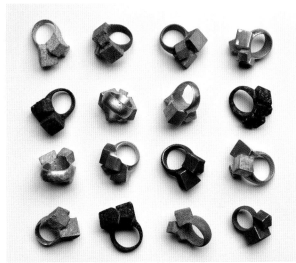

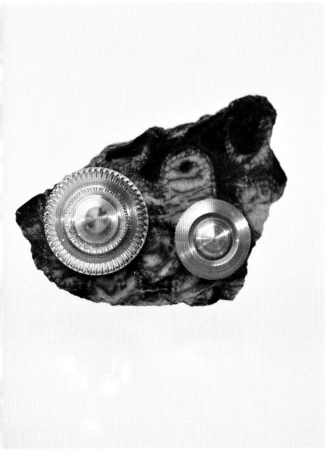

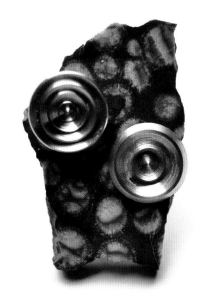

ENG / I'm a collector of collections: books, strange rocks and minerals, seashells, matchboxes... everything that falls into my hands. As long as there is lots of that thing, I am interested. I love mixing themes and concepts to generate personal ideas for my collections. This is why they have names like Freestyle Atomics, JAW, Emoticons for the Advanced, Hotton Wheels, Pearl Paranoia and so on.

I like prehistoric jewellery: shell ornaments, figures made from amber, and also Greek and pre-Columbian gold pieces. I am fascinated by Renaissance pearl figures and pilgrim badges. I find inspiration in the paintings of Brueghel, Bosch or Francis Bacon, or Terry Gilliam films. I have a great admiration for ancient Celtic sculptures and I also love the statuettes of Jean Pierre Dantan and Roel d'Haese.

Although I am primarily a manufacturer of brooches and rings, I'm an all-rounder as far as techniques and materials go. I want to try everything, without limits.

ESP / Soy un coleccionista de colecciones: libros, piedras y minerales extraños, conchas marinas, cajas de cerillas... Todo lo que cae en mis manos, mientras exista en gran abundancia, me interesa.

Me encanta mezclar temas y conceptos y así generar ideas personales para mis colecciones. Por eso tienen nombres · como Freestyle Atomics, JAW, Emoticons for the Advanced, Hotton Wheels, Pearl Paranoia, etc.

Me gusta la joyería prehistórica: ornamentos de conchas, figuras de ámbar, y también las piezas de oro griegas y precolombinas. Me fascinan las figuras de perlas del Renacimiento y las medallas de peregrino. Encuentro inspiración en la pintura de Brueghel, el Bosco, o Francis Bacon, o en las películas de Terry Gilliam. Me producen gran admiración las antiguas esculturas celtas y también me encantan las estatuillas de Jean Pierre Dantan o Roel d'Haese.

Aunque soy principalmente un fabricante de broches y anillos, soy un todo terreno en cuanto a técnicas y materiales. Quiero poder probarlo todo, sin límites.

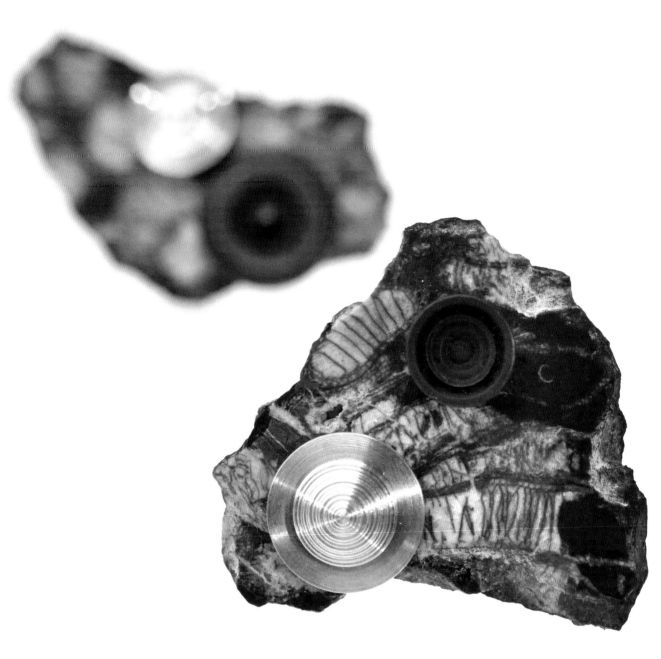

FRA / Je suis un incorrigible collectionneur : livres, pierres et minéraux étranges, coquillages, boîtes d'allumettes, etc. Tout ce que je trouve sur mon chemin m'intéresse, pourvu qu'il y en ait en quantité.

J'aime mélanger les thèmes et les concepts, et en tirer des idées bien à moi pour mes collections. C'est pour cela qu'elles s'appellent Freestyle Atomics, JAW, Emoticons for the Advanced, Hotton Wheels, Pearl Paranoia, et autres !

J'adore les bijoux préhistoriques, les ornements en coquillage, les figurines en ambre et aussi les pièces d'or grecques anciennes et précolombiennes. Je suis fasciné par les ornements en perle dans les tableaux de la Renaissance et par les médailles religieuses. Je trouve mon inspiration dans les toiles de Brueghel, de Bosch ou de Francis Bacon, ou encore dans les films de Terry Gilliam. J'ai une grande admiration pour la sculpture des anciens celtes et les statues de Jean-Pierre Dantan et Roel d'Haese.

Bien que je fabrique surtout des broches et des bagues, je suis un artisan tout terrain au niveau des techniques et des matériaux. Je veux tout essayer, sans aucune restriction.

POR / Sou um colecionador de coleções: livro, pedras e minerais estranhos, conchas marinhas, caixas de fósforos... Tudo o que cai nas minhas mãos, enquanto exista em grande abundância, me interessa.

Eu adoro misturar temas e conceitos e assim gerar ideias pessoais para as minhas coleções. Por isso elas possuem nomes como Freestyle Atomics, JAW, Emoticons for the Advanced, Hotton Wheels, Pearl Paranoia, etc.

Eu gosto da joia pré-histórica: ornamentos de conchas, figuras de âmbar e também as peças de ouro gregas e pré-colombianas. Me fascinam as figuras de perolas do Renascimento e as medalhas de peregrino. Encontro inspiração na pintura de Brueghel, de Bosco, ou Francis Bacon, ou nos filmes de Terry Gilliam. Tenho grande admiração pelas antigas esculturas celtas e também adoro as estatuetas de Jean Pierre Dantan ou Roel d´Haese.

Ainda que eu seja principalmente um fabricante de broches e anéis, sou versátil a técnicas e materiais. Quero poder provar de tudo, sem limites.

Graziano Visintin

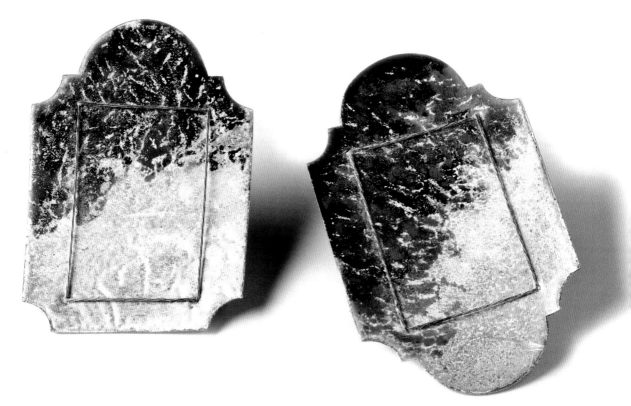

ENG / When I first met Graziano in 1979 outside the Pietro Selvatico in Padua, I had just finished high school in Rome. A deep friendship began between us and we spent many hours together in his studio; I was the young student, he the teacher. Now I see Graziano before me just like thirty years ago, with his beautiful hands, his look of concentration, his great patience and determination. His work still possesses that rare air, a kind of magical silence in which you have to move slowly and gently to feel its beauty and depth. In his pieces each element has its own character, is necessary and complements the others. And everything flows naturally, as if it were being born before our eyes.

The tactile elements of light colours seem to want to break this balance, but surprisingly they strengthen and enrich it. Strong and tender at the same time, the work of Graciano speaks to me in the sacred and ancient language of the great masters and I thank him for it.

Adapted from a text by Francesca di Gaula.

ESP / Cuando conocí a Graziano en 1979 frente al Pietro Selvatico, en Pádua, yo acababa de terminar la escuela secundaria en Roma.

Una profunda amistad comenzó entre nosotros y pasamos muchas horas juntos en su estudio, yo como joven alumna y él, el maestro. Ahora veo a Graziano delante de mí como hace 30 años, con su bellas manos, su mirada concentrada, su gran paciencia y determinación. Su trabajo todavía posee ese aire raro, una especie de mágico silencio en el que tienes que moverte despacio y con delicadeza para sentir la belleza y la profundidad de su obra. En sus piezas cada elemento posee su propio carácter, es necesario y se complementa con los otros. Y todo fluye naturalmente, como si naciese ahora mismo frente a nuestros ojos .

Los elementos táctiles de colores ligeros parecen querer romper este equilibrio pero, sorprendentemente, lo refuerzan y enriquecen.

Fuerte y tierno al mismo tiempo, el trabajo de Graciano me habla con el lenguaje sagrado y antiguo de los grandes maestros y le doy las gracias por ello.

Adaptado de un texto de Francesca di Gaula.

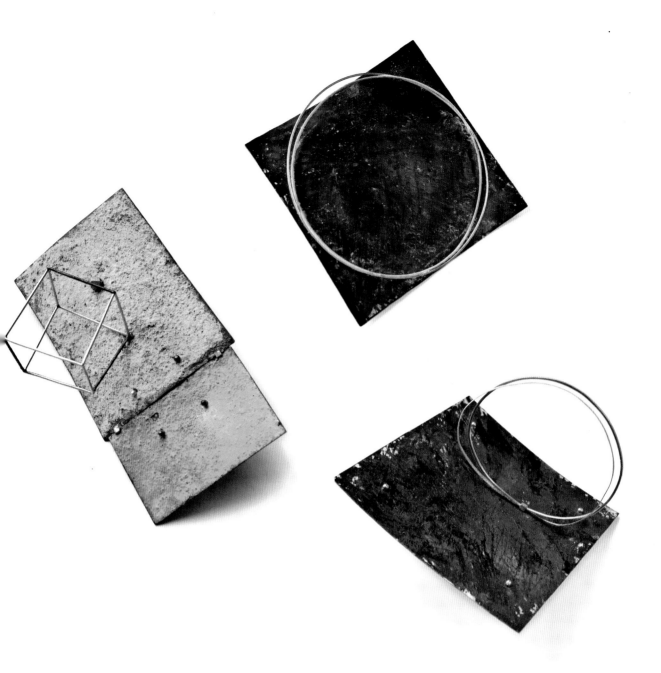

FRA / Lorsque j'ai connu Graziano en 1979 à l'institut Pietro
Selvatico de Padoue, je venais de terminer mes études
secondaires à Rome. Notre profonde amitié remonte à cette
époque. Nous avons passé de nombreuses heures ensemble
à travailler dans son studio : j'étais une jeune élève et lui était
mon maître. Aujourd'hui je retrouve Graziano comme il y
a 30 ans, avec ses belles mains, son regard concentré, sa
patience inépuisable et sa ferme détermination. Son travail
possède encore cette qualité rare, cette sorte de silence magique
qui t'oblige à te mouvoir avec lenteur et légèreté pour pouvoir
percevoir la beauté et la profondeur de son œuvre. Dans ses
créations, chaque élément possède un caractère distinctif. Il
joue un rôle indispensable et s'accorde parfaitement avec les
autres. Et tout semble couler de source, comme si le bijou
venait de naître à cet instant devant nos yeux.
Les éléments tactiles de couleurs légères semblent vouloir
briser cet équilibre, mais curieusement ils le renforcent
au contraire et l'enrichissent.
Fort et tendre à la fois, le travail de Graziano me parle dans
la langue sacrée et ancienne des grands maîtres et je lui
suis infiniment reconnaissante.

Adapté d'un texte de Francesca di Gaula.

POR / Quando conheci Graziano em 1979 em frente ao
Pietro Selvatico, em Pádua, eu acabava de terminar a escola
secundária em Roma.
Uma profunda amizade começou entre nós e passamos
muitas horas juntos no seu estúdio, eu como jovem aluna
e ele, como professor. Agora vejo um Graziano em frente
de mim como há 30 anos, com suas belas mãos, seu olhar
concentrado, sua grande paciência e determinação. Seu trabalho
possui ainda esse ar raro, uma espécie de silêncio mágico em
que tem que se mover devagar e com delicadeza para sentir
a beleza e a profundidade da sua obra. Nas suas peças cada
elemento possui seu próprio caráter, é necessário e se
complementa com os outros. E tudo flui naturalmente, como
se nascesse agora mesmo em frente dos nossos olhos.
Os elementos táteis de cores suaves parecem querer romper
este equilíbrio, mas, surpreendentemente, o fortalecem e o
enriquecem.
Forte e delicado ao mesmo tempo, o trabalho de Graziano
fala com a linguagem sagrada e antiga dos grandes mestres
e eu lhe dou graças por isso.

Adaptado de um texto de Francesca di Gaula.

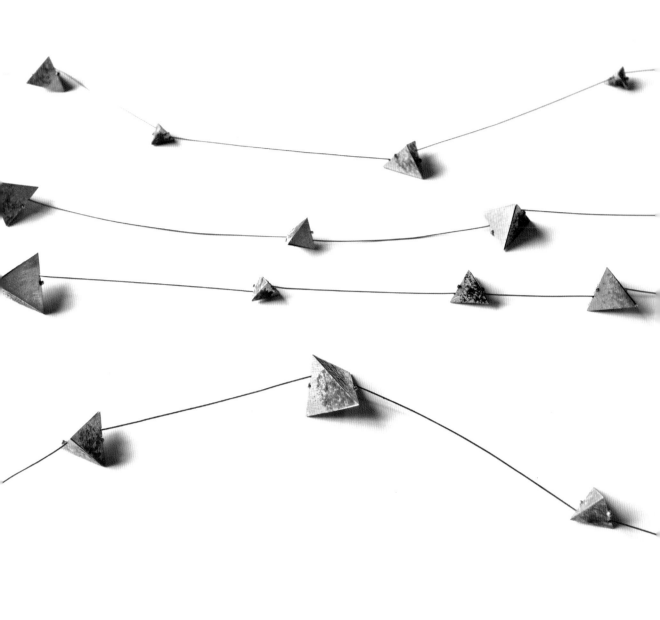

His work still possesses that rare air,
a kind of magical silence in which you
have to move slowly and gently to feel
its beauty and depth.

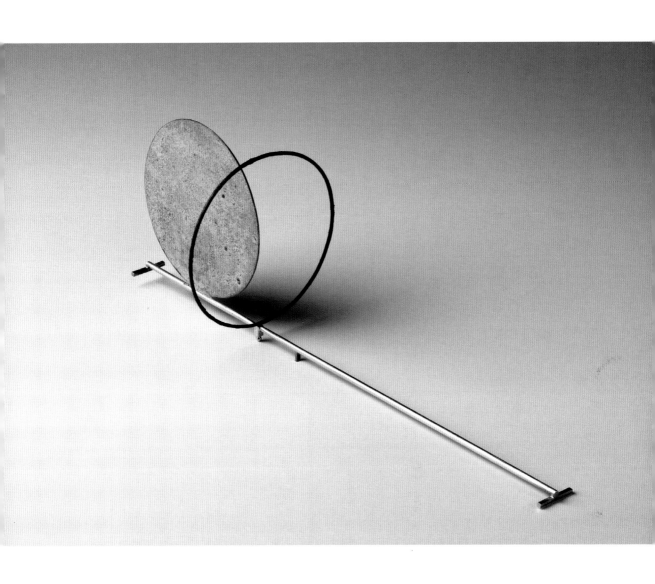

Walka
Studio

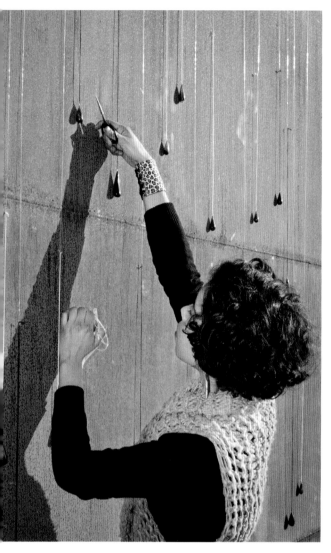

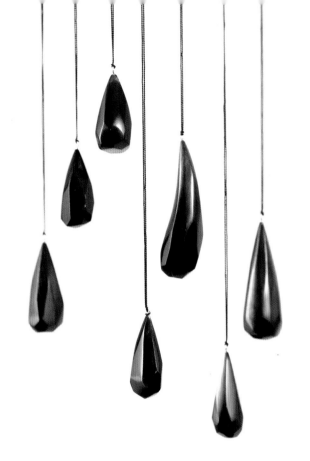

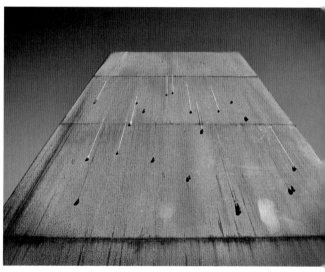

ENG / We look to combine our creative and technical processes in a dialogue that expresses our identity—the Andes and the Pacific Basin—and, within that dialogue, expand the possible terrains of body ornamentation. We explore the historical conflicts of our colonial past, cultural mixing, relationships between art, craft and design. We work with organic materials that are typical of traditional Chilean crafts: horn, horse hair, wood or plant and animal textile materials. We aim to pay tribute to all the anonymous craftsmen who have left us their legacy and techniques, and are part of our heritage. Through our work we seek to explore concepts such as identity, sense of place and a piece's autonomy with regards to statements of principles, and so we investigate the artisanal expressions of Latin America and aspects of pre-Columbian cultures such as funeral rites, jewellery and architecture.

ESP / Buscamos unir nuestros procesos creativos y técnicas en un diálogo que hable de nuestra identidad –Los Andes y La Cuenca del Pacífico- y, en ese diálogo, ampliar los territorios posibles de la ornamentación del cuerpo. Exploramos los conflictos históricos de nuestro pasado colonial, el mestizaje, las relaciones entre arte, artesanía y diseño. Trabajamos con los materiales orgánicos propios de la artesanía tradicional chilena: Cuerno, pelo de caballo, madera o materiales textiles animales y vegetales. Queremos rendir homenaje a todos los artesanos anónimos que nos dejaron su legado y técnicas, y que son parte de nuestro patrimonio. A través de nuestro trabajo buscamos explorar conceptos como la identidad, el sentido del lugar o la autonomía de la obra respecto a las declaraciones de principios, y para ello nos investigamos las expresiones artesanales de Latinoamérica y aspectos de las culturas precolombinas como los ritos mortuorios, la joyería o la arquitectura.

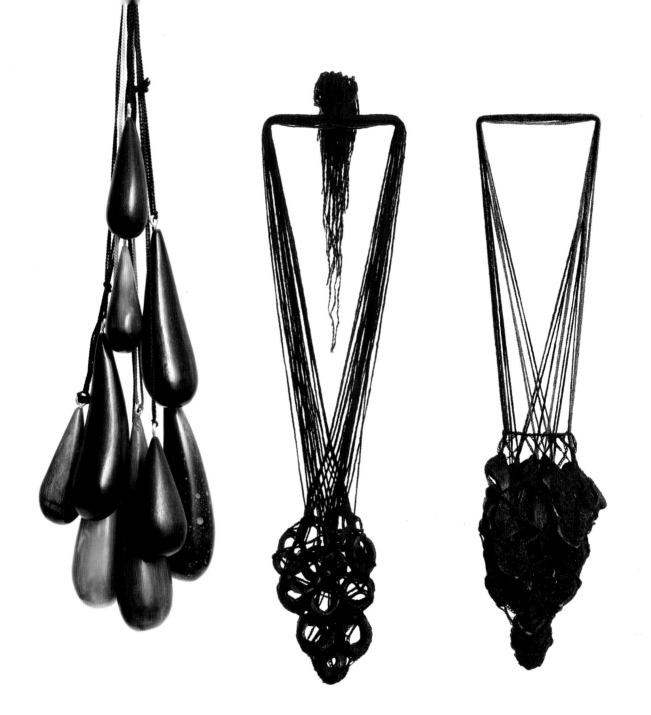

FRA / Nous essayons de combiner nos processus créatifs et nos techniques pour établir un dialogue autour de notre identité – les Andes et le Bassin du Pacifique –, et élargir, à partir de cet échange, le champ des ornements corporels. Nous explorons les conflits historiques de notre passé colonial, le métissage, les rapports entre l'art, l'artisanat et la création. Nous travaillons avec des matériaux organiques issus de l'artisanat traditionnel chilien : corne, crin de cheval, bois ou matières textiles animales ou végétales. Nous voulons rendre hommage à tous les artisans anonymes qui nous ont transmis leur héritage et leurs techniques, et qui font partie de notre patrimoine. À travers notre travail, nous explorons des concepts comme l'identité, l'appartenance à un lieu et l'autonomie de l'œuvre par rapport aux déclarations de principes. Dans ce but, nous effectuons des recherches sur les expressions artisanales d'Amérique latine et les différents aspects des cultures précolombiennes comme les rites funéraires, les bijoux ou l'architecture.

POR / Buscamos unir nossos processos criativos e técnicas num diálogo, que fale da nossa identidade – Os Andes e A Orla do Pacífico – e, nesse diálogo, ampliar os territórios possíveis da ornamentação do corpo. Exploramos os conflitos históricos do nosso passado colonial, a mestiçagem, as relações entre a arte, artesanato e desenho. Trabalhamos com os materiais orgânicos próprios do artesanato tradicional chileno: chifre, pelo de cavalo, madeira ou materiais têxteis animais e vegetais. Queremos homenagear todos os artesãos anônimos que nos deixaram seu legado e técnicas, e que são parte do nosso patrimônio. Através do nosso trabalho buscamos explorar conceitos como a identidade, o sentido do lugar ou da autonomia da obra com respeito às declarações de princípios, e para isso investigamos as expressões artesanais da América Latina e aspectos das culturas pré-colombianas como os rituais funerários, a joalheria ou a arquitetura.

Lisa
Walker

ENG/ I am getting rid of ideas, I'm sick of making pieces that have meaning... All I need to put in a piece is my experience. I do not want my work to be easily led through the established channels. I want people to be forced to work in new positions, with new syllogisms and analogies. I use a huge variety of materials, which I carefully select and which have to be resonant. Once in a while I delve into traditional jewellery and goldsmithing, but I recognise that occasionally distancing myself from the big questions surrounding jewellery is important. Currently my work includes aspects taken directly from artists that inspire me. I'll paint a Chicks on Speed fabric pattern on the surface of a pendant, or a silhouette of a Berthold Reiss painting on another piece: I decorate the decoration. I position my work in history, the future and the limits of the jewellery. I make pieces for the future. Everything feeds my art.

ESP/ Me estoy librando de las ideas, estoy cansada de hacer piezas que tengan significado...Todo lo que tengo que poner en una pieza es mi experiencia. No quiero que mi trabajo pueda ser conducido fácilmente a través de los canales establecidos. Quiero que la gente se vea forzada a trabajar en posiciones nuevas, con nuevos silogismos y analogías. Uso una variedad enorme de materiales, que selecciono muy cuidadosamente y que tienen que ser resonantes. De vez en cuando ahondo en la joyería tradicional y la orfebrería, pero reconozco que apartarme ocasionalmente de las grandes cuestiones que rodean a la joyería es importante. Actualmente mi trabajo incluye aspectos tomados directamente de artistas que me inspiran. Pinto un estampado de Chicks on Speed en la superficie de un colgante, o una silueta de una pintura de Berthold Reiss en otra pieza: decoro la decoración. Posiciono mi trabajo en la historia, el futuro y los límites de la joyería. Hago piezas para el futuro. Todo alimenta mi arte.

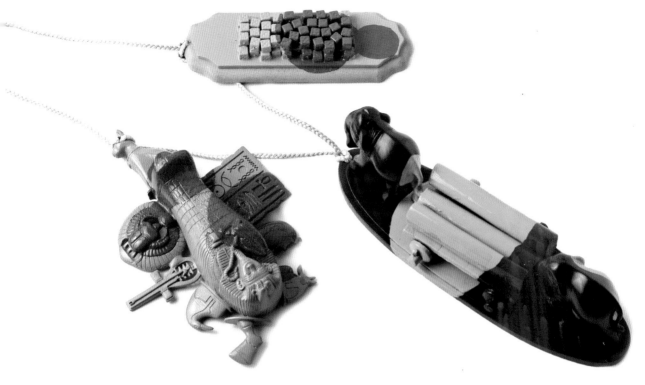

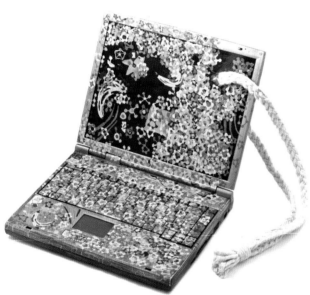

POR / Estou me livrando das ideias, estou cansada de fazer peças que tenham significado… Tudo o que tenho que pôr numa peça é a minha experiência. Não quero que o meu trabalho possa ser conduzido facilmente através dos canais estabelecidos. Quero que as pessoas se vejam forçadas a trabalhar em posições novas, com novos silogismos e analogias. Uso uma variedade enorme de materiais, que seleciono muito cuidadosamente e que tem que ser ressonantes. De vez em quando me aprofundo na joalheria tradicional e na ourivesaria, mas reconheço que separar-me ocasionalmente das grandes questões que rodeiam a joalheria é importante. Atualmente meu trabalho inclui aspectos tomados diretamente de artistas que me inspiram. Pinto um estampado de Chicks on Speed na superfície de um pingente, ou uma silhueta de uma pintura de Berthold Reiss em outra peça: decoro a decoração. Posiciono meu trabalho na história, no futuro e nos limites da joalheria. Faço peças para o futuro. Tudo alimenta a minha arte.

FRA / Je me libère des idées, je suis fatiguée de créer des bijoux qui ont un sens. Mon expérience est la seule notion que j'ai envie de transmettre à mes créations. Je veux que mon travail sorte des sentiers battus. Qu'il pousse les gens à porter sur tout un regard neuf, à élaborer de nouveaux syllogismes et analogies. J'utilise une variété infinie de matériaux que je choisis avec le plus grand soin pour qu'ils séduisent. Il m'arrive parfois d'explorer la joaillerie traditionnelle et l'orfèvrerie, mais je considère qu'il est important de prendre du recul par rapport aux grands thèmes liés à la bijouterie. Actuellement, je travaille sur des aspects piochés directement dans les œuvres d'artistes qui m'inspirent. Par exemple, je peins une affiche de Chicks on Speed sur un pendentif ou le contour d'un tableau de Berthold Reiss : je décore des ornements, en quelque sorte. Je positionne mon travail par rapport à l'histoire, au futur et aux limites du métier. Je crée des bijoux pour le futur. Tout alimente mon art.

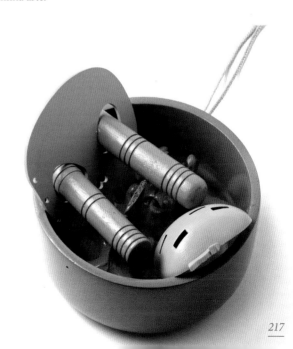

Silvia Walz

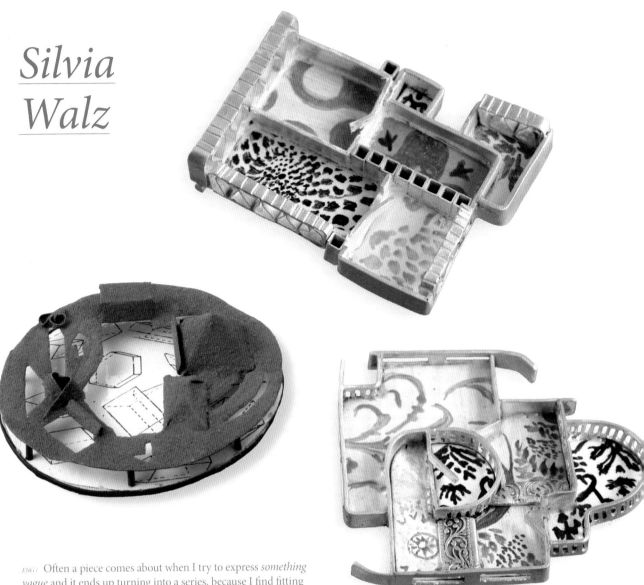

ENG / Often a piece comes about when I try to express *something vague* and it ends up turning into a series, because I find fitting it all into a single object very difficult. At other times they are a product of experience. For example the series *Casitecturas* was born out of moving home: I started out making small, portable houses as amulets, a display of imaginary homes. When I give a piece the name *Karl's House*, for example, everybody tries to imagine Karl, seeing only a miniature plan. Even I love to imagine it. I didn't know Karl before finishing the piece, but little by little he became someone very familiar to me. He lives within the walls of this mini-home and it is as though he speaks through these images. I like to play with shapes and objects or with what I find on my desk.

I construct, deconstruct, move, change and exchange, and gradually small characters that speak to me appear and tell me their stories. "*The shy woman who has butterflies in her stomach and thinks with her feet,*" I don't know if I saw her the other day on the train or if I made her up, but I look at her with suspicion, thinking that maybe I'm a little bit like her. I soon decided that she's called Anabel, so possible similarities are coincidental. I feel a certain fascination for people's stories and I have always pursued ways and objects that can explain their stories without the need for words. My pieces never cease to be a search for an identity, both a common one and my own.

ESP / Muchas veces una pieza nace cuando intento plasmar *algo vago* que termina convirtiéndose en una serie, porque contarlo todo en un solo objeto me resulta muy difícil. Otras veces surgen de la experiencia. Por ejemplo la serie *Casitecturas* nació de una mudanza: me puse a hacer pequeñas casas portátiles, como amuletos, un despliegue de casas imaginarias. Cuando titulo una pieza *La casa de Karl*, por ejemplo, todo el mundo intenta imaginarse a Karl, viendo solo un plano en miniatura. A mí misma me encanta imaginármelo. No conocía a Karl antes de acabar la pieza, pero poco a poco se convirtió en alguien muy familiar. Vive entre las paredes de esta mini-casa y es como si hablara a través de esas imágenes. Me gusta jugar con las formas, objetos o con lo que encuentro sobre mi mesa. Compongo, descompongo, muevo, cambio e intercambio, y poco a poco van apareciendo pequeños personajes que me hablan y me cuentan sus historias. "*Aquella mujer tímida que tiene mariposas en el estomago y piensa con los pies*", no sé si la vi el otro día en el tren o me la he inventado, pero la miro con recelo pensando que quizás me parezco un poco a ella y rápidamente decido que se llama Anabel, con lo cual las posibles semejanzas son casuales. Siento una cierta fascinación por la historia de la gente y siempre he perseguido objetos o formas capaces de explicar su historia sin necesidad de palabras. Mis piezas no dejan de ser una búsqueda de una identidad, tanto común como propia.

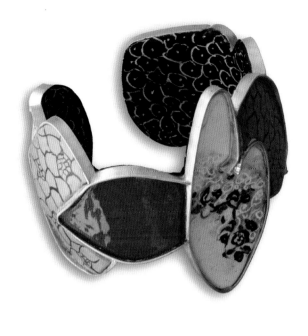

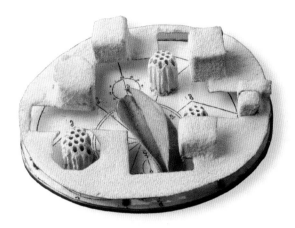

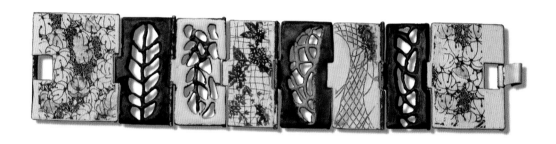

FRA / Il arrive souvent qu'un nouveau bijou naisse sous mes doigts alors que j'essaie d'exprimer *quelque chose de vague* ; et puis cela se termine par une série, parce que j'ai du mal à tout raconter avec un seul objet. Mes créations peuvent aussi être le fruit de mon vécu. Par exemple, la série *Casitecturas* m'a été inspirée par un déménagement. J'ai commencé à fabriquer des petites maisons portatives, des sortes d'amulettes, une collection de demeures imaginaires. Lorsque je baptise un bijou, par exemple, *La Maison de Karl,* tout le monde essaye de s'imaginer Karl, mais uniquement sur un plan miniature. Moi, je me plais à inventer qui il est. D'ailleurs, je ne savais pas qui était Karl avant de terminer le bijou, mais petit à petit, il est devenu un personnage familier. Il vit entre les murs de cette maison minuscule, et c'est comme si je pouvais parler avec lui à travers ces images. J'aime jouer avec les formes, les objets, et tout ce que je trouve sur mon établi. Je compose, décompose, déplace, change, échange, et des petits personnages apparaissent peu à peu : ils me parlent et me racontent leur histoire. « *Cette femme timide qui est angoissée et n'arrive pas à réfléchir* », je ne sais pas si je l'ai aperçue l'autre jour dans le train ou si je l'ai inventée, mais je la regarde avec méfiance en pensant que je lui ressemble peut-être un peu. Et puis je décide très vite qu'elle s'appelle Anabel et que toute ressemblance éventuelle avec elle serait fortuite. J'ai une certaine attirance pour les histoires personnelles des gens, et je suis toujours en quête d'objets ou de formes capables d'expliquer leurs vies sans devoir passer par des mots. Mes créations sont à la base une recherche d'identité commune et personnelle.

POR / Muitas vezes uma peça nasce quanto tento refletir *algo vago* que termina convertendo-se numa serie, porque contar tudo num só objeto me resulta muito difícil. Outras vezes surgem da experiência. Por exemplo, a serie *Casitecturas* nasceu de uma mudança: comecei a fazer pequenas casas portáteis, como amuletos, um desdobramento de casas imaginárias. Quanto titulo uma peça *La casa de Karl,* por exemplo, todo mundo tenta imaginar o Karl, vendo só um plano em miniatura. Eu mesma gosto de imaginá-lo. Não conhecia o Karl antes de acabar a peça, mas aos poucos se converteu em alguém muito familiar. Vive entre as paredes desta mini casa e é como se falasse através destas imagens. Eu gosto de jogar com as formas, objetos ou com o que encontro sobre a minha mesa. Componho, desarranjo, movo, mudo e troco, e aos poucos vão aparecendo pequenos personagens que me falam e me contam suas histórias. "*Aquela mulher tímida que tem borboletas na barriga e pensa com os pés*", não sei se a vi outro dia no trem ou a inventei, mas a vejo com receio pensando que talvez me pareço um pouco com ela e de repente decido que se chama Anabel, na qual as possíveis semelhanças são casuais. Sinto certa fascinação pela história das pessoas e sempre persegui objetos ou formas capazes de explicar sua história sem necessidade de palavras. As minhas peças não deixam de ser uma busca de uma identidade, tão comum como própria.

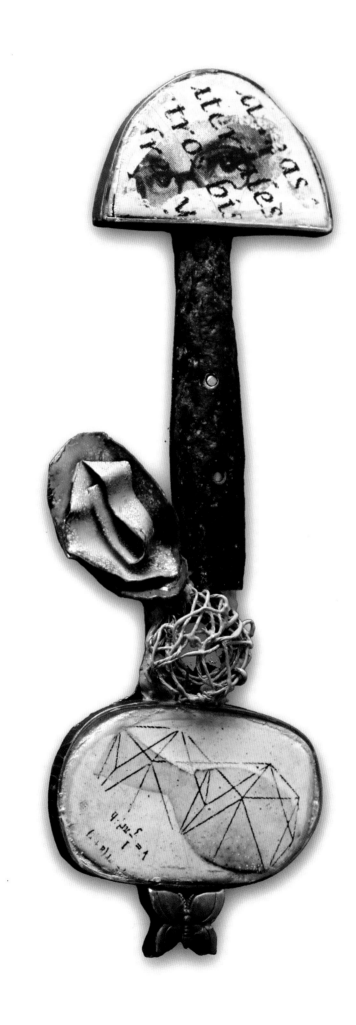

*I construct,
deconstruct, move,
change and exchange,
and gradually small
characters that speak
to me appear and tell
me their stories.*

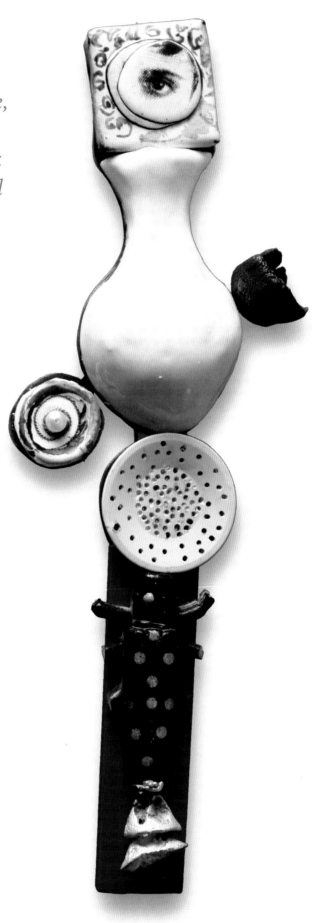

Francis Willemstijn

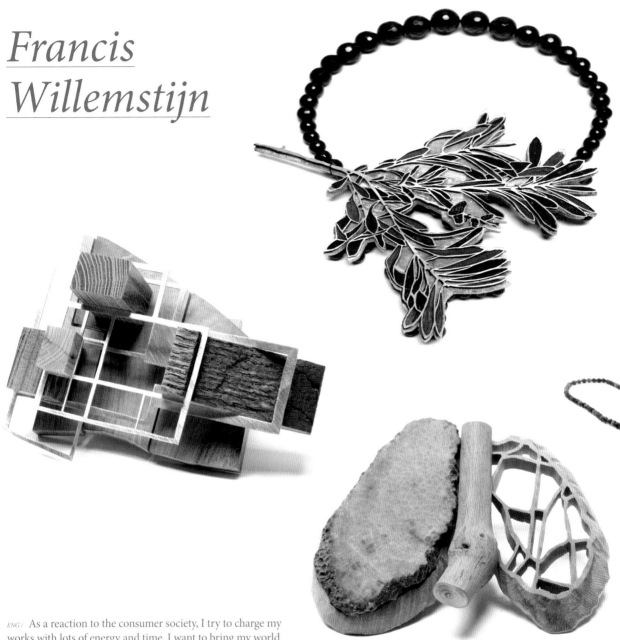

ENG / As a reaction to the consumer society, I try to charge my works with lots of energy and time. I want to bring my world and my past into the jewels, and defend the past. I always work by hand and try to create unique and unreproducible pieces. I use unusual, rare materials; this does not mean that they are expensive, but that they tell a story. A piece of beautiful old wood that is falling apart is more precious to me than a diamond.

When I have an idea for a collection, I select a material that suits it. The materials come first; I need them to tell my story and relate to the things that inspire me. I have used parts of an old Ford Granada, old pressed flowers of a herbarium, cut stones from my garden that turned out to be coral fossils… Often my pieces change: a necklace can become a brooch or a piece can end up being abandoned if I don't see the point of it. But if I had to do things exactly as planned, there'd be no joy involved. I adore sawing and I love working with wood, because it is a beautiful and very inspiring material. I love its hardness, its smoothness, its honesty and its purity.

ESP / Como reacción a la sociedad de consumo, intento cargar mis obras con mucha energía y tiempo. Quiero trasladar mi mundo y mi pasado a las joyas, defender el pasado. Trabajo siempre a mano e intento crear piezas únicas e irreproducibles. Utilizo materiales inusuales, raros, aunque esto no significa que sean caros, sino que cuentan una historia. Un trozo de hermosa madera vieja apunto de deshacerse es más precioso para mí que un diamante.

Cuando tengo una idea para una colección selecciono el material que se adapte a ella. Los materiales son lo primero, necesito que cuenten mi historia y que tengan relación con aquello que me inspira. He usado partes de un viejo Ford Granada, antiguas flores prensadas de un herbario, piedras cortadas de mi jardín que resultaron ser fósiles de coral… A menudo mis piezas cambian: un collar puede convertirse en un broche o una pieza puede acabar abandonada si ya no le veo el sentido. Pero si tuviera que hacer las cosas exactamente como estaba previsto creo que perdería la alegría. Adoro serrar y me encanta trabajar con la madera, porque es un material hermoso y muy inspirador. Me encanta su carácter duro, suave y honesto y su naturaleza pura.

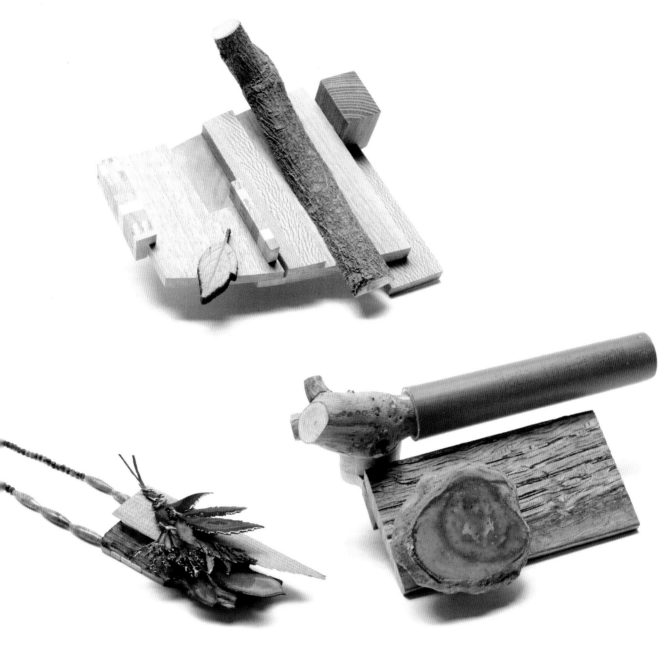

FRA / En réaction à la société de consommation, j'essaie d'investir mes œuvres de beaucoup d'énergie et de temps. Je veux transférer mon monde et mon passé dans les bijoux que je crée. Pour défendre le passé. Je travaille toujours à la main et je cherche à fabriquer des pièces uniques, impossibles à reproduire. Je travaille avec des matériaux atypiques, rares, ce qui ne veut pas dire chers, mais qui ont une histoire. Un joli morceau de bois ancien qui aurait pu disparaître a pour moi plus de valeur qu'un diamant.

Lorsque j'ai une idée pour une collection, je sélectionne en fonction de celle-ci le matériau le mieux adapté. Les matières viennent avant tout le reste. J'ai besoin qu'elles racontent mon histoire et qu'elles aient un rapport avec ce qui m'inspire. J'ai utilisé des pièces d'une vieille Ford Granada, des fleurs séchées d'un herbier ancien, des pierres taillées de mon jardin qui étaient en fait des fossiles de corail...

Souvent, mes créations se transforment en cours de route : un collier devient une broche ou alors je décide que l'objet ne m'intéresse plus et je le laisse de côté. Si je devais réaliser les bijoux exactement tels que je les ai prévus au départ, je n'aurais aucun plaisir. J'aime scier et façonner le bois parce que c'est une belle matière qui m'inspire. J'apprécie sa dureté, sa douceur, son intégrité et sa pureté.

POR / Como uma reação à sociedade de consumo, eu tento carregar minhas obras com muita energia e tempo. Quero transmitir meu mundo e meu passado às joias, defendendo o passado. Trabalho sempre manualmente e tento criar peças únicas e irreproduzíveis. Utilizo materiais incomuns, raros, ainda que isto não signifique que seja caro, mas sim que contem uma história. Um bonito pedaço de madeira velha, a ponto de se desfazer é mais importante para mim que um diamante. Quando tenho uma ideia para uma coleção seleciono o material que se adapte a ela. Os materiais são o primeiro, preciso que contem minha história e que tenham relação com aquilo que me inspira. Usei partes de um velho Ford Granada, antigas flores prensadas de um herbário, pedras cortadas do meu jardim que resultou ser fóssil de coral... Com frequência minhas peças mudam: um colar pode se converter num broche ou uma peça pode acabar abandonada se já não vejo mais sentido. Mas se tivesse que fazer as coisas exatamente como estava previsto creio que perderia a alegria. Adoro serrar e gosto de trabalhar com a madeira, porque é um material bonito e muito inspirador. Eu adoro o seu caráter duro, suave e honesto e a sua natureza pura.

Anastasia Young

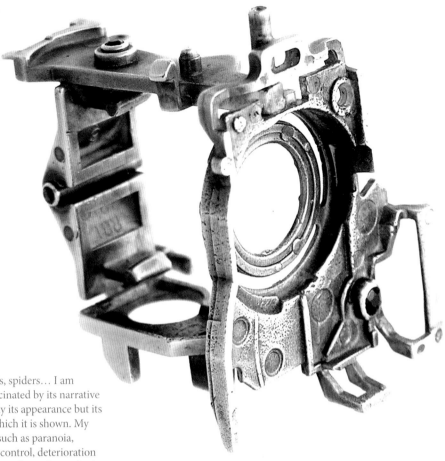

ENG/ I observe objects, mechanical parts, spiders… I am interested in an artefact's past. I am fascinated by its narrative qualities, the stories that hint at not only its appearance but its cultural relevance and the context in which it is shown. My narrative experiments explore themes such as paranoia, degradation, modification of the body, control, deterioration and pseudoscience. I am attracted to surrealism, the aesthetics of Victorian art, crime, taxidermy, imaginary machines... I am inspired by artists like the Quay Brothers, Jan Svankmejer, Joseph Cornell and Marcel Duchamp, or the collages of Max Ernst and Buchinger's Boot marionettes. I believe in playing and experimentation, and I attempt to challenge myself constantly using different techniques and materials. I use hand-made components with objects that I find, parts of machines that I dissect... I often engrave by hand because of the uniqueness of the forms it creates and its historical references. Precious metals are my favourites; they provide greater accuracy. I like to embed stones and create patinas, and I love the challenge of combining metal with objects I've found.

ESP/ Observo objetos, piezas mecánicas, arañas…Me interesa el pasado de los artefactos. Me fascinan sus cualidades narrativas, los relatos que insinúan no solo por su aspecto sino por su relevancia cultural, y por el contexto en que se muestran. Mis experimentos narrativos exploran temas como la paranoia, la degradación, la modificación del cuerpo, el control, el deterioro y la pseudo-ciencia. Me atrae el surrealismo, la estética del arte victoriano, el crimen, la taxidermia, las máquinas imaginarias… Me inspiro en artistas como los hermanos Quay, Jan Svankmejer, Joseph Cornell, Marcel Duchamp o los collages de Max Ernst y las marionetas de Buchinger's Boot. Creo en el juego y la experimentación e intento retarme a mí misma constantemente con distintas técnicas y materiales. Uso componentes hechos a mano con objetos que encuentro, piezas de máquinas que disecciono…Utilizo mucho el grabado a mano por la cualidad única de las formas que se obtienen y por sus referencias históricas. Los metales preciosos son mis favoritos, proporcionan mayor precisión. Me gusta encastar piedras, crear pátinas y me encanta el desafío de combinar el metal con objetos encontrados.

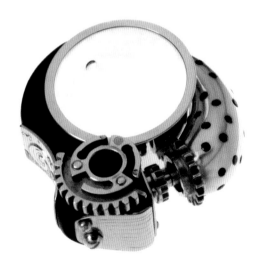

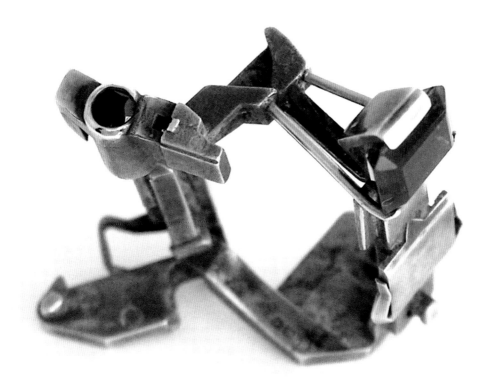

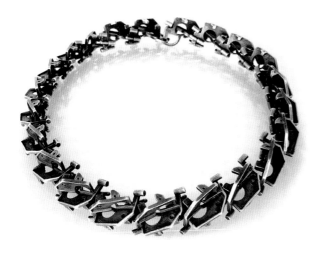

POR / Observo objetos, peças mecânicas, aranhas…
Me interessa o passado dos artefatos. Suas qualidades
narrativas me fascinam, os relatos que insinuam não só
seu aspecto como também sua relevância cultural e pelo
contexto em que se mostram. Meus experimentos narrativos
exploram temas como a paranoia, a degradação, a modificação
do corpo, o controle, a deterioração e a pseudociência.
Me atrai o surrealismo, a estética da arte Vitoriana, o crime,
a taxidermia, as máquinas imaginarias…Me inspiro em artistas
como os irmãos Quay, Jan Svankmejer, Joseph Cornell, Marcel
Duchamp ou as colagens de Max Ernst e as marionetes de
Buchinger´s Boot. Acredito no jogo e na experimentação
e tento desafiar a mim mesma constantemente com diferentes
técnicas e materiais. Usos componentes feitos à mão com
objetos que encontro, peças de máquinas que disseco… Utilizo
muito o gravado à mão pela qualidade única das formas que
se obtêm e por suas referências históricas. Os metais preciosos
são meus favoritos, proporcionam maior precisão. Eu gosto
de castear pedras, criar pátinas e adoro o desafio de combinar
metal com objetos encontrados.

FRA / J'observe les objets, les pièces mécaniques, les araignées…
Je m'intéresse au passé des objets. Je suis fascinée par leurs
qualités narratives, les histoires qu'ils suggèrent à la fois par
leur aspect et leur caractère culturel, et par le contexte où ils
sont mis en scène. Mes expérimentations narratives explorent
des notions comme la paranoïa, la dégradation, la
transformation du corps, le contrôle, l'usure et la pseudoscience.
Le surréalisme m'attire, ainsi que l'esthétique de l'époque
victorienne, le crime, la taxidermie, les machines imaginaires…
Je tire mon inspiration d'artistes comme les frères Quay, Jan
Svankmejer, Joseph Cornell, Marcel Duchamp et les collages
de Max Ernst et les marionnettes de la compagnie Buchinger's
Boot. Je crois au jeu et à l'expérimentation, et c'est moi-même
que j'essaie de représenter sans cesse à l'aide de diverses
techniques et matières. J'associe des éléments faits à la main
à des objets que je trouve ou des pièces de machine que je
dissèque. J'utilise beaucoup la gravure manuelle en raison
de l'exceptionnelle qualité des formes qu'elle permet d'obtenir
et de son illustre passé. J'aime enchâsser des pierres, créer des
patines et relever le défi que pose l'association du métal avec
des objets rencontrés au hasard.

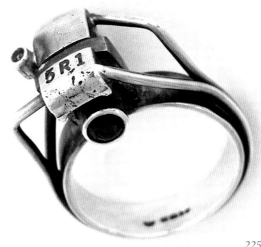

Annamaria Zanella

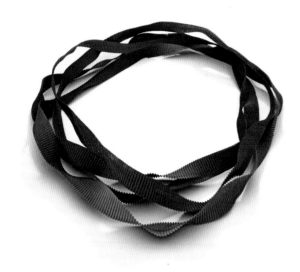

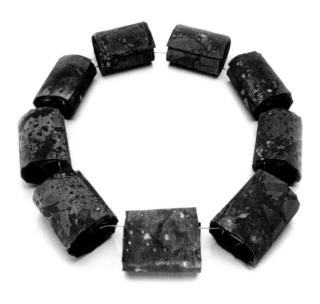

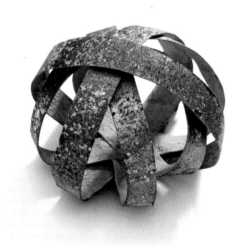

ESP / La perla: una esfera perfecta de carbonato de calcio en forma cristalina. Un pequeño grano de arena que penetra en la ostra, cuya reacción segrega una sustancia que lo cubre por completo: la madreperla. Una pieza es el resultado de reflexiones y pensamientos que se superponen como las capas de nácar. El núcleo es la idea; la materia, el medio que permite crear la esfera. Creo que en casi todas las joyas contemporáneas existe una gestación consciente de la obra. Son pensamientos, recuerdos, emociones, que viven con el creador y que con el tiempo sedimentan y luego reviven a través del trabajo. Busco la poesía en el trabajo con las manos, en el idear formas y colores. La superación de los obstáculos y la exploración de nuevas soluciones es la parte más intensa y mágica de la creación. Me encanta crear objetos que sorprendan y provoquen emociones gracias al uso democrático de los materiales. No deben ser símbolo de lujo y belleza, sino que tienen una poética sutil y definida en un microcosmos abstracto. Es necesario encontrar una cierta armonía entre los elementos, incluso si acercamos un trozo de cristal roto a una lámina de hierro oxidado. Es un gesto firme que se adquiere con la experiencia pero no debemos abandonar la capacidad de juego y de ironía.

ENG / The pearl: a perfect sphere of calcium carbonate in crystalline form. A small grain of sand that penetrates into the oyster, whose reaction to it is to secrete a substance that covers it completely: mother of pearl. A piece of jewellery is the result of reflections and thoughts that are superimposed like layers of nacre. The core is the idea; the material is the medium that allows you to create the sphere. I think that in almost all contemporary jewellery there is *conscious* gestation involved. It takes the form of thoughts, memories and emotions that live with the creator and settle before coming back to life through the work. In working with my hands, conceiving shapes and colours, I am seeking poetry. Overcoming obstacles and exploring new solutions is the most intense and magical part of creating. I love to create objects that will surprise and provoke emotions through a democratic use of materials. They should not be a symbol of luxury and beauty, but instead have a subtle and defined poetry within an abstract microcosm. It is necessary to find a certain harmony between the elements, even if we are putting a piece of broken glass together with a rusty iron blade. It's an assured action that is acquired with the experience, but we must not abandon the capacity for playfulness and irony.

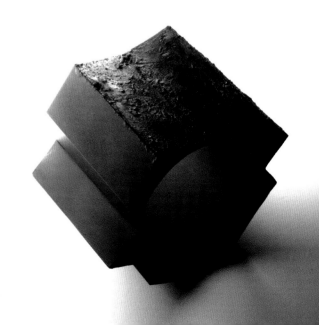

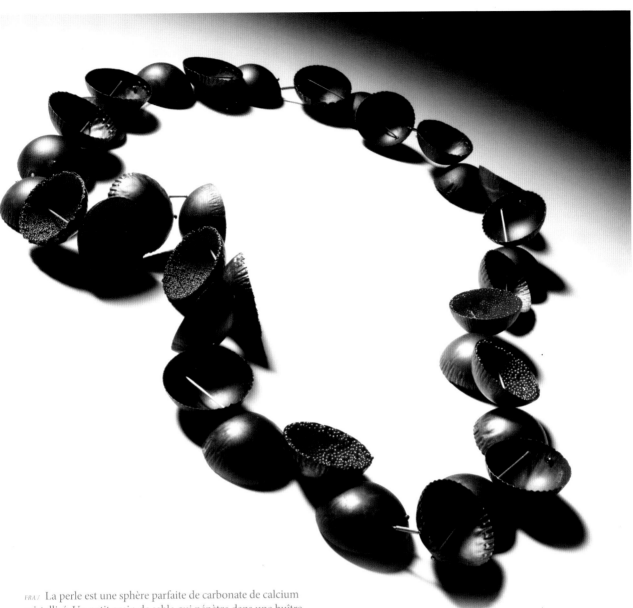

FRA / La perle est une sphère parfaite de carbonate de calcium cristallisé. Un petit grain de sable qui pénètre dans une huître déclenche la production d'une substance qui va l'envelopper tout entier : la nacre. Un bijou est le résultat de réflexions et de pensées qui se superposent à la manière des couches de nacre. Son noyau est l'idée génératrice, et la matière est le moyen qui permet de produire la sphère. Je crois qu'à la base de pratiquement tous les bijoux contemporains, il y a une gestation consciente de l'œuvre. Ce sont les pensées, les souvenirs et les émotions qui cohabitent avec l'artiste et finissent par former des sédiments au fil du temps. Ils revivent ensuite à travers son œuvre. Je recherche la poésie en travaillant avec mes mains, en essayant de façonner des formes et des couleurs. Ce qu'il y a de plus intense et de plus magique dans la création, c'est d'avoir à vaincre des obstacles et à explorer de nouvelles solutions. J'adore concevoir des objets qui surprennent et suscitent des émotions grâce à une utilisation « démocratique » des matériaux. Un bijou ne doit pas être un symbole de luxe ou de beauté : il doit posséder une poésie subtile issue d'un microcosme abstrait. Il convient d'établir une certaine harmonie entre les éléments, même s'il s'agit d'un éclat de verre et d'un morceau de métal rouillé. C'est le résultat d'un geste assuré que l'on acquiert avec l'expérience, mais il ne faut pas abandonner pour autant la capacité de jeu et l'ironie.

POR / A pérola: uma esfera perfeita de carbonato de cálcio em forma cristalina. Um pequeno grão de areia que penetra na ostra, que reage secretando uma substância que a cobre por completo: a madrepérola. Uma peça é o resultado de reflexões e pensamentos que se sobrepõem como as camadas de nácar. O núcleo é a ideia; a matéria, o meio que permite criar a esfera. Acredito que em quase todas as joias contemporâneas existe uma gestação consciente da obra. São pensamentos, recordações, emoções, que vivem com o criador e que com o tempo sedimentam e se revivem através do trabalho. Busco a poesia no trabalho com as mãos, ao inventar formas e cores. A superação dos obstáculos e a exploração de novas soluções é a parte mais intensa e mágica da criação. Eu adoro criar objetos que surpreendam e provoquem emoções graças ao uso democrático dos materiais. Não devem ser símbolo de luxo e beleza, e sim que tenham uma poesia sutil e definida num microcosmo abstrato. É necessário encontrar certa harmonia entre os elementos, inclusive se aproximamos um pedaço de vidro quebrado com uma lâmina de ferro enferrujado. É um gesto firme que se adquire com a experiência, mas não devemos abandonar a capacidade de jogo e de ironia.

Petra Zimmerman

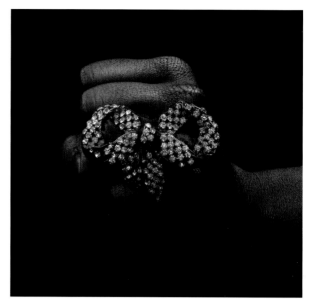

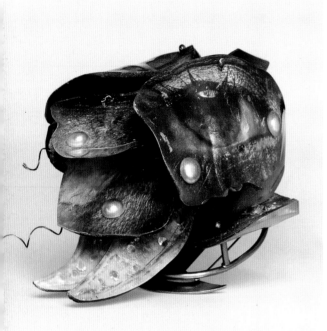

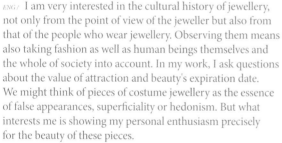

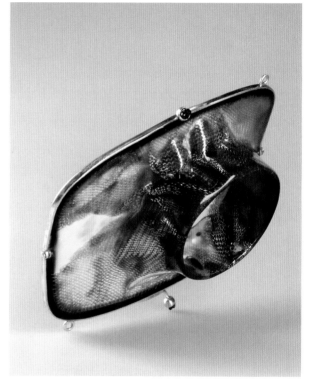

ENG/ I am very interested in the cultural history of jewellery, not only from the point of view of the jeweller but also from that of the people who wear jewellery. Observing them means also taking fashion as well as human beings themselves and the whole of society into account. In my work, I ask questions about the value of attraction and beauty's expiration date. We might think of pieces of costume jewellery as the essence of false appearances, superficiality or hedonism. But what interests me is showing my personal enthusiasm precisely for the beauty of these pieces.

Costume jewellery has a complex social and cultural significance. Throughout the twentieth century, it has gone from being a mere imitation of real jewels to producing its own forms and independent designs, new materials, new colours, new techniques and possibilities. I think that all of this has played a very important role in democratising jewellery. As an artist, I am heavily influenced by late nineteenth-century artistic movements, especially the Wiener Moderne (Viennese modernism).

ESP/ Me interesa mucho la historia cultural de la joyería, no solo desde el punto de vista del joyero sino también desde el de las personas que llevan las joyas. Observarlas significa tener en cuenta también la moda y al mismo ser humano, al conjunto de la sociedad. En mi trabajo me interrogo sobre el valor de la atracción y la fecha de caducidad de la belleza. Podemos pensar en las piezas de bisutería como la esencia de las falsas apariencias, la superficialidad o el hedonismo. Pero a mí me interesa mostrar mi entusiasmo personal precisamente por la belleza de las piezas.

La bisutería tiene un complejo significado social y cultural. A lo largo del siglo XX ha pasado de ser una mera imitación de las joyas auténticas a producir sus propias formas y diseños independientes, con nuevos materiales, nuevos colores, nuevas técnicas y posibilidades. Creo que todo ello ha jugado un papel muy importante a la hora de democratizar la joyería. Como artista, estoy muy influida por movimientos artísticos de finales del siglo XIX, especialmente el modernismo vienés (Die Wiener Moderne).

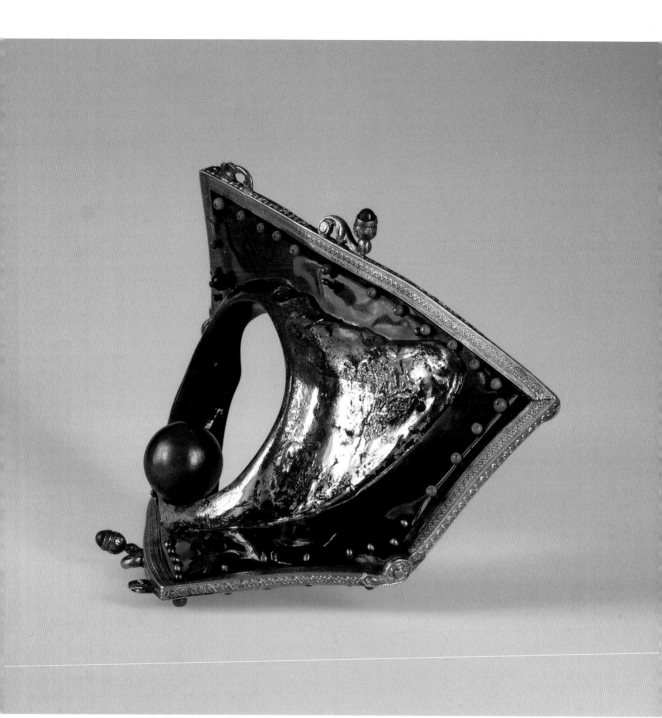

FRA / L'histoire des bijoux m'intéresse, et pas seulement du point de vue du joaillier, mais aussi de celui des personnes qui les portent. Ils représentent la mode, l'être humain en tant qu'individu et l'ensemble de la société. Dans mon travail, j'explore l'importance de l'attirance et la « date de péremption » de la beauté. On peut voir le bijou comme l'essence même des faux-semblants, de la superficialité et de l'hédonisme. Mais ce qui me plaît, c'est de manifester mon enthousiasme pour la beauté des ornements.

Le bijou joue un rôle social et culturel complexe. Au cours du XX° siècle, il est passé de simple imitation de pièces authentiques à un objet jouissant d'une forme et d'un style propres grâce aux nouvelles matières, couleurs, techniques et possibilités de notre époque. Je crois que tout cela a eu une énorme importance au niveau de la démocratisation du bijou. En tant que créatrice, je suis très influencée par les mouvements artistiques de la fin du XIX° siècle, et notamment le modernisme viennois.

POR / Me interessa muito a história cultural da joalheria, não só desde o ponto de vista do joalheiro como também desde o das pessoas que usam as joias. Observá-las significa ter em conta também a moda, o ser humano e o conjunto da sociedade. No meu trabalho me questiono sobre o valor da atração e o prazo de validade da beleza. Podemos pensar nas peças de bijuteria como a essência das falsas aparências, a superficialidade ou o hedonismo. Mas a mim me interessa mostrar meu entusiasmo pessoal precisamente pela beleza das peças.

A bijuteria tem um completo significado social e cultural. Ao longo do século XX passaram de ser uma mera imitação das joias autênticas para produzir suas próprias formas e desenhos independentes, com novos materiais, novas cores, novas técnicas e possibilidades. Acredito que tudo isso contribuiu num papel muito importante na hora de democratizar a joia. Como artista, estou muito influenciada pelos movimentos artísticos do final do século XIX, especialmente o Modernismo Vienense (Die Wiener Moderne).

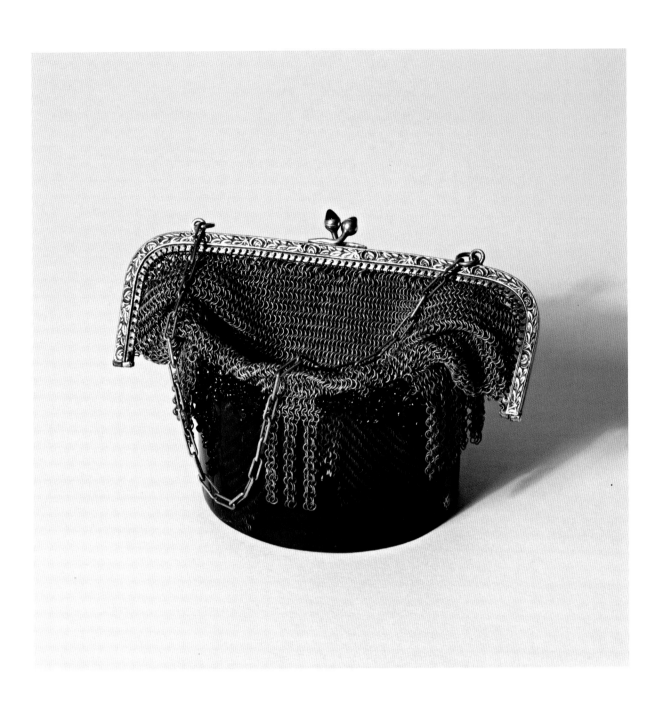

In my work, I ask questions about the value
of attraction and beauty's expiration date.

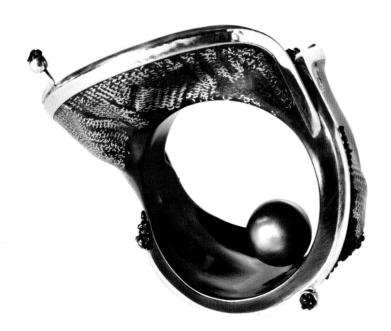

A/Z

A. **_Aboucaya Grozovski, Anat_**
ISRAEL
anatat@bezeqint.net
© Etienne BoisRond

Alm, Tobias
SWEDEN
www.tobiasalm.com
© Tobias Alm

Arnavat, Eugènia
SPAIN
earnavat@hotmail.com
© Antoni Bonnin Sabastià

Atrops, Volker
GERMANY
www.au-abc.de
www.bund-fuer-gestaltung.de
© Volker Atrops

B. **_Babetto, Giampaolo_**
ITALY
www.babetto.com
© Giampaolo Babetto

Bakker, Gijs
THE NETHERLANDS
www.gijsbakker.com
© Rien Bazen
© Sylvain Georget/Carole Hernandez

Bakker, Ralph
THE NETHERLANDS
www.ralphbakker.nl
© Michael Anhalt
© Ralph Bakker

Bermúdez, Ángela
SPAIN
http://angelabermudezp.blogspot.com.es/
© Adolfo López Pérez

Betz, Doris
GERMANY
dorisbetz@freenet.de
© Bernhard Roth

Blank, Alexander
GERMANY
alex.blank@web.de
© Mirei Takeuchi

Britton, Helen
AUSTRALIA/GERMANY
helenbritton@mac.com
© Dirk Eisel
© Helen Britton

Buck, Kim
DENMARK
www.kimbuck.dk
© Kim Buck

C. **_Carmona, Kepa and Pendairès, Marie_**
SPAIN/FRANCE
kepakarmona@gmail.com/
mariependaries@yahoo.fr
© Kepa Carmona and Marie Pendariès

Chen, Attai
ISRAEL
www.attaichen.com
©Attai Chen

Chen, Walter
TAIWAN/SPAIN
walterchen-monteazul.blogspot.com
© Attai Chen
© Mirei Takeuchi

Chitsaz-Shoshtary, Carina
GERMANY
www.where-to-put-it.com
©Mirei Takeuchi

Cho, Sungho
SOUTH KOREA
shcho_7@hotmail.com
© Mirei Takeuchi

Coderch, Andrea
SPAIN
www.andreacoderch.com
©Andrea Coderch
©Polisena Mattia

D. *De Decker, Hilde*
THE NETHERLANDS
www.hildededecker.com
© Hilde de Decker
© Michiel Heffels

Dettar, Katharina
GERMANY
www.katharinadettar.com
© Manuel Ocaña

Domingues, Patricia
PORTUGAL
patricia@borax08001.com
© Manuel Ocaña

Dzuráková, Barbora
SLOVAKIA/THE NETHERLANDS
barbora.dzurakova@gmail.com
© Barbora Dzuráková

E. *Eichenberg, Iris*
GERMANY/THE NETHERLANDS
www.iriseichenberg.nl
© Iris Eichenberg

Estrada, Nicolas
COLOMBIA/SPAIN
www.amarillojoyas.com
© Nicolás Estrada
© Francisco Tolchinsky
© Manuel Ocaña Mascaró

F. *Fischer, Benedikt*
AUSTRIA
http://cargocollective.com/
benediktfischer
© Benedikt Fisher
© Nhat-Vu Dang
© Udo W. Beier

Fritsch, Karl
GERMANY/NEW ZEALAND
schmuckfritsch@mac.com
© Karl Fritsch

G. *Gadano, Fabiana*
ARGENTINA
www.fabianagadano.com.arg
© Damián Hernan Wasser
© Patricio C. Gatti

Gimeno, Carolina
CHILE
www.carlonagimeno.com
© Oriol Miralles

Graf, Christine
GERMANY
christine.graf@web.de
© Christine Graf

Grinovich, Adam
USA
www.adamgrinovich.com
© Adam Grinovich
©Andreas Thorén

Guttmann, Ursula
AUSTRIA
www.ursulaguttmann.com
© Elisabeth Grebe

H. *Hakim, Dana*
ISRAEL
www.danahakim.com
© Yosef Bercovich

Hanagarth, Sophie
SWITZERLAND/FRANCE
www.sophiehanagart.com
© Sophie Hanagarth

Hedman, Hanna
SWEDEN
www.hannahedman.com
© Janna Lindberg

Horvat, Gabriela
ARGENTINA
www.gabrielahorvat.com/
cargocollective.com/gabrielahorvat
© Gabriela Horvat

I. *Ishikawa, Mari*
JAPAN/GERMANY
www.mari-ishikawa.de
© Dirk Eisel

K. *Kamata, Jiro*
JAPAN/GERMANY
www.jirokamata.com
© Jiro Kamata
© Gesa Simons

L. *Larsson, Agnes*
SWEDEN
http://agneslarsson.com
© Agnes Larsson

Lee, Hyorim
SOUTH KOREA
mikihome.hyorim@gmail.com
© Junwon Jung

Legg, Beth
UK
www.bethlegg.com
© Beth Legg

Lehtinen, Helena
FINLAND
www.hibernate.fi/helena/works
© Kimmo Heikkilä

Lorenzen, Jens-Rüdiger
GERMANY
r.lorenzen@online.de
© Bärbel Lorenzen

M. *Manilla, Jorge*
MEXICO
www.jorgemanilla.com
© Tom Lagast
© Bart Vermaercke

Siemund, Vera
GERMANY
vera_siemund@gmx.de
© Vera Siemund
© Miriam Yousif-Kabota

Skubic, Peter
AUSTRIA
www.peterskubic.at
© Peter Skubic

Sophocleus, Despo
CANADA/GERMANY
desp_s@hotmail.com
© Mirei Takeuchi

Speckner, Bettina
GERMANY
www.bettina-speckner.com
© Bettina Speckner

Stach, Gisbert
GERMANY
http://gisbertstach.wordpress.com
© Andrzej Sadowski (PB Group)
© Gisbert Stach
© Rose Stach
© Géza Talabér
© Arion Kudasz Gabor

Stolz, Antje
GERMANY
www.stolzesdesign.com
© Michaela Fanderl

Svensson, Tore
SWEDEN
www.toresvensson.com
© Karl Franz

T. **Tarín, Edu**
SPAIN
http://edutarin.blogspot.com
© Eduardo Tarín

Tridenti, Fabrizio
ITALY
info@fabriziotridenti.it
© Fabrizio Tridenti

Tuupanen, Tarja
FINLAND
www.tarjatuupanen.com
© Lassi Rinno

V. **Van Oost, Nelly**
FRANCE
www.nellyvanoost.com
© Nelly Van Oost
© Carlos Monreal

Veenre, Tanel
ESTONIA
www.tanelveenre.com
© Tanel Veenre

Vermandere, Peter
BELGIUM
www.vermandere-verheyden.be
© Peter Vermandere

Visintin, Graziano
ITALY
isotta91@libero.it
© Graziano Visintin

W. **Walka Studio**
CHILE
www.walka.cl
© Karen Clunes
© Carlos Damanée

Walker, Lisa
NEW ZEALAND
www.lisawalker.de
© Lisa Walker

Walz, Silvia
GERMANY/SPAIN
www.silviawalz.tk
© Silvia Walz

Willemstijn, Francis
THE NETHERLANDS
www.willemstijn.com
© Francis Willemstijn

Y. **Young, Anastasia**
UK
www.anastasiayoung.co.uk
©Anastasia Young

Z. **Zanella, Annamaria**
ITALY
zanella.annamaria@libero.it
© G. Rustichelli
© M.F. Magliani

Zimmermann, Petra
GERMANY
www.petrazimmermann.com
© Petra Zimmermann